Sustaining Loss

atopia

PHILOSOPHY POLITICAL THEORY AESTHETICS

Judith Butler and Frederick M. Dolan

EDITORS

Sustaining Loss

ART AND MOURNFUL LIFE

GREGG M. HOROWITZ

STANFORD UNIVERSITY PRESS

STANFORD, CALIFORNIA 2001

Stanford University Press
Stanford, California

© 2001 by the Board of Trustees of the
Leland Stanford Junior University

Printed in the United States of America
on acid-free, archival-quality paper.

Library of Congress Cataloging-in-Publication Data

Horowitz, Gregg.
 Sustaining loss : art and mournful life / Gregg M. Horowitz.
 p. cm. — (Atopia)
 Includes bibliographical references and index.
 ISBN 0-8047-3967-6 (alk. paper) —
ISBN 0-8047-3968-4 (pbk. : alk. paper)
 1. Aesthetics, Modern. 2. Art, Modern—Philosophy.
3. Materialism. 4. Death. I. Title. II. Atopia (Stanford, Calif.)
BH39 .H647 2001
111'.85—dc21 2001031192

Original printing 2001

Last figure below indicates year of this printing:
10 09 08 07 06 05 04 03 02 01

Typeset by James P. Brommer in 10.5/13 Garamond

For Ellen

Contents

	List of Illustrations	x
	Acknowledgments	xi
	Note on Abbreviations	xiii
1.	Introduction	1
2.	Culture, Necessity, and Art: Kant's Discovery of Artistic Modernism	25
3.	Art as the Tomb of the Past: The Afterlife of Normativity in Hegel	56
4.	Pompeii Beyond the Pleasure Principle: Death and Form in Freud	91
5.	The Tomb of Art and the Organon of Life: What Gerhard Richter Saw	133
6.	Art and Lamentation: Aboard Ilya Kabakov's Lifeboat	170
7.	Conclusion	194
	Notes	201
	Index	233

Illustrations

1. Gerhard Richter, *Skull with Candle* 157

2. Gerhard Richter, *Youth Portrait* 160

3. Gerhard Richter, *Confrontation* (1) 161

4. Gerhard Richter, *Confrontation* (2) 162

5. Gerhard Richter, *Confrontation* (3) 163

6. Gerhard Richter, *Hanged* 166

7. Gerhard Richter, *Funeral* 168

8. Gerhard Richter, *Funeral* (detail) 168

9. Ilya Kabakov, *The Boat of My Life* 186

10. Ilya Kabakov, *The Boat of My Life* (detail) 188

11. Ilya Kabakov, *The Boat of My Life* (detail) 189

Acknowledgments

After completing a book that cautions humility in the practice of philosophy, falling prey to the fear that one has failed to live up to the spirit of one's own counsel is almost unavoidable. That my anxiety is not even greater is due only to my good fortune in having friends and colleagues who were willing to devote some of their time to holding my feet to the fire I am responsible for building. I would like to single out for thanks Robert Ehman and John Lachs, my colleagues at Vanderbilt University, who offered important criticisms of early versions of Chapters 2 and 6; Claudia Baracchi, Lydia Goehr, Tom Huhn, and Michael Kelly, my friends whose constancy I hope was not too sorely tested during the final months of writing; and Jay Bernstein and Idit Dobbs-Weinstein, dear friends whom I am fortunate to count also as colleagues and who, in their quite divergent ways, have served as my models of what a materialist critic needs to do.

I would also like to acknowledge some guardian spirits of *Sustaining Loss* whose faces I would not recognize: the anonymous readers for Stanford University Press for their helpful commentaries, and the University Research Council at Vanderbilt University for providing me with a research grant that enabled me to extend a sabbatical from teaching duties at a key moment in my writing. I would also like to thank the editors of *Constellations* (vol. 7, no. 2) for publishing an earlier but similar version of Chapter 6 in a forum on aesthetics in late capitalism.

Finally, there are four debts I must acknowledge in the face of the certainty that I can never repay them. To my parents, Lynne and Aaron Horowitz, who spent time hatching this book long before they or I knew it had been conceived. To my sister, Donna Horowitz, whose support never flagged even during dark times and who, in that way, taught me how loss is sustained by love. To my teacher and friend Marx Wartofsky, whose death I still grieve; losing Marx forced me to spend months searching alone for errors of argument and tact that

he would have caught in the time it took us to finish our sandwiches. And to my wife and companion, Ellen Levy, who allows me to stay close to her secret knowledge of the many ways art matters to life: because she teaches me every day how love always cohabits with loss, and how these forces come together in the mysterious space between irredeemable aspiration and the concreteness of living, this book is hers also in ways no one will ever quite know.

Note on Abbreviations

Citations for frequently cited works will appear in the body of the text, in parentheses, using the following abbreviations.

Immanuel Kant

CJ *Critique of Judgment,* trans. Werner S. Pluhar (Indianapolis: Hackett Publishing, 1987). References will be of the form (*CJ X*, pp. *YY–ZZ*), where *X* designates the section of the *Critique of Judgment* and *YY–ZZ* the pages in Pluhar's translation. Citations in German are from Immanuel Kant, *Kritik der Urteilskraft* (Hamburg: Felix Meiner Verlag, 1990).

G. W. F. Hegel

ILA *Introductory Lectures on Aesthetics,* trans. Bernard Bosanquet (New York: Penguin Books, 1993). References will be of the form (*ILA XX*), where *XX* designates the pages in Bosanquet's translation. Citations in German are from G. W. F. Hegel, *Vorlesungen über die Ästhetik,* vol. 1 (Frankfurt am Main: Suhrkamp Verlag, 1970).

Sigmund Freud

All references are to *The Standard Edition of the Complete Psychological Works of Sigmund Freud,* trans. under the general editorship of James Strachey (London: Hogarth Press and the Institute of Psycho-analysis, 1953–74). Below is an alphabetical list of the essays to which regular reference is made, along with the volume numbers of the *Standard Edition* in which they are located. References will be of the form (*Essay XX*), where *XX* designates the pages in the volume of the *Standard Edition* (*SE*) listed here. Full citations for texts of Freud to which I refer just once will be found in the Notes.

CW "Creative Writers and Day-Dreaming," *SE* 9
ID *Interpretation of Dreams, SE* 5
MMi "Moses and Michelangelo," *SE* 12
U "The Uncanny," *SE* 17

Citations in German for (a) *Beyond the Pleasure Principle* and "Mourning and Melancholia" are from Sigmund Freud, *Das Ich und das Es: Metapsychologische Schriften* (Frankfurt am Main: Fischer Verlag, 1992); (b) *CW, MMi,* and *U,* from Sigmund Freud, *Der Moses des Michelangelo: Schriften über Kunst und Kunstler* (Frankfurt am Main: Fischer Verlag, 1993); (c) "Fragment of an Analysis of a Case of Hysteria," from Sigmund Freud, *Bruchstück einer Hysterie-Analyse* (Frankfurt am Main: Fischer Verlag, 1993); (d) *ID,* from Sigmund Freud, *Die Traumdeutung* (Frankfurt am Main: Fischer Verlag, 1991); (e) "Notes upon a Case of Obsessional Neurosis," from Sigmund Freud, *Zwei Krankengeschichten* (Frankfurt am Main: Fischer Verlag, 1996).

The aesthetic pundit—a kind of mandarin-tyrant—always puts me in mind of a godless man who substitutes himself for God.

CHARLES BAUDELAIRE

Introduction

> Knowledge no sooner starts from scratch, by way of a
> stabilizing objectification, than it will distort the objects.
> Knowledge as such, even in a form detached from substance,
> takes part in tradition as unconscious remembrance; there is
> no question which we might simply ask, without knowing of
> past things that are preserved in the question and spur it.
>
> THEODOR W. ADORNO,
> *Negative Dialectics*

I

Many would disagree - oath of the Horatii

The first modernist work of art is a painting of death: Jacques-Louis David's *Death of Marat*. So claims one of our foremost historians of modernism.[1] Taking his bait, we could develop a broad and ramifying history of modernism by beginning in 1793 and following the trail of fatalities: Gustave Courbet's *Burial at Ornans* and *The Trout*; Édouard Manet's fragment *The Dead Toreador*; Thomas Eakins's *The Gross Clinic*; Pablo Picasso's *Guernica*; Pierre Bonnard's *Nude in Bathtub*; Joseph Cornell's *Untitled (Bébé Marie)*; Andy Warhol's *Saturday Disaster* and *Gangster Funeral*. And today, the best and most serious visual artists are married to what life has fled from: Bernd and Hilla Becher, David Hammons, Ilya Kabakov, Gerhard Richter, Robert Ryman, Cindy Sherman, Jeff Wall, and so on. *Sustaining Loss* is an effort to understand why, at this late hour, art should become bound to memorialization.

Precise historical periodization is, of course, a fool's game, so attaching a date to the birth of modernism can be no more than a bald provocation. Indeed, no provocation seems to invite derision more immediately than the identification of modernist art's origin with the advent of death as the subject matter of paint-

ing, since the Christian West is positively saturated with images of the dead Christ. However, for every dead Christ in the history of art there is a Christ resurrected, and for every resurrected Christ there is an assumption of the Virgin. Even when such pendant images are not directly displayed, they are always entailed; the image of the dead Christ is only one joint of the great Christian narrative of death and rebirth, fall and revival, incarnation and transcendence.

Death is not like this in modernist art, where the end of life is not absorbed by the beginning of the afterlife. Death now appears without a narrative of transcendence to reflect additional layers of meaning back on to it from another scene of life. But further, in losing its narrative anchoring, death ceases being mere subject matter for art; the absence of a proper sense of its consequences turns death into a *formal* problem of the relation between an earthly medium and a nonearthly significance to which that medium can no longer attain. Death does not stay put in the modernist image; it fatefully penetrates the very medium of art, turning that medium into the site of nontranscendence. Whereas the dead Christ was the very image of life eternal, Courbet's trout is the image of eternal death. And even the works of those modernist artists least likely to have lingered with the dead—Henri Matisse, say, or Agnes Martin—carry with them in their practice the taint of a nonliving past that they do not quite overcome. In modernist art, death does not appear as the prehistory of the significance that will be unveiled in its wake; it simply persists.

Just as artistic modernism is born as a nullification of transcendence, so, too, is modern aesthetics. Periodization in the history of philosophy is just as perilous as in the history of art, but in and after the eighteenth century some novel feature of aesthetic reflection begs for attention that the prior history of philosophy does not prepare us to offer: the effort to provide foundations for the cognitively disreputable judgment of taste. Because a judgment of taste is a *judgment*, it requires foundations for its claims to extrasubjective validity, but because it is *of taste*, of the senses, the norms of such a justification are immensely difficult, if not impossible, to specify. In eighteenth-century aesthetics, to put the same point most directly, the apparent differentiation of the careers of cognition and *aisthesis*, of knowing and feeling, becomes a focal problem. For much of that century, and, indeed, right up to the present, philosophers tried to repair the breach either by making the true object of aesthetic judgment nonsensuous or by inventing a seventh sense with its own proper norms; in either case, the philosophical project aimed to re-equip cognition with the conceptual tools it needed to rein in the scandalous judgment of taste.

Immanuel Kant's great achievement was to show that this project cannot be brought to a successful conclusion. It is from Kant's proof that in principle there

cannot be laws of taste, and that therefore judgments of taste cannot be warranted by any cognitive practice—including philosophy—that we can date the beginning of modern aesthetics. In other words, our aesthetic situation emerges with the dimming of the prospects for a theoretical understanding of judgments of taste, and of our experiences of taste's objects (including art), that would permit us to leave behind their noncognitive and irredeemably personal aspects. Further, because after Kant it is unavoidable that we cease regarding aesthetic experience as a narrative node in the story of the transcendence of *aisthesis*, from that point onward we have also been burdened with the problem of the autonomy of art from other social practices in which it, or at least our understanding of it, might otherwise be firmly and properly embedded. Thus, modern aesthetics and modernist art alike are born of a perception of the finitude of sensuous life. *Sustaining Loss* is also an effort to understand the fateful centrality of this perception to the development of aesthetic theory.

That modernist art and modern aesthetics both grapple with the failure of transcendence could be told as two separate but parallel stories. Nothing forbids writing a history of either one cleansed of all reference to the history of the other. Indeed, in the face of the ever greater eccentricity of the paths of cognition and *aisthesis* since the eighteenth century, it might well be argued that their respective disciplines—philosophy and art—necessarily have progressively less to do with one another both historically and conceptually. As artists veered away from the Renaissance ideal of the roundly cultured humanist, modern aesthetics grew ever more preoccupied with the art of the past; a knowledge of Kant would be a gaudy bauble in a study of Cézanne, while the understanding of Friedrich Schiller, G. W. F. Hegel, and Friedrich Nietzsche would be better supported by a study of Greek art. This might be a bit of an exaggeration and, following the critical writings of Clement Greenberg and Theodor Adorno, a misleading characterization of contemporary practice. It is, however, sufficiently true for the historical period traversed by this book that the effort to conjoin modernist art and modern aesthetic theory in one story needs an initial apology.

From the side of the history of art, the apology is reasonably easy to craft. With the breakdown of the academic and aristocratic control of artistic creation and reception, art lost its straightforward connections to its traditional social bases. A gap opened between the practice of art and its functions, and so between the work of art and its meaning. With the eruption of this instability at the heart of artistic practice, art for the first time floated free of contexts in which its meaning could be normatively determined and thereby became unable to sustain proper standards of judgment. The loss of social mooring is the background both of the birth of artistic modernism and of the emerging problem of the judgment

of taste (judgments of beauty that cannot be grounded in given social norms). In the absence of a stable social context, or, put more precisely, in the *aesthetic* context of the absence of a stable *social* context, the judgment of art came to demand *theoretical* reflection in order to lay any claim to extrasubjective validity at all. In this way, the problems of aesthetic theory can be seen to have arisen at the center of an artistic practice that is already on its way to its modernist fate.

From the point of view of aesthetic theory, however, the apology is more complicated. After all, eighteenth-century aesthetic theory was preoccupied first and foremost by problems connected with beauty and sublimity as natural phenomena and not with problems of art. The ultimate philosophical thesis of *Sustaining Loss* is that the thought of the failure of transcendence that comes to be at the center of aesthetic theory only confronts aesthetic theory with its savage force when aestheticians try, as they must, to extend the philosophy of natural beauty to include the unmoored beauty of art. Art, which ought to articulate the boundary between nature and culture, between the divinely ordered and the freely fabricated, instead makes that boundary impossible to stabilize, because art, set free from the academic and aristocratic norms, appears now as asocial. In the face of that difficulty, the traditional hierarchy of nature and art which was, of course, still active in eighteenth-century aesthetics, grows wobbly, and so, too, the traditional aims of culture. Under such conditions, the task of aesthetic theory as the proper ordering of cognition and *aisthesis* necessarily undergoes a mutation. It is, in short, in the effort to bring autonomous art under its wing that aesthetic theory, and through it ever broader swaths of philosophy, find their own limits. Exactly how this happens is the story of this book, but the consequence of its happening is that aesthetic theory takes on a new shape as a reflection on the lack of an afterlife, the necessary nontranscendence of history, of sensuous existence. And as the nontranscendence of the finitude of sensuous life becomes the central problem of modern aesthetics, modern aesthetics becomes a philosophy of art, a discipline devoted to the problem of the persistence of the past, its nonovercoming by narratives of redemption, and, so, of the traumatic persistence of death in a secularizing age. In this light, modernist art appears as the historical truth of the history of modern aesthetic theory.

In treating the nontranscendence of death as, so to speak, the indigestible grain of sand buried invisibly at the core of aesthetic theory, *Sustaining Loss* aims to be an exercise in materialist aesthetics. The specificity of "materialism" will become clearer as the argument unfolds, but I can comment briefly now about the specificity of its motivation. Whereas most histories of aesthetic theory, for the sake of analyzing art and aesthetic experience more perspicaciously, aim to tell developmental stories in which aesthetic concepts become clearer, sharper, per-

haps even freshly invented, my motivation is to track what aesthetic theory cannot give proper shape to but to which it is historically bound for just that reason. Materialist history treats historical development as a response to a disturbance, a wound, rather than as a free pursuit of a self-arrogated end. In this sense, it is attuned to what remains unspoken in the practice, to what it would be better for us not to hear. A materialist listens for that which makes its demands heard only in its residual insistence that it not be left behind in a glorious self-developing history, that which has not been transcended even as it has been forgotten. _Sustaining Loss_, therefore, is devoted to sustaining not the affirmative achievements of aesthetic theory but rather the moments when aesthetic theory most powerfully sustains the loss of the power of transcendence. To come after—as philosophical history always does—when coming after no longer means redeeming what has been left behind, is to suffer a failure of history. Sustaining this suffering, having no _faith_ in history, is the motivating background of this book.

II

During those times when we humans still had a history, we possessed techniques, or arts, through which our forms of social life were transmitted to coming generations by previous ones. Painting and poetry, theater and song, sculpture and dance, were all generative practices, ways of making the future of cultures by making their past and present agonies and achievements vivid in times yet to come. And just as art was a striving toward a proper future, so too were the various ways of thoughtfully engaging with it. Reflection on art was a way of receiving and unlocking, responding to and living with, the social struggle art transmitted. Indeed, the manifold internal connections between art and the reflection on it were so tight that to start with a distinction between them immediately runs the risk of anachronism. It might be better to say, therefore, that art and its reflection together were constituents of a complex transmissive practice.

Today, of course, this picture of art and reflection seems archaic. It is only a mild exaggeration to say that in current common sense, both the making of art and its reception are individualistic affairs and that therefore, far from being a mode of transmission, art is instead a privileged form, even _the_ privileged form, of the creation of meaning _ex nihilo_. The overarching structure of a normative past orienting a striving present, and the relation of master artist and apprentice-student that was the social-historical cell of that structure, are both in ruins. Art now is thought to arise out of an antagonism between an individual's spirit and what surrounds and precedes it; as an addition to reality, art is regarded as a reflexive enemy of the cultural everyday. Systematic reflection on art exhibits in its

own fashion this contemporary effacement of art's transmissive function, by searching for timeless definitions of art and thereby treating art as in essence disconnected from and no longer emerging from living histories. Art, it seems, has grown mute about its own past, and theorizing about art in turn has grown deaf. This discontinuity in the history of art, as it appears in both art and systematic reflection on it, is the puzzle at the center of this book.

There are two central claims I will be pressing. In my first three chapters I shall argue that the intimate binding of art and reflection around the matter of generational transmission did not disappear quietly. By discussing three figures from modern (as opposed to contemporary) philosophical aesthetics,[3] I will try to show that the efforts to understand the nature of art that constitute the surprisingly coherent history of that reflective practice are in fact efforts to understand the concrete workings of art in an age of transmissive crisis. Kant, Hegel, and Freud in particular will be investigated as theorists of a crisis of the relation of past and future who recognized the central role of art in making vivid—in experiencing—that crisis. Their theories of art will be interpreted as efforts to continue to inherit what art transmits and fails to transmit by means of a rethinking of the nature of artistic creation and aesthetic attention.

In my last two chapters I turn my attention from philosophical aesthetics to specific practices of contemporary art. I will try to show that at least some of the radical transformations of artistic form characteristic of modernism can best be understood as efforts to keep art's transmissive possibilities alive in the age of transmissive crisis. Ilya Kabakov and Gerhard Richter are the two artists I will discuss, since the relation between a lost inheritance and the slender possibility of experiencing that loss is formative for their work. Through a detailed critical analysis of some of their works I hope to show how our noninheritance of the struggles of previous generations is figured as a living fact for us. In those works, in other words, the past is presented in its nonanimacy, its mortification, such that that nonanimacy can be grasped as a relation to a still active past. Informing my analyses will be my second claim, that the experience of nontransmission and noninheritance, the experience to which the phrase "sustaining loss" refers, is the experience to which a reflective philosophical aesthetics must now be beholden. Philosophical aesthetics, therefore, will be portrayed as a mode of historical reflection the contemporary possibility of which depends on its capacity to sustain, to keep active, the loss sustained or suffered by art.

A certain peculiarity in my procedure requires immediate acknowledgment. The thinkers on whom I will focus are from a tradition of reflection which, in the second paragraph of this subsection, I identified as largely finished. Indeed, since the text of Kant with which I open my theoretical discussion, the *Critique of*

Judgment, is often regarded as the founding text of German absolute idealism, and the texts of Freud with which I close it are equally often regarded as the last effort to compose an overarching narrative of European identity, it would not be unreasonable to say that my theoretical discussion is entirely of the distant nineteenth century. Yet when I discuss art, my focus is on late-twentieth-century artists whose work can only be understood in light of the disasters produced by the nineteenth century's obsessive focus on identity. Is this conjunction arbitrary, or deliberately anachronistic? In the end it will be up to the reader to decide whether my defense is adequate, but it is this: the tradition of modern philosophical aesthetics from the mid-eighteenth through the early twentieth centuries, in which Kant, Hegel, and Freud are the central figures, is the site of an extended *critical* interrogation of identity in the age of the crisis of inheritance. Put both more and less simply, in Kant, Hegel, and Freud the problem of post-traditional identity, the problem of enlightened modernity, receives deep investigation, and it is in this context that the specific fate of art becomes uniquely burdensome. Neither this problematic context nor the crisis of art it generated have disappeared. To the contrary, one might say that the disasters of our time to which Kabakov and Richter respond with their search for innovative forms are produced over and again not by too much concern with modern identity, but by its inadequate attainment. To the extent that reflection on the crisis of art was a way of coming to grasp the nature of identity in enlightened modernity, the concerns informing the themes and arguments of the nineteenth century are still our concerns. From this point of view, the idea that the critical orientation of nineteenth-century philosophical aesthetics is somehow behind us and that we have moved on to something new and better contributes to our difficulty in grasping the problem of noninheritance; it threatens to consign to historical oblivion those resources left to us through which we might grasp our present condition. Paradoxically, then, the reception of Kant, Hegel, and Freud —the reception of their own receptions of the problem of historical transmission—has become even more pressing for us directly in proportion to its increased difficulty.

How, though, are we to try to inherit them—to understand them—in our present moment? It might not be the only way, but one possibility is to inherit them through contemporary modernist artists whose work can only be grasped in light of the problem of sustaining loss. Kabakov and Richter are great artists whose achievements, I will argue, can best be comprehended in light of the question of what art can do when it can no longer forthrightly transmit the struggles of previous generations to future ones. If I am right, then the effort of understanding they impose on us can be met only with a reflection informed by a kind of "thinking otherwise" that is in danger of liquidation. From Kabakov

and Richter, in other words, can be gleaned the continuing necessity of the reflections by Kant, Hegel, and Freud on the crises of continuity and discontinuity. Thus, perversely, through an effort to hear what contemporary art stutteringly strives to voice, we might still orient our reflections toward the older problem of the place of systematic reflection on art in the project of historical transmission, albeit "under new and difficult conditions."[4]

In the remainder of this introduction I will pursue three aims. In section III, I will put a little bit of flesh on the skeletal picture of the discontinuity within the history of art I referred to above. In section IV, I will do the same for the discontinuity within the history of reflection on art. In section V, I will lay out the conceptual background of my efforts to inherit the thoughts about art, reflection, and historical transmission in Kant, Hegel, and Freud, as well as some of the complexities and pitfalls that await it.

III

By the time the Greek philosophers got around to reflecting on art, its transmissive capacities were already deeply troubled. The defeat of Athens in the Peloponnesian War was only the most pressing evidence that the repeating of traditional wisdom was insufficient for its effective transmission, since were it sufficient then Athens would not be trembling at the edge of its fall. Art's implicit claim to transmissive authority rested on the successful regeneration of the *polis*, so the moment that the claim became explicit was simultaneously the moment it was falsified. Once one could ask whether a piece of received wisdom was true regardless of its having been handed down properly through artistic traditions, the intertwining of art and legitimated inheritance had begun to come apart.

This, at least, is the argumentative strategy Plato adopts in the gently mocking Socratic interrogation of Ion the rhapsode. Ion is a specialist in the reciting of Homer, a specialty that to contemporary sensibility would seem to be a performance skill. But the common ground of conversation for Socrates and Ion is the belief that the performance of poetry is not extrinsic to the acquisition of knowledge; it is, rather, one of its primary modes. In Greek education, students were not taught poetry as a mere adjunct to an otherwise prosaic education; they were taught by means of poetry. Poetry was both tool and subject of Greek pedagogy.[5] Hence, implicit in Ion's claim to expertise in the recitation of Homer there is also a privileged claim to knowledge of what is being transmitted from the time of Homer. After Socrates has gotten Ion to acknowledge that he lacks the arts with which to judge the truth of Homer's descriptions of charioteering and fishing, the

rhapsode finally falls back on his knowledge of what generals should say to their troops, a knowledge of the rhetoric of leadership, authorizing his claim by saying, "I learned this also out of Homer."[6] But when Socrates asks Ion whether what he claims to know is right and at the same moment forbids Ion from answering in the affirmative just because it is Homeric wisdom he can recite, the rhapsode is reduced to silence.[7] Ion has no other criterion to consult than the divine tradition of which he is the vehicle, and at this point in Athenian history the question whether that tradition is self-validating—is really divine—is obviously doubtful.

The pedagogical function of poetry for the Greeks is reasonably well known.[8] Perhaps somewhat more obscure, but by no means unexamined, is the pedagogical function of painting and sculpture. Again, the interesting point for now is not so much that these media were something the Greeks taught, which is obviously true, but that they taught by means of them. In his analysis of the development of canons of perspective in Greek art, E. H. Gombrich argues that the techniques of perspective construction were developed under the pressure of the "eyewitness principle," the demand that painting and sculpture illustrate and preserve cultural history and prehistory for those not able to witness it directly.[9] What mattered for the artist, therefore, was the invention of forms capable of generating a nonreflective conviction of witness (hence the oft-repeated legend of Parrhasius's deception of Zeuxis). As in poetry, so too in painting: the art was a technique of preserving *what* had been known before *as* it had been known.[10] It is therefore no surprise that when Plato turns his cold eye on the arts again in the final book of *The Republic*, painters are also convicted of ignorance parading under the mask of wisdom.[11]

The Platonic interrogations came late in the history of the Mediterranean, in the specific sense that so many of its cultures were by then literate. With the invention of writing, tragedy and comedy—which of all the Greek arts have been most analyzed as wisdom practices—had developed into a script-and-dramaturgy form such that we have been able to inherit their fragments. However, it would be anachronistic to think of them therefore as essentially written forms. Just as they had been in their earlier, preliterate history, drama and comedy, like poetry, were sung, that is performed, transmissions of knowledge (and the written portion of the performance was a script, a writing for the sake of being spoken aloud). For the Greeks, theater was a brew of cultic, religious, and civic elements in which the myths and legends that had been heard since before written records were re-enacted or re-presented in an exhibition that staged cultural continuity. Friedrich Nietzsche goes so far as to argue that the tragic theater was a ritual of cultural *renewal*, an artistic festival for the celebration of culture's perpetual rebirth from nature. By inviting Dionysus into the space of cultural life

through the *scæna* that articulates nature and culture, Greek theater vouchsafed cultural continuity by exhibiting its source in the disruption of uncultivated and timeless nature. If we understand "nature" as that which culture has always taken itself to have left behind but with which it still must settle accounts, then even Nietzsche's radical interpretation entails that tragedy is a means for reweaving the future of culture out of its historical past.[12]

We have so far made our point about transmission largely indirectly, by means of inferences from the confessions elicited by Plato's Socratic questioning. However, the mention of tragedy provides an occasion to make the same point more directly. Aristotle is to all appearances an apologist for tragedy against the Platonic charges. For this reason, Aristotle's arguments in the *Poetics* can be interpreted as if he has accepted the basis of the Platonic indictment that art is not a purveyor of wisdom yet mounts nonetheless a noble defense of the value of the emotional turmoil art produces in its audience. But this interpretation is entirely wrong. While Aristotle does defend the undergoing of emotion induced by art, he does so by restoring to that emotion an essential cognitive component—that is, by explaining how emotion is a means of knowledge. The catharsis suffered in watching tragedy is made possible by the artistic imitation of actions that instantiates universals through which the audience experiences the emotions suitable to those actions. The audience, in other words, learns through imitation. Aristotle's point, then, is that art properly understood is still a form of teaching and learning, of transmitting and inheriting. (No other argument, really, would be a response to Plato.) While it has been noted often enough that Aristotle therefore judges poetry of greater philosophical import than history, since poetry is of universals while history is only of particulars, it has *not* been noted often enough that history is the proper contrast for Aristotle because it and poetry contend for the privilege of transmitting the past. Even when the tragic poet keeps to actual names in the service of credibility, it is still a poetic error to confuse credibility with possibility or necessity; the poet's work is to present the actual in its modality, that is, as an actual outcome of a flow of necessities and possibilities.

> It is also obvious from what we have said that it is the function of a poet to relate not things that have happened but things that may happen, i.e. that are possible in accordance with probability and necessity. For the historian and the poet do not differ according to whether they write in verse or without verse— the writings of Herodotus could be put into verse, but they would be no less a sort of history in verse than they are without verses. For this reason poetry is a more philosophical and more serious thing than history; poetry tends to speak of universals, history of particulars. A universal is the sort of thing that a certain kind of person may well say or do in accordance with probability or

necessity—this is what poetry aims at, although it assigns names [to the people]. A particular is what Alcibiades did or suffered.[13]

In a judgment only possible after the writing of Thucydides, who described his aim as making the lessons of the Peloponnesian War "a possession forever," Aristotle judges that history, in hewing too closely to the actual, is ill-equipped to present the actual in a way that can make perspicuous how it became actual.[14] In other words, history evades the modal question of *how* the actual becomes available to us through imitation. Aristotle's defense of poetry, thus, is a defense of it as the privileged mode for the transmission of wisdom.

In order that this point about the traditional function of art not be thought to apply only to oral or transitionally post-oral cultures, let us consider another example of the same function of art from a later historical period. In his treatise *De pictura* (1436), Leon Battista Alberti offers an argument for art—painting specifically—as an intellectually significant enterprise.[15] Although it is in arguments like his that later conceptions of the fine arts as distinguished from mere crafts would retrospectively find their origins, ascribing the making of such a distinction to Alberti would be anachronistic. Rather, Alberti's aim was to identify painting as a craft with a unique function: to make vivid to the painter's contemporaries that the legitimacy of the newly powerful Italian city-states arises from their proper embodiment of ancient virtues and, in making this vivid, to make those contemporaries proper citizens of those states. In painting, a syncretic image of time past and time present could be forged; just as painting could be a classical art, so too could the cities in which it thrived be sites of classical renascence.[16] Although the syncretism of the practice Alberti had in sight is so obvious to modern eyes that the claims for historical continuity are hard to credit, nonetheless that continuity was the basis of Alberti's effort to accord special craft status to painters.

While Alberti's treatise was intended to be read by the educated elite (Florence was a literate city, but reading Latin was still an elite capacity and, in any case, it was from the elite that patronage would flow to the new style of art Alberti was defending), it would be a mistake nonetheless to infer that his historical apology was valid only for those who could grasp it in its literary form.[17] The aim of *De pictura* was to formalize and disseminate a practice of painting, not just a theory of it; in other words, the establishing of the continuity between past and future glories was intended to be artistically achieved. One piece of evidence for this aim is the treatise's publication both in Latin and then in the "unadorned" vernacular (as *Della pittura*) so that it could be used as a manual by craftsmen.[18] But another and more important piece of evidence is Alberti's claim that the final judgment of the adequacy of a painting had to be made *nel*

lume della piazza, in the light of the public square. That classical knowledge had been transmitted to educated elites in a sense went without saying, since they could be presumed to understand the treatise in a language, Latin, that in itself bespoke classical education. But the transmission to and by means of elites was characteristic of the medieval monastic separation of knowledge from civic life, and the function attributed to painting by Alberti was the transmission of wisdom for a broader public.[19] The light of the public square, as David Summers has shown, was the enlightenment of the public, its being rendered capable of bearing the knowledge that constituted the rebirth of classical virtue.[20] The public square was thus both the subject and the site of Albertian painting, and its illumination both the means and the product. Painting could only succeed, and so deserve the status of a special craft, to the extent that it served as a vessel for the distribution of the wisdom of the past.

Since these brief discussions of the traditional transmissive function of art are only intended to provoke interest in the question of art's fate in the era of transmissive crisis, there is no point in multiplying them further. In any case, were we to attempt to generate later examples, we would begin butting up against the era of crisis itself. We can see in Alberti already the seeds of the crisis in his apology for establishing a determinate relation to the past by means of what seems *even to him* to be a kind of fiction. In other words, by the fifteenth century, the *querelle* over the transmission of the past had already begun to give rise, or give way, to the contest between the past and the present that is our proper subject.[21] So let us leave our examples behind and begin to draw a more general conclusion. However, we need to start with a proviso. While sketching art's traditional function, metaphors such as "vessel" and "carrier" offered themselves naturally. Such metaphors suggest that by "artistic transmission" we should understand art, in its traditional uses, to be a means for communicating semantic content across generations. And indeed, we should understand it that way in part. But we must not be misled by these metaphors into construing "means" as "mere means." Art did transmit content, but it was not an empty bucket into which content was poured. Rather, art also transmitted the manner of representing and preserving that content. In transmitting the content it also transmitted itself or, put most precisely, it transmitted the content by transmitting itself. With our proviso in mind, then, the general point is this: since what was at stake in art was transmission, we must understand the very idea of artistic content, as well as artistic form, in terms of its transmissibility.

This idea of the self-transmission of art can be grasped most easily through one of its most obvious instances: carved or incised stones used for funerary monuments. In older cemeteries one finds monuments etched with versions of

the imperative "forget me not." Such stones are the most powerful testimonials to the profound forgetfulness of human beings. Even though these messages were meant for the closest relatives of the deceased, those we would think least likely to be in danger of forgetting, there was nonetheless the need of a reminder to remember. Further, these sorts of monuments are frequently found in cemeteries containing remains from communities in which a later reacquaintance with the deceased was devoutly expected. Again, not only was the imperative still required, but further it was borne in material destined to outlive those to whom the imperative was addressed. The stone is the medium in which the striving for transmission is carved because the stone can be counted on to transmit itself. Unlike those to whom it is addressed, the stone needs no other means of transmission than its own stoniness. Thus, it is the stone which is transmitted, and the art of stone carving can be construed as the art of self-transmission.[22]

We continue to respond today in an especially powerful way to the memoriousness of the funerary stone. This makes it a particularly useful example for reminding ourselves of the mnemic function of all the diverse techniques of art. Rhyme and rhythm, iconography and choreography: they were all forms of etching crafted to inscribe their different materials. They were forged to be set against forgetting, as immunizations against the memory loss to which we are everlastingly committed. Art, we might say simply, was what outlived the passing of the generation that manufactured it. What art transmitted between generations, thus, was certainly this memory or that, but first and foremost the very power of memory itself. In passing along the incapacity to forget, art also passed along what was thus rendered memorable, but it did so by means of rendering inseparable the means and content of memory.[23] In all past art, thus, we can locate an implicit conception of generations as bound together through representational and affective practices. Succeeding generations were conceived as the bearers of the past in which the past imagined itself overcoming its finitude, and art was the sensuous vehicle of this transmission. The making of art was a culture's way of making its future by tending its past, of receiving from its past a mandate and license to preserve that past and pass it on.

An alternative way to put this point would be to say that what we now call art was once a social practice charged with the difficult and uncertain task of cultural generation and regeneration, of the transmission, which is to say also historical preservation, of forms of social life. However, what we call art was by no means alone in this struggle. Alongside material production and reproduction, the transmission of forms of social life was traditionally the most pressing concern of all cultural practices. From the everyday phenomena of manners and childrearing to the more exalted domains of religion, politics, and philosophy,

social life was inherently pedagogical. The universality of pedagogy tells us much about the dialectics of fate and faith, since just as each new generation was the vessel of the older one's survival of its passing, the new vessel was inherently untrustworthy and thus needed to be bent to its responsibilities. Put simply: social life was saturated with art. A lingering echo of this blending of social practice and the concern for its transmission to future generations can be heard in the continued use of the word "art" to refer to certain practices that do not correspond to any plausible contemporary sense of fine or high art whatsoever. Ted Williams's still influential book on baseball, *The Art of Hitting*, is a book on art insofar as it preserves for later batters the refinements in skill Williams attained for himself. To be an artist of hitting is to develop one's capacities in ways that others may imitate, and unless others may imitate them the capacities are not so much art as mere luck. The concern to make a gift of nature into an art is nothing but the concern to preserve that gift for those who will come later.

IV

Since generational transmission was the aim not just of "the arts" as we now understand them, but of other social practices also, it stands to reason that thinking about art as well as art itself was oriented by this goal. Because both art and reflection on it were elements of the same grand transmissive project, the idea that art might be a practice with a purpose different in kind from other cultural practices is not to be found in the history of thinking about art prior to modern times. While no single instance can establish this general point, let us return to a fragment of Western cultural history (which we have touched on already in the discussion of Plato) that would seem to offer the most powerful counterexample to it: the quarrel between philosophy and poetry that is as old as the former if not the latter. Because it is intuitively plausible to think of the philosophical contestant in this quarrel as committed to a view of art as pursuing an end different from its own, the quarrel seems to be *prima facie* evidence that art was seen from at least one perspective as having a different purpose from other cultural activities. This intuition, however, is based on a misapprehension, since, in fact, the famous quarrel depended on precisely the opposite presumption—that art and philosophy were after the same end. In the Platonic critique that sought to dislodge poetry from its place of cultural privilege, art was judged as failing to live up to the standards of the mission it had arrogated to itself. Philosophy then claimed that it was better suited to the task of historical transmission; in virtue of being a practice based on rendering accumulated knowledge

nonperspectival and thus logical, philosophy, it was argued, is able to sift real from apparent truths and pass on only the genuine articles. As Nietzsche observed, Platonic philosophy emerged as the effort to inherit the pedagogical functions at which art was failing.[24] Thus, when philosophy claimed the mission of historical preservation as its own, it did so not by offering a new definition of art but rather by endorsing art's self-image in order to appropriate and transform it. In the immanent critique of art through which philosophy's future career was established, art continued to be thought of as a flawed practice of cultural transmission, and so as one which shared its aim with philosophy.

Thus, just as art was a way of preserving and transmitting social life, so too was reflecting on art. Traditional thinking about art was, we might say, a way of assisting in the inheritance of what art was seeking to transmit. Even when striving to supplant art, it remained nonetheless a part of art's social function. The historical reach of this traditional conception of art and art reflection ought not to be underestimated. Indeed, in order to grasp the precise nature of our present moment, we need to work especially diligently to salvage the earlier conception from the historical oblivion imposed on it by the anachronistic projection backwards of contemporary concerns.[25] It is only in our century that the philosophical prospect of a timeless definition of art as such has arisen; put otherwise, only recently has the theorization of art sought to pursue its own aims independently of a reflective engagement with art's cross-generational purposiveness. There are, to be sure, contemporary thinkers of a pragmatic or constructivist bent who believe that the right way to pursue a philosophical account of art is in terms of its purpose, but it is an unavoidable philosophical issue, even for such thinkers, whether an historical approach is a philosophically respectable one.[26] But even as recently as the nineteenth century, during art's great era of crisis, the deepest thinkers about art—Hegel, Arthur Schopenhauer, Charles Baudelaire, Nietzsche—never broached the question of art's definition in abstraction from its transmissive purpose. It is only in this century that the idea has come to consciousness that art might be different in kind from other cultural practices—in particular, that it might not be essentially transmissive—and therefore that it might be possible to define it in itself. It now can look practically obvious that art always was ontologically distinct from the rest of culture even while granting that for most of its history it was being put to extrinsic cultural purposes; it can also look obvious, therefore, that the aim of the philosophy of art is to discern the extracultural site of art.[27] But in treating art as undialectically distinct from the cultural demands which surround it, we presuppose a philosophical illusion of our own moment. In this way we actively obscure the transmissive function of art and so find ourselves disposed, unsurprisingly, to denying that that func-

tion ever was intrinsic to it. We thus obscure simultaneously the transmissive function of art and reflection.

The list of nineteenth-century names above points us toward another way of making this same point about the historical continuity of the thought of art as transmissive. Until recently, thinking about art was always one way among several of thinking about cultural and historical life in general. That this was true for the vaunted Renaissance man—Leonardo, Alberti, Vasari—is so obviously true as to have become cliché; but even in those figures from whom the contemporary philosophy of art takes its orientation (and now we need to add David Hume, Edmund Burke, Kant, and Freud to the list above), thinking about art *was* thinking about culture, and vice versa. But even this formulation can be misleading if it suggests that art was one of the many things a thinker about culture might ponder at a reflective remove. It is more precise to say instead that both art and reflective thinking were aspects of social life that were commonly concerned with the transmission of that life. This is why systematic thinking about culture—or, simply, philosophy—always traced a great circle through metaphysical, epistemological, ethical, and aesthetic issues, regardless of where on the circle any particular philosopher might start. Systematic concern with culture always passed through the specific concern with art because there was a continuity between all aspects of cultural transmission. Art and philosophy, along with the other practices of thinking, teaching, and learning, were interconnected participants (which is not to deny that they were also frequently combative ones) in the overarching project of generational transmission.

However, the days are past when thinking about art was both thinking about and performing a transmission from past to future. It is common nowadays (although not universal) for the criticism and theorizing of art to exhibit no concern for art's connection to the transmission of culture and, in turn, for those concerned with the dynamics of cultural transmission to have no concern with art. This carving up of art theory and cultural theory can be witnessed in its several remnant domains. Art criticism has become an independent journalistic specialty. Its practitioners are largely makers of tastes and markets, agents and players in an "art world" which is itself relatively autonomous, institutionally if not economically, from other realms of social action. In turn, systematic philosophical thinking about art, which once was tied so intimately to critical reflection that one might reasonably have regarded it as part of an earlier regime of training for criticism, has also become autonomous. With rare exceptions, contemporary philosophy of art handles its special problems without much concern for the concrete struggles of art. The dominant approaches in contemporary philosophical aesthetics either pursue timeless definitions in the sense described above[28]

or are degenerately expressivist.[29] These two orientations, despite their real differences, share the belief that the relation between singular reflection on works of art and systematic philosophy is an extrinsic one.[30] And as the narrowly empirical concerns of art criticism and the broadly abstract ones of philosophy of art fitfully cohabit while hopefully awaiting their final divorce,[31] what passes for cultural reflection (or, as it is barbarously called, "cultural theory," as if it were somehow a discipline different from culture) floats free of the quarrel; by employing material production and reproduction as the appropriate model for cultural production and reproduction, the sociology of art has lost the ability to imagine the meaningful continuity between any two historical moments of what thereby becomes only in thought the same culture.[32] From no available point of view is art now regarded as a means of passing the accumulated burdens and achievements of previous generations to future ones.

However, to say that there is no longer any reflective perspective from which art can be seen as transmissive is to say that it is a peculiarity of our historical present that we have not inherited the transmissive function of art in a reflective fashion. The modes of reflection we have available to us do not offer us a way to receive and in turn transmit the practice of art as a mode of transmission. This loss, this failure of transmission and inheritance, is not, it needs to be stressed, like the quite common disappearance of a particular thought from memory. It is the loss of a power or capacity to think, on the order of the loss of a language or a people. In sketching the state of disinheritance characteristic of contemporary cultural reflection, then, I am also suggesting that contemporary cultural reflection, taken as a totality, is discontinuous with the history from which it emerges. We stand now in a relation of estrangement from the past that lived in the art that was sent our way.

A certain way of thoughtfully living a relation to art has disappeared, and with it, too, a certain solicitous concern to transmit culture between generations, the thoughtful living in relation to other people of which art was a central expression. That this marks a failure of art—necessarily so, given art's traditional function—is worthy of philosophical scrutiny. However, since it also marks a failure of scrutiny, the form such scrutiny must take is far from clear. If we live in the wake of the failure of art, then philosophy—understood, again, as systematic cultural reflection—must take care not to compound the loss by refusing to acknowledge its own commensurate disability. That there is a problem to confront can be acknowledged simply by noting that in contemporary philosophy, and not just in the philosophy of art, the idea that philosophical practice is intrinsically, and not only as an accidental by-product, a mode of transmission, has also fallen from favor. In its pursuit of truth for all times, truth not just un-

threatened but in principle immune from historical oblivion, philosophy has jettisoned its age-old concern to generate not just knowledge but knowers.[33] For ill or good, philosophy has recoiled from its own participation in the work of generation. It is thus a living question whether the appropriate form of scrutiny for art's failure is properly philosophical, at least in the sense of "philosophical" which is canonical today. I hoist this flag in warning: as we trace the ways we have not inherited the practice of art as an agent of historical transmission, we may also be limning a form of historical oblivion to which, without sufficient care, we might also contribute. It is with this warning in mind that I will turn to Kant, Hegel, and Freud, since it is with their assistance that I believe we may attend to our noninheritance without at the same time magnifying it.

V

No doubt the way I have set out the problem of art, reflection on art, and the relation between past and future generations, has aroused the suspicion that I court self-contradiction. To meaningfully call a relation between any two items "discontinuous" requires making a comparative judgment between them. Any claim about historical discontinuity in particular requires a framework in which the two elements can be contrasted as two instances of the same sort of thing. Regardless of the historical technique used in establishing such a framework, it remains a desideratum of specifically historical explanation that the identity of the later element be able to support a reasonable contrast with the earlier one. For instance, while it might be claimed truthfully that marriage laws in the postbellum South are discontinuous with the rules of the wool guild in Renaissance Florence, the claim would be historically vacuous; no imaginable framework can identify the later marriage practices as a transformative break from the earlier wool-trading ones. For a discontinuity claim to be an historical explanation (or a part of one), the identity of the later element must be a function of its difference from the earlier one. If we add the (logically independent) premise that what we call the "identity" of an historical practice is a norm, a means, that is, whereby two instances can be identified as of the same practice, then we must conclude that some principle of proper identification has been inherited across the purported divide. Now, if the later element in question is the very practice within which the discontinuity claim is being made, then for me to be able to make such a claim I must have inherited at least some of the criteria of identity—of continuity—the claim itself denies we have inherited. Therefore, the claim must be false.

This is a serious argument against certain forms of genealogy and historiography that are committed to radical discontinuity claims. It can be brought to

bear (arguably) against Foucault and the cult of synchronicity spurred by his ar-chaeological method.[34] It would be a just charge against the case I am making too if I were claiming that we now stand on the other side of a specifiable his-torical discontinuity across which we have inherited nothing and relative to which our period has its own proper coherence. However, I am making no such claim. To the contrary: I argue that we stand within—*we are*—the discontinu-ity in question. We moderns are the failure to inherit the relation of art and cul-ture that is nevertheless our own past. It is our knowledge of what we cannot re-member that shapes our identity. This will be a hard enough claim to establish, but it is in no danger of being ambushed by this particular logical absurdity.

It might also be suspected that the way I set out my theme guarantees I will run into a different problem, which, while perhaps not as threatening as the outright absurdity sketched above, will make my discussion of the problem in-coherent nonetheless. While successful inheritance establishes the coherence of a practice by locating its normativity in its relation to its own proper past, failed inheritance, by contrast, characterizes practices cut adrift from possible sources of normativity. If this is true, then failure to inherit cannot be an identity-establishing feature of any historical moment whatsoever—our own, naturally enough, included.

It should be admitted, before explaining that this problem will not foreclose my inquiry either, that it is nonetheless deep enough to inhibit it. I am open to the thought that modernity is not, properly speaking, an historical moment at all but rather a break in the logic of historical succession. Since I intend to de-velop a concrete alternative to this line of argument, let me at least note one of its major attractions (which I regard as an important aim of my own approach as well): it demystifies the idealizing of historical inheritance characteristic of a certain strain in the philosophy of history. It is a constituent feature of modern self-reflection that the determinate relation of the *Neuzeit*—the time of reflec-tion—to the past must be established ever anew in what is, ever anew, the pres-ent.[35] Modernity, put simply, burdens us with a debt we can never put to rest. Now, we sometimes seek to discharge overpowering debts by transforming them into universal conditions of life; we disavow their *particular* claims on us by sub-liming them into *philosophical* necessities. Thus, modern reflection often finds itself attracted to crafting philosophies of history through which we would grasp, not historical succession, but its universal logic. Philosophy then appears, like the gambler who agrees to do a favor for his bookie, to trump all its unpaid debts at once. If, in this light, we turn the tables by regarding the philosophy of history as a symptom of the burdensomeness of modernity rather than as a lightening of the load—if we treat it as philosophy's refusal to acknowledge its

specific historicity—then the noninheritance that characterizes modernity can be seen as a break in historical succession the experience of which gives rise to the impulse to suture it supra-experientially. Conceiving modernity as ceaseless rupture, instead of simply as a new challenge to our philosophical capacities for conceptual repair (the deep thought underlying the view that modernity is not a proper historical moment), thus would allow us to rethink the emergence of modern philosophy's compensatory relation to broken experience, its effort to re-establish normativity on "higher" ground. Such a suspicious hermeneutic would work to desublimate modernity's problem with normativity.

However, despite its manifest attractions, I shall not adopt this response to the charge that the failure of inheritance can give rise to no practice. Even sharing the conviction that philosophy of history cannot conjure up the normative grounds that history denies us, I still find the thought that modernity is simply bereft of norms too sweeping. I prefer instead to explore the possibility that modernity finds its norms elsewhere than in the moment of reflection, that modernity is the uncanny experience of one's norms not being properly one's own. This experience of a lost normativity moves me, roughly speaking, in a direction opposite to the attractive one sketched above: failed inheritance does give rise to a practice, the practice of sustaining loss, of undergoing it ceaselessly. Failures, no less than successes, have forms, albeit forms that never arrive at their final shape. The two practices of sustaining loss I focus on are philosophical-historical reflection and modernist art. I shall close this introduction with a first effort at defining what such practices are.

That historical reflection is a central movement of modern thinking almost goes without saying. Indeed, if we attend closely to the specific burdens placed on reflection in post-Kantian philosophy, we might well regard anxiety about the past's relation to the present time as our foremost stimulus to reflection. The writings of Kant, Hegel, and Freud are determined by their efforts to properly judge the relation between historically disjoint structures of meaning or, put more expansively, by their efforts to specify the nature of posttraditional modernity as a determinate nonrelation to what preceded it. However, these writings are not crucial to us simply because they aim to establish the discontinuity of the modern and the premodern, but more precisely because they claim for historical reflection a special role in doing so. The burden of the uninherited past, of the past which cannot be made to live in the present, generates needful reflection as the site in which our anxious relation to the past is represented and handled; post-Kantian reflection is haunted by the undead ghosts of what it reflects on. Reflection's privilege, therefore, is also a symptom of anxiety.

In treating reflection as an activity burdened by the relation of the modern

INTROD

22

rests on an
ing the p
conce
pro

and the premodern, Kant, Hegel, and Freud reg[...]
artifact in which our historical situation is expre[...]
diametrical to the many other forms of historic[...]
of its historical burden by presuming for it a c[...]
history it represents. This putative transparer[...]
pacity to show the scene of its origin without[...]
way showing its emergence from that scene,[...]
tery over its contents by locating the truth of histo[...]
scension of posterity to earlier historical necessities. From the self-assu[...]
a certain sentimental species of reflection derives from its attachment to the be-
lief that "those who do not remember the past are condemned to repeat it," we
may infer that it assumes that the disciplining of memory by historical reflection
offers a way into a time of free nonrepetition, a new time called, hopefully, the
future. The antitranscendent arguments I shall trace, on the other hand, eschew
the comforts of reflective mastery. By emphasizing the needfulness of historical
reflection they stage its entrapment in the webs of the historical generativity it
can never fully master. In Kant, Hegel, and Freud, historical reflection provides
a framework for transcending the specificity of the present moment, but only by
way of expressing also the need that constitutes the present moment as requir-
ing transcendence to begin with; as such, historical reflection for them never
ceases to be self-reflection and so perpetually shows back to us moderns our
own endless coming-to-be. Hence, as much as historical reflection is work on
the past, it is also the work of the past.

The specificity of the line of thought I follow may be put this way: historical
reflection is a necessity for us not merely because through it we witness the past
in reflective detachment from it, but rather because, even as such reflection
maximizes our detachment by representing the past as dead and gone, the force
of the dead past never expires in it. The privilege of history as memory's pros-
thesis derives from its transmission of the matter of the past, of what memory
fails consciously to transmit. Because the deadness of the past is its mode of re-
currence, our *need* for historical reflection is the past's revenge on its noninheri-
tors. However, whereas traditional ancestor worshipers suffered the greatness of
their predecessors, their extremeness of force, we suffer their weakness—and we
suffer it vividly as the endlessness of historical reflection.[36] The ceaseless return
to the scene of the crime, which is the very animacy of historical reflection, de-
rives from our not having been bequeathed the means we require to determine
where we stand. Somehow, our progenitors were too weak to craft for us, to
craft as us, what they needed from us, so we stand in the shadow of their inca-
pacity. Put in a (putatively) more philosophical vocabulary, historical reflection

unstable distinction between its concepts and its object; despite be-
imal concept of historical reflection, "history" magically names both a
t and its own proper object at once. That "history" is thought to be a
er concept at all, rather than the index of a need in which concepts suffer a
ameful confrontation with their material histories, suggests a profound wish-
fulfillment in modern consciousness. It is this wish-fulfillment that Kant, Hegel,
and Freud seek to expose and avoid. In short, "history" for them is not the story
of the transcendence of the dead past.

In the persistence of the nontranscended past within historical reflection,
Kant, Hegel, and Freud confront the trauma at the heart of post-traditional
modernity. On the one hand, modern historical self-consciousness knows itself
as unable to derive orientation from its historical predecessors; history is not for
us a mutual dialogue across time, but an unbalanced encounter in which we can
see the dead but they cannot see us. But among the myriad traditional orienta-
tions most palpably not available to modern historical self-consciousness is the
idea of history as the story of the transcendence of the past. The narratives of
history as redemption have been exposed as mythical by historical understand-
ing itself, and thus now are the mere detritus of the past we moderns cannot
take at face value. The past lingers as what we come after, and also as what, in
lingering, denies us the comfort of thinking of ourselves and our understanding
as its hidden purpose. To put the point a touch too dramatically, modern his-
torical self-consciousness can avoid falling back into myths of transcendence
only by acknowledging that the past, while dead, is not gone, and that we coex-
ist with it not as its afterlife but as its survivors.

However, we still need to ask how historical reflection can remain faithful to
the avoidance of narratives of transcendence. We need to find out more about
how the loss to which historical reflection is beholden can remain vivid in it.
These are the key questions my inquiry into Kant, Hegel, and Freud must ad-
dress, but they are not, we must caution immediately, to be answered in an a
priori manner. They are not, in other words, questions philosophy can answer
by reflecting on its *own* limitations; such a procedure, in making the limitations
in question already philosophical, would reassert philosophy's mythical tran-
scendence and thereby make it false to the self-critical thrust of its rationality.
Instead, we must return to the texts in which historical reflection in the service
of philosophy generates confrontations with specific, concrete failures of tran-
scendence. This is the ultimate reason to return to Kant, Hegel, and Freud: in
their writings, the urge for the transcendence of history comes face to face with
needs no transcendence can satisfy. Therefore, when I argue in the coming
chapters that the other face of historical reflection is art, that the loss historical

reflection can neither transcend nor redeem appears in art, I hope to show that aesthetic theory is the site of a mournful encounter between historical reflection—the discipline of memory—and the past that rises up before it as reflection's own untranscended condition of possibility in the present.

But why art? How has art become, as Hegel put it, "a thing of the past," a practice whose eminent force confronts historical reflection as reflection's uncannily present past? This is the question of how art, too, became a practice of sustaining loss, how it came to locate its norms in a past which, for the sake of fidelity to it, it hurtled away from. Artistic modernism stands in a mournful relation to its own past, in the specific sense that in a post-traditional age art can locate its norms, the standards that make it a coherent practice, only in a past it must, but cannot quite, live up to. Art is now perpetuated by the effort to introject its own past—which is to say by a mimesis of death. For the sake of a transmission yet to happen, for the sake of an experience that suffers from an inability to be represented and so stands in a traumatic relation to representation, art tarries with the dead. This is the source of the mournfulness of modernist art, of its unwillingness to leave behind a past that is nonetheless dead for it. Art continues only in sustaining this loss, and it is just this sustaining, this failure of art to transmit the past, that aesthetic theory encounters as the untranscended past harbored in the work of art.

It is this untimeliness of art that so often tempts us to call it "eternal." Since art has no progressive history (in the sense that Matisse is not an improvement on Manet merely in virtue of knowingly coming later), it is easy to infer that art is outside of time and thus is historically transcendent. When we recall, though, that art's nondevelopment is a feature of modernist art and not of some historically transcendent practice called "art," its untimeliness stands revealed as an immobilization, a nontranscendence of history. Art's preservation has come to depend on its being stuck, on its making itself stuck, in an imaginary moment before the impossibility of development flashed up before it. Timelessness, in other words, is the nontranscendence of suffering that confronts aesthetic theory as art's uncanny power: art appears timeless only because immortality is the one fate which is worse than death. The past stands out in art as the matter historical reflection needs to digest but which nonetheless it cannot swallow. Aesthetic theory is the locus of this reversal of history.

VI

One brief proviso is required before undertaking to make good on the promises of this introduction. The chapters on Kant, Hegel, and Freud are intended to

work cumulatively. They represent my effort to trace out a genealogy of materialist aesthetics from the struggle, spread out over the long nineteenth century, to understand how art came to exceed the power of aesthetic theory to conceptualize it. If successful, this genealogy will have the peculiar negative shape of showing how aesthetic theory came to terms with the limitations of its power. Its consequence, however, is that the recognition of the necessity of the failure of aesthetic theory to validate its conceptual coinage provides a silence in which the crisis of artistic and philosophical transmission can give voice to the claims of the dead. No one wants the prize of study to be merely negative, but the alternative, I fear, is deafness.

That the claims of the dead are at the center of modernist art, and that they are what allows art to matter still today, deserves a full-scale study in its own right. The chapters on Richter and Kabakov that bring *Sustaining Loss* to its conclusion may be considered as refugees from that study, as exiles invited into this one for the sake of uncovering the residue of suffering in aesthetic theory. I can only hope that asking them to embrace their exile does not constitute a moral hazard, although there is no doubt that it does. Equally without doubt, the thought of Kant and Hegel (less so of Freud) as materialist aestheticians will strike many readers as an act of violence against the history of aesthetic theory. Against that charge, I have no defense. Kant and Hegel are, of course, idealists, in almost every way which matters, and no less than when they deputize art in the service of systematic philosophy. That the effort to be a systematic idealist should turn out to be a way of fertilizing materialist blossoms is nothing less than the cunning of unreason. However, monstrous growths can be regarded as signs of the unexpected fertility of the best-tended garden. For the love of order, they should be weeded out. Nonetheless, a different history appears in them, a different relation between the past and the future. The tending of monsters might be tolerated for the sake of wishes as yet unclaimed.

Culture, Necessity, and Art: Kant's Discovery of Artistic Modernism

Authentic works must wipe out every memory trace of
reconciliation—in the interest of reconciliation.

THEODOR ADORNO,
Aesthetic Theory

I

It is a truism about Kant that his philosophy of art is a mere corollary of the critique of taste and the philosophy of natural beauty. The *Critique of Judgment*, where Kant develops his systematic aesthetic theory, is devoted to forms of judgment first and foremost and only secondarily to the objects that are judged. In other words, the subject of critique is a power of mind—judgment—rather than an element of the world, and the question whether there is an element of the world that corresponds to judgment's claims can only be addressed through the grounding and delimiting of that power. Thus, the question whether there really is a beautiful object at all can only be broached after asking whether there is a power of mind through which such an object may be acknowledged. Further, once Kant deduces an affirmative answer to this second question, it turns out that the beautiful object which does exist can only be beautiful nature, nature appearing as beautiful, and from this it follows that art can only be beautiful if it appears at the same time to be nature. Because the critique of taste, as well as the characterization of the object of the judgment of taste which critique grounds, are philosophically complete—which is to say logically over—before the theory of art

even begins, the constraints on Kant's philosophy of artistic beauty flow from his theory of taste and natural beauty rather than from a direct encounter with art.[1]

Just as it is a truism that Kant's philosophy of art is a dependent of his account of natural beauty, so too it is a commonplace of Kant interpretation that this is the central defect, the source of all the paradoxes and limitations, of Kantian philosophy of art. So powerful is the Hegelian demotion of natural beauty to dependent status in philosophical aesthetics, and so central the experience of art to contemporary thinking about aesthetic experience, that Kant's efforts to fit a theory of art into the place left available after a theory of natural beauty is completed makes his systematic aesthetics appear *prima facie* inadequate. This commonplace is buttressed by the focal belief that the work of art of which judgments of taste are made is the product not of nature but of the artist, and that therefore any theory that voids the significance of the artist in the evaluation of our experiences of art is beneath consideration. Since Kant's theory of beauty insists on purely philosophical grounds that beautiful art is beautiful in the same sense as nature is, it does not draw on artistic intentionality to explain art's beauty. However, if art is intentional while nature is not, then any philosophy of the Kantian sort which treats artistic beauty within the logical space of an account of natural beauty must entail false conclusions about art.[2]

It is a central aim of this chapter to defend Kant's siting of the philosophy of art within the confines of the philosophy of natural beauty. I am prepared to concede this much, however, to the critics of Kantian aesthetics: the presence of the artist makes a theoretical and practical difference to which any adequate philosophy of art must attend. However, this concession is almost too easy to make, since Kant does so himself. Indeed, it is a prime virtue of Kant's theory of art that it indicates how the activity of the artist, understood as the intentional production of the artistic artifact, is both the sine qua non of artistic beauty and its single greatest *obstacle*. The paradox of artistic beauty is that the artist must intentionally excuse himself from the site of artistic production for such beauty to arise. This, too, may well be unacceptable from the perspective of the cult of artistic authorship, but it is a view that does not absurdly deny the centrality of the artistic difference—the presence of the cultural producer—to a theory of art. Rather, it helps us to see why the notion of "artist" on which the cult of artistic authorship so much depends is itself riven by paradox. Only by insisting that a theory of art must arise out of a theory of natural beauty can Kant bring into focus the ways in which art becomes a moment of cultural production turned against itself. Further, by insisting this way, Kant also crafts, almost absurdly *avant la lettre*, the conceptual tools we need for understanding artistic modernism, that sort of artistic production that emerges when art turns against its own history for the sake of the continued possibility of art.

To say that my aim is a defense of Kant's philosophy of art needs to be restricted. First, I mean primarily to defend Kant's aesthetic theory against the charge that it fails in ignoring the artifactuality of artistic beauty. Those who argue against Kant on this matter assume that from the fact that art is intentionally made by humans—again, a fact which Kant never denies—it follows that art's beauty, or any other aesthetic property a work of art may have, is an artifact of that intentionality. It is just this inference, however, that Kant attempts to block by deriving his account of artistic beauty within the constraints imposed by the demand that artistic beauty be beautiful in the same sense as natural beauty is beautiful. The intentional work of the artist, on Kant's view, is a necessary condition for art, but it is not a sufficient condition for artistic beauty. Because I believe Kant to be correct about this—more correct, perhaps, than he knew—I will defend the premise that the work of art is best grasped within the context of a philosophy of natural beauty.

Second, my defense of Kant's account of the "natural beauty of art" is instrumental for my major goal of clarifying a specific philosophical purpose that the account serves. Late in the critique of aesthetic judgment, as Kant is comparing the relative importance of taste and genius in fine art, he makes a claim which, given the insistence of his argument to that point that fine art is an art of genius, is nothing short of astonishing: where there is conflict between taste and genius in a product of fine art, such that one or the other must be sacrificed for the work to come to completion, it is genius that must be slain. Where genius does not spontaneously submit to the demands of taste, taste must clip its wings. "[Taste] introduces clarity and order into a wealth of thought, and hence makes the ideas durable, fit for approval that is both lasting and universal, and [hence] fit for being followed by others and fit for an ever advancing culture" (*CJ* 50, p. 188). Both art's contribution to culture and its capacity to give rise to its own proper legacy—jointly, art's being historical—are explained by Kant as a function of the sacrifice of the claims of genius. This, I think, is the moment at which Kant discovers artistic modernism. Now, there may be other facets of Kant's philosophy of art which are inconsistent with this insight; indeed, given how untimely Kant's discovery is, it is practically inconceivable that the entirety of his aesthetic theory would harmonize with it. In any case, I will not be concerned with those other facets here; it almost goes without saying that Kant's premises can found other arguments than the one I believe Kant to be making. My aim is to allow the brilliance of this bit of historically displaced knowledge to cast light back on to its most important premises, key among which is the idea that artistic beauty is a species of natural beauty.[3]

To achieve this aim, we must first retreat into the depths of the critique of taste. I shall try to move forward from there in four steps. First, I will interpret

Kant's claim about the grounding of the universality of the judgment of taste in the beauty of nature as entailing that free subjectivity can appear in the world only as an interruption of mechanical causality. I will then move to Kant's philosophy of art proper in order to interpret it as an effort to block metaphysical claims about art's transcendence of natural causality. From these two points I will move to Kant's effort to resolve the antinomy of art—that it both is and is not an interruption of mechanical causality—in a theory of genius understood as the traumatic return of nature within culture. Finally, I will return to the relation of art and culture in order to show that the very possibility of a culture befitting humanity depends on the sacrifice of the claims of genius to transcend culture. A culture suitable for human nature, it turns out, is only possible if the interruption of purposive causality by the work of the genius gives rise to a mode of historical transmission which is other than what is intended by culture itself.

II

Through the critique of taste, Kant seeks to discover what conditions justify us in asserting a judgment of the form "*X* is beautiful." Such a judgment begs for critique because it appears, at least in its grammatical form, to blend illicitly a subjective with an objective voice. On the one hand, it is an exclamation of happiness, an avowal of pleasure in a sensuous experience. As such, it is merely subjective, in the sense that nothing is asserted through it about the world but rather only about the pleasuring of the judge. On the other hand, in attributing to the object or event that is the occasion for the avowal of happiness some characteristic—paradigmatically beauty—in virtue of which the judge is pleased, a judgment of taste makes a claim about the world. Thus, in its avowal of pleasure the judgment has a subjective basis while in its assertoric moment it has an apparently objective basis. Taste seems to leap over the bounds of cognitive propriety, thus making critique necessary to restore its proper grounds and limits.

The easy way to do away with taste's overstepping would be to dispel the appearance of an objective basis by interpreting the grammatical form as merely a bit of runaway language. Perhaps through the use of the objective voice the judge innocently overemphasizes the uniqueness of taste's pleasure, or perhaps, more deviously, the judge uses it to hide the embarrassing fact that taste has no leg on which to stand other than the subjective basis.[4] In either case, the appearance of an objective basis would become a mere appearance that the judge can do without. For Kant, however, while it will turn out that the objective basis is apparent only, it is no mere illusion. Rather, the ground of the normativity of the judg-

ment of taste is lodged in that appearance. Whereas "I like X" makes no claim beyond the purported fact that X pleases me, "X is beautiful" claims further that X pleases me because something about X is such as to produce pleasure. In other words, my pleasure in X is a *right* acknowledgment of X. Whereas the judge who simply likes X might have her liking explained in virtue of some feature of X, she does not invoke that feature to justify her liking; as the art appreciator scornful of the purported expertise of the connoisseur is wont to say: "I may not know art, but I know what I like." The judge who thinks X beautiful, on the other hand, invokes the beauty-making feature of X as the justification for her liking and so stands ready (in principle, at least) to defend her judgment rationally.

However, even if the apparently objective basis of the judgment of taste is not a mere illusion—that is, even if the judge would be false to a dimension of her experience if she exchanged the judgment of beauty for a mere avowal of pleasure—that basis nonetheless cannot be simply objective either. If it were, no special problem about the normativity of aesthetic judgments would arise; they would then be objective in the same sense as nonaesthetic ascriptions. Beauty, though, is no objective feature of the world. There are no objective principles of taste, no rules for inferring from any set of indubitably objective features of the world to the aesthetic "concepts" deployed in a judgment of taste (*CJ* 34, p. 149). Without objective principles, however, the judge of taste apparently loses the grounds for making a normative judgment. Unless some other ground can be discovered, we would be obliged to consider judgments of taste as a species of authoritarian judgment in which a merely subjective pleasure is offered as a proper reason in itself for others to have it. We would want to hand this problem over to the group psychologists at that point were it not for the fact that the problem goes deeper than the intersubjective level. If judgments of taste harbor an authoritarian force, then that force aims to rule over the judge herself. When she asserts that X's beauty is a reason to take pleasure in X, then she is prescribing *intra*-subjectively that her future encounters with X ought to please her also merely because a present encounter does. (I suppose we can think of this as the aesthetic equivalent of Elizabeth Taylor disease, the affliction that compels a person to marry everyone with whom she has sex.) The logical problem is one of normatively connecting two or more moments of judgment regardless of whether those moments index distinct persons. It may be no comfort to say so, but if the judge has no grounds for judgment other than private pleasure, she would be forced to be an equal-opportunity pedant.

Famously, Kant restores the ground for the normativity of aesthetic judgment by means of an analysis of the uniqueness of the pleasure it expresses. There is no need now to rehearse the entirety of Kant's much mooted argument

about disinterested pleasure, but using as our guide the danger Kant senses that judgments of taste not limited by a proper critique mask authoritarianism, we may illuminate two features of that argument that are rarely adequately analyzed: (1) The tendency toward authoritarianism which inauthentic judgments of taste voice is rooted in the very naturalness of nonaesthetic pleasure. (2) The aesthetic interruption of that tendency offers no escape from the nature of pleasure; rather, it points toward a different world hidden within this one where the necessity of pleasure would not equal the domination of the world.

A disinterested liking is a pleasure felt in a perception in circumstances in which the perceived object or event neither satisfies a need of the feeling subject nor gives rise to one. An interested liking, by contrast, is guided by a need. In fact, the phrase "interested liking" is, for Kant, almost redundant, since "interest is what we call the liking we connect with the presentation of an object's existence" (*CJ* 2, p. 45). To have an interest is just to have an affective stake in an object's existence because the object serves to fulfill (or impedes the fulfillment of) a need. When I have a need, I cannot remain indifferent about the objects toward which the need drives me; those objects interest me because they serve to quell the imperative which a need is. Liking, thus, is simply what I feel for those objects that are instrumental for my purposes.

Disinterested liking must puzzle us, therefore, since if interest and liking are so intimately connected, then disinterest should be a break in affective determination. It is worth noting that the puzzle arises not from the idea of disinterest as such; we hope that judges in courts of law will be disinterested in the sense of not being personally invested in the outcome of the cases they hear. Not being personally invested means having no interests at stake and so not having any rational grounds for preferring one outcome over another. Neither outcome, in other words, would especially please or displease a disinterested judge. There is nothing conceptually difficult about this because disinterestedness in such cases presumes that the link between judgment and pleasure is broken. However, the clarity about legal disinterest makes vivid the difficulty with Kantian disinterested *pleasure.* How is liking possible under conditions of disinterest? How can anything other than the satisfaction of interest give rise to pleasure?

Let us pursue this puzzle further by excavating the depths of the connection between pleasure and interest. This will also permit us to see why Kant thinks authoritarianism is built into interested pleasure and also how he imagines nonauthoritarian pleasure. In comparing interested with disinterested liking, Kant writes:

> Only the liking involved in taste for the beautiful is disinterested and *free,* since we are not compelled to give our approval by any interest, whether of sense or of reason. . . . Neither an object of inclination, nor one that a law of reason

enjoins on us as an object of desire, leaves us the freedom to make an object of pleasure for ourselves out of something or other. All interest either presupposes a need or gives rise to one; and, because interest is the basis that determines approval, it makes the judgment about the object unfree. (*CJ* 5, p. 52)

So, interested liking is compulsory liking because satisfying objects passionately move us toward them. Whom I love looks touchable to me and when I hunger food looks tasty. Indeed, we can think of the claim that persons are moved by objects of satisfaction as a synthetic a priori truth; it is discovered through experience alone yet is nonetheless the transcendental principle for any empirical psychology whatsoever.[5] Interest is what the world has for us when it is instrumental for our purposes. Put somewhat differently, instrumental regard connects feeling to the world in lawlike patterns of regularity. He who wills the end, as the law says, wills the means. No doubt we can come to regard the world as without interest for us, as depressed people do, but then we would be living in a world of no possible use to us. To be depressed is to live in a world in which nothing in it can make one happy; from the position of depression, the world appears as that from which the depressed self has been extruded. Being needy, being alive, and finding interest in the world are simply different descriptions of the same state.

The hint above that a world of no interest is the world of the depressive, that is, that it is a world that lacks all possible satisfactions and so is painted all-over black, helps us to make our point about the internal connection between interest and pleasure in an ultimate sense. If being needy is but an alternative way to describe being alive, then being alive is a relation to the world mediated by, or as Kant would put it, presented in terms of, purposes. Depression is like being buried alive because one's purposes fail to conjure an interesting world. By contrast, in the undepressed relation to the world, neediness shapes the fit of life to the world. Needs, in short, are the psychical orientations of living creatures in the world; they are what we feel when we feel alive. Put even more strongly, needs give living creatures their world by staining objects in various hues of satisfaction that creatures then perceive as arrayed in spectra. Living creatures no more choose their satisfactions than they choose their natures; their satisfactions determine the kinds of creatures they are. Being alive mediates need and its objects in such a way that passion, or what Kant calls compulsion, carves purposive paths through what thereby is the creature's world. The demand for pleasure, the demand of need, is thus inherently authoritarian, since it does not "leave us the freedom to make an object of pleasure for ourselves out of something or other." As neediness traverses the routes of movement it has opened before the living being, it never doubts itself.

This logical imperativity of pleasure, this compulsion in virtue of which "in-

terest is the basis that determines approval" authoritatively, is the mechanical necessity of animal nature within life. Natural beings are alive because they are driven by what is unquestionable for them. Putting the point so, however, reveals immediately that Kant views natural necessity from the perspective of the autonomous subject. Natural necessity is compulsion only when it is antagonistic toward some other force which might resist it. A lion is not compelled to eat its meat raw since it would never experience its own nature as an impediment to a desire to cook it. Only for a being for whom its nature is not identical with its desire could nature become compulsion; only there could nature's authority become the seed of authoritarianism.

From the point of view of the autonomous subject, however, its nature is indeed compulsion since its nature is just its needs. The autonomous subject is in implacable conflict with natural necessity, since, again, who wills the end also wills the means. Needs are demands for satisfaction. In this light, the deliberative reflection of the autonomous subject is a moment of resistance to creaturely passions since the premise of reflection is that it is not clear which way to go. Natural pleasure thus not only needs no reflection—it positively abhors it. Reflection then repays the insult by forcing the subject to rear up on its hind legs in fear and loathing of its own nature, affects through which the subject attains its autonomy by foregoing the pleasures that it is its nature to pursue. The autonomous subject, put simply, is an interruption in the animal connectedness of need and pleasure.

Here, though, we reach a crucial crossroads in the Kantian dialectic of nature and freedom. On the one hand, the autonomous subject comes to be as an interruption of natural necessity. In this sense, the autonomous subject is free. On the other hand, this subject is free only insofar as it is compelled by the moral law, "for where the moral law speaks we are no longer objectively free to select what we must do" (*CJ* 5, p. 52). The imperative nature of morality colors the whole world of nature in deathly shades of fear and anxiety. As subject to the moral law, the autonomous subject is thus the battlefield of morality and nature on which competing necessities meet in a struggle to the death. This dire conclusion was foreshadowed when we noted that the autonomous subject is in implacable conflict with its own needy nature. The anxious denial of need's imperativity, what Kant calls in its positive formulation respect for the moral law, rends the human between two powers, leaving it never to rest until the state of dreamless sleep. It is not exactly right, therefore, to say that the autonomous subject is free; it is more precise to think of it as the site where the moral law belligerently establishes its autonomy from nature.

The autonomous subject thus never rests at home in itself. This too was fore-

shadowed in the earlier discussion of the internal connection among need, nature, and life. A living creature has a world in virtue of its needing a world. It is, we might say, at home outside itself. The autonomous subject, by contrast, is saddled with a world, the world of its own nature, in which it is not at home. Having been interrupted by the voice of the moral law, human needs, despite their power remaining undiminished, become incapable of binding us, incapable even of distinguishing the binding from the optional. The world we imagine that our nature presents us is thus no longer a world. Our world is lost, and in its place has arisen a limitless realm of meaningless ends. We gaze out, or in, at the world governed by the mechanical force of nature, freed of it yet hunkered down against it for all that.

This, of course, is nothing other than a description of melancholy. When natural necessity has been denied, when the world is just the no-man's land the subject gazes on from behind its fortifications, then the force of nature becomes a disvalue. And when that has happened, it is proper to say we are disoriented.[6] One cannot live in a world without interest or flavor, for the sheer obdurateness of its existing merely in itself is the occasion for the replenishing of melancholic despair.[7] This melancholic regard for the world, insofar as it is a disoriented one, can also be described as the loss of normativity. The melancholic is not without needs; instead, her condition is that those needs offer no guidance in the world toward which they are inevitably turned. Put otherwise, the melancholic world with no normativity, no bearings, contains only mere objects that sustain no recognition; only dead things live there. It is also, therefore, a world of pure instrumentality in which nothing matters in itself; its inhabitants, stripped of all inherent value, might be purposively used with impunity—it could be the sadist's Eden—if only the lack of a sustainable reason for using them did not turn impunity into indifference. It is a world, in short, with no nature. Whence such a world? According to Kant, from culture, in particular from what he calls the culture of discipline.

> The culture of discipline (*Zucht, Disziplin*) . . . is negative and consists in the liberation of the will from the despotism of desires, a despotism that rivets us to certain natural things and renders us unable to do our own selecting; we allow ourselves to be fettered by the impulses that nature gave us only as guides so that we would not neglect or even injure our animal characteristics (*Tierheit*), whereas in fact we are free enough to tighten or slacken, to lengthen or shorten them, as the purposes of reason require. (*CJ* 83, p. 319)

In the culture of discipline, which is a moment on the path to a culture befitting humanity, the moral law runs amok. Under its tutelage, we regard even our own natures, our "animal characteristics," as means toward the sustaining of pur-

posiveness. The disciplined or cultivated person is free only in the negative sense of being emancipated from all needs except those useful for the execution of purposes—which is to say, simply, liberated from need. Indeed, our nature is tolerated in the culture of discipline only as an instrument useful for self-preservation; our nature is "allowed" only insofar as it protects us from harm, but our "nature" then must mean our reflexes, the rudimentary functioning of our bodies stripped of even the memory of possible satisfactions. In regard to nature, the culture of discipline is perfectly disinterested. It cleanses the natural world of pleasure, thus opening it to endless achievement.

But what, then, of disinterested *pleasure*? If disinterestedness is disorientation, how can it ground a unique pleasure? There is, I think, only one possible answer to this question: disinterestedness must be capable of becoming the site of a renewed necessity, and freedom from need thereby the occasion for the resurgence of nature within the subject. Because this is the only possible answer, it is gratifying to report that Kant develops it.

> If someone likes something and is conscious that he himself does so without any interest, then he cannot help judging that it must contain a basis for being liked [that holds] for everyone. He must believe that he is justified in requiring a similar liking from everyone because he cannot discover, underlying this liking, any private conditions, on which only he might be dependent, so that he must regard it as based on what he can presuppose in everyone else as well. He cannot discover such private conditions because his liking is not based on any inclination he has (nor on any other considered interest whatever): rather, the judging person feels completely *free* as regards the liking he accords the object. Hence he will talk about the beautiful as if beauty were a characteristic of the object and the judgment were logical (namely, a cognition of the object through concepts of it) even though in fact the judgment is only aesthetic and refers the object's presentation merely to the subject. He will talk in this way because the judgment does resemble a logical judgment inasmuch as we may presuppose it to be valid for everyone. On the other hand, this universality cannot arise from concepts. For from concepts there is no transition to the feeling of pleasure or displeasure (except in pure practical laws; but these carry an interest with them, while none is connected with pure judgments of taste). It follows that, since a judgment of taste involves the consciousness that all interest is kept out of it, it must also involve a claim to being valid for everyone, but without having a universality based on concepts. In other words, a judgment of taste must involve a claim to subjective universality. (*CJ* 6, pp. 53–54)

Kant is accounting in this passage for the grammatical form of the judgment of taste. The judgment is spoken in a voice that is "as-if" objective because that

is the only voice available to subjective universality—intersubjective validity must dissemble to get itself heard by pretending it is objectively grounded.[8] However, our interest ought to be compelled also by the dialectic of freedom and necessity at work here. The disinterested judge *feels* completely free, Kant writes, while in fact she is bound by necessity on every side. Let us reconstruct this scenario. The judge roots around in her empirical ego, trying to say, "I like *X*." However, the culturally achieved freedom from interest deprives the judge of taste of all power to claim the pleasure as her own. That is, finding that she has no interest served by *X*, the judge becomes aware that she is not the ground of her own pleasure and so cannot say "I." Thus, the connection between need and happiness, interest and pleasure, is broken. And for just that reason the judge *"cannot help judging"* that . . . , *"must believe"* that . . . , *"must regard"* herself as free. In the absence of interested determination, which is to say in the state of subjectivity free of instrumental considerations, incontrovertible necessity absolutely forces the judgment that "*X* is beautiful." Out of the rubble of the disinterested ego, out of the depths of melancholy, the voice of nature speaks, beholden to extortionate beauty: what I cannot help but judge, what renders me so instrumentally powerless that I cannot even locate myself, is beautiful to me. Beauty binds my pleasure with the force of lost nature; only what has the force of nature can be beautiful for an autonomous human subject. The pleasure in the experience of the beautiful, Kant might well say, is the subject's gratitude for the return of nature within culture.

Now, we need to be doubly careful here. The return of nature in the form of the compelled judgment of taste is not the return to life of the lost nature of the world. The formation of the autonomous subject by the culture of discipline guarantees that that nature is lost and that we (moderns) have no natural home. Put the other way around, the return of nature as a force is only possible against the background of the culture of discipline and its commensurate destruction of the nature of the animal subject; nature is a force only for a subject that would contest it. Therefore, it is the return of nature *within the subject* that Kant has in mind, its return as a force that demands immediate approval or disapproval. And being the medium of this forceful return is just the mark of the freedom of the judge of taste. The free subject, then, is neither the natural one nor the autonomous one, but only the one for whom compulsion is experienced neither as threat nor as instrument but rather as the devastating feeling of life. The free subject is postautonomous, in the sense that only after discipline has done its job does the delirious undergoing of beauty become possible. In this feeling of life, this nonpurposive affect, nature in the subject takes its revenge on culture.

Again, however, we need to be careful, for this talk of undergoing beauty can

mislead us. We must recall at this moment the central premise of Kant's argument: the judgment of taste has no real objective basis, so that beauty is not in the world. The subject in the throes of aesthetic pleasure is in the strictest sense in the grip of nothing. Because the beauty of the object does not really exist but is nonetheless a necessary presupposition of disinterested liking—because it is both necessary and unreal—the experience of it as objective is the illusory appearance "elsewhere" of living nature. Furthermore, this is an illusion that cannot be dispelled, since the free subject has no consciousness of itself as the basis of the judgment at all; because she feels completely free, the judge "will [necessarily] talk [mistakenly] about the beautiful as if beauty were [which it is not] a characteristic of the object" (*CJ* 6, p. 54). The beautiful object is the illusion the autonomous subject is compelled to generate in order to undergo pleasurably the force of its own disavowed nature. What the autonomous subject cannot avow as itself, which yet makes it autonomous—what it is in its nature to not acknowledge as its nature—it inevitably confronts in the form of a necessary illusion. Hence, beautiful appearance interrupts the natural causality that is naturally dead and alien to the autonomous subject. It is the illusion that marks the place in its nature where the subject that is not impeded by nature is not yet free to go. Beauty is the impossible reconciliation of the autonomous subject and its own lost nature.

If we drop "impossible" from the preceding sentence, we get romanticism.[9] Kant, though, is no romantic. Beauty is necessary *semblance* because no reconciliation between nature and the autonomous subject is possible. Even as we are grateful for the beautiful, the relation of nature and subject it figures forth cannot be cognitively grasped by the subject who judges it.[10] The beautiful is news from another country, and it transfigures the rubble of the lost world not one bit.[11] Beauty, in short, does not transcend this world. Because nature emphatically must stay dead for the cultured individual, it perpetually threatens to return to life; the illusion of objective beauty only deprives nature's deadness of the veneer of exclusive and inevitable fate. If, therefore, beauty appears as a shining through this cultured world of another one, it is because it commands us, in the voice of dead nature, to change. Beauty is nature's obscene yet unapproachable afterlife.

In sum: beauty *must* appear as nature, but the necessity here expressed is the necessity of an illusion. The aesthete who orients her life by the compass of beauty is thus guilty of a philosophical error, since beauty does not reorient us in the world. Rather, it expresses the loss of the world that cannot be recovered. Because beauty sustains the loss of a binding nature that would offer orientation if it existed, the aesthete errs in taking what sustains the loss culture demands for a different culture. But beauty is not culture; it is, rather, the ghost of nature's claim against the culture of discipline. Neither disciplinary culture nor an-

imal nature, beauty is a frontier phenomenon between them. It must appear as nature in order to promise a transcendence of culture it cannot deliver, since it is an experience possible only for a cultured subject. And just as beauty is the illusion of a subjectivity befitting humanity, art is the illusion of a culture befitting humanity. We are now ready to turn to Kant's philosophy of art.

III

Kant's philosophy of fine art is derived from his account of how the disinterestedness of the judgment of taste entails abjuring considerations of real purpose. In the following passage he spins out from the idea of disinterestedness the pleasure of a purely subjective purposiveness.

> Whenever a purpose is regarded as the basis of a liking, it always carries with it an interest, as the basis that determines the judgment about the object of pleasure. Hence a judgment of taste cannot be based on a subjective purpose. But a judgment of taste also cannot be determined by a presentation of an objective purpose, i.e., a presentation of the object itself as possible according to principles of connection in terms of purposes, and hence it cannot be determined by a concept of the good. For it is an aesthetic and not a cognitive judgment, and hence does not involve a *concept* of the character and internal or external possibility of the object through this or that cause; rather, it involves merely the relation of the presentational powers to each other, so far as they are determined by a presentation.
> Now this relation, [present] when [judgment] determines an object as beautiful, is connected with the feeling of a pleasure, a pleasure that the judgment of taste at the same time declares to be valid for everyone. Hence neither an agreeableness accompanying the presentation, nor a presentation of the object's perfection and the concept of the good, can contain the basis that determines [such a judgment]. Therefore the liking that, without a concept, we judge to be universally communicable and hence to be the basis that determines a judgment of taste, can be nothing but the subjective purposiveness in the presentation of the object, without any purpose (whether objective or subjective), and hence the mere form of purposiveness, insofar as we are conscious of it, in the presentation by which an object is *given* us. (*CJ* 11, p. 66)

The structure of this argument is clear enough. Were there a determinate subjective or objective purpose served by the judged object or event, the judgment would be determined by either a law of nature, a practical precept, or the moral law. It would then be an unfree judgment. Therefore, considerations of purpose must be set aside and the object or event judged instead by means of

the liking it occasions for that subject who has no need of it. The judge of taste must regard the object or event that induces aesthetic pleasure apart from any concrete end it might be intended to serve. Now, since the judgment of taste ranges over both natural objects and human artifacts, for works of art to be proper objects of aesthetic judgment they too must be judged without regard to purpose. This, however, generates an antinomy: if an artifact is distinguished from a natural object in having a determinate purpose, and a work of art is an artifact made to be the object of a judgment of taste, then a work of art is an artifact made with the purpose of not seeming to have a purpose, of not seeming to be an artifact (*CJ* 43–44, pp. 170–73).

This antinomy creates both a dilemma and an opportunity for Kant. The dilemma develops as follows: an object is an artifact if it has been made as the object of a human purpose. If an object exists with no such purpose in its causal history then it is instead a natural object. Thus, for an artifact to not look like an artifact it must seem to be, without really being, nature (*CJ* 45, pp. 173–74). The object must be made through a rational choice but that choice must be made, so to speak, invisible. But this is a recipe for trickery, not fine art, and a trickery all the more deviously purposive the more successfully achieved. Kant provides the following example to illustrate the aesthetic failure of trickery:

> What do poets praise more highly than the nightingale's enchantingly beautiful song in a secluded thicket on a quiet summer evening by the soft light of the moon? And yet we have cases where some jovial innkeeper, unable to find such a songster, played a trick—received with greatest satisfaction initially—on the guests staying at his inn to enjoy the country air, by hiding in a bush some roguish youngster who (with a rush or reed in his mouth) knew how to copy that song in a way very similar to nature's. But as soon as one realizes it was all deception, no one will long endure listening to this song that before he had considered so charming. (*CJ* 42, p. 169)

For the achievement of the look of nature to be an achievement of fine art, the charge of trickery must be repelled by a blindness, a nonpurposiveness on the part of the artist that corresponds to the abjuring of judgment in terms of determinate purposes on the part of the judge of art. The invisibility of purpose must be the product of a real absence of determinate intention; it must be the appearance of that absence, in the making of what is, after all, an artifact, a purposive object. That is the dilemma: Kant's theory of art demands the production of artifacts that body forth an absence of purpose in their production. But how is this possible?

Kant's answer to this question involves a radicalization of a specific bit of eighteenth-century art theory. On the one hand, his description of the hidden

artifactuality of art is quite similar to the common eighteenth-century academic imperative that art should not smell of the workshop. That the artwork not appear to be produced with academic rules foremost in the artist's mind, that "the academic form must not show," is in keeping with the traditional goal of artistic illusion (*CJ* 45, p. 174). However, that the artwork not appear rule-governed, that it appear natural, because in some way it truly is not rule governed, despite, of course, still being an artifact, is an altogether different demand. Indeed, insofar as the rule for this class of artifacts—to have no determinate rule—is a contradiction, the demand is perhaps unsatisfiable. But it is just here that Kant transforms a dilemma into an opportunity by filling in the conceptual hole with a mutation in nature itself, nature in the form of genius. "*Genius* is the talent (natural endowment) that gives the rule to art. Since talent is an innate productive ability of the artist and as such belongs itself to nature, we could also put it this way: *Genius* is the innate mental predisposition (*ingenium*) *through which* nature gives the rule to art" (*CJ* 46, p. 174).

In passages like this, the Kantian genius can far too easily seem to be the romantic genius, unconstrained by rules, magisterially creating without precedent but thereby establishing precedent for the generations which will be beholden to his original acts of creation. Since the work of the genius is performed in the absence of conscious rules of production, the genius is a force of nature, but a force which thus manifests the freedom of the genius from social convention. The genius in this sense symbolizes a reconciliation of nature and freedom. This conceptual space for the romantic idea of genius is held open by the contradictory artifactuality of the artwork. However, it is crucial to remember that despite Kant's providing a positive characterization of the features of the mind he calls genius out of which the romantic reading could grow, his motivation to propose the concept at all within his aesthetics is the underlying concern, not with what genius is, but rather with how it may *appear*. Kant's paradox, again, is how an artifact can look like nature, so the deep problem of genius for him is how an artifact can look like a work of genius, which is to say how it can look free of determinate purpose. To understand what he is really after, we must hew closely to Kant's concern with appearance.

Despite the romantic-idealist interpretation of the concept of genius as an affirmative moment of reconciliation between freedom and nature, Kant quite explicitly recognizes that the nonpurposiveness of the work of art, that is, the work of genius, can appear only as a *lack* of reconciliation between the artist and purposive structures. The idea that genius appears when the standard relation between purpose and artifactuality is swept away, when the artist ignores issues of technique, is rejected by Kant as a mistake which produces misguided proto-

cols, or a misguided lack of protocols, in artistic education. Where "genius" so-called appears *instead of* purposive activity, out of indifference to it, there we have, not art appearing like nature, but nonsense (*CJ* 50, p. 188); this version of genius reeks of the adolescent conviction that authentic selfhood depends on the liquification of the grounds of selfhood. For Kant, the work of art is an artifact, and so genius appears not instead of purposive activity but rather by means of it. That is, genius appears when the technique that guides the production of the artifact *visibly* fails to produce its appearance. An artifact thus is a work of fine art when the mechanical relation between purpose and artifact is seen to be broken, when something shows itself as the underdetermination of the artifact by any specific purpose.

Kant's acknowledgment that the appearance of genius is a moment of non-reconciliation, a lack of fit between determinate purpose and the object whose concept it is, is notable in several similar passages. Consider the following:

> In [dealing with] a product of fine art we must become conscious that it is art rather than nature, and yet the purposiveness in its form must seem as free from all constraint of chosen rules as if it were a product of mere nature. (*CJ* 45, p. 173)

And:

> It is advisable . . . to remind ourselves that in all the free arts there is yet a need for something in the order of a constraint, or, as it is called, a mechanism (*Mechanismus*). (In poetry, for example, it is correctness and richness of language, as well as prosody and meter.) Without this the spirit, which in art must be free, would have no body at all and would evaporate completely. This reminder is needed because some of the more recent educators believe that they promote a free art best if they remove all constraint from it and convert it from labor into mere play. (*CJ* 43, p. 171)

The spirit, Kant says, must be free in art—which is to say it must be undetermined by any purposive structure. At the same time, though, it must be constrained by a mechanism because without constraint it evaporates, turns to mere spirit, mere vapor. It appears Kant is saying that for spirit to be free it must be bound to a body, bound by a mechanism. This sounds like a contradiction plain and simple, even if it does correspond to standard practices in the training of artists. However, it is only a contradiction if we take "constraint" to mean that which imprisons; in that case, Kant would be saying something like "the free person is the one who lives in a jail cell," which, while neither an unheard of nor an unreasonable proposition from a certain otherworldly point of view, is distinctly non-Kantian. That Kant does not mean it this way is highlighted by his

qualification of what is needed as "something in the order of a constraint," which suggests something like a constraint yet not, something like a constraint that does not constrain.

To get closer to the moment of nonreconciliation Kant is imagining, let us reflect on the name he gives to the constraint that makes free spirit possible: mechanism. The oddity of the usage is patent; given arguments Kant develops elsewhere regarding heteronomous and autonomous determination of the human will, mechanism does not as such have the power to function as a constraint on freedom. Rather, the freedom of the will, that is, moral agency, is constituted by an indifference to mechanical nature, a turning away from the realm of heteronomous determination as such.[12] Kant, in short, typically treats mechanism not as a constraint on freedom, but as its opposite. Here, though, in stressing mechanism as the name of a constraint, Kant is aiming to highlight what *limits* freedom of spirit rather than what is independent of it—and one can attempt to overcome limits in interesting ways because, in contrast to metaphysical bulkheads, limits are already internally related to what they limit.

It may seem as if we are overplaying this distinction between mere mechanical nature and mechanism as constraint. After all, several times in the *Critique of Judgment* Kant identifies the merely mechanical with nature as such, so perhaps nothing special is being said here. However, since mechanism is presented in this passage and others as constraint, there is still a novelty of usage to be explained. More importantly, as Kant argues elsewhere, even if the claim that the production of material things is possible according to mechanical laws is necessarily presupposed by determinative judgment, that claim on its own cannot prevent judgment from presupposing that the production of *some* material things may also be possible according to some special nonmechanical principle (*CJ* 70, pp. 266–68). In other words, while a mechanism is a process that determines the nature of the thing produced through it, a determining mechanism cannot determine further that it is *only* through that mechanism that the thing can be produced. Reflective judgment, thus, is not mechanically constrained by the fact of mechanism; or, put differently, it is possible to imagine a world perfectly consistent with mechanical laws that nevertheless does not have those laws as its actual and only principle. Mechanism is in this sense a constraint on the free spirit, but only as the determining source of the things of the world that spirit *could* be the source of. This important implication of Kant's position can be derived only if there is a second sense of mechanism not just as a principle of natural explanation but also as a constraint on the will.

This clarifies immediately why Kant rejects the idea of genius as operating beyond mechanism. For the work of genius to appear the artist must produce some-

thing—the spirit of genius is the opposite of the renunciation of the world—and that thing must be capable of being made according to natural laws.[13] The artist who says, "I will create what nature itself could not produce," is speaking very strict nonsense. *That* artist's genius could never appear. Every artist thus needs constraint, a bit of pedagogy Kant derives from his metaphysics. However, this does not entail that the artist needs to regard the necessarily possible production according to mechanical law as the principle for the production of the work of art. The artist may seek—indeed, I would suggest this is Kant's point—the artist *does* seek to make the work come into existence as the product of another principle, the principle of freedom.

How, then, does the alternative principle appear? It cannot appear as an evacuation of mechanism, that is, as an artifact that could not have been produced mechanically. Thus, it must appear as the negation of mechanicity, as the denial that mechanism alone was the originating principle. Now, if mechanism is a regularity binding an effect to its cause, the point may be put thus: the free spirit appears, that is, an artifact is a work of art, not when mechanism is absent but rather when the mechanicity of mechanism, its determinative power, is visibly absent. In more commonsense aesthetic terms, the free spirit appears in the transformation of mechanism from constraint into raw materials for art.

The work of art is an apparent break in the chain of necessity, not, therefore, because the thing made could have been produced only through freedom, but because in negating the mechanical necessity of mechanism it visibly was so produced. This requires that for the artist to produce something visibly non-necessitated, he must be intimately, precisely familiar with the mechanical necessitation he must dismantle. The artist's horizon of action, his raw material, is thus the entire domain of necessity—let us call it the world—as that which may constrain him; the break in necessity then appears as the constraint not constraining, the mechanism not determining. "*That*," the artist says, "will not force my hand." Hence, the work of genius, the work of the free spirit, can only appear along with what in the work fails to determine it, along with its nonconstraining constraint; it can only appear as a mutation in nature that reveals nature's incompleteness as mechanism. To put the point in the terms that got this discussion moving, the work of genius appears in nature as a moment of non-reconciliation between spirit and nature.

On Kant's view, then, the work of art is an achievement of appropriative negation; more expansively, it is the negation, achieved within mechanical nature itself, of the mechanicity of melancholy nature. Hence it becomes even less of a wonder that Kant says the artist requires a mechanism without which the work would have no body and the spirit not be free. Without the constraint of

mechanism there is nothing for the artist to do, and so rather than constraint being something to be neglected in the name of artistic autonomy taken as a kind of isolation from nature, it is the very arena in which that autonomy is achieved. The work of art is the visible transformation of mechanical necessitation into incompleteness of determination and so is the manufacturing of freedom. Emphatically, then, the work of art is not the transcendence of mechanism. And to give this interpretation one final piece of support, let us recall that Kant's ultimate charge against the misguided art pedagogues is that they treat art as play rather than labor. Kant insists, which is to say reminds us of what many forget, that a work of art is called work (*opus*) for a reason. Art is the labor of remaking the world of mechanism as a world that need not be the realm of inhuman necessity.

Now, insofar as art is a kind of labor it is the production of artifacts; however, the labor of art appears as a negation of mechanicity, a break in the determinate productive chain. Hence the appearance of genius. Here we are back at the original paradox, but now I think in a substantially more comprehensible form. For Kant, the artwork appears as nature because it does not appear to have a determinate purpose, that is, it does not appear to be a production through human labor. Thus the work of art appears as the look of free labor, of labor having freed itself from what makes labor necessary. Artistic appearance is indeed the result of labor, but of "undisciplined" labor not tethered to any extrinsic goal. The artwork, in short, is the appearance of unnecessary work. In being unnecessary, the artwork is the appearance of the absence of external determination; in this way the artwork appears like nature, which is now to say that like the system of nature nothing outside it determines it. Because artistic appearance is what culture makes possible yet does not determine, it looks like nature within culture and therefore undermines the repression of nature by discipline.

IV

We can now turn to the question of what, for Kant, the work of art looks like. As we now see, for Kant this question is identical to what might seem to be a different question at first glance: What does negation look like? How does negation appear? (And this is a question of aesthetics, in contrast to the question "What is negation?" which is a question of metaphysics—or, more precisely, politics.) The normal answer to this question in post-Kantian philosophical aesthetics is that it looks like freedom, an answer that has led to the aforementioned idealist-romantic valorizations of artistic autonomy. However, despite the apparently bountiful support for this view in Kant's writings, if our interpreta-

tion of Kant is so far right, Kant's considered answer is that artistic negation looks like the failure of freedom.

The idealist misinterpretation of the autonomy of art rests on an inference from art's non-necessitation by worldly circumstances to its metaphysical isolation from the realm of necessity. The inference is false because it mistakenly takes Kant's claims about the non-necessitation of art to be about causally anomalous, metaphysically unique objects; instead, such claims are about art as working on the *external* circumstances that might have necessitated it, the dismantling of which is the appearance of another necessity. In other words, if art is work's refusal to let anything outside itself determine its form, then the artwork is just the appearance of that refusal. The work of art thus only appears as nonreconciliation with the world of external determination by reproducing or representing that world as deprived of its determinative powers. But this of course entails that the work is bound *irredeemably* to what does not determine it, is constrained to show what does not constrain it. For the work's power of negation to appear it must visibly negate something and can only appear as the negation of that thing. Thus, for the work of art to be autonomous it is bound to show what it is not bound by and so to reveal itself as incapable of escaping from the world it seeks to transcend.[14] The work of art functions as a symbol of the unbridgeable abyss across which freedom has been segregated from nature, a symbol which, if true to the nature of freedom, had better not be itself free; if it were, it would cease being a symbol and take up residence in the realm beyond appearance. Freedom from mechanism, rather than the effort to negate it, would make the work of art metaphysically impossible. For the work of art to interrupt mechanical necessity, it must fail to be free, and it is just this nonreconciliation between freedom and nature in art which is the symbol of freedom.

This interpretation reveals that Kant sees set in motion in the work of art a dialectical war between nature and free spirit *that free spirit cannot win*. It is, however, just the failure to win that keeps art in motion, keeps it unreconciled and so doing battle against the realm of external determination that itself grows more obdurate with each failure. Art, far from dying of failure, would die of success. But what is this perpetual conflict between freedom and nature? What is this process of the always renewed nonreconciliation between the self-determination of spirit and external determination? Since art fails to attain the freedom it strives for it is impossible to treat it as free spirit, but because it remains unreconciled to that failure it is also impossible to treat it as mere dead nature. It is instead necessary to treat art's renewal of its commitment to failure as the story of the perpetual self-creation of life through nonreconciliation. It is necessary, in other words, to treat art as historical.

Kant's derivation of history from art's nonreconciliation can be examined most perspicuously if we first recall (a) that the nature (mere nature) to which art remains unreconciled is the dead nature of the culture of discipline, and (b) that what remains unreconciled in art is genius, that is, the spirit that art can only signify in its flight from the totality of determined appearance. Spirit's nonreconciliation is driven by the autonomous subject's already having been ejected from a nature it no longer recognizes as its own, an ejection which is the precondition for and at the same time the greatest threat to the causality of freedom. It is as if spirit's own development, its own coming into existence, were a traumatic process which, carrying its moment of greatest danger along as the continued prick of autonomy, can never end. The strife of spirit and nature thus occurs *within* cultivated subjectivity in the form of an illusory tussle with a nature that has already given up the ghost. What drives spirit's unconsolability is the inadequacy of its own, proper other which it has itself necessarily generated. It is in the nature of free spirit to find itself face to face with dead nature and to strive to keep it alive as its own alienated self. Again: "without this [mechanism] the *spirit*, which in art must be *free* and which alone animates the work, would have no body and would evaporate completely" (*CJ* 43, p. 171). Art in this light is the material struggle arising from human disorientation within the culture of discipline.

Therefore, it is necessary on Kant's view not just to treat art as historical, but *as human history*. When he writes that genius is "nature in the subject" that gives the rule to art, we must not forget that it is not nature, but its traumatizing power in the subject, which is art's lawgiver. Nature no longer gives rules to humans immediately; it does so only through culture. But the culture of discipline is the denial of nature's normativity. Therefore, nature can be normative only insofar as it appears within culture, that is, through the disciplined subject. Even if it made sense to think of genius romantically as nature *simpliciter*, it would be possible to acknowledge its bindingness only when it has been sacrificed, that is, killed. Thus, Kant writes: "Taste, like the power of judgment in general, consists in disciplining (or training) genius. It severely clips its wings, and makes it civilized or polished; but at the same time it gives it guidance as to how far and over what it may spread while still remaining purposive" (*CJ* 50, p. 188).

Taste is the agent of culture that cultivates and domesticates genius, yet it is the only agency through which nature can come to appearance, can be normative. Nature retains its power to bind in culture by means of appearing to cultivated subjects as a self-sacrificial nature calling out for acknowledgment—only, that is, as living nature dying over and over again before our eyes. Art is history, therefore, because it is the recapitulation of the never-ending initiating moment

of culture, and the exercise of taste is the pleasure we take in nature's insistence beyond death. Kant concludes the thought begun above:

> [Taste] introduces clarity and order into a wealth of thought, and hence makes the ideas durable, fit for approval that is both lasting and universal, and [hence] fit for being followed by others and fit for an ever advancing culture. Therefore, if there is conflict between [genius and taste] in a product, and something has to be sacrificed, then it should rather be on the side of genius; and judgment, which in matters of fine art bases its pronouncements on principles of its own, will sooner permit the imagination's freedom and wealth to be impaired than that the understanding be impaired. (*CJ* 50, pp. 188–89)

In this striking argument, "fit for being followed by others" and "fit for an ever advancing culture" function as synonyms for the afterlife of durable ideas. Culture's demand, executed by taste, that nature appear within it is the moment of the demand for the sacrifice of nature. Taste delights in rendering the jumble of genius fit for eternal approval by making it lucid and sober; taste, in other words, institutionalizes genius in the form of lasting markers of its once dynamic relation to the subject in which it was embodied. Taste, in other words, is *taste for memorials* that give spirit its (dead) nature. However, because these memorials are the works of genius that are fit for being followed by others, they are also the site of the renewal of the threat to culture, the renewal, that is, of the power of genius as nature in the subject. Taste creates a cemetery of art, but since this cemetery is populated with the works of genius, it is a cemetery of undead spirit fit for being followed by an ever advancing, which is to say essentially open, culture. Art thus gives rise to the afterlife of sacrifice—which is to say, to history—by occupying the frontier between disciplinary culture and nature at which deathly freedom and the living dead pass restlessly over into one another. It sustains and recapitulates the loss of nature achieved by culture in order to transmit that loss to those who follow. The loss of nature is the historical truth of disciplinary culture, the official history of which, in its perpetual and tasteful falsification of nature's sacrifice, renews the need to retell the campfire story of culture's advent on the way to a culture befitting humanity. In this sense, art is that moment when disciplinary culture turns against itself.

The distinction between the historical truth of culture and its official history, between the constantly renewed loss of nature which art sustains and the dream of the final overcoming of nature which fantastically grounds the culture of discipline, appears in Kant's thinking as the opposition between "following," on the one hand, and "copying" or "aping," on the other. These concepts represent alternative modes of coming after, or inheriting, previous cultural achievements.

The aper takes the precedent achievement as offering to culture a battery of methods that may be redeployed in the service of later purposes. The aper simply copies the work of the genius as if the achievement of genius were a technical one, thus revealing that she is under the spell of disciplinary culture's official history of endless achievement. Whereas for the aper the new rules established by the work of genius are ratified by repetition, for the follower, by contrast, the repetition that the work of genius compels violates the specificity of those rules, that is, their newness. Copying takes the rules of culture, which are the agents of nature's sacrifice, for an absolute achievement of art, but the follower, inspired by the work of genius, takes that work as exemplary of the non-iterability of artistic normativity. The follower, thus, prolongs the moment of the death of nature that the aper takes to have happened in the past. Here is how Kant puts it.

> Since, then, [the artist's] natural endowment must give the rule to (fine) art, what kind of rule is this? It cannot be couched in a formula and serve as a precept, for then a judgment about the beautiful could be determined according to concepts. Rather, the rule must be abstracted from what the artist has done, i.e. from the product, which others may use to test their own talent, letting it serve them as their model, not to be *copied* but to be *imitated*. How that is possible is difficult to explain. The artist's ideas arouse similar ideas in his apprentice if nature has provided the latter with a similar proportion in his mental powers. That is why the models of fine art are the only means of transmitting these ideas to posterity. (*CJ* 47, pp. 177–78)[15]

And later:

> The other genius [the lucky apprentice], who follows the example, is aroused to it by a feeling of his own originality, which allows him to exercise in art his freedom from the constraint of rules, and to do so in such a way that art itself acquires a new rule by this, thus showing that the talent is exemplary. (*CJ* 49, p. 187)

In treating the techniques of earlier works as if they were fully successful art, mere copying forgets the death of nature in the work of art and becomes thereby a happy mimesis of death. The follower, however, is freed by the exemplarity of the precedent from the constraint of rules, even though the invention of those very rules from which the follower is freed is what made the exemplary original worthy of being followed in the first place. It is as if the exemplary work of genius establishes a metarule—"Establish new rules!"—that cannot be executed since heeding it entails inspiring others to follow by not heeding the rules the original established. The work of genius can only establish binding conviction

in its followers if those followers fail to be bound by its artistic achievement—
if, in other words, the work fails to transmute the culture to which it is sacri-
ficed. The historical truth of artistic following thus appears to Kant as a non-
narratable ("difficult to explain") history of discontinuous exemplarity in which
every follower sees the ghost of life emanating from dead nature. The history of
art is an endless crisis of the transmission of cultural mediation.[16]

This transmissive crisis becomes pressing for Kant in the contradiction be-
tween teaching art and inheriting it. The teaching of copying to those who come
after genius is easy enough, since copying simply requires abstracting from the
achievement of the genius those rules of taste that enabled the genius's nature to
appear in culture. However, since that appearance is just taste's clipping of the
wings of genius, to teach the copying of it is the opposite of transmitting genius;
it is, instead, instruction in the canons of the distaste for nature that is discipline's
engine. Teaching, in other words, is at odds with following even as it is requisite
for any later artistic achievement whatsoever. The capacity to follow cannot be
taught—it can only be ignited by a teaching that does not teach too well. Now,
this scenario of the structural failure of the teaching of art stands in stark contrast
to the Vasarian academic narrative of cultural transmission in which culture is
sustained by means of masterful accomplishments being taught to student-ap-
prentices. Instead of a temporalizing coordination of the taught and the learned,
Kant detects at the heart of artistic inheritance a conflict between the teaching of
the purposive skills of art and the renewal of nature's sacrifice at each moment of
following. In sensing this subterranean animus impeding the purposiveness of
cultural transmission, Kant discovers artistic modernism.

Kant does not, to be sure, swallow his discovery readily. The interruption of
the continuous official history of culture by the bond of sacrifice and loss that
constitutes following leads him back again and again, like a tongue to a tooth-
ache, to the traumatic scene of artistic instruction. We have seen already several
descriptions of this scene and we will shortly close our discussion by focusing on
one more. The relation of master and student-apprentice is, of course, the nu-
cleus of artistic transmission, the cell of cultural reproduction in which lineages
of influence and filiation are established. In it, the past of a culture forges its fu-
ture as the locus of its self-preservation. However, the trauma that incessantly
draws Kant back to this scene is the crisis of mastery at its core. The master
artist is licensed to teach future masters in virtue of having become a master in
the past. The infinite yet determinate line of masters and students organizes cul-
tural continuity—it is just what is traditional in premodern art. For Kant, how-
ever, the master artist is the genius whose talent "cannot be couched in a for-
mula and serve as a precept." What licenses a master to teach is at the same time

essentially unteachable. Every genius, that is, every master in the infinite line of masters, is also a break in the lineage. Thus, every moment of artistic instruction is an event of discontinuity logically presumed by the structure of a specifically artistic pedagogy.

The inability of the master to teach makes the scene of artistic instruction into a theater of the master's nakedness before his own mastery: he cannot be said to have properly mastered his own mastery. The embarrassing powerlessness of the master is, however, simply another name for the master's genius. That the genius's mastery cannot be grasped in a formula, that it is a cognitively groundless achievement, makes him at once both worthy of siring the next generation and impotent to do so. Looking forward to the generation of students, the master is a father actively pursuing his posterity, but looking backward to his attainment of the warrant of mastery, he is a midwife passively birthing the work of nature in the subject. The master is thus in no position to claim his achievements to the credit of his purposive work, despite such a claim serving as the basis of the entitlement to sire. Where paternity was to be, there is, traumatically, unclaimable fecundity instead. Artistic education is the scene of the unmasking of the mastery of the genius.

In the theater of artistic discipline, a generational vacancy bores through the claims of tradition. Copying can be taught to the aper, but that is a nongenerative reproduction of the same; what is generative, on the other hand, cannot be taught. The master's posterity is thus dependent on what he is powerless as such to produce: the power of the student to follow. This power, which, once again, is "difficult to explain," is not however a simple little extra that nature sometimes adds to the skills that the student learns from the master; it is, more ominously, an ability to regard those skills as that from which the student must attain freedom in order to become an artist. The power to follow is just the power to deny the claim of paternity the master implicitly but groundlessly claims. Put otherwise, once skill and fine art are distinct, genius becomes a traumatogenic nonreconciliation not just to dead nature but to formal history, for the student recognizes, in the powerlessness of the master to teach, that formal history is just dead nature. Artistic transmission is, we might say, *unruly* history in which the normative force of an artistic achievement is gained only retrospectively once it has incited the overturning of the force of culture that called it into being.

That the history of art appears at the site of generational vacancy supposes that the landscape of art's past is littered with the corpses of prior moments of nonreconciliation that have become all too tasteful. The student studies the exemplary works of the past in search of their achievements, but insofar as the free spirit of the genius failed to transform dead nature into living nature, those

works are now mausoleums of vaporized spirit. They bind, if they do, not because they live on as the undying achievements of the past, but because they are records of suffering. Taste, recall, has made them fit for being followed—and following, as opposed to aping, is only possible after failure. The future of art thus becomes not the preservation of cultural achievement, but the sustaining of the endless dying of nature at culture's hands. Art is always born for Kant from the shards of the dead history of works of genius, each one whispering the same sentence in its own dead language: here a humanity intimate with its own nature once breathed its last.

This idea of a future for culture built on the ruins of its own past opens the prospect of an historical temporality different from an orientation by substantive tradition—it invites us to prospect for an orientation in the wreckage of substantive tradition. The failure of freedom in past art, its having failed to shake off the dead nature which called it into being, makes its claim on the student insofar as it appears as the master's generative disability. Past works thus take their place as sites of the necessary suffering of nature in the subject at the hand of the culture it cannot normatively transfigure. The failure of past art to sustain nature, and not its success at doing so, generates art's future by staking artistic transmission to the student's inevitable turn away from the failure of tradition and the tradition of failure. Even more strongly, as Kant's limning of the trauma of artistic instruction suggests, artistic transmission happens *just as this turning away*. The natural revulsion at the spectacle of ceaseless loss carries that loss along into a renewed effort to master it. Nature in the subject, we can say, is preserved in the necessary Oedipal repudiation, which constitutes the loss of substantive tradition as nature, of the false master.[17] The student's disavowal of the teacher, justified in the name of the teacher's incapacity, is the student's nonreconciliation to the history of art and therefore is the sine qua non of the transmission of culture as lost nature. Art's history is then structured not by a strong tradition, but by its perpetual breakdown.

In teasing out the antitraditional logic of artistic transmission, Kant redescribes artistic inheritance in recognizably modernist terms. It seems odd, of course, that Kant could develop this logic half a century before the advent of the phenomenon whose logic it is. However, it is not really so surprising since Kant, like the modernism yet to come, was deeply attuned to the internal yet tense relation between the necessity that beauty appear as nature and art's function as culture's preserve for the claims of dead nature. Put another way, because of his insistence that beauty be seamless across nature and art, Kant was ready, even if not able in his own taste, to understand the necessity for art to begin tilting against its own scored history in order simply to preserve its promise of nonreconciliation.[18]

To say that modernist art's history is the story of its perpetual ruination is also to say that it is in art that the modern idea of history as the realm of the unreconciled takes shape. Indeed, if the idea of history is the modern gamble that a culture befitting humanity can yet be built out of the denormativizing of substantive tradition, then artistic modernism's ceaseless striving for the new, in which it exemplifies the logic of Kantian exemplary originality, is nothing but the infrathin space of nonreconciliation within disciplinary culture in which the dice are thrown.

I shall conclude this chapter shortly with a discussion of Kant's thinking about how self-differentiation within nature takes up residence in *artistic* modernism in particular, but for the moment let us note that the thought of history as the working of nonreconciliation perfectly captures the dynamic of modernism. One need not get involved here in the various debates about the periodization of modernism, but from concerns with the materiality of the artwork in Rimbaud, to concerns about the disappearance of perceptual experience in Cézanne, to concerns about cultural valorizations of handiwork in Duchamp, to concerns, in situationist art, about the social isolation of spaces of display, modernist art has been impelled to show itself to be unreconciled to what—from the point of view of its self-proclaimed newness—stands revealed as its own past failure to be free.

The extremes to which modernist art must go to hold open the project of nonreconciliation with the history of its own failure are notorious. But the only way to hold history open is, precisely, to insist ever more furiously on the necessity of the failure of art. No more poignant instance can be found than in Thomas Mann's *Doctor Faustus*. The composer Adrian Leverkuhn is grief-stricken over the death of his nephew Nepomuk in whom he had invested all his hope that there could yet be goodness on the earth. In his anguish, Leverkuhn curses life itself to his friend Zeitblom, who narrates the composer's instructional tirade.

> I was leaving when he stopped me, calling my name, my last name, Zeitblom, which sounded hard too. And when I turned round:
> "I find," he said, "that it is not to be."
> "What, Adrian, is not to be?"
> "The good and the noble," he answered me; "what we call the human, although it is good, and noble. What human beings have fought for and stormed citadels, what the ecstatics exultantly announced—that is not to be. It will be taken back. I will take it back."
> "I don't quite understand, dear man. What will you take back?"
> "The Ninth Symphony," he replied. And then no more came, though I waited for it.[19]

That the "Ode to Joy" could not save Nepomuk makes its joyfulness a mockery, not a redemption, of human suffering: to live in a world with it but without the child is to be condemned to a life of being scorned by an eternal, yet eternally unfulfilled, promise of the redemption of pain and guilt. Hence, the Ninth failed at the pinnacle of its redemptive power and so must be repealed. But how can one repeal a failure that is part of the texture of the world? One could say in a voice of philosophical wisdom and world-weariness, as will Hegel, that art is passé, thereby removing it from *this* world. Or one could, like Leverkuhn, write the "Faust Oratorio" to perpetuate Beethoven's failure within a failure of one's own and to show thereby that *of course* it had to fail—it was only art. Art's response to its own failure is to seek to negate it by incorporating it. This might yield, as it does for Leverkuhn, a lamentation, but that lamentation is nonetheless a roar of protest against false reconciliation—against, that is, art's own lamentable history of failing to be free.

V

That it is art that transmits history seems a heavy burden for a single and fragile human practice to bear. Indeed, given Kant's argument that artistic beauty is the sepulcher of dead nature, it would seem as if art at least could share its load with the aesthetic experience of nature. Of course, Kant does not hold that the onus of the historical transmission of the trauma of the culture of discipline was always shouldered by art alone; however, the epoch in which the beauty of unmediated nature was a site of history is already imagined by him as passing by the late eighteenth century. As he closes his critique of aesthetic judgment, he conjures a future in which art alone is left for historical transmission. That future is our "now," and what Kant conjures is artistic modernism.

In a textually belated appendix to the *Critique of Judgment,* "On Methodology Concerning Taste," Kant ponders a pedagogical question that was anachronistic for him but surprisingly timely now: what constitutes the proper curriculum for artistic training? Because the artistic work of the master cannot be transmitted directly, there can be no method in the strict sense for art education. "The master must show by his example what the student must produce, and how," but if the aim of instruction is to encourage the student to become a master herself, then the example of the master must be followed rather than learned. Technical art instruction is mnemonically necessary for the student to remember that she is not yet a master; it is the bare bones of the pedagogical situation. However, what matters in artistic training is the development of the student's humanity. The propadeutic for all artistry is the study of the humanities in or-

der to cultivate in the student the "universal feeling of sympathy, and the abil-
ity to engage universally in very intimate conversation." The combination of a
feeling of sympathy and a capacity for intimacy in communication together
constitute what Kant calls "the sociability that befits our humanity"(*CJ* 60, p.
230). Artistic training, thus, is training for the production of a culture suitable
for humans. The universal feeling of sympathy for the struggle of humanity and
the capacity for intimate communication, that is, for maximal closeness with
others whom one nonetheless recognizes as separated from oneself across a gap,
permits the artist to become unafraid of the historical nature of humanity. Art-
ists are thus poised to take on themselves the role of historical transmission.

But take it on from where, from what other practice? Kant's brief answer is
religion and politics.

> There were people during one age whose strong urge to have sociability *under
> laws*, through which a people becomes a lasting commonwealth, wrestled with
> the great problems that surround the difficult task of combining freedom (and
> hence also equality) with some constraint (a constraint based more on respect
> and submission from duty than on fear). A people in such an age had to begin
> by discovering the art of reciprocal communication of ideas between its most
> educated and its cruder segments, and by discovering how to make the im-
> provement and refinement of the first harmonize with the natural simplicity
> and originality of the second, finding in this way that mean between higher
> culture and an undemanding nature constituting the right standard, unstatable
> in any universal rules, even for taste, which is the universal human sense.
> (*CJ* 60, pp. 231–32)

Once upon a time, art's function was explicitly and entirely political. It opened
relations of reciprocity between two classes which, despite occupying the same
space, were nonetheless trapped in a war of nonrecognition. Because they co-
habited in a shared discursive space, the classes were politically conjoined, but
relations of reciprocal recognition were nonetheless lacking; the members of this
polity were antagonistically bound together somewhere on the road between be-
ing a people and being citizens of a commonwealth. Under these conditions of
unsociable sociality, art served "the strong *urge* to have sociability under laws."
Art, thus, was the practice in which was prefigured a political norm that was in
fact nowhere to be found. It was the agency of a political norm—Kant says, of
legal equality as a political norm rather than a mere form of law—and thereby
the legitimation by means of the imagination of a common ground between
classes of a fully human politics that did not yet exist. Straddling the higher cul-
ture that repudiated nature and the cruder segments whose crudity was the life
repudiated by higher culture (the higher logically depending on the lower it is

higher than), art kept the two classes from falling apart into two belligerent and separate societies by figuring forth a culture that was grounded in the interests of neither class. Art was thus the necessary supplement of divided social life without which its diremption could not be seen as a political split at all, that is, as a split internal to the constitution of society; it was the appearance of the precondition for politics with which actual politics was not synchronized. Art was for this reason the traumatic image of a politics yet to come in the alluring form of a harmony already here.

Now, it surely is just as presumptuous to saddle Kant with a radical egalitarianism as it is to find in his writings the prematurely developed logic of artistic modernism. Nonetheless, Kant here argues that art is the representative of an egalitarian political normativity without which social life is nothing but refined war. This is a subtle but vicious attack on the belief in its own refinement by higher culture, charging that, unless that culture can turn against itself by seeking to communicate reciprocally with what, from its refined perspective, is beneath contempt, it is nothing but a self-interested illusion. Insofar as art is this turning, it is also the mere appearance that discloses to higher (disciplinary) culture its interminable double bind: without art, disciplinary culture would stand revealed as a form of warfare oddly ashamed of its own bellicosity, while with art it stands revealed as false to its self-description as elevated above nature. Art, thus, is a product of cultural mastery that exhibits the illegitimacy of the masters. Because mastery needs art to arrogate its own refinement, art is just as much the site of culture's self-criticism as of its normativity: the war against crude nature turns into a culture befitting humanity only when it is turned against disciplinary refinement as an unconquered piece of culture's nature. At the heart of culture, art is an outcropping of nature's claim against those who, in warring against nature, turn it into a belligerent force. As the image, but only the image, of a political rapprochement, art transmits the normativity of nature that the culture of discipline simultaneously presumes and disavows.

The illusory objectivity of the disavowal of nature—the insistence of nature in the subject at the height of its disavowal—was the natural beauty of both nature and art. As a corpse-littered field of devastated nature, the history of beauty is the compelling residue of the human struggle, which Kant calls culture, with its own self-dirempting nature. It is, we might say with Kant, a graveyard of failed efforts to imagine the "mean between higher culture and an undemanding nature constituting the right standard . . . which is the universal human sense"; that is, the family vault of those evanescent yet shattering appearances of the *sensus communis*, which, *as a sense*, is the standard for a culture befitting humanity. However, Kant's just-so story is related in the context of advice about how to train

artists in *humaniora*, the capacity to intimately and sympathetically undergo the humanity of other people. In other words, the critique of taste closes (and, since this is an appendix, closes a second time) with one more scene of artistic instruction in which Kant tries to imaginatively reanimate for his contemporaries the historical struggle of past art, which, insofar as instruction is required, has failed in its original political function of producing the mean. That artists need instruction in humanity as an essential adjunct to their technical training presupposes that the ghosts of futures past no longer speak naturally in the form of beauty. Kant's contemporaries are we moderns who live in a *Neuzeit*, after the age of nature. Thus, the artistic models of nature—which as models rather than nature have suffered the process of acculturation—are ever more burdened.

> It is not likely that peoples of any future age will make those models dispensable, for these peoples will be ever more remote from nature. Ultimately, since they will have no enduring examples of nature, they will hardly be able to form a concept of the happy combination (in one and the same people) of the law-governed constraint coming from highest culture with the force and rightness of a free nature that feels its own value. (*CJ* 60, p. 232)

In the enduring future of an ever advancing culture, no examples of nature will endure. Everything will become culture, even those islands of nature preserved for eco-tourists. As we grow remote from nature through our refinement, the claims of undead nature that traumatically interrupt the traumatic journey of cultivation will become fully dead. This is just what Rousseau feared: intimacy and sympathy will become exotic creatures from another world—which could have been ours—to be scrutinized from a curious distance traversed only by the unsettling recognition of a lost familiarity. This, of course, is simply a way of dramatizing the implosion of substantive tradition, of the determinative transmission of norms, which is the condition of our modernity. At exactly that moment, the models of exemplary art, the persistent records of a previous struggle for a culture befitting humanity, will be all that is left of disturbing nature.[20] History, then, will belong solely to art. For the sake of a free nature that *feels* its own value, for the sake of a lost politics befitting humanity, artists then (now) will need to be educated to turn from nature to art's own traumatogenic past. In allowing himself to be transfixed by the crisis of artistic education, Kant comes to ask if art can sustain this loss of mastery. Thereby, and perhaps accidentally, he discovers artistic modernism.

Art as the Tomb of the Past: The Afterlife of Normativity in Hegel

For every image of the past that is not recognized by the present as one of its own concerns threatens to disappear irretrievably.

WALTER BENJAMIN,
"Theses on the Philosophy of History"

I

Hegel's *Lectures on Aesthetics* open with a feint. In a peremptory tone that self-consciously highlights the arrogance of all philosophical beginnings, Hegel declares that the proper (*eigentlich*) subject matter of aesthetic theory is fine art. In so asserting, he continues, "we at once exclude the beauty of nature" from the systematic philosophical treatment of beauty (*ILA* 3). The integrity of philosophical aesthetics, its capacity to develop itself as a proper study of a proper object, depends on this exclusion, since "in dealing with natural beauty we find ourselves too open to vagueness, and too destitute of a criterion; for which reason such a review would have little interest" (*ILA* 5). In deference to common usage, Hegel consents to retain the name "Aesthetic" for his study, while noting nonetheless that the possibility of making such a study *philosophical*, that is, systematic, requires the prior limitation of its field of objects to works of art. The philosophy of art begins by leaving nature behind.

Hegel acknowledges almost immediately after drawing it that this line "may appear to be an arbitrary demarcation, resting on the principle that every science has the prerogative of marking out its boundaries at pleasure" (*ILA* 3).

Such an appearance cannot be allowed to stand, however, because, as Hegel's reference to the pleasure in drawing lines suggests, the warrant of the distinction would then be just as subjective as the responses to nature it seeks to keep at bay. Any legitimate distinction must be grounded, not in the pleasure of whimsical line drawing, but in a submission to the nature of the domain in question. In other words, the distinction between natural beauty and artistic beauty must not be imposed on the subject matter but drawn from it. For a systematic aesthetics to be possible, then, the field of objects for which it is to be developed must be a self-dirempting field, falling on its own into two distinct domains. The line between nature and art must be drawn by the object of study itself, by the work of art, in order for Hegel to ward off the charge that he has willed it for the natural pleasure of doing so.

Returning to the founding distinction, Hegel therefore refines his claim: the excision of the beauty of nature from the empire of philosophical aesthetics is justified by the beauty of art being "higher" (*höher*) than natural beauty. However:

> "Higher" is an utterly indefinite expression, which designates the beauty of nature and that of art as if merely standing side by side in the space of the imagination, and states the difference between them as purely quantitative, and, therefore, purely external. But the mind and its artistic beauty, in being "higher" as compared with nature, have a distinction which is not merely relative. Mind, and mind only, is capable of truth, and comprehends in itself all that is, so that whatever is beautiful can only be really and truly beautiful as partaking in this higher element and as created thereby. (*ILA* 4)

The point Hegel makes here is not that art is *more* beautiful than nature. To the contrary: "even a single fancy as may pass through a man's head," and which therefore may be lacking in beauty-making characteristics, nonetheless "is higher than any product of nature; for such a fancy must at least be characterized by intellectual being and freedom" (*ILA* 4). The elevation of artistic beauty above natural beauty is justified not by quantity of beauty but by artistic beauty's freedom, its own self-distancing from nature. The relation between natural and artistic beauty is not external, therefore, because it is internal to the self-constitution of the work of art; art's privilege within aesthetic theory follows from its power to demarcate its boundaries, a power mere nature lacks. As a spiritual enterprise, the work of art thus *distinguishes itself* from nature.[1] "The beauty of art is the beauty that is born . . . of the mind," where the mind is that intellectual being which has freed itself from nature.[2] Any aesthetic theory aspiring to systematicity, therefore, must track its object, the work of art, in its self-constituting repudiation of nature.

If Hegel is right about the constitution of the work of art, then he is also right that the distinction between the philosophy of art and aesthetics is not willful but necessary. If he is right, however, it also follows that the being of the work of art it is the special project of the philosophy of art to explicate carries with it the very distinction between art and nature that was supposed to serve as the philosophy of art's disciplinary a priori. In other words, if the philosophy of art is to clarify the work of art, it is also essential to its task to adumbrate the distinction between art and nature that is purportedly at work in art itself and therefore to remain an aesthetic theory in the broader sense. Hence, the expulsion of nature that Hegel initially declared a precondition for protecting the integrity of a philosophical aesthetics he equally quickly reincorporates into the discipline itself.

> The above prefatory remarks upon beauty in nature and in art, upon the relation between the two, and the exclusion of the former from the region of the subject proper, are meant to remove any idea that the limitation of our science is owing merely to choice and to caprice. But this is not the place to demonstrate the above relation, for the consideration of it falls within our science itself, and therefore it cannot be discussed until later. (*ILA* 5)

The distinction between nature and art, and the denial of a place in systematic aesthetics to the former, is vouchsafed against capriciousness because it can be grounded by the theory of which it appeared at first to be the ground. By means of this feint, Hegel opens the discussion of the circular self-grounding of the work of art, that is, of its peculiar autonomy from nature. It is easy to be misled by Hegel's dramatizing of the dilemma of philosophical beginnings into thinking that the distinction between art and nature is simply given for the philosophy of art, when in truth it is precisely the job of the philosophy of art to demonstrate, to clarify and systematize, its own foundations.

> I regard the pursuit of philosophy as utterly incapable of existing apart from a scientific procedure. Philosophy has to consider its object in its necessity, not, indeed, in its subjective necessity or external arrangement, classification, etc., but it has to unfold and demonstrate the object out of the necessity of its own inner nature. Until this evolution is brought to pass the scientific element is lacking to the treatment. (*ILA* 13–14)

The philosophy of art, in other words, must forge a conceptual distinction between nature's powerlessness and art's power just where it has not yet been made systematic. The distinction between art and nature in the realm of the beautiful remains merely apparent, merely a semblance of a distinction. However, since distinctions become real only when they are thought, the task of Hegel's philos-

ophy of art is to remake art's own shadowy distinction between itself and nature
into a properly philosophical one, thereby legitimating the claim to power over
nature art asserts but is yet not powerful enough to establish. Precisely because
art both distinguishes itself from nature and at the same time remains confused
with it, the grounding distinction of the philosophy of art lingers. In its refusal
to stay in the subordinate position to which art consigns it, nature's difference
from art penetrates to the heart of the discipline it grounds. Because the philos-
ophy of art thereby receives the task of dealing with the remains of nature in art,
I will retain the name "philosophical aesthetics" while discussing Hegel—in def-
erence to common usage.

II

The lingering of nature's remains is the subject of this chapter. At first glance,
this is a less than promising approach to Hegel. After all, the most famous claim
in his aesthetic theory, that art is a thing of the past, seems to mean that art, the
sensuous manifestation of truth, is dead and that the discursive rationality that
founds the abstract norms of modern life by denying that sensuous particularity
can be the site of truth is the murderer. On this view, when he argues that "our
present in its universal condition is not favorable to art" (*ILA* 13), Hegel is
thought to imply that art is a mode of cultural production whose central signif-
icance has been surmounted in modern culture by discursive rationality. This in-
terpretation, however, is at odds with another of Hegel's key claims, that the
reawakening of philosophy, that is, discursive rationality in its highest and most
self-reflexive form, is itself responsible for the "higher estimation" of art in mod-
ern culture (*ILA* 61). Indeed, the emergence of philosophical aesthetics as a sep-
arate branch of philosophy devoted to art alone, of which Hegel takes his own
theory to be the most developed instance, is a key contributor to this heightened
esteem. The contradiction between art's retreat into the mists of premodern his-
tory and the modern attachment to it is only apparent, though, and by under-
standing the logic of lingering that Hegel descries at work in art and its philos-
ophy, we shall be able to grasp Hegel's point that art is held in highest esteem at
the moment when it most tarries with its own pastness. That Hegel has some-
thing like this in mind is signaled by the too often neglected second half of the
claim that art is for us a thing of the past: that art *remains* (*bleibt*) for us a thing
of the past (*ILA* 13). Persisting in its pastness is the cultural specificity of art in
modern culture. Art, for Hegel, is and remains a thing of the past because it sus-
tains an undigested moment of lost nature with which modernity continually
must wrestle. And because art in particular is the tomb in which modernity pre-

serves the possibility that discursive rationality might yet confront its own per-
petual entanglement with dead nature, the special task of aesthetic theory is to
come to grips with our unresolved trouble with nature's unburied remains.

In pursuit of lingering, let us pick up the thread of our argument. Art, it is
supposed, "impart[s] to phenomenal semblance a higher reality, born of mind"
(*ILA* 11). As a remaking of nature's appearance, art reveals to minded creatures
that the phenomenal semblance that impedes direct access to reality is in fact
born of spirit's own practical drive to know reality; art thus makes of phenome-
nal semblance a mode of reality's disclosure. However, this project remains in-
complete insofar as art accomplishes its end only in unthinking sensuous form.
Through art, spirit may grasp implicitly that semblance is its own proper
medium, but it does so only in the opaque mode of nonrecognition; art is mind-
edness locked up in the unfamiliar site of sensuous things. That art is semblance
born of mind is a truth that thus remains merely latent in the concrete sensuous
work of art. "The work of art . . . presents itself to sensuous apprehension. It is
addressed to sensuous feeling, outer or inner, to sensuous perception and imag-
ination, just as is the nature that surrounds us without, or our own sensitive na-
ture within" (*ILA* 40).

For Hegel, the confusion between nature and art is built into the very nature
of art. Because art is the reworking of nature through which spirit remakes na-
ture as an appearance of spirit, on its own art does not fully distinguish itself
from nature. The initial distinction, therefore, must be taken up into aesthetics
as the want of compelling demonstration of nature's externality to spirit: art, re-
maining entwined with its proper other, does not clearly expel nature on its
own. Thus, just as much as it is in the self-constitution of art to distinguish it-
self from nature, it is equally necessary that it appear entangled with nature. Be-
cause art's expulsion of nature is perpetually incomplete, nature trails art into
the realm of philosophical aesthetics.

That the job of philosophical aesthetics is to stabilize the anomalous relation
between art and nature accounts for the peculiar hostility between art and phi-
losophy.[3] We will return to this antagonism later in the chapter, but we can of-
fer a first snapshot of it now by focusing on how art's internal relation to exter-
nal nature confronts philosophical reflection. The work of art is a thing in the
world that appears as if it possesses an inner life, an intrinsic significance, de-
spite the fact that "the work of art has no feeling in itself, and is not through and
through a living thing" (*ILA* 33). The philosopher knows that "the work of art
attains a semblance of animation on its surface only" and is a work of art not in
virtue of the natural properties of its medium, but only insofar as it is nature
that has "received the baptism (*Taufe*) of the spiritual" (*ILA* 33). Although it may

be true that "the sensuous aspect of the work of art has a right to exist only insofar as it exists for man's mind" (*ILA* 40), nonetheless this philosophico-judicial judgment is at odds with both the experience of and the making of art.

> Artistic contemplation accepts the work of art just as it displays itself *qua* external object, in immediate determinateness and sensuous individuality clothed in color, figure, and sound, or as a single isolated perception, etc., and does not go so far beyond the immediate appearance of objectivity which is presented before it, as to aim, like science, at apprehending the notion of such an objective appearance as a universal notion. (*ILA* 42–43)

> [The production of art] is neither, on the one hand, purely mechanical work, as mere unconscious skill in sensuous sleight of hand, or a formal activity according to fixed rules learnt by rote; nor is it, on the other hand, a scientific productive process, which passes from sense to abstract ideas and thoughts, or exercises itself exclusively in the element of pure thinking; rather the spiritual and the sensuous side must in artistic production be as one. (*ILA* 44)

The work of art, like the exercise of human skill, concept formation in natural science, and the reflexive critique of philosophy, is an activity of minded creatures and so presses a claim of spirit. In the case of art, however, this claim is pressed in the theater of nature in which spirit is as one with its appearance. The claims of spirit thus appear in the work of art as if they were the claims of nature itself. From a philosophical point of view, spirit and nature are, as the quotes above demonstrate, two distinct sources of claims against experience and activity—two discrete norms, that is—which in art are fused. Art thus generates a world of animated nature, nature filled with the breath of inspiration. This claiming nature is, however, really artifice, since the nature which appears animate in art is nature which has been *reanimated* as an "offspring of spirit" (*ILA* 3). In the world of artistic illusion, a nature which is not animated—which is in itself without spirit—appears again alive. In describing the central importance of the human form in classical art, Hegel writes: "Personification and anthropomorphism have often been decried as a degradation of the spiritual; but art, in as far as its end is to bring before perception the spiritual in sensuous form, must advance to such anthropomorphism, as it is only in its proper body that mind is adequately revealed to sense" (*ILA* 84–85).

The sensuous nature from which art incompletely separates itself is the nature that once housed spirits, and the beauty of art the reappearance of spirit in the nature from which spirits have been banished. Beauty, thus, is the fragile claim of nature, a claim which clings to nature's mere semblance, on our immediate concern, but into this anthropomorphic world of art philosophy delivers the bad

news that nature, despite appearances, is inanimate. And since philosophy is it-self an activity of spirit, its judgment is the recoil of spirit from its naturalized appearance in art. Put in the theoretical voice of the philosophy of history, phi-losophy overcomes artistic animism.[4] Here is the first sense in which philosophy and art are hostile competitors. But its antagonism to art's magic notwithstand-ing, the philosophical announcement that nature is dead must have for art the eerily familiar sound of deja vu. The anthropomorphism of classical art is, Hegel says, a stage to which art must advance. Art's task, to fuse spirit and sensuous-ness, is the satisfaction of spirit's demand to comprehend itself in the sensuous-ness from which it has become alienated. As an advance, therefore, artistic ani-mism logically presumes the perception of nature's inanimacy as what must be overcome. Artistic animism is thus necessarily *belated*; in fact, insofar as ani-mism is a *Weltanschauung*, a global perspective on the natural world, it is really the spiritual afterlife of animation provoked by the intolerability of the percep-tion of inanimate nature. Nature's baptism by spirit is a perverse religious ritual in which spirit confuses baptism with funereal atonement by using on corpses a rite properly reserved for newborns. Art, hence, is the pretense that alienated na-ture may yet be "sufficiently powerful to call forth a response" from us, that is, may yet become normative for us. In confusing nature and art, art generatively disavows its own proper knowledge that nature is dead by making that death into the beginning of spiritual life.[5]

To say that art cannot tolerate the end of animism is, of course, a reifying ex-pression. It would be clearer to say instead that art is the practice that arises out of spirit's incapacity to tolerate its ejection from an unreflective identity with na-ture, from, that is, the spirited world. In holding tight to an internal relation to external reality, art, for Hegel, is forever haunted by a disavowed memory of the traumatic moment at which nature and spirit fell apart and spirit was sent on its way. As spirit lifts itself out of self-contained nature (or, put in nonhistoricist terms, as rational human autonomy differentiates itself from natural compul-sion), it witnesses nature for the first time as external to itself. However, because it is *spirit* that has left nature behind, nature appears not just external to spirit but also bereft of spirit—that is, *dead*. More strongly, since spirit is self-determining freedom, that nature be bereft of power is the very condition of spirit's existence. Spirit's arrogation to itself of self-determination, its mythical autochthony, is thus *both* its mortifying perception of having been born from a murder of nature of which it stands already convicted *and* a denial of that perception. Put in a way that echoes our interpretation of Kant, spirit is the traumatized survivor of a calamity that, from a spiritual point of view, had befallen nature before spirit ar-rived but for which it senses its responsibility nonetheless. Indeed, every later

moment of attributed self-determination in which spirit externalizes nature by placing itself external to nature—every moment, that is, of the mutual alienation of autonomy and nature—is an amplification of nature's deadness. Spirit grows out of a dead nature that becomes ever more fetid in direct proportion to spirit's increasing vigor. *It is this endlessly dying nature to which spirit is bound in art by bonds of unconscious guilt.* Art, thus, remains oriented by the dead nature that spirit judges disorienting.

Because art is the unconsciousness through which spirit lives out its guilty relation to nature, we can see why Hegel shuttles between two different descriptions of the nature from which art cannot fully distinguish itself. On the one hand, he refers to it as "external" or "outer" (*äußere* and its various forms) nature. Under this description, nature is the stuff that is available for the externalization of spirit in the work of art. This is the naive view of the inanimacy of the raw material from which art is made as simply there for spirit to play with; it is the perspective of the happy unconsciousness that remains innocent of its dependence on that inanimacy. However, at the edges of this charmed perspective a more ominous characterization lurks.

> Man is realized for himself by practical activity inasmuch as he has the impulse, in the medium which is directly given to him, and externally presented before him, to produce himself, and therein at the same time to recognize himself. This purpose he achieves by the modification of external things upon which he impresses the seal of his inner being, and then finds repeated in them his own characteristics. Man does this in order as a free subject to strip the outer world of its stubborn foreignness, and to enjoy in the shape and fashion of things a mere external reality of himself. (*ILA* 36)

Man has the impulse to cancel the external world that rises up before him. This impulse is an internal drive elicited by the perception of the external world as external, as if man recognized that the externality of the external world concealed a meaning addressed darkly to him. But in being recognized as meaningful, the world's externality is at the same time perceived as internal to spirit. In particular, the unique significance of externality resides in its being the sensuous limit of man's self-determination insofar as it is "directly given to him" rather than spun out of his rational "inner being"; it is external because it does not submit spontaneously to the drive it calls forth. The externality of nature is thus not merely given—it persists in its givenness as an obstacle to spontaneous activity that such activity must cancel. Externality just is the impediment proper to spontaneous freedom. Inanimate nature is in its essence stubborn, therefore, in that it makes claims on spirit that spirit cannot fail to heed despite the fact

that spirit does not hear the source of the claims speaking a human language. Despite external nature's appearing fully external, it turns out that it is not external enough. In its claim on human activity, inanimate nature is also oddly, persistently animated.

This uncanny animacy of the inanimate is captured in Hegel's second description of the nature to which art is bound: dead nature (. . . *das Kunstwerk . . . ist . . . als äußerliches Objekt betrachtet tot*). This description exhibits the unhappy consciousness that nature is inanimate insofar as spirit has stripped it of its power to propel itself from within. Hegel suggests this characterization obliquely early in the lectures when he declares that "the beauty of art is the beauty that is born—born again, that is—of the mind" (*ILA* 4) (*aus dem Geiste geborene und wieder geborene*), thereby implying that intrinsically spirited nature must have already died once before. The hint about the lost life of nature is then made explicit later on when, in justifying his overturning of the traditional hierarchy which placed nature over artifice, Hegel writes:

> It was an obvious opinion for the common consciousness to adopt on this head, that the work of art made by man ranked below the product of nature. The work of art has no feeling in itself, and is not through and through a living thing, but, regarded as an external object, is dead. But we are wont to prize the living more than the dead. We must admit, of course, that the work of art has not in itself movement and life. An animated being in nature is within and without an organization appropriately elaborated down to all its minutest parts, while the work of art attains the semblance of animation on its surface only, but within is common stone, or wood, or canvas. . . . But this aspect, viz., its external existence, is not what makes a work into a production of fine art; it is a work of art only in as far as, being the offspring of mind, it continues to belong to the realm of mind, has received the baptism of the spiritual, and only represents that which has been moulded in harmony with the mind. (*ILA* 33)

Common consciousness is wrong to value the beauty of nature more highly than artistic beauty, but not because it is wrong about the one being borne by the living and the other by the dead. Rather, "we must admit" that common consciousness is correct that the work of art, "regarded as an external object, is dead," that it "has not in itself movement and life." The error of common consciousness is that it fails to acknowledge that the death of nature, its loss of the power to sustain normative claims against spirit, is the precondition for nature's being "moulded in harmony with mind." Indeed, when Hegel returns to this error one more time, it turns out that the undervaluation of the death of nature is nearly definitive of common consciousness.

The work of art, although it has sensuous existence . . . does not require sensuous existence and natural life; indeed, it even ought not to remain on such a level, seeing that it has to satisfy only the interests of mind, and is bound to exclude from itself all desire. Hence it is, indeed, that practical desire rates individual things in nature, organic and inorganic, which are serviceable to it, higher than works of art, which reveal themselves to be useless for its purpose, and enjoyable only for other modes of mind. (*ILA* 41–42)

Only sensuous existence stripped of life, only the semblance of sensuousness, is the true medium of art, for it is only when nature loses its capacity to satisfy living desire that it can be regarded with disinterest. Even those living things and artifacts that are beautiful but also still useful—flowering medicinal plants, say, or swords etched with fine filigree—satisfy more than interests of the mind insofar as they play roles in practical life in virtue of their real sensuous properties. Only what satisfies no palpable desire can satisfy *only* interests of the mind. Hence, Hegel must conclude unavoidably that nature without spirit is the only suitable medium for the work of conscious human self-recognition. Because we do not freely and rationally infer that a living creature is alive but rather immediately see its life, the life of living nature compels recognition; therefore, the self-recognition of the human as spirit occurs only in dead nature, which, in no longer compelling recognition, leaves the human freely self-determining. We preserve ourselves where we have deadened what delays our self-acknowledgment, or, put otherwise, we depend on dead nature to remind us of our freedom. The pretense of art that alienated nature may yet be sufficiently powerful to compel a response from us itself rests, therefore, on a logically prior acknowledgment of the claims of dead nature. Hence, the following densely encrypted thought:

> Upon that which, in works of art, the mind borrows from its own inner life it is able, even on the side of external existence, to confer permanence; whereas the individual living thing of nature is transient, vanishing, and mutable in its aspect, while the work of art persists. Though, indeed, it is not mere permanence, but the accentuation of the character which animation by mind confers, that constitutes the genuine pre-eminence as compared with natural reality. (*ILA* 34)[6]

It is not so much the mere permanence of fine art that elevates it over nature, Hegel suggests, although he does acknowledge that art's permanence is not irrelevant in understanding art. Our grasp of the satisfactions art offers would be hampered were we to discount the significance of the joy spirit feels in nesting in the hollowed-out cavities of the dead; as Hegel says, *even* on the side of external existence where everything else is fated to expire, the mind is able to confer permanence on its own inner life. However, since such joy is expressed in all adap-

tations of nature to human uses for which nature was not in itself destined, it cannot be the whole story of artistic satisfaction. Rather, the special and elevated satisfaction of art derives from the accentuation in it of specifically spiritual animation, of what brings to life those interests of mind that exceed the interests in self-preservation that are satisfied by the mundane use of nature. If the common interests of the human animal are satisfied by the transience-by-ingestion of this or that consumable bit of nature, then the specifically spiritual interests of mind are satisfied by the animated escape from the whole animal dynamic of transience and permanence. The beauty of fine art is the spectacle of spirit appearing as whatever outlives the endless death of nature at the hand (or paw) of the human animal; in art, spirit appears as outliving the animal nature of human interests. Thus, not only is spirit born again as beauty, it is born in an external nature so stubborn that not even its death-by-ingestion puts a halt to its capacity to compel us; the mere domination of external nature is not enough for the human animal, which also demands the *idea* of the domination of nature. In this light, the distinctive normativity of fine art is that in it spirit appears as that which outlives the eternal *abattoir* of nature. The "accentuation of the character which animation by mind confers" is thus, simply, the hypervaluation of whatever we leave alone because it is useless to us. It is the appearance of the interests of spirit that surpass the deathless cycle of life and death. However, since spirit is reflected back to itself in art only by whatever subsists after everything mortal dies—only, that is, by a nature that cannot have natural life because death does not kill it—spirit-as-art must take as its vehicle an animatedly dead nature from which it perpetually seeks, but without ultimate success, to differentiate itself. A dying nature that spirit needs to remember and reimagine in order to grasp its own essential preservation against vanishing is the nature to which art is internally bound. Therefore, art's "genuine pre-eminence as compared with natural reality" becomes a specific sort of permanence: a repetition compulsion. Indeed, it is just because art needs the lingering of perpetually dying nature as the condition of its own capacity to express spirit's permanence that dying nature keeps popping up all over Hegel's lectures on the philosophy of art.

III

Since Hegel says that the aim of art is to distinguish itself from nature and the aim of philosophical aesthetics to legitimate that distinction, the tidal motion of resurgent nature should oblige us to conclude that his systematic philosophical aesthetics is a failure. However, his equally systematic reanimation of dead nature's power to compel attention, a power renewed with each iteration of its

death, opens up for us the possibility that a quite different aim is exerting a pull on Hegel's argument: to sustain philosophically the uncanniness of nature's remaining power to resist spirit's claim to free self-determination. It must be admitted, of course, that the death of nature in art appears in Hegel primarily as the end of nature's power to compel recognition, that is, as the death of nature's normativity that is necessary to clear the way for spirit's self-preserving rebirth as beauty. However, even though Hegel might gladly offer to pay the price of a natural world stripped of authority in exchange for a gain in reflectiveness, we cannot ignore how in his writing the death of nature's normativity restlessly turns into the normativity of nature's death, how inanimate nature gives rise to spirit's binding guilt. And we cannot ignore it because Hegel himself cannot ignore it. Every moment of spirit's rebirth as artistic beauty is dogged by a confrontation with a norm that has no power to bind yet that *binds nonetheless through its very powerlessness.* It is as if the official Hegelian project of legitimating art's expulsion of nature harbors inside it a secret history of art in which art distinguishes itself from nature only in order to continue heeding nature's undying death-rattle. Even supposing, as our best interpreters of Hegel urge on us, that his philosophy aims (insofar as it establishes reason's spontaneity by depriving it of a proper natural history) to legitimate modernity as a postnatural triumph over its conditions of emergence, we still cannot resolve the ambivalence at work in that philosophy.[7] The ambivalence is most audible when Hegel seeks to deny it, and if we listen against the grain of Hegel's official voice, we can hear art murmuring an esoteric question in a nearly forgotten language: what do the dead want of us?

As we shall see when we turn in the next section to Hegel's critique of irony, responding to the desire of the dead puts the most tortuous pressure on his philosophy. Even in the lectures we are considering—which exquisitely cultivate a slight but uniform distance from everything extant—the proximity to the demands of the dead bends the discourse toward outright mimicry of them. Let us examine one passage at length in order to understand the force nature possesses, but only insofar as it is dead, in Hegel's thinking. The passage occurs as Hegel begins to divide aesthetic inquiry into its historical and generic moments. Such a division is a necessary part of any philosophical aesthetics that aims to avoid treating the multiplicity of styles and media in which art appears as extrinsic to the concept of art; nonetheless, the division must be guided by the norms of art in general as a practice striving to reconcile spiritual content and sensuous form "into a full and unified totality" (*ILA* 76). Hegel elaborates three such generic norms. First, the content of art must be worthy of representation in plastic form. Second, the content of art must not be an abstract idea that would be more at home in religious or philosophical modes of representation. These first

two norms deal with issues of artistic content insofar as such content is to be amenable to unity with sensuous form, while the third, which I shall quote at length, deals with the complementary issue of the demands issued by the external world itself if it is to be a proper medium for spirit's progress beyond its alienated relation to nature:

> If a true and therefore concrete content is to have corresponding to it a sensuous form and modelling, this sensuous form must . . . be no less emphatically something individual, wholly concrete in itself, and one. The character of concreteness as belonging to both elements of art, to the content as to the representation, is precisely the point in which both may coincide and correspond to one another; as, for instance, the natural shape of the human body is such a sensuous concrete as is capable of representing spirit, which is concrete in itself, and of displaying itself in conformity therewith. Therefore we ought to abandon the idea that it is a mere matter of accident that an actual phenomenon of the external world is chosen to furnish a shape that is conformable to truth. Art does not appropriate this form either because it simply finds it existing or because there is no other. The concrete content itself involves the element of external and actual, we may say indeed of sensible manifestation. But in compensation this sensuous concrete, in which a content essentially belonging to mind expresses itself, is in its own nature addressed to the inward being; its external element of shape, whereby the content is made perceptible and imaginable, has the aim of existing purely for the heart and mind. This is the only reason for which content and artistic shape are fashioned in conformity with one another. The mere sensuous concrete, external nature as such, has not this purpose for its exclusive ground of origin. The birds' variegated plumage shines unseen, and their song dies away unheard, the *Cereus* which blossoms only for a night withers without having been admired in the wilds of southern forests, and these forests, jungles of the most beautiful and luxuriant vegetation, with the most odorous and aromatic perfumes, perish and decay no less unenjoyed. The work of art has not such a naïve self-centred being, but is essentially a question, an address to the responsive heart, an appeal to affections and to minds. (*ILA* 77–78)

This is a dazzling and dazzled argument. We ought to drop the idea, Hegel says, that the connection between a work of art and its ideational content is accidental, as is supposed by those who see art as one among several means for peddling ideas already properly and fully formed in some other medium. Fine art has neither an expedient nor an extorted relation to its sensuous form, but, quite to the contrary, a freely necessary one. Its form is the only proper exhibition for its content. This, however, can only be so when the truth of that ideational con-

tent depends immediately on its sensuous form. That spirit is the proper self-governance of the human body is such an idea, the truth of which can only be exhibited in the comely deportment of the body's parts. It is thus that the Greeks, who, for Hegel, held this view, had a need for art and gymnastic as cultural practices with which to focus the spirit of their culture.

That an ideational content may be necessarily connected to a sensuous form entails, however, that such a content is misrepresented when it is abstracted from that form. To be able to paraphrase an artistic content in critical or philosophical concepts—not to mention being able to shape such a content before it goes forth into the work—is *eo ipso* to reveal the merely accidental nature of the sensuous appearance. Such a disclosure, while a distinct gain for reflectiveness, comes at the price of an insurmountable aporetic moment in reflection, for this inhibition of thoughtful self-appropriation which is the precondition for spirit's appearance in the full and unified totality of the "wholly in itself" work of art humbles spirit; as a mere minded spectator, spirit is the remainder of what appears to have no remainder at all.

> But inasmuch as the task of art is to represent the idea to direct perception in sensuous shape, and not in the form of thought or of pure spirituality as such, and seeing that this work of representation has its value and dignity in the correspondence and the unity of the two sides, i.e. of the Idea and its plastic embodiment, it follows that the level and excellency of art in attaining a realization adequate to its idea must depend upon the grade of inwardness and unity with which Idea and Shape display themselves as fused into one. (*ILA* 78–79)

This blow to spirit's autonomy and self-esteem must therefore be compensated by a commensurate sacrifice by sensuousness of its independence of spirit; sensuousness acquires inwardness, and the work of art power over the minded spectator, only to the extent to which spirit has already nested there in unrecognized but importunate form. As Hegel said earlier, the artistic semblance of nature "refers us away from itself to something spiritual which it is meant to bring before the mind's eye" (*ILA* 11). Spirit is subdued by mere sensuous stuff only because the stuff already expresses the demand, which it has taken into itself as an artistic norm, to become animated.[8] Works of art thus are made for minded spectators not because they come alive only in those spectators (works of art are emphatically not for Hegel phatic in nature), but rather because, like living things—like things with spirit—they demand recognition of the claims of their proper *conatus* even as they cannot justify them. Spirit tolerates its self-sacrifice because it receives in turn the free sacrifice of the mortifying self-possession of

sensuous nature. In art, sensuousness takes up as its proper fate the mere semblance of sensuousness.

In this respect, the sensuous form of the work of art distinguishes itself from "the mere sensuous concrete, external nature as such." The beauty of fauna and flora perishes and decays, leaving behind no pleading afterlife. In their self-centered naivete, natural beauties die alone and sink back unmemoriously into the inanimacy of their contentless being. Indeed, in picking out for special attention "the most odorous and aromatic perfumes" of "luxuriant vegetation," Hegel emphasizes the unquestioning capitulation to transience, the unceremonious acquiescence to nonrecognition, which is the surest mark of the unspiritual. Smell is the most unaesthetic of all the senses, having to do with "material volatilization in air" (*ILA* 43) (thus, all aromas, however pleasing, are the sensation of rot); and the perfumed vegetation is luxuriant, not merely in wasting itself in volatilized decay, but, more decadently still, in turning itself over without remainder to the further unchecked growth of the forest. No question: the life of the forest is the waste of death all around. Yet in this passage Hegel luxuriantly recalls and repeats the waste of death in order to point out how, by contrast, the work of art is spirit's survival of nature's death in essentially—which is to say memorably—sensuous form. On the one hand, art distinguishes itself from even the most beautiful nature by interrupting the finality of nature's death; on the other hand, this can only be known if wasted death is philosophically preserved as art's proper contrast. The beauty of art is the pathos of dead yet still aspiring nature and art itself nature's beautiful afterlife, but this is grasped only when Hegel recruits unmemorialized dead nature to confront cheerful spirit with its forgotten conditions of emergence.

In revivifying dead nature philosophically, Hegel sets the happy unconsciousness of art side by side with the guilt it did not, manifestly, surmount. The secret history of spirit's ruthless constitution as the death of nature—as, that is, nature's loss of power—thus returns against spirit. It is in this sense that "art no longer affords that satisfaction of spiritual wants which earlier epochs and peoples have sought therein, and have found therein only; a satisfaction which, at all events on the religious side, was most intimately and profoundly connected with art" (*ILA* 12). Simply to know that the inanimate materials of art are the remains of a once living nature is a cold awakening from the dream world of art, on the order of the communion wafer turning in the mouth of the believer into a part of the actual body of Christ. Because art was just the disavowal of the knowledge that spirit's survival is the other side of decay, the end of art is as simple as the conscious avowal of what art is—and that, of course, is the sole aim of philosophical aesthetics. Philosophical aesthetics is the end of art in the sense

that it takes on itself *as knowledge* the guilt of spirit's progress toward free self-determination. If art is a guilty practice, the philosophy of art is guilty knowledge. Nature's remains thus linger at the heart of philosophical aesthetics.

The knowledge that art cannot reanimate dead nature is dialectically complex. On the one hand, it represents an essential step forward in spirit's progress beyond magic toward secular self-knowledge. Art bore its knowledge that nature's death is internal to spirit's liberation in disavowed form only, and in that sense preserved nature's claims against spirit in its unconscious bondage to sensuousness. In unlocking this thanatotropic mystery, aesthetic theory provides knowledge of what spirit thereby comes to know as its prehistory. The history of art then becomes the story of a spiritual diaspora, a wandering through a constitutively alien land, while the philosophy of art, the knowledge that what looked like exile was just the long way home, becomes spirit's regathering. "Before the mind can attain the true notion of its absolute essence, it has to traverse a course of stages whose ground is this idea itself" (*ILA* 79). Knowing what art was is spirit's self-awareness that it had to go out of itself, of an inner necessity, in order to find itself, and that therefore it was never really out of itself at all; this knowledge finally cancels the externality of the natural world by reappropriating its (falsely animistic) claims as spirit's own alienated claiming against itself. Spirit's attachment to nature, which was expressed as art's necessary sensuous form was, it is discovered, just spirit's own internal need. Philosophical aesthetics thereby liberates spirit from its previously unaccountable reliance on sensuous nature and finally frees it from all norms extrinsic to itself.

In finally shedding nature's normativity, philosophical aesthetics grasps that spirit is what emerges from nature and is, in this light, no more than the announcement that spirit's dependence on nature is a thing of the past. But such self-knowledge, in its full-blown denial of nature's normativity, is also nothing other than the awareness that spirit is *inherently* guilty of murdering nature—it is the reflexive knowledge that spirit comes into its own as the power of free self-determination only when the pleas of living nature are consigned by spirit itself to (what thereby becomes) spirit's historical past. Thus—and here is the other hand—while Hegel's philosophical aesthetics is progressive, it is not the progressive overcoming of guilt. Rather, it is progressive in coming to know that binding guilt about sacrificed nature is spirit's perpetual burden insofar as spirit is driven by the bellicose demand to overcome. Philosophical aesthetics is the self-knowledge that self-knowledge cannot be at home in dead nature and is thus the liberation of the guilt that was sheltered unconsciously in art. This is the deepest meaning of art's being a thing of the past: the artistic promise of a return from exile from nature, the promise of the full and unified totality of the

sensuous and the spiritual in art, can no longer be fulfilled, because atonement is a thing of the past. The progressive liberation of spirit from its specifically artistic exile renders exile secular, general, and permanent: guilt without the hope of exoneration. From this point of view, the philosophical translation of art's mystery into spirit's own alienated claiming against itself does not cancel the claim, but, rather, preserves it in postartistic perpetuity.

We can now see why Hegel thinks that art's being a thing of the past and its being esteemed highly are one and the same. In an age in which spirit and nature are antitheses, art looks like a reconciliation that is unavailable to us. It figures forth the beautiful image of a nature that can tolerate its own afterlife, of a spirit that can both be itself and yet be at home within a natural world. But just as the beauty of art was the pathos of dead nature, so, more direly, it is now the pathos of a reconciliation that has gone by. Art is thus more beautiful now than ever because, as "thought and reflection have taken flight above fine art" (*ILA* 12), art becomes the embodiment of an impossible reconciliation to the whole history of endlessly dying nature. Art is the past of the modern age, which, in its reflective knowledge of spirit's essential and eternal exile, sees in art its own innocent childhood. Art is modernity's privileged bearer of what it had to sacrifice to attain spiritual maturity.

But further: on the basis of this argument, we can see not only why art is, but also why it remains, a thing of the past. Modernity grounds itself historically, that is, as the *Neuzeit* that is self-articulating insofar as it distinguishes itself from the claims of nature that have no claims on it. As Marx observed, for us "all that is solid melts into air."[9] But since the specificity of modernity must be self-produced out of a deafness to the claims of sensuous nature it must actively maintain, modernity is just the age of the end of art. For this reason the modern age needs art as never before as the tomb of the normativity it must remember not to heed. In the same respect in which art is esteemed so highly now, it persistently remains a thing of the past; the present needs art as the persistent past the nonresponsiveness to which is the regeneration of the endless present. Put otherwise, art is the beautiful display of an alternative career of nature about whose nonrealization we may feel perpetually guilty. Modernity, thus, is the age of the knowledge that makes art stillborn; it is the age of the museum and of art history.

> In all these respects art is, and remains for us, on the side of its highest destiny, a thing of the past. Herein it has further lost for us its genuine truth and life, and rather is transferred into our ideas than asserts its former necessity, or assumes its former place, in reality. What is now aroused in us by works of art is over and above our immediate enjoyment, and together with it, our judgment; inasmuch as we subject the content and the means of representation of

the work of art and the suitability or unsuitability of the two to our intellectual consideration. Therefore, the science of art is a much more pressing need in our day than in times in which art, simply as art, was enough to furnish a full satisfaction. Art invites us to consideration of it by means of thought, not to the end of stimulating art production, but in order to ascertain scientifically what art is. (*ILA* 13)

Jammed in the gears of modernity's self-reflexive self-unfolding, art is the preservation of the normativity of nature modernity knows itself to have killed but from which it can never fully liberate itself. The museum of art thus really is a church, as some have suggested, but one in which, as Flannery O'Connor put it, "the lame don't walk, the blind don't see, and the dead stay that way."[10] Because art is the dream of the dead that self-knowing modernity feels as the constant incitement to know even more, it remains the proper loss of nature for haunting us moderns. The fact we seek to hide from ourselves, but which our aesthetic religiosity reveals, is that we love dead nature. And philosophical aesthetics strives to sustain this loss of nature. As Hegel says of the competition between the abstract norms of modern life and the sensuous forms that in the glare of this abstract normativity appeal to the "natural faith and will" that knows no justified normativity:

All that philosophy does is to furnish a reflective insight into the essence of the antithesis [that modern culture has elaborated most distinctly and forced up to the point of most unbending contradiction] in as far as it shows that what constitutes truth is merely the resolution [*Auflösung*] of this antithesis, and that not in the sense that the conflict and its aspects in any way are not, but in the sense that they are, in reconciliation [*Versöhnung*]. (*ILA* 60)

A difficult thought here, unthinkable by perhaps anyone but Hegel: the truth of modernity is that it is the age that cannot represent itself to itself except in the form of a nature that is always dropping dead on it; it is the age of the end of art in which what looks like a failure of representation is simply the condition of exile from sensuous life to which we need to be philosophically reconciled. If, as Hegel thinks, philosophy is its own age reflected in thought, then the truth of philosophical aesthetics is that the very best image of modernity is a sepulcher in which dead nature remains unaccountably thought-provoking.

IV

Our interpretation of Kant in the previous chapter emphasized the significance for his aesthetics of the scene of artistic instruction. The central aim of that in-

terpretation was to show how, for Kant, modernity's historical self-transmission has come to depend on the breakdown of the relation between master and student, between art and what follows it. Let us take advantage of Kant's hot fascination with this disturbing scene to highlight Hegel's own peculiar version of it. To be sure, this sort of approach to Hegel is on one level at odds with the spirit of his argument. An important consequence of his claim that art is and remains a thing of the past for us moderns is that "art invites us to consideration of it by means of thought, not to the end of stimulating art production, but in order to ascertain scientifically what art is" (*ILA* 13). The unending obsolescence of art means that works of art no longer actively transmit past shapes of culture, that they no longer spur their own future in the form of further works. Art, in other words, has ceased to be instructive. On another level, however, the fact that art that no longer provokes more art itself issues an invitation, according to Hegel, to consider the nature of art. The obdurate pastness of art, its present lack of cultural fecundity, thereby becomes instructive. Indeed, we might approach Hegel's philosophical aesthetics as one enormous history-theater of instruction in which what is to be learned from the end of art and who is to learn it are at stake. That art is a thing of the past is, as the third section of this chapter argued, a loss that constitutes modern culture, and the question this raises for Hegel is whether a specifically modern *Bildung* is possible in which the lesson of that loss can be learned, whether, that is, the loss can be sustained in what succeeds it.

Once we begin to think of the spectacle of art's recession into the modern past as instructive, we quickly notice that Hegel identifies three students competing to learn the lesson properly: the art scholar or connoisseur, the philosopher of art, and the ironic artist. In order to avoid the obvious charge that the contest is rigged from the start since it is run by a philosopher, Hegel must demonstrate that the students are all after the same goal—to inherit what art's end transmits. Thus, his analysis must show that the connoisseur (*Kenner*), the philosopher, and the ironist are fighting over the future of the remains of nature that once were uncannily animated in art—that is, that they are in conflict over the future of modernity's past. And this turns out to be a dialectical struggle over the proper orientation to our exile from nature, over the proper handling of the dead.

Of the three, the connoisseur gets the most cursory treatment, because in the end he does not grasp the stakes of the struggle. However, despite its brusqueness, Hegel's reasoning remains interesting. Connoisseurship, the scholarly approach to the "entire circumference of the individual character in a work of art" (*ILA* 39), was a fairly recent development in Hegel's day, for reasons he himself clarifies.[11] As the discipline charged with knowing the sensuous side of art, con-

noisseurship rests on the assumption that art is artifice, the making of which can be independently studied. In the premodern world, in which the work of art appeared as intrinsically spirited, such an assumption would have been impossible; no cognitive position would have been available from which to assay *only* the external features of the work of art.[12] Connoisseurship becomes an historical possibility only when art, as a thing of the past, presents itself as an artificial soldering of sensuous and spiritual components that have been disarticulated and farmed out to distinct intellectual disciplines. Of course, Hegel agrees that art is artifice, so he endorses a necessary place in any systematic approach to the work of art for the knowledge cultivated by the connoisseur.

> For a work of art, owing to its nature as at once individual and material, is essentially originated by particular conditions of the most various kinds, to which belong especially the time and place of its production, then the peculiar individuality of the artist, and in particular the grade of technical development attained by his art. Attention to all these aspects is indispensable to distinct and thorough insight and cognition, and even to the enjoyment of the work of art; it is with them that connoisseurship, or art scholarship, is chiefly occupied; and all that it can do for us in its own way is to be accepted with gratitude. (*ILA* 39)

However, even though the artificiality of works of art ("the intention of the work of art explains how it is in no way meant to be a natural product and to possess natural life" [*ILA* 40]) demands of those who would know them that they possess scholarly knowledge of their circumstances of production, such knowledge is at best prerequisite to adopting the posture required for being addressed by the works. By focusing on technical and historical detail, the connoisseur brings the genesis of the work qua artifact to the fore, but for that very reason leaves out of the picture that for the sake of which the work is generated. Because "the sensuous aspect of the work of art has a right to existence only in as far as it exists for man's mind, but not in as far as *qua* sensuous thing it has separate existence by itself" (*ILA* 40), the sensuous element can only be grasped as the sensuous element *of a work of art* if its function of penetrating to the thinking mind is also remembered. The connoisseur, however, holds the work at a distance from his own mind in order to bring the sensuous element into relief objectively, that is, independent of any effect it may have on him. Such exclusive attention to the genesis of the work displaces the question of the validity of the sensuous form the work itself raises insofar as its interest has outlived its now dead historical moment.[13] Connoisseurship, in other words, treats the history of art as a collection of mere artifacts that are, because inert in them-

selves, significant only relative to the manufacturing intentions of their makers; it thus remains deaf to the invitation that works of art issue to the minds of us, their readers, auditors, or viewers.

> Though such scholarship is entitled to rank as something essential, still it ought not to be taken for the sole or supreme element in the relation which the mind adopts towards a work of art, and towards art in general. For art scholarship (and this is its defective side) is capable of resting in an acquaintance with purely external aspects, such as technical or historical details, etc., and of guessing but little, or even knowing absolutely nothing, of the true and real nature of the work of art. It may even form a disparaging estimate of the value of more profound considerations in comparison with purely positive, technical, and historical information. (*ILA* 39–40)

[margin handwriting: what is defective about art scholarship]

The key to Hegel's judgment of the connoisseur is contained in the condemnatory use of the word "purely" (*bloß*). That art has an external dimension cannot, as we have seen, be doubted; that the external dimension is purified of internal relations is the scholar's error. For the connoisseur, that there is no future for art is a mere positive fact that allows art to be known, but the conditions that bring art to the point of being exhausted in being known are left unexamined. When the mind adopts as its highest aim in considering art "an acquaintance with purely external aspects," it treats art as dead but does not know that this is what it is doing. Connoisseurship, in other words, produces knowledge of things that have no future because in the eyes of the connoisseur they have no internal relation to their own history.[14] Thus the work of art is as good as dead even though its interest for us has survived, and the issue of nature's remains never arises. Because dead nature remains hidden from the connoisseur behind the veil of "pure" exteriority, dead nature abandons him in turn; the connoisseur fails to make contact with the significance of what is after all his main interest, the external figure of, specifically, the work of art.

In sum: a lack of historical self-consciousness restricts the intellectual reach of the connoisseur. Because, according to Hegel, dead nature is the medium of art, historical scholarship is necessary—the work of art does not bear its meaning in its medium alone, so its surface must be penetrated in search of the meaning it secretes. This restriction on immediate understanding makes connoisseurship crucial for the knowledge of art just as dissection is for forensic pathology. But the historical knowledge connoisseurship yields is not on its own historically self-conscious, that is, it is not essentially connected to any awareness that its production of scholarly knowledge depends on the sensuous form having become a corpse, which, in no longer making living claims, relies on inferential knowledge

to be heard. Just as it is extrinsic to the work of forensic pathology to mourn the corpse it dismembers, so too is it outside the task of art history to remember the claims of the sensuous form of the work of art.[15] Hegel's charge against the connoisseur is not that he does not attend to the life of the work of art, since in its external aspect the work is not alive. Rather, it is that connoisseurship, by the nature of its cognitive discipline, fails to make thematic how the work of art came to be delivered to it to be known. Despite the historical belatedness of connoisseurship, which puts it into the competitive mix with irony and philosophy, it has no place for memory. The afterlife of the work of art remains safely outside art scholarship's place in the modern cognitive universe, despite the fact that the release of that afterlife is a condition for such scholarship.

The cognitive *cordon sanitaire* around the connoisseur stands in marked contrast to the ironist's truck with the dead. Not only does this second student of art's end know that art is the tomb of dead nature, he organizes his entire bearing around that knowledge. The quantity and unrestrained hostility of the scorn Hegel heaps on the ironist is startling at first, but we can find our footing by recalling that once the connoisseur no longer competes seriously to inherit the loss of art, the ironist is the philosopher's only real obstacle to the mantle. Indeed, the assault on the ironist comes at the end of Hegel's discussion of the treatment of art in modern aesthetic theory (i.e., Kantian and post-Kantian aesthetic theory), so that the criticism of the flaws in the ironist's position is, in sheer order of presentation, the crafting of the proper ground for the philosophy of art. This bibliographic fact betokens a sibling rivalry over the inheritance of the end of art. And, our suspicion is borne out amply when we see that, according to Hegel, the ironic perspective stands in direct and brutal contradiction with its own content such that the critical isolation of that contradiction, which is the liberation of the content from its nonrecognition by the ironist, is just the philosophical ascent to the proper perspective. The propriety of the philosophical handling of nature's remains is measured by its avoidance of irony.

Irony, on Hegel's view, is a certain outgrowth of the Fichtean *Ich-philosophie*. In his most absolute of absolute idealisms, Fichte argued for the freedom of the ego as the negation of all mere externalities. In this scheme, the fulfillment of the ego's destiny to become free is the infinite negation of externality as such, or, put the dialectical other way around, its attainment of a position infinitely external to externality as such. The free ego is the infinitely concentrated negation of every possible content, a sort of free Hobbesian sovereign for whom the continued existence of all apparently intrinsic values really rests on its revocable will not to annihilate them. The free ego thus takes all continued external existence as the dissimulation of its own essentially extraworldly willfulness, and the world

becomes a nature-theater animated only by what, remaining infinitely external to it, remains unabsorbed in it.

The Fichtean ego is inherently ironic. Because this utterly abstract ego is by its nature always in flight from the world—which is for it, as the theater of its appearance, only semblance—it can never be, as Hegel puts it, in earnest in the world. The whole world is a nonactuality that the free ego may take or leave as it wishes. The freedom of the ego is in this sense a metaphysical indifference toward all concrete existence. While such a philosophical doctrine ought to be criticized on metaphysical grounds, that is, for its simultaneous abstraction and particularization of the ego, as a bit of practical philosophy it is utter disaster. The free ego feels itself only in the repudiation of all its connections to the world, as if the contingency of those connections were a mark against their legitimacy. Nothing is worthy of playing the role of binding limit to the ego's capriciousness because nothing matters in itself. A life so lived, which Hegel calls the "ironical artist life," is oriented by a "God-like Geniality" (which is to say, it is entirely disoriented). The ironist sees himself expressed in the impotence of all claims against him, an impotence which he was certain of from the start and by which he is regularly entertained. "This is the universal import of the genial God-like irony [*genialen göttlichen Ironie*], as that concentration of the I into itself for which all bonds are broken, and which will only endure to live in the bliss of self-enjoyment" (*ILA* 72).

The paradox of the artistic ironist is that even as he imagines himself the author of all values, he lives entirely in a world without beauty. Since nothing in the world is compelling unless licensed, and known to be licensed, by ironical condescension, the world is bereft of all normativity—including aesthetic normativity. To experience the beauty of something is to be taken (in) by it, but for the ironist being taken in can only ever be simple bad faith, a lapse of self-consciousness. But for just this reason the wholesale impotence of the world turns into the mortifying impotence of irony itself. Not only does nothing have intrinsic value, but in the foreknowledge that intrinsic value is a metaphysical surd (the appearance of such values being a cipher for the inevitable disclosure of their fatuity), the ironist loses all reason to create. The ego-preserving powerlessness of the world dialectically inverts itself in the form of ego-dessicating anomie.

> The proximate form of this negativity which displays itself as irony is, then, on the one hand the futility of all that is matter of fact, or moral and of substantive import in itself; the nothingness of all that is objective, and that has essential and actual value. If the I remains at this point of view, all appears to it as nothing worth and as futile, excepting its own subjectivity, which thereby becomes hollow and empty, and itself mere conceit. But on the other hand, the

reverse may happen, and the I may also find itself unsatisfied in its enjoyment of itself, and may prove insufficient to itself, so as in consequence to feel a craving for the solid and substantial, for determinate and essential interests. Out of this there arises misfortune and antinomy, in that the subject desires to penetrate into truth and has a craving for objectivity, but yet is unable to abandon its isolation and retirement into itself, and to strip itself free of thus unsatisfied abstract inwardness (of mind), and so has a seizure of sickly yearning which we have also seen emanate from Fichte's school. The discontent of this quiescence and feebleness—which does not like to act or touch anything for fear of surrendering its inward harmony, and, for all its craving after the absolute, remains nonetheless unreal and empty, even though pure in itself—is the source of morbid saintliness and yearning. (*ILA* 72–73)

Insofar as the ironist does not like to act or touch, it is not clear how he can be an artist. From that on which the artist works, the ironist recoils. All that remains of the artistic impulse in the ironist is its first half (which is false in its abstraction): the desire to destroy the claims of the merely external world. Systematic irony is a machine for turning all norms into garbage, with no thought needed about whether the norms so processed are legitimate; because the certainty of the ironist's metaphysical sickness guarantees that being a norm is just another name for being garbage, he is incapable of destroying the externality of the world in the name of anything. Ironic art is a reflexive twitching at the approach of a putative norm—and the twitching mistakes itself for life. It is the aesthetic version of the maxim that nothing is worth dying for.

This stunning critique of irony as the aesthetic principle of self-preservation rests on a delicate rhetorical reversal. Irony in the abstract refers just to self-dissimulation; it names a moment of self-disclosure which remains shrouded within a "but I do not really mean it." In this sense, Christianity, the self-withdrawal of God from latent unity with any particular concrete existence, is an ironical religion, which for that reason alone ranks it higher on the Hegelian scale than Greek pantheism.

> Christianity brings God before our intelligence as spirit, or mind—not as particularized individual spirit, but as absolute, in spirit and in truth. And for this reason Christianity retires from the sensuousness of imagination into intellectual inwardness, and makes this, not bodily shape, the medium and actual existence of its significance. (*ILA* 87)

Christianity, however, is far from genial. As Hegel signals by inserting the negation of bodily shape into the affirmative description of Christianity's significance, God's withdrawal from sensuous imagination is effected by a process of in-

carnation, sacrifice, and rebirth, which is to say by a self-annihilation of abstract inwardness leading to recuperation. The knowledge of God's significance is mediated by the emptiness of sensuous existence. This endless withdrawal is not, though, the purpose of the Christian God's existence but rather his means. In other words, sensuousness, for better and worse, is the medium of the Christian's God's becoming—God deigns to die in order to live in truth. The ironic artist, by contrast, does not deign to die, but instead guarantees his self-preservation by surveying the universal wreckage of the earth that cannot touch his infinitely withdrawn inner self; his existence is not staked to a self-dissimulation he survives, since he is always withdrawn before he starts simulating. The ironist has washed his hands *before* getting them dirty. "The ironical, as 'genial' individuality, consists in the self-annihilation [*Sichvernichten*] of what is noble, great, and excellent; and thus even the objective shapes of art will have to represent the mere principle of absolute subjectivity, by displaying what has value and nobleness for man as null in its self-annihilation" (*ILA* 73). Ironic subjectivity knows itself not in dissimulation, but in an art that exhibits the futility of all action and dissimulation. In ironic art, every aspiration mocks itself by coming to nothing, thus apparently teaching the lesson of the pointlessness of striving—the ironic artist thus propels himself backward into the safe position of spectator of his own insincere efforts to make art. The ironic artist, rather than fulfilling the traditional ironic goal of self-dissimulation, refuses to dissimulate himself, preferring instead to watch the spectacle of the world's self-annihilation. The ironist sees the deep truth that art is a preserve of that very slight slippage between the world as it is and the world as it may be, and for that reason alone exterminates it lest it disturb his genial indifference.

As Hegel notes, in pulling back to watch the world trip over the gap between its aspirations and its actuality, the ironic artist bears a surface resemblance to the comic artist, since both aim to puncture pretense; but whereas comedy punctures pretense in order to show the mismatch between a bogus norm and the foible it shields, thus hewing closely to the aesthetic sine qua non of authenticity that we humans universally fail to live up to, irony takes the very idea of embodied normativity to be the foible in need of puncturing. It is in taking embodied normativity as such as its foil that irony is a serious competitor for learning the lesson of the end of art. The ironist understands that the end of art is the disclosure of spirit's world as the denormativized dead, and therefore refuses to participate in the world, preferring instead to escape death by fleeing inward. That nothing inherently survives the world, that everything is contingent, leads the ironist to fantasize a subjective inwardness metaphysically immunized against the taint of death. And here we find the rock bottom of Hegel's

critique of irony: the ironist, unlike the connoisseur, is oriented by the death of nature, but only in the form of an everlasting denial that death has anything to do with him. *In closing itself off from the world, irony is spirit's last defense against the memory of dying nature.*

In this denial the ironist is indemnified against "touch[ing] anything" dead. However, since that denial is always a priori, it presumes the omnipresence, indeed the omnipotence, of the dead. The structure of ironic dissimulation is itself determined by the dead nature it needs to keep close in order to assure its difference from it. This is like a mob protection racket: to live, ironic subjectivity consents to being locked into a casket fabricated out of the very deadness it is supposed to keep out. The free ego of the ironist chooses life, but that life looks just like death—hence, the "morbid saintliness" of irony, a distancing from the dead world that is itself in love with death. Not to put too fine a point on it, Hegel maliciously rubs the ironist's face in the death he is inevitably attached to.

> And then this skill in living an ironical artist life apprehends itself as a God-like geniality, for which every possible thing is a mere dead creature [*wesenloses Geschöpf*], to which the free creator, knowing himself to be wholly unattached, feels in no way bound, seeing that he can annihilate as well as create it. He who has attained such a standpoint of God-like geniality looks down in superiority on all mankind besides, for they are pronounced *borné* and dull in as far as law, morality, and so forth retain for them their fixed, obligatory, and essential validity. And the individual who thus lives his artist life assigns himself indeed relation to others, lives with friends, mistresses, etc., but as genius he sets no value on this relation to his determinate reality and particular actions, or to what is universal in its own right; that is, he assumes an ironical attitude towards it. (*ILA* 72)

In treating every *possible* thing as an *actual* dead creature, every death that will happen as therefore having happened already, the ironist does in fact come face to face with spirit's flight from nature. However, because he does so under the protective aegis of death's *necessity*, the ironist betrays that he is just as afraid of the contingent in which he rightly sees the work of death as the spirit he seeks to distinguish himself from. The fearful repudiation of death is thus the ironist's flight from the *contingency* of sensuous experience, which, just because it is an a priori commitment rather than an engagement, is a mimesis of the contingency he fears. The fear of nature's death is the fear of living with dead nature—and death repays the insult by striking the ironist dead in turn. Insofar as the problem of the end of art is the problem of living with the death of nature the end of art has forced on consciousness as its own unavoidable memory, irony does offer a quick solution: such a life cannot be lived.

That irony was so powerful an attraction in Hegel's day, and that it is the dominant attitude now, forces on us the possibility that the question of modernity—can our exile from dead nature give shape to a culture in which art is and remains for us a thing of the past?—has been answered with a resounding, nihilistic no. The ironist kicks the dead in order to assure himself he is alive because the omnipresence of the dead is the reminder that he, too, will die. In an ontological version of Freud's narcissism of small differences, the deadly hatred of death becomes the assurance of life. Hegel never exactly doubts that ironic artistry is in the end an orientation to the exile of modern life, a way of handling the remains of the dead, but in its secularized commitment to self-preservation in exile, it never rises to the question the end of art poses for it: what do the dead want of us? The dialectical necessity of returning to the finite and particular is heeded by the ironist, but only in the form of a refusal. Thus, for Hegel, it falls to aesthetic theory to learn the lesson of art's end by heeding the lingering remains of nature which, by means of a criticism of the ironic strategy of self-preservation, it has forced irony to hand over to it.

V

To see exactly what is at stake, for Hegel and for us, in the development of an anti-ironic aesthetic theory that does not transcend the dead nature in the work of art, it will be useful to tolerate a digression into the present that will help bring the past into focus. If our modernity is an historical era distinguished from its predecessors by knowing itself to be distinguished from its predecessors, then our modernity, as suggested above, just is awareness of exile from the past. We moderns get our bearings, if we are lucky enough to get any at all, from the condition of not taking our bearings from the past.[16] Modernity, in this sense, is a truly unprecedented regime of endless and unsettling skeptical nonvalidation of all belief. Our condition is radical, for we do not even have the security of thinking of ourselves as living in a revolutionary moment. Revolutionaries are oriented by the past they seek to overthrow, thus finding their justification in the inversion of the values of the *ancien régime*. Our modernity is not revolutionary, but postrevolutionary—for us, the totality of *anciens régimes*, which is captured in the concept of *ancien régime*, is simply nonprobative. The novelty of our modernity is thus not its disruption of the past, but its postdisruptive indifference toward it. The bathetic wisdom of Santayana that those who do not remember the past will relive it is now met with the all-purpose dismissal, "That's history." Or, as a recent television commercial put it, "Is this a great time . . . or what?"

This modern indifference to the past does not imply an escape from the past;

the revolution was the escape, and it failed. Modern indifference is, rather, a stripping away from the past of its normative power, so that it no longer much matters whether we escape it. A nightmare weighing on the brains of the living? Hardly. More nearly, a treasure trove of trinkets that we may recycle endlessly in order to help pass the remaining time. Our modernity is not beyond the past, but is instead a cool way of living with it. It is a way of making the past weightless.

And yet, as with all postures of cool, our modernity rests on unstable bedrock. As with the second naivete that Nietzsche identified as the aporia of Apollonian culture—a naivete which, imagining itself to have overcome the violence that called it into existence, loses sight of the force of imagination—so, too, the weakness of cool indifference shows itself in the way it heedlessly lets atrophy its resources for warding off the potentially catastrophic revenge of the past. If every past decays, and the time of that decay is the endless present, then no past is worth warding off even if its unfinished business should press on the present. Equally, no unfinished business is worth finishing since, if there is anything we are sure of, it is that we should keep our noses out of other people's business. The paradox of cool modernity may be put this way: while we know ourselves to be in exile from all past norms, which is to say from all norms relative to which the present is continuous with what thereby could be apprehended as its own past, we exiles fantastically take this condition to be a *proper* one. As we scare ourselves with images of the oppressive totalitarianism of past shapes of culture, we cool moderns take refuge in the phantasy of the present as entirely and completely open-ended. Cool modernity not only does not care enough to preserve even its own specific differences from the past—it cannot care enough. It is an historicism of the present in which all history is equally present and equally past at the same time. Were it not for the fact that the harmony of disordered time is maintained only by means of the a priori negation of all claims of the past, we might almost want to call this utopia.

It is, however, through just this a priori negation that the paradox of modernity makes its appearance: in the public square in which all claimants are equal because none really means it anyway, the condition of being heard is that everyone lay down the belief that their claims are claims to justice. The site in which a free, modern citizenry gather to debate its common fate becomes its common fate, so that no claim ever needs to be cashed. This is a dialectical inversion that continues to surprise the wounded who discover therein that recognition is not all it's cracked up to be. Yet even the wounded cannot deny the importance of cool modernity's negation of the validity of each and every claim, for this negation is, in a strong sense, the only context in which the claiming of the wounded is also entitled a priori to be heard. In the modern marketplace of ideas, every

voice circulates because its rough edges have been shaved off; it is an agora in which any idea, so long as it does not take itself seriously, is welcome. When "I hear you" is all any claimant is entitled to hear, the cancellation of a claim has become its proper fulfillment. Once the price of participation has been posted in public, then a priori, nothing is ruled out a priori.

And yet: what about those rough edges? Insofar as they were what violently abraded one another in the past, they were the impediments to the advent of cool modernity. This is a logical point as much as an historical one: that the edges were rough is a property they acquired in virtue of the way their differences functioned socially as contradictions. The rough edges, in other words, were the obdurate particularities of claims that prevented their smooth circulation in the marketplace of ideas. Indeed, so long as people held on to those rough edges as the concrete particulars to which their identities were staked, they were in themselves what inhibited the creation of a marketplace to begin with.[17] Just as no free trade in land was possible until land was objectified as a commodity rather than subjectified as the site of identity (as, say, the ancestral home), so too no free trade in ideas was possible until ideas were stripped of their material histories, of their subjectified and subjectifying status. Since the cool modern marketplace of ideas is possible only once ideas lose their particularity, once they can be alienated and fairly compensated, the marketplace is an institution at war with all particularity; what does not trade becomes incomprehensible. In other words, as an institution in which identity derives from exchangeability, the modern marketplace has overcome the war among particulars by universalizing it into the war against *particularity as such*.

Here, exactly, is the most naked appearance of the paradox of cool modernity. "Particularity as such" is simply the name philosophers give to abrasive rough edges; it is the concept in which the unidentifiable enters reflective thinking. Therefore, "particularity as such" is already a universal that threatens to render the particular it names suitable for the circulation it was purportedly resistant to.[18] The judgment that "so-and-so is a particular taste" is the first line of an advertiser's pitch to a manufacturer looking for a niche market or, put in a proper philosophical voice, the perception of a particular qua particular takes place already from the point of view of its appointed site in a universalizable exchange. The recognition modernity promises equally to everyone in their particularity renders that particularity simultaneously valuable and worthless, alive because intrinsically dead. As a form of circulation unimpeded by its tokens, cool modernity seems to be the conquest of sensuous particularity by means of respect. It is the universalization of universality.

Nowhere is the paradox of modernity more pronounced than in the market-

place for art. There, phantasmatically, sensuous particulars circulate freely; indeed, the more particular, the greater the ease of flow. This is a paradox because modernist art was to have the role of being the last refuge of the sensuous particular, in the sense that the value of the modernist work was to be its originality and specificity, its overt resistance to exchange. For this reason, the compelling quality of great modernist works was inseparable from their recidivism. They were, as T. J. Clark put it, achievements to the extent that they embodied the bad conscience of the bourgeoisie that had sacrificed its ethos of individuality as the condition of its rule.[19] But as overemphatic compensation for what was already sacrificed, modernist works were born in anticipation of their annihilation at the hands of those who most desired them. Thus, their ascent to the status of the purest commodity, the commodity in which the ostentatious display of sensuous particularity turned into no obstacle to exchange at all, was a fate written into their condition of possibility. Art becomes the supercommodity once particularity is fetishized as a property which an exchangeable object may or may not, depending on circumstance, possess. Of course, concrete sensuous particularity always was a defenseless property of defenseless objects—what else could it be?—yet it never before had a public relations manager for its claims, the *concept* of sensuous particularity. As the art marketplace forces art to take on the function of advertisement for itself, cool modernity wages its last battle against the final impediment to its universalization of universality. As T. J. Clark says now, quoting Wallace Stevens, farewell to an idea.[20]

Clark might as well say, however, in direct response to Hegel, farewell to the Idea. Here we must return from our digression, since Hegel knew nothing of the fate awaiting art in an ever expanding marketplace of ideas. He did, though, know something about the universalization of universality, something that permits us now to focus on the death of the concrete. When Hegel moves from the critique of irony to philosophical aesthetics, he is moving away from a specifically modern resentment against the sensuous particular that had convicted it of the crime of contingency; irony was, and still is, the refusal to live with the inability of the concrete to withstand the claims of universality, with its pathos-riddled weakness in sustaining the claims of a rough, disfigured subjectivity. The movement to philosophical aesthetics is Hegel's effort to adopt what might yet merit the honorific title of a "position" from which the end of art can be seen as the expiring of the hope that the concrete can press its claim *as art*—but from which the force of that claim can be undergone nonetheless. Whereas in irony this expiring produces the fearful perception, which is nonetheless acute, that nothing in the world guarantees the claims of rough subjectivity, for Hegel it amounts to the final stage of subjectivity's exile from the very idea of a necessary

or proper sensuous form for itself. Put most simply, the end of art is, for Hegel, the moment when the fact of exile penetrates into thought itself. In virtue of the perception that nothing guarantees the subject's self-preservation, that no home shelters it from its own contingency, exile becomes the untranscendable condition of subjective life: to be a subject is to be sent away.

From the point of view of the thought of exile from proper sensuous form, the end of art is just the end of the necessity of spirit's ties to this or that concrete sensuous particular. It is also therefore the end of that restless vacillation by spirit between the poles of its identity: concrete sensuous existence, in which spirit lives within a world it recognizes, and abstract universality, in which the failure of the world forces a retreat from the hazard of contingent life.[21] Now, at the end, universality and concrete sensuous existence come into open war, with each accused of a betrayal of the highest needs of the other. In such a form of life, the claims of a *purely* sensuous existence become simultaneously newly audible in virtue of their dialectical differentiation from abstract universality *and* essentially recidivist in virtue of their drag on the development of spirit's autonomous relation to its history. The claims of concrete sensuous existence sound to the free rationality of abstract discourse like nothing but brute refusals to circulate in the world of fair exchange and compensation. If one endorses those claims, they will sound, of course, like an aristocratic rejection of the flattening of life that every market generates. But in either case, the claims of the sensuous particular, insofar as they are finally jettisoned from the discursive rationality freed from its ties to what, from its point of view, are merely contingent particulars, sound like failed—in the sense of passé—efforts to make for humans a "full and unified totality" that have been hunted down to their last redoubts where they have ceased making sense. *And this hunting down is guided by nothing other than our high esteem for art.* It is our treasuring of art as the privileged domain of a concrete sensuous existence that no longer speaks for itself, as the domain where the remaining essential of concreteness is paid for by the renunciation of abstraction, that points the way to the cancellation of the idea that concrete sensuous existence has *rational* claims to press against discursive rationality. Art in modernity is the charmed circle in which the claims of concrete sensuous existence that fall outside exchange are protected because they cannot protect themselves; in every respect except odor, the art world of modernity is a zoo for endangered species, which is to say for species that have no future on their own and thus are, and will remain, a thing of the past.

What, then, of the fate of this concrete sensuous existence when art has become an organon of its lost power? What is the "highest destiny" of sensuous life when its proper home in art is at the same time the tomb in which the very pos-

sibility of its rational claiming has fallen away? These are the central questi
Hegel's philosophical aesthetics, in the specific sense that Hegel asks after the
tionality of the nonrational claims of concrete sensuous existence by asking
where *in thought itself* those claims are pressed. To make Hegel's final break with
irony as sharp as possible, let us say that since these are the questions that irony
flees from and thereby renders itself both concrete and irrational, they are also
the questions a philosophy of art cannot dismiss if its own claim to being a dis-
cursively systematic philosophical aesthetics is to be vindicated. The sine qua
non of systematic aesthetics is allowing itself to be penetrated by the claims of
what the entire culture of cool modernity deems beyond rational claiming.

In establishing that these are the questions shaping Hegel's philosophical aes-
thetics, we have also come to some clarity about why the expulsion of nature
must linger there. Art, in its necessary cleaving to dead nature, seeks to locate a
sensuous home for spirit, a body proper to it. It seeks, in short, to craft a human
body. It is the failure of this project that gives rise to systematic aesthetics. It is
thereby dead nature, as that which irreparably disorients spirit, which is deliv-
ered over to thought by the end of art, thus making of thought an endlessly
mournful project. Philosophical aesthetics begins as the knowledge that the
whole history of art has not succeeded in reanimating nature; it begins, in other
words, saddled with a nature which is really, ultimately dead. In philosophical
aesthetics, death finally catches up with spirit, and spirit mourns its own exile at
the artistic tomb of normativity.

As we bring this argument to a close, tact demands that we acknowledge that
Hegel is not completely reconciled to the conclusion I have drawn out of him.
Indeed, I would not wish to try to disprove the critic who, accusing me of over-
emphasizing the mournfulness of Hegel's aesthetic theory, charges that I have
ignored its optimistic moment that is expressed in the famous claim that
"thought and reflection have taken their flight above fine art" (*ILA* 12) toward a
reflective stabilization of autonomous spirit's relation to nature. Rather, I would
suggest that, insofar as "taking flight" is what the critique of irony renders of du-
bious value, there is an inner contest in Hegel's systematic aesthetic theory. One
contestant for the soul of Hegel speaks in a way that surely casts doubt on my
argument:

> These are antitheses which have not been invented, either by the subtlety of
> reflection or by the pedantry of philosophy, but which have from all time and in
> manifold forms preoccupied and disquieted the human consciousness, although
> it was modern culture that elaborated them most distinctly and forced them
> up to the point of most unbending contradiction. Intellectual culture and the
> modern play of understanding create in man this contrast, which makes him an

asmuch as it sets him to live in two contradictory worlds
nsciousness wanders back and forward in this contra-
ked from side to side, is unable to satisfy itself as itself on
ther. . . . Such a discrepancy in life and consciousness
ture and its understanding the demand that the
resolved. Yet the understanding cannot release itself
... the fixity of these antitheses. The solution, therefore, remains for con-
sciousness a mere ought, and the present and reality only stir themselves in the
unrest of a perpetual to and fro, which seeks a reconciliation without finding it.
Then the question arises, whether such a many-sided and fundamental opposi-
tion which never gets beyond a mere ought and a postulated solution, can be
the genuine and complete truth, and, in general, the supreme purpose. If the
culture of the world has fallen into such a contradiction, it becomes the task of
philosophy to undo or cancel it, i.e. to show that neither the one alternative in
its abstraction nor the other in similar one-sidedness possesses truth, but that
they are essentially self-dissolving; that truth only lies in the conciliation and
mediation of the two, and that this mediation is no mere postulate, but is in its
nature and reality accomplished and always self-accomplishing. (*ILA* 59–60)

The contradiction between the universalizing thrust of the abstract intellect
and the concretizing force of sensuous existence is as old as the idea of human
autonomy. Modernity is the age in which this contradiction is forced into its
most unyielding form. Philosophy is the reflective knowledge of the truth of this
contradiction, that is, the insight into the underlying identity of the antagonists.
Through philosophy, the abstract opposition between universal and particular is
overcome in a higher reflective synthesis that dissolves the contradiction. The di-
alectical critique that philosophy wields against the concrete particular unlocks
its buried claim against the universal in a language discursive rationality can
heed, thereby permitting that claim to circulate properly. Now, insofar as philo-
sophical aesthetics is that branch of philosophy that has to do with the signifi-
cance of the apparently recalcitrant concrete sensuous particular, it is the avant-
garde of the reflective aspiration to undermine, by means of elevating translation,
the special pleading of particularity. Philosophical aesthetics is the guide back to
discursive rationality, the home of human autonomy, for prodigal particularity
and so, on this view, is reflective thought's means for overcoming the brutal con-
tradiction of modern life.

The other contestant for Hegel's soul, the one I have been bringing into the
open in this chapter, concludes the thought quoted above by saying:

All that philosophy does is furnish a reflective insight into the essence of the
antithesis in as far as it shows that what constitutes truth is merely the

resolution of this antithesis, and that not in the sense that the conflict and its aspects in any way are not, but in the sense that they are, in reconciliation. (*ILA* 60)

Philosophy here does not seem much of a conciliator. Rather, the only thing philosophy qua reflective thinking can do is show that the truth of the conflict between the universal and the particular, insofar as it is a conflict, is a reconciliation that philosophy cannot itself achieve. Confronted by the rationally enfeebled sensuous particular and the omnivorous abstraction of cool modernity, philosophy is *nothing but* the translation into thought, the bringing to awareness, of a conflict it is beyond modernity's resources—*including philosophy*—to mediate.[22] In this light, systematic aesthetics does not contribute to modernity's progressive distancing of itself from the past; rather, in its "defense" of the claims of the concrete sensuous particular right at the heart of a discursive rationality that cannot acknowledge the legitimacy of those claims, systematic aesthetics impedes the universal's arrogation to itself of reflective autonomy. A philosophical aesthetic theory, insofar as it is thought's heeding of the lost normativity that remains locked up in the work of art, is the survival of the past from which reflective thought is supposed to be autonomous within reflective thought itself. It is, thus, not a reflective means toward the end of reconciliation, but rather reflection's medium for thinking about modernity's incapacity to be reconciled to its own proper exile from nature. Philosophical aesthetic theory is the knowledge that modernity, for all its coolness, is haunted by a norm it recognizes but does not know how to heed.

In interpreting Hegel this way, we might almost want to say that philosophical aesthetics is where modernity confronts the limits of universal reconciliation. However, that is too affirmative a formulation, too discursive an accounting of the relationship Hegel is giving form to. Since such an aesthetic theory is attuned to the lost rationality of the work of art, to the knowledge that the work of art fails to effect a reconciliation of spirit and nature, it is more accurate to say that it is how modernity confronts, over and again, the loss of the possibility of reconciliation. The triumph of discursive rationality and universal exchangeability is the very condition for the appearance of the work of art as the traumatic past, which never quite recedes into the past, of the universal—the work of art, in other words, is the traumatizing speech of the dead only in and for the modern age. That is why the question of modernity, the question that can arise only in modern self-awareness, is whether a culture is possible in exile from nature. The question of the end of art is, then, simply this: can the end of art be sustained in culture?

Art is in ruins. The dream it bore has collapsed, revealing that within it, as

within all satisfying dreams, there is a traumatic nucleus. That revelation is for knowledge, is addressed to knowledge, and can even be couched in the language of reflective knowing—that is, in philosophy. This knowledge does not, however, resolve anything, but rather points to a condition, our condition, of perpetual nonresolution. What is life like when the condition for asking just that question is that the most fulfilling answer is always—remains—in the past, from which therefore we are always in exile?[23] It is mournful life that for Hegel, as for Kant, calls out to a world yet to be, a world revealed in its default in the work of art. As Hegel concludes his dialectical reconstruction of the problem the work of art presents to modern self-consciousness, he says that the reconciliation which is the truth of modernity, into which philosophy offers reflective insight, is beyond the power of modernity to attain. It is not, however, to the detriment of our highest modern hopes, beyond the modern power of aesthetic perception. In a final clinching of the critique of irony, Hegel claims that this truth is always revealed as the past of modernity with which modernity is never done, and in that way is its future as well. The truth of modernity is revealed in a traumatic confrontation with the power of the dead, who, because dead, point to a different future than the one we moderns have in mind for them. The unrecognizable truth of modernity is disclosed in a ruined and ruinous representation we can recognize but not decipher. Whether we can undergo recognition we know not quite how is also the question whether philosophical aesthetics can embrace the unmastered work of art: "Art has the vocation of revealing the truth in the form of sensuous artistic shape, of representing the reconciled antithesis just described, and, therefore, has its purpose in itself, in this representation and revelation [*Darstellung und Enthüllung*]" (*ILA* 61).

Pompeii Beyond the Pleasure Principle: Death and Form in Freud

> The world has long since dreamed of something of which
> it only needs to become conscious for it to possess it in
> reality. . . . Our task is not to draw a sharp mental line
> between past and future but to *complete* the thought of the
> past. Lastly, it will become plain that mankind will not
> begin any *new* work, but will consciously bring about
> the completion of its old work.
>
> KARL MARX,
> letter to Arnold Ruge

Me↓ [handwritten]

I

Between Kant and Hegel on the one hand and Freud on the other, a shadow falls. While the philosophers discussed in the preceding two chapters deal systematically with the problems that enter unbidden into reflective thought from the world in which it is embedded, Freud is a committed skeptic—indeed, one might say with some justice that he is a cynic—about the possibility of systematic philosophy. A system of philosophy, just insofar as it aims at systematicity, seems to Freud committed to erasing the contingency of its own motivations from its realm of transparent order. In wanting everything to have a proper place in organized and organizing thinking about the world, system-building smells too much to him of the sort of paranoid ideation that labors to scotomize the fearsome perception of contingency and chaos. Quite theatrically, therefore, Freud distances the practice of psychoanalysis from the construction of philosophical *Weltanschauungen.* In the *New Introductory Lectures on Psychoanalysis* he uses the same lines from Heine to refer to the philosopher that he had used in *The Interpretation of Dreams* to refer to the process of secondary revision through which the dreamer works to avoid the meaning of the dream:

91

what is systematic philosophy? [handwritten]

he sees psychoanalysis as very different from philosophy? [handwritten]

With his nightcaps and the tatters of his dressing-gown
He stops up the gaps in the structure of the world. (*ID* 528)[1]

Freud, of course, is himself systematic in his hunt for the contingent and chaotic elements that hide themselves in systematicity. However, in opposing systematic thinking to thinking within a system, thinking that remains unsettled by what eludes it to thinking that rests settled in the conviction that nothing can elude it for long, he seeks to open up a distance between himself and his philosophical inheritance.[2]

Depending on what we wish to emphasize in Freud, we might refer to what separates his thinking from that of the system builders in different ways: the victory of capital over traditional life forms both in Europe and in its colonial empires and excolonies; the consolidation of the nation-state as the acme of political legitimation; the full elaboration of explicitly localistic and traditionalistic ideologies (as opposed to simply local and traditional forms of life, the end of which is presumed in the elaboration of their ideological afterlives); the emancipation of personal life, and thus the "feminine," from stable social hierarchies. For the sake of economy of expression, we can refer to these developments as "the nineteenth century." On its own that is not a very informative designation, but it is a convenient way to refer to a set of historical developments that have in common a liberationist view of the relation of the present to the past it takes itself to leave behind. Between the subjects of the preceding chapters and Freud, what falls is a century of the growing triumph of the perpetual present in the endless *Neuzeit* of modern life.[3]

Do not worry: I am not preparing to mount a sociological account of psychoanalysis. Just as philosophical histories of thinking fantasize an extrahistorical dialogue of minds, sociological histories of thinking fantasize an analytic perspective outside of thought's embeddedness in life from which the ephemerality of thought's achievements can be reassuringly disparaged.[4] What the entirely internalist and entirely externalist postures toward thought's historical embeddedness share is the conviction that genuinely critical thinking is not really possible unless its development is internal to its own needs. Both philosophical and sociological histories of thinking, in other words, stage a nondialectical confrontation between history and thought, between the realms of unreconciled contingency and penetrating reflection. Thus, both are tainted by the nineteenth-century liberationist view of the relation of the present (of thinking) to the past (of its contingent motivations). If we are to make sense of Freud as coming *after* this nineteenth century, it can only be in virtue of his also coming *before* it, since he speaks against the victory of a modern culture which celebrates a triumph over the past, a triumph which, if Freud can help it, it will come to see that it never achieved.[5]

The distinction undergirding this chapter's presentation of Freud's relation to art and culture is between triumph and triumphalism. Triumph is simple enough: it refers simply to conquest. Triumphalism, however, is a constellated form of faux celebratory culture that enables the feeling of conquest in the face of what has not been vanquished. Triumphalism is not, therefore, the lived experience of triumph but a sign of its absence. It mimics triumph by interposing a screen between the fearful living and the fearsome dead onto which the conviction that the dead have lost can be projected. In this sense, triumphalism is a species of mania, a sense of power inflated not by victory, but by the effort to hide from the anxiety about its not having happened, an anxiety which is triumphalism's true source of power.[6] The nineteenth century that falls between Kant, Freud, and Hegel is a time of manic triumphalism from out of which Freud seeks to recover the elements of anxiety that gave that century its cast.

The argument that follows will turn largely on interpretations of what seem at first glance those texts least likely to help us make a case for reading Freud as an antitriumphalist: his writings on art and the aesthetic. Although I will not allow these interpretations to go unsheltered by Freud's writings on metapsychology, interpretation and history, the preference for the writings on art and the aesthetic is not purely perverse. As we shall see, there is a deep sense in which Freud's experience of art establishes the central example for the psychoanalytic interpretation of psychical form as a sustaining of loss, that is, as a residue of historical exile.[7] Making that claim plausible is the burden of this chapter. However, because by now it is no secret that the very idea of bringing those texts to the forefront of an interpretation of Freud is also motivated by the place of aesthetics in the systematic writings of Kant and Hegel, let us rehearse briefly a theme from the previous two chapters in order to set the stage.

With Kant and Hegel we saw two ways in which the remains of nature were delivered to reflective thinking by art. Thinking, the centerpiece of human autonomy, thus received its impetus and its orientation from a residue that appeared in art as unmastered; because dead nature continued to be compelling after the end of art, orientation in thinking was provided not by reflective mastery but by reflection on unmastery. In this light, we refused to characterize the task of philosophical aesthetics in Kant and Hegel as attaining reflective access to what remains obscure after other modes of practice are complete. The superabundance of the sensuous in art is not what is left over by art for aesthetic theory to master conceptually; it is instead the residue of cultural practices that enters thinking as both unconceptualized and compelling because unconceptualized, as the "old work" in the passage from Marx which serves as this chapter's epigraph. Thus, we aimed to describe the work of aesthetic theory as criticizing (in the Kantian sense)

systematic thinking in terms of its grounding and impetus in what falls outside of logically prior cognitive achievements, yet without assuming that the goal of criticism is the formation of new concepts with which to name what falls outside. Criticism is the work of exhibiting the conditions under which the fabrication of new concepts shows a lack of sound judgment.

Hence, I emphasize once more a central theme of my Kant and Hegel interpretations: in their aesthetic theories, they reify neither thinking with concepts (a redundancy to be tolerated for the sake of emphasis) nor what falls outside of conceptualization. Rather, they seek to think systematically about the internal connection between thought and what overpowers conceptualization. And this is not merely a point of aesthetics in its narrow sense, since were there no distinction *in thought* between (in Kantian terms) phenomenal appearance and the noumenal *ding an sich*, or (in Hegelian terms) the history of forms of appearance and the negativity of spirit, thinking would be an idle pastime rather than a kind of work. Because the unmastered residue is at the heart of thinking, not safely outside its boundaries, aesthetic theory, in its broadest sense, is reflection on the place of the unthinkable in thought. Aesthetic theory is, therefore, theory without method.

 It would be a comfort, of course, to be able to say at this point that our interpretations of Kant and Hegel (and, soon, Freud) join them together into a lineage which we might call German materialism. And perhaps we should accept that novel genealogy gratefully. However, we would be entitled to do so only with a prior and ambivalent acknowledgment that the concept required to establish such a lineage, the concept of "matter," cannot itself be a proper concept. If it is, then we could know a priori the place of the unthinkable in thought and thereby vitiate the need for philosophical aesthetic reflection. As long as we avow that materialism commits us to placing maximal pressure on the concept of "matter" (as well as on its cognates and disguises), then materialism is an excellent name for the philosophy being elicited here from Kant and Hegel. Matter, we need to say, is what shatters the effort to conceptualize it; it is what thinking must theorize from a stance of nonmastery. This is why, whenever Kant, Hegel, and Freud approach matter with the unavoidable expectation of finding it inert, what they find staring back at them in its place is the dead, a loss thinking cannot make up, something that does not stay put despite the concept used to think about it. For all three, where matter was, there corpses shall be.

It must have been thoughts like this that for Kant and Hegel made central in philosophical aesthetics the question of whether thinking could remain oriented by what resists it, by what, in virtue of remaining unredeemed in thought yet nonetheless never losing its claim to being properly thought's own, negates

thought's triumphal celebration of its autonomy. Philosophical reflection in this sense *did not provide* thinking with an orientation it otherwise lacked—it *strove to keep* thinking oriented by criticizing its tendencies to speculative aloofness from what remained unthinkable. And just because the task of philosophy depended on thoughtful reflection already being in place, it never crossed either Kant's mind or Hegel's that philosophy might be a practice that could be maintained independently of cultural life. They thought of philosophy as the pinnacle of culture not because it was above culture, but because it was the discipline in which culture's ceaseless coming-to-be was reflected back into it. Philosophy, practiced only within culture, was where thought's aspirations to the transcendence of cultural life were turned back toward culture itself as leftovers from culture's cultic origins. For Kant and Hegel, when a culture seeks to slip its finitude, its mortality, philosophy reflects back to it the necessary illusoriness of that hope. This, I suppose, is the deepest significance of Hegel's idea that philosophy is its own age reflected in thought: philosophy is the finiteness of an age's being one age among many reflected in a thought that critically repudiates the hope that an age can become immortal in thought. Philosophy, thus, was imagined as where secular culture would embrace its contingency in secularized thought. In its refusal of transcendence as wishful illusion, philosophy was to turn the hope for otherworldly transcendence into the practice of acknowledging mortality: philosophy, in this version of it, was to turn hope into mourning.

Such at least was the dream that came to light as aesthetic theory. It *was a* dream, though, because it suspended philosophy's fate from a culture committed to its own thoroughgoing disenchantment. Looking back now, it seems as if Kant and Hegel had assumed that the revolutionary process of de-Christianization had been a success, at least tendentially, and that therefore a dialectical philosophy that offered a desacralized view of a desacralized life could be continuous with culture in general. Perhaps—who can say?—for a brief moment this was not merely a dream; perhaps the separation of culture from cult was actually on one of the available historical horizons.[8] But even if so, the moment passed, and in its place emerged the (renascent?) forms of a triumphal, sacred teleology of complete victory over contingency. As Year One turned into Year Two and history started all over again, the burden of the unmastered proved too much to bear and the idols were reborn, even more powerful in their twilight. Not surprisingly, therefore, as the triumphalist culture of the European nineteenth century unrolled, philosophy took on a more decidedly iconoclastic air just in order to preserve itself. Those who disagree with my interpretation of Hegel's aesthetics will see him, in the manner of Right Hegelianism, as on the side of the triumphalists in demonstrating that reason is untouched by the history,

which is its theater, that Christianity therefore has dodged the bullet of secularizing modernity. That disagreement, I would wager, has its source in the post-Hegelian view of philosophy as the sworn enemy of the idols from which it must maintain a studied detachment. Such detachment, however, in its iconoclastic bathos, just is philosophy's postcultural self-preservation at all costs; it is the old ideal of autonomous thinking's transcendence of the contingent, the dream of life tortuously re-emerging from a calamitous death.

It is, therefore, no surprise that post-Hegelian philosophy clung to the trash of triumphal European culture, becoming increasingly centered around aesthetic theory. As the European nineteenth century systematically turned from the awareness of historical contingency, especially its own, to a war against that awareness, it threw overboard the cultural ideals (idols?) from which Kant and Hegel had hung the possibility of secular reflective thinking. Who could continue (who can continue?) to hold on to the thought of the non-necessity of the state, the market, the empire, the free self, the work of art, as it appeared in the late eighteenth and early nineteenth centuries? Who could remember (who can remember?) the web of contingent historical relations into which Kant and Hegel reflectively placed those institutions, in the face of the inevitable forward march into which they were recruited? In its reincorporation of all contingency into its own bright, necessary future, the triumphal nineteenth century achieved a form of social life which was a pitch-perfect parody of systematic thought. Thus, Kierkegaard, Schopenhauer, Nietzsche: survivors of a shipwreck, clinging to the flotsam as if only it offered the possibility of a rational orientation for thinking.[9] As long as their commitment did not roll over into a mystical reification of an ineffable in-itself outside of culture, privileged access to which would save systematic thinking from becoming trash also, they held on to philosophical aesthetics as the final site of reflection on a *possible* culture, a culture yet to be, oriented by the rational but incomprehensible claims of the dejected, ground down by history and muttering to themselves in the gaps of triumphal culture.

However, the aesthetic appeal of the dejected, even if it is all the beauty triumphal culture leaves in its wake, is no friend to reflective thought. It is a disfigured, disfiguring force, alive in such undead ghastliness that it might seem a bad joke to use the concept of beauty to refer to its appeal. Indeed, as it emerges from the history that has deformed it and deforms it in turn through its appeal, the dejected shows itself in artistic modernism as the compulsion of the ugly. This peculiar deforming force disruptive yet propulsive, misshapen yet attractive, is what Freud discussed under the rubric of uncanniness, the return of what has been superseded (*U* 219–56). But only for a triumphal culture can the superabundance of sensuousness fit that definition, since it is the *modus vivendi* of tri-

umphalism that what is most its own, the excessiveness of the concrete sensuous, is at the same time what it most rejects and treats as alien. In artistic modernism, this uncreditable internal relation to the conceptually unmastered, which Kant and Hegel had supposed to be the special reserve of philosophical aesthetics as a part of culture, turns against the triumphal culture that both lives off it and despises it. But not just in artistic modernism: it is this eerie life of the dead in an age without ghosts, that is, the matter that escapes the concept that ought to master it by making it thinkable, that Freud has in mind when he discusses his difficulty in writing up his analysis of his patient Dora in intelligible form. Freud finds himself stumped by the bewildering character of the symptoms of Dora's neurosis because that very character keeps "coming to light,"—that is, coming into consciousness—"with every attempt at explaining [the symptoms]." There is no way for Freud to present those symptoms except as disruptions of cogent explanation. He continues:

> In the face of the incompleteness of my analytic results, I had no choice but to follow the example of those discoverers whose good fortune it is to bring to the light of day after their long burial the priceless though mutilated relics [*Reste*] of antiquity. I have restored what is missing [*das Unvollständige*], taking the best models known to me from other analyses; but like a conscientious archaeologist I have not omitted to mention in each case where the authentic parts end and my constructions begin.[10]

This will not be our last encounter with Freud's mordant pleasure in the "good fortune" of coming face-to-face with relics that resist all efforts to make the time of their lives compatible with the time in which they are explained. The "good fortune" of the archaeologists is to disinter the survivors of a vanished antiquity that have been twice mutilated by the mere process of surviving—first by being buried so that they may outlast the death of the culture that was their proper home, and then by being excavated so that they may re-enter the light of *the wrong day.* Mutilation is for Freud just another name for surviving history, for, that is, appearing at an improper time. The process of conceptual construction, therefore, can be responsible to its objects only if it satisfies two conditions: first, it must acknowledge its survivor's guilt, since construction is the aftermath of the destruction of the life from which the relic is balefully exiled; second, it must acknowledge its falsity to the "authentic parts" that remain mutilated despite construction and thereby deny construction the power to redemptively make history whole through prosthetic fabrication. Psychoanalysis, Freud suggests, is a confrontation between history as mutilation and the power(lessness) of thinking. Put otherwise, it is a generalization of aesthetic theory beyond the

boundaries within which the secular aspirations of Kant and Hegel had sought to maintain it. In this sense, psychoanalysis is, along with artistic modernism, a reflection on the revenge of the dejected against triumphal culture.

Two paragraphs back I observed that in artistic modernism "the internal relation to the conceptually unmastered, which Kant and Hegel had supposed to be the special reserve of philosophical aesthetics as a part of culture, turns against the triumphal culture that both lives off it and despises it." If, in this formulation, we replace "the internal relation to the conceptually unmastered" with "the unconscious," "philosophical aesthetics" with "psychoanalysis," and *leave "as a part of culture" just as it is*, we may also replace "Kant and Hegel" with "Freud." Psychoanalysis and artistic modernism, as confrontations with the mutilated, are belated efforts to make the centrality of the conceptually unmastered, of the dead who lurk compellingly behind concepts such as "matter," fully incompatible with triumphal systematicity, and to make that centrality the sine qua non of thinking. We may reasonably expect therefore to gain some illumination about artistic modernism by bringing Freud's writings on art and the aesthetic to the center of our attention.

II

At first glance, however, Freud's writings on art appear singularly *unlikely* to help us in our efforts at understanding modernism, and I think it will be worthwhile to spend some time canvassing the reasons. To begin with, despite being widely cultured, Freud's taste never steered him on to a path toward modernism. Instead, it moved him in the two other directions available to a bourgeois gentleman of his time, toward the art of canonical post-Renaissance European culture on the one hand and toward the popular art of the day on the other. His writings are full of references to Ariosto, Shakespeare, Goethe, and Schiller, while the targets of his essays on the plastic arts are Leonardo and Michelangelo. When not thinking about canonical writers and artists, Freud took his pleasure in popular artists: Zola, Twain, Kipling.[11] Of the writing and art of early modernism, the time frame of which almost perfectly corresponds to that of Freud's life, we find no discussion. No Courbet or Manet, no Monet or Cézanne, no Matisse or Picasso; no Flaubert, no Baudelaire, no Mallarmé, no Joyce. There is no mention even of those modernists whose own testimony informs us that Freud's was a sympathetic or influential style of thinking, such as Mann, the surrealists, and the Bloomsbury writers. While it may be unwarranted to say that artistic modernism left Freud cold, it certainly did not move him to write about it.

Furthermore, insofar as the pursuit of formal innovation is a *conditio sine qua*

non of artistic modernism, even if not its only source of energy, Freud's interest in content analysis appears to make his essays on art almost useless as models. When writing of Leonardo, for instance, Freud sets his sights on understanding the enigmatic smiles of Leonardo's women—St. Anne, the Madonna, La Gioconda—in terms of the artist's childhood.[12] Even if we were convinced that Freud's psychobiographical analyses duly explain the representational content of the images in question, it is hard to imagine how this sort of analysis could be applied to modernist works in which what is at stake is the very possibility of representation. Freudian content analysis thus seems at least *prima facie* irrelevant for thinking about modernist works. The same dilemma confronts us when we turn to literary analysis. In "Creative Writers and Day-Dreaming," for instance, Freud seems barely to advance beyond discussing plot, taking a couple of feeble stabs at analyzing narrative voice in popular fiction before drawing to a close (*CW* 143–53). Anyone interested in the crisis of voice in later Mann or Beckett, the crisis of character in Kafka or Faulkner, or the fragmentation of language in Joyce or Blanchot, would come away from this essay with little useful material.

It is not my business here to dispute the criticisms just raised. To the extent that Freud's aesthetic and art historical writings have given rise to a long line of flat-footed content analyses, they must contain the seeds of that style of thinking. Instead, I would like to argue that there is much more in Freud's essays on art and the aesthetic than content analysis. We can glean this even from the unquestionably content-analytic essay on the creative writer just mentioned, but we will need to take a somewhat circuitous path to a propitious starting point. What makes Freudian content analysis appear so fruitless at first is that it seems to be motivated by a dubious assumption: that a work of art, appearances to the contrary notwithstanding (and what a deadly clause in any aesthetic analysis that is!), has as its content some feature of the childhood experience of the artist. This assumption often inclines Freud's analyses toward psychobiography, but even if it did not it would continue nonetheless to lead him to treat the work of art as a suitable form for a content that has its original home elsewhere—namely, in the childhood of the artist the work encodes. It is this second inclination that feeds the deepest distaste for psychoanalytic aesthetics, since it implies treating the work of art as an expressive container in which a content otherwise hidden in the artist's inner life can see the light of day. Because it is not regarded as making intrinsic demands on thought and experience, the work of art is pictured in content analysis as a transparent expression of its content, the medium in which can be made public what tact might otherwise suggest ought to be kept private. The aim of content analysis is then to force the inessential container to fall away, leaving its content exposed to ordinary perception.

How Freud's content analysis is very psychoanalytical.

Ronald Britton puts his finger on the dilemma when he writes that in the early cultural texts (all written, we should note, before the development of the structural theory of the mind):[13]

> Freud's enthusiasm was at its height for the explanatory power of his notion that the pleasure principle, subjugated in daily life by the reality principle, had found a region where it could operate freely—in dreams and in neurotic symptoms. In ["Creative Writers and Day-Dreaming"], he added children's play, *Phantasie*, and imaginative writing.[14]

Put otherwise, the separation from reality that is the condition of possibility for dreams, neurotic symptoms, play, and so on, is carried over into art untransformed by Freud. Passages such as the following lend credence to Britton's point:

> The creative writer does the same as the child at play. He creates a world of phantasy which he takes very seriously—that is, which he invests with large amounts of emotion—while separating it sharply from reality. Language has preserved this relationship between children's play and poetic creation. It gives [in German] the name of "*Spiel*" [play] to those forms of imaginative writing which require to be linked to tangible objects and which are capable of representation. It speaks of a "*Lustspiel*" or "*Trauerspiel*" [comedy or tragedy; literally, pleasure play or mourning play] and describes those who carry out the representation as "*Schauspieler*" [players; literally show-players]. (*CW* 144)

The separation from reality to which Freud refers here, which is the condition for the emotional seriousness of play and poetry, is the suspension of the demands of reality, that is, the suspension of the essential demand of the reality principle that a distinction be drawn between the world as it is and the world as it is wished for under the sway of the pleasure principle. The child playing at swords does not render the garbage can lid literally unreal, but rather liberates it from the demand that it keep out the raccoons by incorporating it into the world in which it is a shield. But since in play the reality principle is suspended, the garbage can lid *becomes* a shield, a transparent expression of the wish it bears. A formal analysis of the lid would be beside the point in such conditions, and if art is like play in this respect then attention to the formal dynamics of art is equally otiose.[15] If Freud thinks of the work of art this way, then he is not just uninterested in issues of form. Assuming wishfulness is all one needs to know to understand art, Freud would seem to be *committed* to remaining uninterested in issues of form. Those who wish to see in him inspiration for an inquiry into modernism must worry about this implication.

However, there is a notable misstep in Britton's reading, attention to which

will put us on the track of a different interpretation of Freud's argument. Britton is undoubtedly correct that Freud assimilates art to dreams, neurotic symptoms, and play, but he is clearly wrong to say that Freud thought of dreams, symptoms, and play as sites of the free expression of the pleasure principle. Neurotics, Freud writes in "Creative Writers and Day-Dreaming," are the best source of our knowledge of phantasy, not because the pleasure principle operates freely in their symptoms, but because the pleasure principle is in those symptoms in implacable conflict with the reality principle. The defining feature of neurotic illness is that reality will not yield to desire, and the neurotic cannot tolerate it; in neurosis, no "free sublimation" of desire is possible. If the pleasure principle did operate without impediment, neurotics would not be neurotic; we would be either the happiest people alive (in virtue of the ease with which we would throw off the obstacles to our true desires) or psychotics (for the same reason). Freud is quite explicit about this aspect of his analytic orientation: "a stern goddess—Necessity—has allotted [neurotics] the task of telling what they suffer and what gives them happiness" (CW 146). Neurotic symptoms have an analyzable form not because they are liberated from the reality principle but because they *manifestly* are not.[16] The same, we might note, is also true of dreams, contrary to Britton. "The interpretation of dreams is the royal road to a knowledge of the unconscious activities of the mind," not because in them the pleasure principle is unimpeded—in that case interpretive knowledge would be unnecessary—but rather because in dreams the insistence on pleasure comes into conflict with defenses against it (ID 608). A dream is a compromise between the pleasure principle that rules only in the unconscious, "which is cut off from internal perception," and the reality principle, which guards conscious awareness. A dream, in other words, is only able to enter consciousness once an unconscious wish has been submitted to the transformations of censorship, and it is just the lawful necessity of the dream-work, its story of submission and protest, which is the subject matter of the interpretation of dreams.[17]

So it is false to say that Freud's primary interest in dreams, neurotic symptoms, and play is motivated by the thought that in them the pleasure principle transcends reality and operates freely. Rather, his incitement to interpretation is the intrapersonal conflict these psychic phenomena make audible. Passages of the potentially ambiguous sort that lead to Britton's misinterpretation occur regularly in Freud's writings. For instance, in "Formulations on the Two Principles of Mental Functioning":

> There is a general tendency of our mental apparatus which we can trace back to the economic principle of savings in expenditure; it seems to find expression in the tenacity with which we hold on to the sources of pleasure at our disposal,

and in the difficulty with which we renounce them. With the introduction of the reality principle one mode of thought-activity was split off; it was kept free from reality-testing and remained subordinated to the pleasure principle alone. This activity is phantasying, which begins already in children's play, and later, continued as day-dreaming, abandons dependence on real objects.[18]

It is possible to read this passage as implying that children's play, insofar as it is structured by phantasy, is kept free from reality testing. However, that cannot be what Freud has in mind, since if freedom from reality testing is understood as the abandoning of all dependence on real objects, as in daydreaming, then children's play, which does not give up on the world of objects, is fundamentally not free of reality testing. Britton errs in taking the mental function Freud does claim to be free of reality testing, that is, unconscious phantasy and thought, and identifies it with the psychical activities through which it comes into contact or conflict with the reality from which it has been withdrawn.[19] Play, neurotic symptoms, and dreams are all psychical activities the specific nature of which derives from their being sites of friction between the freedom of the unconscious from reality and the reality the unconscious rubs up against.

That what is at stake in the interpretation of play, neurotic symptoms, dreams, and therefore art is the conflict and not the coordination of the form and content of psychical expressions can be shown from another angle as well. Freud regularly rebutted the criticism that his metapsychological theories of the mental apparatus were skewed by having neurotic mental functioning as their base of data by arguing that the distinction between neurosis and normalcy is a mere matter of the degree of ability to tolerate frustration. The neurotic, as the passage above from "Creative Writers" claims, differs from the normal person only to the extent to which frustrated desires spill out into the public world, where they are not tolerated. Neurosis is a species of suffering rooted in an impolitic claiming—the neurotic is fated to suffer out loud what the normal person accomplishes *sotto voce*. Now, the clamor of neurosis is not merely a symptom of the suffering; the inability to keep the peace is the suffering itself.[20] Because neurotic symptoms, like play and dreaming, are bits of psychical life which desire demands be made public, they are in part constituted by their tactlessness; they demand interpretation outside the "normal" pathways of psychical life. For Freud, all psychical life, even when entrenched in its normal pathways, calls for interpretation, but that part of normal mental functioning that the neurotic lacks is the capability for satisfying self-interpretation in the terms the world makes available. Neurosis, in short, is a demand for the interpretation of desire when that desire is in intolerable conflict with the unsatisfying reality that "ought" to be its proper interpretation. A neurotic symptom, therefore, is not a free expression of the pleasure prin-

DEATH AND FORM IN FREUD 103

ciple, but an expression of an unavowed hostility to a reality it has all too fully ac-knowledged. For this reason, a neurotic symptom is just the demand for a new interpretation of reality. The motive for psychoanalytic interpretation, thus, can-not be to retrieve the latent wish from its inessential expression, but to grasp how the expression is a misalliance between the unconscious and the reality that the wish confronts.

That the drive to know once and for all the inner workings of the mind would overwhelm the endless psychical work of interpretation, that it would strive to identify the unconscious content of psychical phenomena with the significance of the phenomena themselves, is a danger Freud tried to guard against. However, because it is the most common sin among psychoanalysts who find themselves overenthused about the technique of analytic interpretation, Freud's warnings clearly did not work with the force he wanted. Thus, in 1925 Freud added a testy footnote to the new edition of *The Interpretation of Dreams*, published in his *Gesammelte Schriften*. He placed the note near the end of the chapter on sec-ondary revision in dream-work, a revealing choice since secondary revision, let us recall, is the last-ditch effort by the dreamer to arrange the elements of her dream in a form approximating waking thought processes. Freud approvingly quotes Havelock Ellis's description of secondary revision as a mental process that deceives conscious thinking by parodically fulfilling its demands.

> Sleeping consciousness we may even imagine saying to itself in effect: "Here comes our master, Waking Consciousness, who attaches such mighty impor-tance to reason and logic and so forth. Quick! gather things up, put them in order—any order will do—before he enters to take possession." (*ID* 501)

Secondary revision, in short, is the component of the dream-work that takes the norms of waking consciousness into account in order to transform the man-ifest dream into what appears to be a less rational version of rational thinking; in allowing the awake dreamer to dismiss the gaps and mendacities in the man-ifest dream as *failures of thinking* rather than as *successes of the dream-work*, sec-ondary revision lulls waking consciousness to sleep by playing to its egoistic de-mand that everything must be immediately intelligible on its terms. In this light, secondary revision may be characterized as a preinterpretation of the dream that the dream itself generates so as to throw waking consciousness off the scent. It is, therefore, the foremost obstacle to the interpretation of the dream-work. In placing his critique of the identification of the significance of the dream with the latent dream-thoughts near the end of his account of secondary revision, Freud implies that such an identification is itself a falsification by consciousness of the significance of the dream, and as such is also an obstacle, hence a key, to dream interpretation.

I used at one time to find it extraordinarily difficult to accustom readers to the distinction between the manifest content of dreams and the latent dream-thoughts. Again and again arguments and objections would be brought up based upon some uninterpreted dream in the form in which it had been retained in the memory, and the need to interpret it would be ignored. But now that analysts have become reconciled to replacing the manifest dream by the meaning revealed by its interpretation, many of them have become guilty of falling into another confusion which they cling to with equal obstinacy. They seek to find the essence of dreams in their latent content and in so doing they overlook the distinction between the latent dream-thoughts and the dream-work. At bottom, dreams are nothing other than a particular *form* of thinking, made possible by the conditions of the state of sleep. It is the *dream-work* which creates that form, and it alone is the essence of dreaming—the explanation of its peculiar nature. (*ID* 544–45)

The dream-work is not just an expression of its latent content, even as that latent content *is* its content. It is also a defense against that content, and the easy interpretation which the secondary revision of dreams proffers, its seduction into ready-made meaning, is part of the defense. The dream that comes to consciousness is a form of mental activity through which an unconscious wish, the fulfillment of which would be unpleasurable were the dreamer to be aware of it, is worked up into a form that the dreamer can become aware of because she cannot understand it. Here is Freud discussing a point of his self-analysis.

I should come upon dream-thoughts which required to be kept secret in the case of *every* dream with an obscure or confused content. If, however, I were to continue the analysis on my own account, without any reference to other people (whom, indeed, an experience so personal as my dream cannot possibly have been intended to reach), I should eventually arrive at thoughts which should surprise me, whose presence in me I was unaware of, which were not only *alien* but also *disagreeable* to me, and which I should therefore be inclined to dispute energetically, although the chain of thoughts running through the analysis insisted upon them remorselessly; and that is to suppose that these thoughts really were present in my mind . . . but that they were in a peculiar psychological situation, as a consequence of which they *could not become conscious* to me. . . . Thus we are led to the concept of a "dream-distortion," which is the product of the dream-work, and serves the purposes of dissimulation, that is, of disguise.[21]

In this passage, there is a formidable dialectical complexity to Freud's characterization of the object of the psychoanalyst's awareness: it is a thought that can-

not become conscious to him yet but that he is having nonetheless. In other words, the analyst becomes conscious through analysis both of the latent thoughts expressed in the dream and of his inability to have them consciously as his own. Dream-thoughts, in short, are disowned thoughts; when they are finally cast in a form conscious awareness can tolerate, they have been so well defended against already that the need for there to have been a defense has been rendered invisible. Because awareness of defense is awareness of threat, the aim of dream-work is not simply to disguise the wish but to disguise the disguise. The disagreeable dream-thoughts, which is to say the conflicts with reality they portend for the dreamer, have already been disavowed—both acknowledged and effaced from memory—by the time the manifest dream reaches consciousness. As a rebus of an old wish conjoined to an old submission, the dream expresses both a wishful thought and the fear of its fulfillment, and it expresses both by manifestly expressing neither. The object analysis brings to awareness, the dream-work, is thus *both* a proper thought *and* the impropriety of it. When dream-thoughts appear in consciousness, they appear in alien form, that is, not as thoughts at all; they appear instead as dissimulations of thought that are therefore not properly present in the mind of either the dreamer or the analyst, despite the insistence of the analysis that they are forms of thinking, an insistence that is therefore ruthless toward the perception of the alienated form. The dream analyst's task is to hew to the insufferable wishes that are suffered in dreams under a cognitive disability, under, that is, the guise of submission to the demands of reality.

As with dreams, so too with neurotic symptoms and play—and also art: for Freud, all are sites of conflict between the demands of unconscious pleasure and the demands of reality, or, to put this point as sharply as possible, between the demands of immediate pleasure and the demand that immediate pleasure not be an immediate demand. Thus, the reality principle leaves its fingerprints all over the work of art, as the necessary hiding place (perhaps it is not too soon to call it the necessary form) of alienated thought. For this reason alone, the uncovering of the infantile phantasy of immediate pleasure cannot be the specific interest of the interpretation of the work of art, anymore than of dreams, because the uncovering discards what is most at stake, that is, the forms of defense that disclose what impedes fulfillment and thereby turns the wish into, precisely, a wish. In both cases, what is at stake is the persistence of the content of the phenomenon, the persistence of the wishful phantasy, in a place—the conscious mind, the consensual social world—that is constituted by the disavowal of the very existence of the phantasy. Where the entirety of mental life is identified with conscious awareness, where the entirety of the social world is identified with the homogeneous totality of particulars exchanging without remainder—

somewhere there the wishful phantasy demands to be suffered. In a moment of universalizing *Schadenfreude*, Freud writes that "a happy person never phantasies, only an unsatisfied one. The motive forces of phantasies are unsatisfied wishes, and every single phantasy is the fulfillment of a wish, the correction of unsatisfying reality" (*CW* 146). The work of art embodies the phantastic fulfillment of an unsatisfied wish, but it does so in antagonism to the well-formed body which bears it.

The artistic antagonism between wish and reality complicates content analysis tremendously. Let us examine two such complications as Freud handles them in "Creative Writers and Day-Dreaming." First, despite the fact that infantile phantasies are the content of works of art and adult daydreams both, they do not serve as content *in the same way.* After analyzing some popular heroic and erotic story forms as expressions of the imperial ego, Freud reminds us that the direct confession of such an inflated infantile sense of self would bring us none of the pleasure that we find in the stories.

> You will remember how I have said that the day-dreamer carefully conceals his phantasies from other people because he feels he has reasons for being ashamed of them. I should now add that even if he were to communicate them to us he could give us no pleasure by his disclosures. Such phantasies, when we learn them, repel us or at least leave us cold. (*CW* 152–53)

We all know just what Freud means here. People who prattle on unselfconsciously about how powerful or attractive they are tell us more about themselves than we need to know, and the less they know that that is what they are doing, the more acute our embarrassment. Further, the closer a novel or film comes to such authorial confession, the more likely we are to judge it unartistic (which is not the same as saying we are more likely to stop enjoying it—guilty pleasures are a staple of most diets, but that they are guilty is the point here). Now, *ex hypothesi*, the unmediated or poorly mediated confession and the work of art both have infantile phantasy as their content, yet one causes unease and the other pleasure. Thus, the different expressions bear their content in different ways, and this difference is just that between confession and art.

> When a creative writer presents his plays to us or tells us what we are inclined to take to be his personal day-dreams, we experience a great pleasure, and one which probably arises from the confluence of many sources. How the writer accomplishes this is his innermost secret; the essential *ars poetica* lies in the technique of overcoming the feeling of repulsion in us which is undoubtedly connected with the barriers that rise between each single ego and the others. (*CW* 153)

art's confessional quality

To have disclosed that the content of the work of art is a wish-fulfillment is to have brought art over to the side of dreams, but, as with dream interpretation's disclosure of the latent content of dreams, it is not yet even to have begun explaining how art as *ars poetica* sustains this content. The abbreviated suggestion Freud makes here is that art differs from confession not in virtue of an essentially different, specifically artistic content, but rather insofar as art keeps its phantasy content away from conscious awareness even as it discloses that content. The feeling of repulsion we feel at the untoward confession is a reaction against the too quick recognition that we, too, have such infantile phantasies; we feel repulsion rather than indifference because shame forces us to play at being high-minded, and thus assists us in getting the cat back into the bag. The work of art employs techniques for overcoming the repulsion, for bypassing the (ego) centers of defensiveness rather than attacking them head on, and thus permits us a pleasure in what would otherwise be threatening. The specific *ars poetica*, like the *ars oneirica*, is thus not a technique of confession but a way of keeping a secret. That, in the end, is why the "innermost secret" of the artist is not the phantasy the work of art bodies forth but the capacity to bear it.

Put differently, the work of art is a technique for hiding a disavowed pleasure in plain sight and thus, for the sake of a pleasure the reality principle disallows, for maintaining, or even strengthening, the disavowal. The *ars poetica* is the technique for defending the wish in its fateful hostility to reality by satisfying the demands of the reality principle *to all appearances*. Again, even if it remains necessary for us to acknowledge that Freud sees art as being on the same side as the other wish-fulfillment techniques with which psychoanalysis deals, he is nonetheless far from denying that the wish is mixed with reality in the work of art. "A strong experience in the present awakens in the creative writer a memory of an earlier experience (usually belonging to his childhood) from which there now proceeds a wish which finds its fulfillment in creative work. The work itself exhibits elements of the recent provoking occasion as well as of the old memory" (*CW* 151).

All the elements of the dreaded content analysis are present in this thought. The creative work has its unity as a work in its threading together a wish left unfulfilled with an imagined future, figured forth imaginatively in the work, in which the wish is fulfilled. If we leave off interpreting the thought at this point, however, we will have left out one of the three times that "are strung together, as it were, on the wish that runs through them": the present (*CW* 148). Here, then, is the second complication: "the work itself exhibits elements of the recent provoking occasion as well as of the old memory." Ideally, we might like Freud explicitly to incorporate the work of making art itself into the recent provocation

(as he does with the dreamwork), but we will have to look elsewhere to find him doing that. For now, though, we see him characterizing the work as exhibiting recent experience along with old desires, just as the dream exhibits the residues of the previous day. Something in the waking experience of the artist, something perfectly consistent with the reality principle, offers nonetheless an opportunity to settle old scores, as if reality were not quite so antipathetic to the demands of pleasure as children are always told. Here, of course, we must keep in mind the distinction between the blathering confessor and the artist, since the former merely ignores social reality in a moment of merely subjective liberation, while the artist mediates the phantastic content through a submission to a reality which, it turns out, is not so uninflected as it seems. The work of art makes the old memory present by means of a manipulation of present experience because the present experience functions as an innocent hiding place for the archaic one. The present is thus not immune to the imagination of the past's future.

The dialectic of hiding and revelation will ramify further as we go, but it is already sufficiently complex to let us see that while Freud thinks of the content of the work of art as something very old, he also thinks of the specificity of the work, its capacity to express its content, in terms of a mediating disguise for that content. In the work of art, the present, the adult reality that is under the sway of the reality principle, is hollowed out as a hiding place for an archaic element of mental life. (And here we might perhaps be allowed to observe that the knee-jerk repulsion at the idea that art might have the archaic, the specifically child-ish, as its content, is part and parcel of the defense against the infantile element in life with which art must wrestle. Is there, behind this repulsion, a phantasy of specifically adult, fully mastered desires?) For this reason alone, we can say al-ready that Freud thought of the work of art, not as a transparent container for the expression of phantasy, but as exactly the opposite. It is the opacity of the work, its unity in difference of the wishful and the real, which gives Freud his orientation. The work of art harbors a past that aims at a different future than the one it finds itself bound to, and so points to a different future than what the present intends. But it does this from the heart of the present. By making the demands of desire both compelling and obscure, the work of art negates the power of the reality principle by making reality less than all that is the case. In this way, it sustains the loss of the infantile demand for pleasure. Perhaps, though, this ought not to surprise us, since by highlighting the work of the dreamwork (*Traumarbeit*), the specificity of which Freud took himself to have discovered in *The Interpretation of Dreams* to be the work of wishing for every-thing reality leaves unaccomplished, he paid homage indirectly to the disap-pearing work of the artwork (*Kunstwerk*).

III

Nowhere in Freud's writings is the dialectic of hidden content more dramatically exhibited than in another essay on art and the aesthetic, "The Moses of Michelangelo." On the surface, the "Moses" essay has a straightforward art-historical purpose: to retrieve what Michelangelo intended when he presented Moses with the particular attributes of his statue. Freud ekphrastically presents the statue and then surveys and criticizes the various explanations of it that have been offered in the literature; he finishes by offering his own account, recommending it in virtue of its capacity to better organize and explain the facts laid out in the ekphrasis than the other interpretations, and thus to better grasp Michelangelo's intention in carving his statue. For those ill-disposed toward content analysis, "The Moses of Michelangelo" could well serve as the supreme example of the genre.

However, in several respects the "Moses" essay veers away from its surface function of reconstructing Michelangelo's inner thoughts. Let us begin by considering two of the peculiar framing devices Freud deploys. The first, while a touch gossipy, is of interest nonetheless. Although Freud published the essay in *Imago*, the journal he founded, he did so anonymously, thereby denying the essay the authority it would have acquired merely in virtue of being the judgment of the master. And further, as if it were not enough to put the essay out trailing behind it no extrinsic claim to mastery, Freud attached a footnote to its title—after announcing its subject but before starting any analysis—which appears to disown the essay by declaring it nonstandard. The footnote, though, is not anonymous; it speaks in the authoritative voice of the editors of the journal, the collective guardian of psychoanalytic propriety, which warns that the judgments of the essay should not be thought to be authorized by any proper use of psychoanalytic methodology at all.

> Although this paper does not, strictly speaking, conform to the conditions under which contributions are accepted for publication in this journal, the editors have decided to print it [*hat diesem . . . Beitrage die Aufnahme nicht versagt*], since the author, who is personally known to them, moves in psychoanalytic circles, and since his mode of thought has in point of fact a certain resemblance to the methodology of psycho-analysis. (*MMi* 211)

"The Moses of Michelangelo" enters the world without the authority its author might have provided it, and it is then further orphaned when the editors—or Freud in their voice—ostentatiously refuse to grant it any more credit than is due the camp follower who fictionally wrote it. That the piece has no more than

adjunct status is echoed early in the essay proper when Freud describes the fictional author, the I of the essay, as someone who has "followed the literature of psycho-analysis closely," as, in other words, an amateur who wishes to explain the *Moses* using a methodology in which he is no expert. From the center of the center of psychoanalysis, Freud denies to his own argument any authority that might accrue to it from its authorial history.

This framing deauthorization can be regarded as a kind of stage setting in which the power of a certain figure of authority, Freud himself or his chorus, is kept out of the mise-en-scène. The second framing device, on the other hand, sets up a visible conflict of authority right on the stage—a conflict that would not be possible were psychoanalytic authority not cleared away first. This second frame is announced as the essay begins by naming the authorities among whom the author must not be numbered but with whom he will take issue.

> I may say at once that I am no connoisseur [*Kunstkenner*] in art, but simply a layman [*Laie*]. I have often observed that the subject matter [*Inhalt*] of works of art has a stronger attraction for me than their formal and technical qualities, though to the artist their value lies first and foremost in these latter. I am unable rightly to appreciate many of the methods [*viele Mittel*] used and the effects obtained in art. I state this so as to secure the reader's indulgence for the attempt I propose to make here. (*MMi* 211)

On the stage cleared of psychoanalytic methodology, we find a curious but uninformed amateur of art counterposed to the connoisseur, the former interested in the subject matter of art and the latter knowledgeable in matters of form and technique. The figure of the connoisseur will never be far from the unauthorized amateur, accusing him now and again of speaking beyond his competence. Indeed, once the essay's frame is in place, it is just the connoisseurs, those who have closely studied the form of the statue, with whom the student must do battle for the right to judge. While the stakes of that battle might appear to be a normal art-historical conflict of interpretation, in framing it as a battle between the amateur and the well-informed connoisseur Freud also sets it up as a conflict between an I who does not yet know something and those who, by contrast, are already too knowing. That the amateur is uninformed does not mean, of course, that he has nothing in his head; to the contrary, his thoughts are filled with the power of the work. Freud describes in various ways how he is in the grip of the statue, how he is overwhelmed or in awe of it, and how, therefore, he is in need of being set right by interpretation of the too powerful work. The conflict he is staging, then, is between a layman disarmed by the work and the connoisseur who has already come to grips with it. It is for the sake of high-

lighting the experience of being disarmed that the fictional I of Freud's essay is an amateur for whom the knowledge of the connoisseur, to the extent it focuses on formal or technical issues alone, functions as an inadequate defense against being moved by the work. Freud's amateurism is not a denial that real historical knowledge is necessary for an understanding of the *Moses*; rather, it embodies a denial that formal or technical knowledge can explain on its own what is most in need of understanding in the work.

> I do not mean that connoisseurs and lovers [*die Kunstkenner oder Enthusiasten*] of art find no words with which to praise such objects to us. They are eloquent enough, it seems to me. But usually in the presence of a great work of art each says something different from the other; and none of them says anything that solves the problem for the unpretending admirer. . . . [But] the product itself after all must admit of . . . analysis, if it really is an effective expression of the intentions and emotional activities of the artist. To discover his intention, though, I must first find out the meaning and the content [*Sinn und Inhalt*] of what is represented in his work; I must, in other words, be able to *interpret* it. It is possible, therefore, that a work of art of this kind needs interpretation, and that until I have accomplished that interpretation, I cannot come to know why I have been powerfully affected. I even venture to hope that the effect of the work will undergo no diminution after we have succeeded in thus analyzing it. (*MMi* 212)

In framing his interpretation in terms of a conflict between lay interest and connoisseurship, Freud clearly does not promote ignorance over knowledge. He seeks instead to establish a contrast between a form of knowing that brings the force of the work into reflection and another form which denies that force by isolating formal issues. And, although no form of knowing can claim for itself a priori the power to sustain the force of the work (such a claim would be self-contradictory if guaranteed a priori), the connoisseur's form of analyzing the *Moses* in terms merely of form or technique can be assayed a priori as set against such an *undergoing* of the work; it does not so much explain the statue as hold it at objectifying arm's length in order to avoid its power. The frame Freud constructs establishes, we can say, a contrast between two different orientations toward the work, one of which seeks to make vivid the *need* for interpretation within the interpretation itself (so that the interpretation becomes expressive of the obedience of reflective thought to the felt demand for it), the other of which proceeds as if need had nothing to do with it.

After interpreting the significance of Freud's framing of his expedition into art history, we find ourselves back with our central claim that the fundamental

problem for aesthetic theory is that reflection on the work of art is also a confrontation with those limits of reflective thinking that rear up in the work itself. The power of the work can be identified neither with its profound subject matter nor its profound technique, since the problem for reflective thought is that the neatness of this distinction, its easing of thinking's way, renders it inapt in the face of what is a force only because it remains untrapped by the distinction. To put the point this way, however, perhaps overemphasizes the purely epistemic dimension of the dilemma, as if the problem were that we have not yet found the right language in which to recast the work's spell. But Freud's point is more extreme than this: there is a problem, inherent in all proper thinking about art, that the propriety of the thinking does nothing to dispel the work's power. Proper thinking about art is a form of suffering, of undergoing the force of alienated thought. Thus, Freud writes, grasping Michelangelo's intention, which is necessary to understanding the *Moses*, is not "merely a matter of *intellectual* apprehension." He continues:

> What [Michelangelo] aims at is to awaken in us the same emotional attitude, the same mental constellation as that which in him produced the impetus to create [N.B.: he aims to make us unhappy in the same way he was]. But why should the artist's intention not be capable of being communicated and comprehended in *words*, like any other fact of mental life? Perhaps where great works of art are concerned this would never be possible without the application of psycho-analysis. (*MMi* 212)

What is it that the application of psychoanalysis to the words spoken about art teaches us about the inherent difficulties of communicating and comprehending an artist's intention? In their ordinary analytic function in art history, words are the agents of what Freud calls the striving for "thought identity," the effort to conjure an identification without remainder between a concept and a perceptual experience (*ID* 602). With words, connoisseurs try to forge an identity between thinking about the work of art and the work being thought about, and in this way to "correct" the primary-process insistence on "perceptual identity," which, in its hallucinatory pleasure, brings thought to a stop. The pursuit of thought identity, the perfect alignment of concept and particular, must reject all perceptual identity (which here means what Hegel meant by picture thinking) in order not to remain satisfied with the pleasurable mimetic relation of mental contents to their objects.[22] The search for thought identity thus rests on a repudiation of mimesis upon which all the more "delicate" mental functions depend and, insofar as words are the expression of thought identity, *they become tools of repudiation*. The noncommunicability or noncomprehensibility

why art is hard to discuss

of the work of art is, in this light, the revenge of mimesis against identity think-
ing, against, we can even say, the secondary process as such. The work of art is
the significant object that nonetheless withholds itself from conceptual ab-
straction. This does not imply that the work of art has a meaning which can be
communicated or comprehended extralinguistically, but rather that its mean-
ing, its mimetic identifications, hides within words and is experienced as the
persistent need for further interpretation. It is as if the work both is already the
perfect translation of the artist's intention and at the same time the place where
that intention refuses further translation into concepts: the work *needs* inter-
pretation. The only use of words that can convey *this* is a use still tinged with
the residue of perceptual identity, a nonknowing use (*not* an unknowing use)
touched by what Freud calls the affective intensity of ideas. In the interpreta-
tion of art, words get distracted from their goal of becoming abstractions. This
is why Freud calls the illumination of the problem of communication and com-
prehension a lesson of psychoanalysis: it is nothing less than the central idea of
the talking cure.[23]

Perhaps the simplest way to put Freud's point in framing his *Moses* interpre-
tation as a conflict between the connoisseur and the amateur is this: for the am-
ateur, thinking about art begins where concepts of art leave off. Again, the point
is not that amateurism is aconceptual, but that in the inner movement of the
soul provoked by the still work of art, something remains unthought within the
concepts connoisseurship cultivates. Those concepts are the only ones we have,
but they are wrecked by the movement they give shape to. *Proper thinking about
art is, therefore, ruined thinking.* On this basis, we can make sense of the pecu-
liar confession with which Freud brings the initial framing of his *Moses* inter-
pretation to a close.

> Another of these inscrutable and wonderful works of art is the statue of Moses,
> by Michelangelo, in the church of S. Pietro in Vincoli in Rome. As we know, it
> was only a fragment of the gigantic tomb which the artist was to have erected
> for the powerful Pope Julius II. It always delights me to read an appreciative
> sentence about this statue, such as that it is "the crown of modern sculpture." . . .
> For no piece of statuary has ever made a stronger impression on me than this.
> How often have I mounted the steep steps from the unlovely Corso Cavour to
> the lonely piazza where the deserted church stands, and have essayed to support
> the angry scorn of the hero's glance! Sometimes I have crept cautiously out of the
> half-gloom of the interior as though I myself belonged to the mob upon whom
> his eye is turned—the mob which can hold fast no conviction, which has neither
> faith nor patience, and which rejoices when it has regained its illusory idols.
> (*MMi* 213)

This passage is so wildly overdetermined that one hardly knows where to start with it.[24] But comforting ourselves with the thought that we need not know how to finish in order to begin, let us take our orientation from our observations about Freud's amateurish, that is, loving and fearing, relation to the statue. In a nearly hallucinatory encounter with the *Moses*, Freud, first of all, perceives in it the power of its subject, the angry Moses, master-father of the Jews, to turn his wrath on his beholder. Moses's wrath, of course, was spurred by the sight of the Jews worshipping an idol rather than holding fast to the promises of a God, belief in whom was to be vouchsafed by the voice of the commandments rather than by any visible appearance in the world; the very perception of his people demanding the infantile satisfaction of the perceptual identity between God and his appearance forced Moses to rise up in rage. The anger of Moses, in other words, is directed at the refusal of the Jews to submit to the need to read what is written (to interpret) rather than to see (to rejoice). And the *Moses* of Michelangelo confronts Freud with a perfect historical repetition of that wrath, now poured down on the head of he who would mistake the idol for (God) the father. No wonder Freud is delighted to read a connoisseur's judgment that the *Moses* is "the crown of modern sculpture," since the categorization of the figure *as* sculpture allows for the comfort of disavowal, of knowing the difference between form and subject matter. However, against this delight, Moses, or the *Moses*, is poised to take his revenge, a revenge that in the end he nonetheless refrains from taking. Determining the significance of his holding back, then, is the task Freud undertakes in interpreting Michelangelo's statue—whereas the fact that Moses stays his hand, that he is positively inanimate, is just what is missing from the connoisseur's delightful judgment. The connoisseur does not see, cannot see, the threat that has passed such that the statue remains immobile, and for that reason does not see, cannot see, the threat that still hangs over the world. If only comfort could be found that way! But Moses commands, "Understand me." And he adds, "But do not think understanding is an escape from suffering the force of the commandment."

How, though, does mere carved stone come to bear such terrifying meaning? Or, put in the phrasing we used above, why do the judgments of the connoisseurs fail to defend against the *Moses*? This question cannot be addressed until we have a sense of the subject matter of the statue, so now is the moment to present Freud's disagreement with the connoisseurs. The crux of the conflict is whether the *Moses* depicts Moses in the moment just before rising to smash the Tables of the Law and punish the faithless Jews, or in the moment after he has held back from meting out the punishment his anger demands, suppressing his rage by turning it back against himself. The consensus of all the connoisseurs

save one is that Moses is about to give in to his emotions and spring up and forward, but Freud comes to the opposite conclusion.

> What we see before us is not the inception of a violent action but the remains [*der Rest*] of a movement that has already taken place. In his first transport of fury, Moses desired to act, to spring up and take vengeance and forget the Tables; but he has overcome this temptation, and he will now remain seated and still, in his frozen wrath and in his pain mingled with contempt. Nor will he throw away the Tables so that they will break on the stones, for it is on their especial account that he has controlled his anger; it was to preserve them that he kept his passion in check [*zu ihrer Rettung seine Leidenschaft beherrscht*]. In giving way to his rage and indignation, he had to neglect the Tables, and the hand which upheld them was withdrawn. They began to slide down and were in danger of being broken. This brought him to himself. He remembered his mission and renounced an indulgence of his feelings. His hand returned and saved the unsupported Tables before they had actually fallen to the ground. In this attitude he remained immobilized, and in this attitude Michelangelo has portrayed him as the guardian of the tomb. (*MMi* 229–30)

It will not serve to reconstruct the entirety of Freud's interpretation here, but we should note the importance of the last point in this passage. The *Moses* was to be one of the figures guarding the tomb of Pope Julius II; it would have been supremely inartistic, therefore, to depict him as about to stand up. The life the tomb commemorates has gone over to its eternal rest, and so "we cannot imagine that [the *Moses*] was meant to arouse an expectation in the spectator that it was on the point of leaping up from its seat and rushing away to create a disturbance on its own account" (*MMi* 220). Moses, in other words, is subjugated by the mission of the whole of which he is a part, and Michelangelo depicts him in that subjugation. This, however, makes Michelangelo's intentions even more obscure because Moses, the Law-giver of the Jews, is an exemplar of the *vita activa*, more readily imagined as wrathfully on his feet, creating a disturbance in order to give the Law its sanction. How can the tradition of Mosaic anger be made compatible with a subjugated Moses? That the connoisseurs deem Moses to be rising offers a more plausible answer to this question.

For Freud, though, the solution to this puzzle is to be found in an instability in the distinction between the *vita activa* and the *vita contemplativa*. The assumption that for Moses to be active he must be shown to act is correct, but it does not follow that the action in question must be directed outward at someone else. "Now wrath and indignation lay hold of him; and he would fain leap up and punish the wrongdoers, annihilate them. His rage, distant as yet from its object, is meanwhile directed in a gesture against his own body" (*MMi* 225).

Moses has acted against himself. His repose, therefore, is a dynamic repose, "the remains of a movement that has already taken place" (*MMi* 229). To turn one's anger inward, to exercise it against one's own body, is actively to withhold the gift of judgment from the transgressors. Moses's repose is not a predecessor to action or a failure to act; in his eternal posture, Moses is eternally saving himself from the loss entailed by outer-directed action. His repose, Freud says, is sublime, which is to say perceptually indistinguishable from inaction. Michelangelo, in other words, has depicted Moses as a superman who has "struggl[ed] successfully against an inward passion for the sake of a cause to which he has devoted himself" (*MMi* 233). And it is this refusal to strike out, to be the violent enforcer of the Law, that is the source of Moses's eternal sanction of the Law.

> The figure of Moses, therefore, cannot be supposed to be springing to his feet; he must be allowed to remain as he is in sublime repose. . . . But then the statue we see before us cannot be that of a man filled with wrath, of Moses when he came down from Mount Sinai and found his people faithless and threw down the Holy Tables so that they were broken. And, indeed, I can recollect my own disillusionment when, during my first visits to San Pietro in Vincoli, I used to sit down in front of the statue in the expectation that I should now see how it would start up on its raised foot, dash the Tables of the Law to the ground and let fly its wrath. Nothing of the kind happened. Instead, the stone image became more and more transfixed, an almost oppressively solemn calm [*heilige Stille*] emanated from it, and I was obliged to realize that something was represented here that could stay without change; that this Moses would remain sitting like this in his wrath forever. (*MMi* 220–21)

Freud's disillusionment in coming to acknowledge that Moses will not rise is a complex and ambivalent mix of both liberation, since Moses is fated by his role as the sanction of the Law never to punish, and paralysis, since without Mosaic punishment Freud cannot ever be certain that he is subject to the Law, that he is Chosen. This disillusionment could be allayed only if Moses were to rise up and strike the idolatrous Freud—only, that is, if the connoisseurs were right. The Moses of the connoisseurs is always ready to show that he is in charge and thereby to take on his own head the guilt-relieving job of enforcing the Law. This is the comfort of disavowal the connoisseurs offer but which Freud cannot bring himself to take.

The inability to overcome his anxiety before Moses is not exactly a choice on Freud's part. Even knowing what the connoisseurs have taught, even knowing that Moses will not rise, does nothing to inhibit his sense of awe. Indeed, it magnifies it. Knowing that this is a statue, a great work of art and so essentially immobile, offers no solace, because it is just the immobility of Moses that ignites

the unending fear of being crushed. The power of Moses is memorialized in the statue and therefore remains perpetually threatening, that is, Freud remains perpetually overpowered by it. No defense works against the *Moses* because to defend against it, to turn one's rage at it back against oneself, is to acknowledge its power. That he is "nothing but" carved stone does not do it, because Moses's wrath—the content of the statue—seeps through the stone; Moses's wrath is expressed in his stoniness, not in some merely "inner" emotion that the statue keeps bottled up. *The* Moses *threatens, not despite being a work of art, but just because it is a work of art. Its repose, recall, is sublime.*

The knowledge that the *Moses* is art can no more protect Freud than it can, in the end, protect the connoisseurs. In a stunning set piece, Freud reconstructs in a series of drawings the imagined stages on Moses's path to his final posture. The drawings are visual aids for the retrospective hope that Moses really did punish his people and thus, in revealing himself to be all too human after all, did give up his sublime authority. The drawings are defenses against the sublimity of the Law out of which the historical guilt of the Jews flows. Freud then maps onto his reconstructive sequence the errors made by various connoisseurs while describing the statue, showing how, despite the "official" judgment that the Moses depicted by Michelangelo is about to act, the connoisseurs still see in the statue the content against which their own "official" judgment defends. Behind the art-historical disavowal of Moses's special wrath, the anxiety about it is working away nonetheless as the *motive for a purposive nonrecognition*. "It almost seems as if [the connoisseurs] had emancipated themselves from the visual image of the statue and had unconsciously begun an analysis of the motive forces behind it, and that that analysis had led them to make the same claim as we have done more consciously and more explicitly" (*MMi* 229).

The failure of the connoisseurs' defense against the statue can be seen in their errors in describing what they could not have failed to see: the flow of the leftmost lock of the beard, the posture of the "despotic" finger, and so on. In the descriptions of these minor details, suffering and defense perform their fateful dance. When Freud then attends to these details, he compares his procedure to that of another connoisseur, Ivan Lermolieff, who had argued that attributions ought to be grounded in minor features of works of art because the eye of the copyist usually takes in only the gross features of the work being imitated; the copyist is betrayed by the signs he leaves behind of what he has not noticed. "It seems to me," Freud writes, "that this method of inquiry is closely related to the technique of psycho-analysis. It, too, is accustomed to divine secret and concealed things from despised or unnoticed features, from the rubbish-heap, as it were, of our observations" (*MMi* 222). A detail, the stated goals of Lermolieff's

connoisseurship notwithstanding, is not just any feature of a work; rather, it is a feature which we see but do not notice. We call it a detail because it is irrelevant to the main interest of the work, and thereby we consign it to the perceptual trash. For Freud, however, that means no less than that the detail is where the work of art is to be found. The art of the *Moses* is made up of what resists "official" perception.

Freud concludes the interpretive portion of the "Moses" essay by returning to the anomalous moment in Moses's life that Michelangelo, on Freud's interpretation, chose to portray. It is so peculiar that even in Michelangelo's own time his choice was not acknowledged; Condivi, a contemporary, described Moses as contemplating the burden of leading the feckless Jews. It is as if the *Moses* has always been surrounded by a protective shroud of disavowal on which the "proper" Moses could be seen instead of Michelangelo's odd one. However, Freud cites the biblical passages about the episode of Moses and the golden calf in which this moment is described in order to show that the Bible, too, is full of inconsistencies and slips, full, that is, of moments in which something darker than the official version, something against which the official version is constructed, shines through. And it is out of that darker stuff that Michelangelo made his *Moses* in such a way as to preserve the absence of illumination, to contrast the official with the dejected. Already in the Bible something archaic is being dissembled, and Michelangelo's statue is a perpetuation of that dissemblance through which that archaic content is preserved. The statue is made of the discarded junk of Michelangelo's biblical culture, which he passes on in its dereliction, and therefore this junk continues in the *Moses*, when Freud confronts it, to need interpretation.

The essay ends with a final bit of framing. The amateur is once again hounded by the spirit of the connoisseur who accuses him, in essence, of making it up. For the connoisseur, what the canonical art of European culture hands down is a coherent set of formal and technical skills, knowledge of which permits stable interpretation of its art. A knowledge of form and technique that the amateur lacks would have saved him from his troubles. Historical knowledge of art, in other words, keeps meaning in its proper place. This, of course, is just what artistic modernists doubt, and so too does the amateur ego who undergoes the uncertainty that remains after formal analysis is complete.

> What if we have taken too serious and profound a view of details which were nothing to the artist, details which he had introduced quite arbitrarily or for some purely formal reasons with no hidden intention behind? What if we have shared the fate of so many interpreters who have thought they saw quite clearly things which the artists did not intend either consciously or unconsciously? I

cannot tell. I cannot say whether it is reasonable to credit Michelangelo—an artist in whose works there is so much thought striving for expression—with such an elementary want of precision, and especially whether this can be assumed in regard to the striking and singular features of the statue under discussion. And finally we may be allowed to point out, in all modesty, that the artist is no less responsible than his interpreters for the obscurity which surrounds his work. In his creations Michelangelo has often enough gone to the utmost limit of what is expressible in art; and perhaps in his statue of Moses he has not completely succeeded, if his purpose was to make the passage of a violent gust of passion visible in the signs left behind it in the ensuing calm. (*MMi* 236)

In this final sentence we get what with justice we might treat as the Freudian "definition" of artistic form: the failure to make comprehensible a violent gust of suffering from the past. The *Moses* is, in this sense, not just a guardian of a pope's tomb; it is itself the tomb in which a life that has passed is made palpable. Here we have the most powerful motive for rich content analysis, for when Freud looks back on the history of art, he sees something uncanny, something that does not come to appearance in the form proper to it yet which is still the active content of that form. This is the uncanniness of art that needs interpretation by a psychical work that is never done. It is, we might say, the traumatic kernel of historical knowledge.

IV

As Freud sets himself up as an amateur of art, a wounded lover, he sets himself against the connoisseur who attends knowingly to the form of art. Even more particularly, whereas Freud finds himself caught in a web of glances—between himself and Moses, himself and Michelangelo, Moses and the Jews, Moses and Michelangelo, Michelangelo and Pope Julius, and so on—the connoisseur arrogates to himself the only active glance in the encounter with the statue. The singularity of his living glance enables the connoisseur to escape the suffering to which the amateur is prone, but the price of doing so is identifying the form that he knows with the complete immobility, the immutable stillness, of the work. The connoisseur's historical mastery, from which Freud begs to take his leave, is thus inextricably tethered to the death of the art it surveys.

Freud, however, is not the first writer to have treated connoisseurship as the wrong kind of knowledge of art. Indeed, even those of my readers who remain unconvinced that Freud is the proper inheritor of the materialist strain in aesthetic theory cannot deny that in this regard he is in a direct descent from Kant and Hegel. In trying to give shape to the concept of form, Kant does battle with

Batteux and Lessing, and Hegel with Winckelmann (*CJ* 33, p. 148; *ILA* 69). The issue in question for both Kant and Hegel is whether the unity of form and content in the work of art is an objective property of the work or, put otherwise, whether "form" is an exhibitable concept. If it is, then knowledge of art just is another type of historical knowledge; if on the other hand it is not, then the knowledge of the connoisseur stands revealed as a manner of warding off the excess of art that form makes palpable. For instance, Hegel treats connoisseurship as a way of regarding art that is an alternative to aesthetic theory; he writes of Winckelmann that he "[s]hould be regarded as one of the men who have succeeded in furnishing the mind with a new organ [*ein neues Organ*] and new methods of study in the field of art. On the theory, however, and the scientific knowledge of art his view has had less influence" (*ILA* 69).

This judgment echoes across the years separating Hegel from Freud. The growth of a new organ signals an unaddressed need, a disturbance in the field of knowledge. However, as we have seen already, the disturbance of the end of art is for Hegel the spur that systematic aesthetic theory must incorporate into itself. It is the unendingness of that end, the lack of a final overcoming, which makes of philosophical aesthetics a mournful activity. In this light, Winckelmann's insufficient attention to the wound that drives his cognitive development also limits his contribution to the systematic study of art. The connoisseur, for Kant, Hegel, and Freud, develops a new organ for the perception of form in the aftermath of, and as a defense against, the historical trauma of the unceasing cessation of artistic mediation. For the connoisseur, on the other hand, the new organ is a gift of knowledge rather than a corporeal memory of loss.

To read Freud in this way, as an inheritor of Kantian and post-Kantian aesthetic theory, forces us to confront the internal connection within aesthetic theory between form and death. But it is also at this juncture, where the stakes of our genealogy are most explicit, that psychoanalysis's dialectical overcoming of aesthetic theory "proper" is most pronounced. Once we come to understand that the connoisseur's taking possession of the only active glance in the encounter with perceptually stabilized artistic form functions as a denial of the suffering which form memorializes, we might well be sorely tempted to reopen the issue within aesthetic theory by redescribing art, in order to defend it against the epistemic predation of the connoisseur, as a living being with, therefore, an *organic* form. On that basis, the encounter between spectator and artwork would become like that between two persons, an encounter in which, of course, everyone is an amateur. No doubt giving in to that temptation would offer us a way through the impasse of connoisseurship. And, indeed, anyone so tempted can, by means of the slightest jiggering with the arguments of Kant and Hegel, cob-

ble together a basis for the belief in the "living" work of art. For instance, when Kant says that "fine art is an art insofar as it seems at the same time to be nature" (*sofern sie zugleich Natur zu sein scheint*), all one need do to reanimate the work of art is replace the "seems" clause with an "is" clause; similarly, with Hegel, when he says that "the spiritual and the sensuous side must in artistic production be as one" (*müssen im künstlerischen Produzieren eins sein*), all one need do is elide the "as" implied by the imperative voice (*CJ* 45, p. 173; *ILA* 44). Following these formulas, one might well be able to repatriate art to the world of living nature from its existence in what Hegel calls the shadow world: that is, one might well use aesthetic theory to bring art back to life from its afterlife.

This, however, is precisely the way through the connoisseur's defense against mourning that Freud avoids because, while the deployment of a purely aesthetic theory of form appropriately denies that the connoisseur's encounter with art is a one-sided standoff between the essentially active and the essentially inert, it inappropriately posits that a two- or multi-sided encounter must be between or among living beings. Rather than criticizing the connoisseur for implicitly derogating the claims of the dead that insistently wound us in our encounters with artistic form, this idealist temptation to reanimate the work would have us amplify the insult by supposing that only the living can make claims that surpass conceptual comprehension. Idealist aesthetics is an overemphatic and macabre effort to amputate the new organ the connoisseur has grown (or, the new organ connoisseurship is) by forcing the work of art to live again in an imagined past before even the conditions that necessitated the development of connoisseurship took hold. Idealist aesthetics, in short, is distorted by its nostalgia for integral life. The work of mourning that aesthetic theory becomes after the end of art thus cannot be sustained as aesthetic theory alone because *the very idea of aesthetic theory alone* harbors the hope for a new life and, therefore, a proper end to mourning. When Freud treats artistic form as threatening, then, it is not because it rears up as another living thing, but because in it the dead, the violent gusts of suffering from the past, continue to call on us. Freud blocks idealist aesthetics by placing the work of art not in "life"—which is already a dematerialized and dematerializing concept—but in the space between the living and the vast realm of the keening dead. In Freud's writings on art and the aesthetic, the traumatic kernel of historical knowledge worms its way through artistic form, laying waste to the stable perceptual relationship between the connoisseur and the form of the work; but it burrows further, also threatening, again^t the aesthetic critique of connoisseurship, to close the all too hopeful, all too
ist gap between the living and the dead. In the face of this, Freud de
niques for listening to the dead insofar as they really are dead, an

awaiting rebirth, techniques that collectively constitute psychoanalysis. Psycho-analysis thus says good-bye to the possibility of completed mourning, which is to say it is never done saying good-bye to the possibility of a self-contained aesthetic theory. Perhaps we can say this: psychoanalysis is the work of mourning for the *ideal* of mourning, in the face of the unendingness of the loss that the end of art unleashes on the world.[25]

The traumatic relation of the past to the present, of the dead who do not stay quiet to the living who are appalled to hear them, is one of the overarching themes of Freud's work. From the early claim that hysterics suffer from reminiscences to the late speculation that Christianity was born as the return of the priestly religion that had been repressed by patricidal Judaism, Freud ceaselessly listened for the echoes of the relics of the past that subsist in the present. More specifically, he listened for them in the fissures they produced in the putatively seamless texture of present experience. Against the self-possession to which the firm differentiation of past and present seeks to attest, Freud sensed in the present the continued force of the dead. To say that he listened *against* the present is, however, one-sided, since he believed that the force of the past was nowhere more powerful than in the defenses against it—in reaction formations, character traits, and so on—the maintenance of which requires so much psychical energy. It is only a slight exaggeration to say that for Freud the present is a system of forms and institutions that draw their energy from the past they defensively reproduce.

Nonetheless, despite his continuous concern with the community of the living and the dead, there was a shift of emphasis between the second and third phases of Freud's career.[26] That the three phases are genuinely discrete is a matter of dispute, but it is legitimate for our purposes to mark the distinctness, if not the utter discontinuity, of the third phase, by means of the issues which Freud himself thought raised problems for his earlier views: the compulsion to repeat, the death instinct, the return of the repressed as traumatic experience. The texts in which the new problematic is introduced are Freud's two great masterpieces of the logic of haunting: "The Uncanny" and *Beyond the Pleasure Principle*. In both essays, Freud shifts his emphasis from the paramount distinction of the earlier phase, that between the conscious and the unconscious, to one between the coherent ego and the repressed; furthermore, in both essays the shift is mandated by the special demands of studying cases where the compulsion to repeat, that is, the uncanny return to or of unpleasurable experiences, overpowers the ego's direction of the pursuit of pleasure (*U* 234–38).[27] In other words, Freud shifts his focus from successful defenses against the past that the dominance of the pleasure principle presupposes to unsuccessful defenses in which the repressed returns into conscious awareness. The name he uses for this over-

powering of the present by the past is "traumatic neurosis." As we turn now to discuss the details of this malady, we should try to keep one important fact in mind: even if the emphasis on trauma sounds a new note in Freud's clinical and metapsychological inquiry, all of the themes he raises there are echoes of themes he has already addressed in his writings on art and the aesthetic.

We can characterize the difference between what Freud confronted in traumatic neurosis and in other types of neurotic illness as follows: in the latter cases, he encountered psychical forms that took coherent shape as defenses against their own past, but in traumatic neurosis he confronted situations in which the continuing force of the past prevented coherent forms from taking shape at all. Working defenses serve to keep the force of the insistent past out of conscious awareness, both for the worse, as in the case of, say, the ritualistic hand-washing of the obsessive, which, at a very high price, keeps something "polluting" out of mind, and for the better, as in the case, say, of the ability to find a sexual object that both satisfies the demands of love and yet avoids falling afoul of the incest taboo. In traumatic neurosis, by contrast, the past successfully storms the fortified present. Now, as our discussion of the dreamwork showed, a working defense does not escape the past, but instead generates forms in which the force of the past is lived. Thus, since the defenses are themselves modes of the past's preservation, traumatic neurosis must be understood as a conflict between two modes of history, one mediated by forms of defense and the other antagonistic to such mediation. In traumatic neurosis, in other words, the past takes its revenge against the very possibility of a mediated relation to it, against, that is, the possibility of memory. In such a condition, the community constituted by the homeostatic truce of the living and the dead has broken down into a civil war.[28]

If hysteria and obsessive disorders are made of defenses working overtime, then traumatic neurosis is made of defenses not working at all. In putting the very possibility of defense into question, traumatic neurosis is uncanny experience, the reappearance of the surmounted past in a time to which it does not belong. It is on this basis that Freud describes the central puzzle of the condition: those who suffer from it return in their dreams and in hallucinatory flashbacks to the scene of the disaster despite the fact that no pleasure can be obtained through doing so. It is as if the sufferers need to return to the moment of being traumatized in order to build up the proper anxiety retrospectively; they need to become prepared for an event that has already happened. For this reason, he proposed, the event in question is properly characterized not as remembered but as relived, repeated again and again in an endless present, in an effort to make it recede into a past that only then will have been bound tight by a proper present

that at long last it gives rise to. Traumatic neurosis, thus, is the derangement of historical time. For the sufferer, not even the knowledge that the event is past is enough to experience it as past. Perhaps, then, it would be right to see traumatic neurosis as the inverse of the old definition of hysteria—whereas the hysteric suffers from reminiscences, the trauma survivor suffers from the inability to reminisce. The aftermath of the traumatogenic event is not a life full of recollections, but a life deformed by eruptions of the past which cannot be recalled. As past and present penetrate one another, traumatic repetitions *interrupt* the present and thereby disable the formative impulses of the pleasure principle (hence, Freud's formulation of trauma as "beyond" the pleasure principle). Trauma is a break in the order of experience that blasts apart the great project of psychical life, the binding of past, present, and future.

In trying to understand this feature of traumatic suffering, Freud came to realize that traumatic neurosis, unlike the other neuroses, is not a species of failed sublimation, of failed wish-fulfillment. Whereas the past typically informs "later" psychical life, the traumatic past deforms it. In other words, when the traumatic event recurs, it does so as itself, that is, as unsublimated; it thus confronts the sufferer as what cannot be represented as other than it is, which is to say, as what cannot be represented. The interruptive demands of traumatic symptoms, their abortion of the mediation of past contents, suggests that what constitutes trauma's psychical disability is the destruction of *the very capacity* to mediate the past, to transmit it into what might have become the psychical present. "This," the traumatic repetition monstrates, "cannot be represented." Whatever constitutes the representational idiom of the sufferer is thereby confronted by its inadequacy to weave together past and present, as if the capacity to weave time, which is just the ability to live with the past, were destabilized by the past it seeks to incorporate. Traumatic neurosis is, put most simply, a disease of inheritance, an impossibility of taking up the past, due to the crushing of the mechanism of inheritance the past would have provided as its legacy. At the heart of present forms of the past's future, the past juts out; in remaining unmediated by the available forms of mediation, traumatic insistence is the ruination of the representational relation.

Hence, whereas the demand of hysterical or obsessive neuroses is to find a more satisfying way to be true to desire when desire's present representation is a source of pain, the demand of traumatic neurosis is to find an entirely novel representational idiom. When no extant form will do to mediate desire, the demand for form becomes a remorseless assault on the ego's claim to be the center of its own experience. In practice, this demand is a self-demolishing drive against the self's capacity to mediate the past, to carry the burden of its own history; trau-

matic neurosis is history's inexhaustible fury directed against the power of form. The dead press their claim against the living (in the light of which the living reveal that "the living" is an alias for "the survivors") just where the living believe they know themselves to be alive. Trauma, in this sense, is the nonattained future of the past bursting through form and making the present derelict.

We can now see why Freud thought that we confront the death drive, the all too human urge to destroy the *principium individuationis* head-on in traumatic suffering.[29] Traumatic neurosis is the experience of being unable to be oneself, the experience of one's self getting in the way of what one is fated to become. An event is traumatogenic only when there is a form it may betray, but equally it is only traumatogenic when the available forms are a betrayal of it. Traumatic neurosis, thus, is a peculiar *mésalliance* between form and content in which the content is experienced as turning against all forms of representation, as being excessive to representation; it is the mortifying arrival in consciousness of the internal connection between psychical form and past content at war with one another. And this understanding of what is traumatic about trauma, of what makes surviving an accident a source of illness, is just the radicalization of the mournfulness of aesthetic theory which becomes psychoanalysis. Freud's receptivity to the vengefulness of the dead, his effort to listen to the suffering of those who should have died but outlived their appointment with death, has been forged in the crucible of the traumatizing encounter with artistic form's failure to contain, to keep within comprehensible limits, a violent gust of suffering from the past. Psychoanalysis arises out of the thought that no method will save us from undergoing the perpetual mourning that the end of art—the end of the idea of proper, traditional form—imposes on us.

Let us pin this point down by considering the circumstances surrounding Freud's writing of *Beyond the Pleasure Principle*, the text in which traumatic neurosis is most directly addressed in its clinical, metapsychological, and biological dimensions. At the same time as he was composing it, he was also working on "The Uncanny."[30] Because it ought not to surprise us any longer that Freud would think through an especially complex theoretical or clinical problem alongside a problem of aesthetic form, we will keep our observations on the interconnection between these two texts to the minimum necessary. That both are about the same problem is obvious—each addresses in its own context "the factor of involuntary repetition," in *Beyond the Pleasure Principle* as it appears in the symptoms of traumatic neurosis, and in "The Uncanny" in the hypothesis that "whatever reminds us of this inner 'compulsion to repeat' is perceived as uncanny" (*U* 238). The intrication of the two essays goes further than this, however. The uncanny in literature, Freud writes, is "a much more fertile province

than the uncanny in real life" (*U* 249), because the writer can "increase his effect and multiply it far beyond what could happen in reality, by bringing about events which never or rarely happen in fact" (*U* 250). The power of fiction, which is the power to invent, permits the writer to represent as real what is unlikely to be so. The fertility of fiction for the experience of the uncanny thus rests on fiction's hollowing out of what otherwise seems to be the seamlessness of the real.

This much is territory familiar from our discussion of the "Creative Writers" essay. However, Freud then makes a surprising move when he observes that our awareness that fiction is fictional works *against* the effect of the uncanny. "We retain a feeling of dissatisfaction, a kind of grudge against the attempted deceit" of the writer when we know it is deceit she aims at. For a return of the past to remind us of something surmounted, we cannot, after all, also be conscious that the returning element has all along been in the conscious possession of the writer. The writer of the uncanny, therefore, is challenged by the reader's canny belief in her, the writer's, own canniness. Echoing Kant, Freud therefore infers that the artist must evade our knowingness through the creation of the appearance that she is not in calculating control of her powers of literary form.

> The writer has one more means which he can use in order to avoid our recalcitrance and at the same time to improve his chances of success. He can keep us in the dark for a long time about the precise nature of the presupposition on which the world he writes about is based, or he can cunningly and ingeniously avoid any definite information on the point to the last. (*U* 251)

These points seem at first glance to be about matters of technique, such as narrative ordering or the details of setting. And indeed they are, but the two points Freud mentions as matters of technical accomplishment, being in the dark and being lost, no less than his characterization of the cunning and ingenious nature of the writer, are themselves instances of uncanny experience he traces back to the long surmounted fears of childhood. The possibility of uncanny experience in fiction, therefore, rests on its formal preservation of the experiences it also takes, in the case of stories about the uncanny, as its content. Fiction as such, regardless of its specific genre, thus carries the taint of the return of the repressed. "Emotional effects," Freud says, "can be [independent] of the actual subject-matter in the world of fiction" (*U* 252).

If this is so, and if the uncanny is made of the same material as traumatic symptoms, then fiction itself must have about it an air of trauma. Something in art must resist coming to conceptual clarity despite sustained reflection on it, and so art must be the bearer, not just of instances of the uncanny, but of the dy-

namic of uncanniness itself. Art must present us with a failure of form that even the most devoted work of mourning will not bring to completion or cessation. And our demand that it be this experience of art to which Freud must be adverting does not go unsatisfied. Near the end of "The Uncanny," Freud writes:

> We have clearly not exhausted the possibilities of poetic license and the privileges enjoyed by story writers in evoking or in excluding an uncanny feeling. In the main we adopt an unvarying passive attitude towards real experience and are subject to the influence of our physical environment. But the storyteller has a *peculiarly* directive power over us; by means of the moods he can put us into, he is able to guide the current of our emotions, to dam it up in one direction and make it flow in another, and he often obtains a great variety of effects from the same material. All this is nothing new, and has doubtless long since been fully taken into account by students of aesthetics. We have drifted into this field of research half involuntarily [*wir sind auf dieses Gebiet der Forschung ohne rechte Absicht geführt worden*], through the temptation to explain certain instances which contradicted our theory of the causes of the uncanny. (*U* 251–52)

The students of aesthetics mentioned here are, of course, the connoisseurs of form. Under the sway of a theory of art, Freud has semi-involuntarily drifted into a field of questions for which the connoisseurs *must* have answers, since, after all, "all this is nothing new"—in fact, it is archaic, as old as storytelling. Nonetheless, the peculiarity of the storyteller remains ungrasped, undigested, excessive to form, and thus passively undergone. This is not to say that the storyteller has no power, since the uncanniness of art is the return of the repressed its form alone makes possible. Rather, it is to say that the power in question, the power of art to traumatically disable all *methods* of aesthetic inquiry, is the trauma of the inadequacy of artistic form to the task to which it is appointed. In this light, the belief that art is a wish-fulfillment stands revealed as itself a wish-fulfillment. Art—to interpret, or perhaps parody, the idealist dream of it—is the perfect disunity of form and content. And that hurts.

V

In examining the relations among the aesthetic theories of Kant and Hegel, the writings on art and the aesthetic of Freud, and the psychoanalytic fate of matters that resist the best efforts to conceptualize them, we have crisscrossed the territory of materialist aesthetics in various directions. Sometimes we have even found ourselves back at a familiar signpost despite having started off from a new

position. Yet, with all this traveling about, we have not revisited the issue, raised quietly in the first section of this chapter and then explicitly in the second, which is the target of our inquiry: the relation of Freud's writings on art and the aesthetic to artistic modernism. Since we turned to Freud in part with the hope that we might gain his help in understanding modernism, we would be remiss to conclude without returning to this issue.

No apologies are necessary, however, for the lateness of our return, since we could not have fruitfully investigated the relation of psychoanalysis and modernism before first coming to some clarity about what would count as assistance for us. It was in order to find out what we want from a theory of modernism that we tarried with the relation of psychoanalysis and aesthetic theory longer, perhaps, than we had planned. Doing so enabled us to end the previous section by culling from Freud's essays on the uncanny and on what is beyond the pleasure principle the thought that artistic form is traumatic for aesthetic theory. The work of art calls for a response fortified by the theoretical equipment an aesthetic theory might offer, but only because the experience of the end of art which Hegel had theorized is the experience of the work of art failing to contain, to hold and to hold tight, its content. In the face of artistic content unleashed on the unprepared world in, so to speak, the wrong place, it becomes vivid that the concept of "artistic form," which an aesthetic theory ought to clarify, is no proper concept at all. Early in section I, the suggestion was made that a materialist aesthetic theory must be oriented by the anomalous conceptuality of "matter," and the fruit borne from trying to be true to that aim is that "form," too, has turned out to be anomalous. "Form" refers both to an objective feature of the work of art and to the psychical overcompensation for the failure of the work of art to bury the dead. We wanted aesthetic theorizing to craft for us a proper concept of "form" that would permit us to ascertain the power of art and therefore to say precisely what we may learn from it, but that is *the one thing* an aesthetic theory which remains systematically true to the work of art cannot do. The end of art is carried into the aesthetic theorizing that such an end both demands and disables.

An acknowledgment of the joint necessity and impossibility of aesthetic theory entails that it would be perverse to approach psychoanalysis in search of a self-contained and self-justifying theory of modernism. This would amount to asking for a method of inquiry immunized against the very possibility of cognitive deformation by the object of inquiry, a request Freud would sooner put on the couch than satisfy. If we can suspend such a desire by characterizing it as the paradigm of nonresponsiveness, of deadness to the work of art, then we can begin to move toward what we really want from an aesthetic theory, what we have

wanted all along: a style of reflection in which, by means of concepts which fail to transcend their history, we may suffer the work of art. In the next chapter we shall see how far we can go in the direction of satisfying this wish, a task Freud is of inestimable help in undertaking.

We are ready to begin completing the thought of the past, that is, only after we have acknowledged that doing so requires developing an aesthetics that sustains the loss that the work of art, at its end, itself sustains. For more than three centuries the field of aesthetic inquiry has been mapped out by the manic triumphalism and the melancholic morbidity that have been developed, refined, and exchanged by connoisseurship and idealist aesthetics. The concept of "form," the symptom of a disturbance, has been carved up into its incompatible objective and subjective senses, and aesthetic reflection has vacillated between the two orientations those two senses falsely promise to establish. The aim of the genealogy of materialist aesthetics which the chapters on Kant, Hegel, and now Freud have proposed can be summed up thus: to force the history of aesthetic theory to disgorge the trauma of uninheritable history it has sheltered even from itself and, thereby, to force us into a confrontation with the mournful life that has been awaiting us.

However, it would be both wrong and in bad faith to claim that the possibility of mournfulness has been lying *dormant* all along, awaiting the philosophical awakening my kiss can provide. Wrong because, as we have seen, it was already at work within the aesthetic theories of Kant and Hegel, and in bad faith because, if our reading of Freud teaches us anything, it is that bringing the dead back on stage is not a matter of philosophical will. The ghosts that haunt us do not please to dance to the demanding music of any philosophical system, which is why art has escaped all philosophical efforts to capture its nature and function. The end of art, the rupture of form and content, is the eruption of the past into the present, the past's turning against the very idea of the self-contained present. At its end, art is thus the site of culture turning against itself and vomiting up all the unredeemed promises that have been effaced, even derogated, by every philosophical history of culture. And here, finally, we approach very near the dynamic of artistic modernism, of, that is, an artistic practice formed and deformed by a history, its own history, the undigestible burden of which is being disgorged within it. We philosophers testify to this event with our demands for a theory of it, but, at the end of the day, we are only witnesses. To spoil a beautiful phrase: aesthetic theory is not master in its own house.[31]

The dynamic disruption of historical time which Freud labeled uncanny is, to be sure, not restricted to artistic modernism. Every modern institution confronts its own past as archaic or, to put the point more dynamically, paints its

past in archaic colors just because it is its past.[32] This is not the whole story of modernity (no story ever is), but to the extent that the past is intolerable, to that extent it shall be intolerable.[33] As Marx put it, in modernity "everything that is solid melts into air," and we moderns suffer from the vapors. This is an age of the crisis of historical transmission and so, also, of the suffering of the past. Not just hysteria or obsession for us—in seeking to evade mournful life, we are made to be traumatized. The question that remains is whether we can sustain the loss which modern life is for us, whether we can have a culture that neither fears nor insults its past but mourns it instead—whether, that is, we can live endlessly with our endless dead. The answer may well be no.[34]

In any case, the question of sustaining loss is not a question Freud puts directly to artistic modernism. It is, as we have seen, the question he puts to himself in part by submitting himself to the violent gusts of suffering directed from the art of the past to the concept of "artistic form." And so, too, with artistic modernism: it is art's putting to itself the question of how to sustain loss by submitting to the history of its own failures. The specificity of artistic modernism is the specificity of psychoanalysis, as both undergo the same suffering and strive to sustain the same loss of the end of art. This is why Freud offers us no *theory* of artistic modernism but rather the possibility of a critique of it: the effort to force the struggle between the concept of "artistic form" and the work of art into consciousness can only be properly made when the driving force of aesthetic reflection becomes the *failure* of art to live up to its concept. We turn to Freud for the sake of grasping this mournful regard that is at the core of artistic modernism, not for the sake of patching up aesthetic theory.

Freud was a collector. What was dismissed or thrown away—"trashed" as we might say—such as dreams, parapraxes, neurotic symptoms, and so on, he salvaged for the sake of "the crumbs of knowledge" they offer.[35] Among the junk of his world, nothing more incited his greedy drive to accumulate than Egyptian, Greek, and Roman (and late in his life, Chinese) antiquities. From testimony by his acquaintances and photographs of his study and consulting room, we know that Freud lived and thought in intimate contact with his collection.[36] He spoke to and addressed his artifacts and sometimes took whichever one was most inspiring to him at the moment to the breakfast table. At his desk, Freud arranged a phalanx of small statues as an audience for his work, in the center of which he placed a bronze Roman copy of a Greek Athena, the goddess born from thought alone, in whom war and wisdom are condensed. When Freud fled Austria ahead of the Nazis, he carried his Athena with him, but continued to express grave concern for the rest of the collection; he wanted it to follow him into exile so that he might die in its company. Satisfying this wish was a hard and

complicated task for his friends and followers, since at the time of his death his holdings amounted to two thousand objects. Lynn Gamwell informs us that Freud was able to amass such a vast collection despite the financial insecurity that plagued him most of his life because antiquities were cheap, their prices kept down by the slow market for them in Vienna.[37] What no one else wanted was an obsession for Freud.

Exactly what Freud felt and saw when he exchanged touches and glances with his "overthrown idols" is much mooted.[38] In a letter to Wilhelm Fliess, he reported that they were a source of *Erquickung* for him, of quickening or the feeling of life.[39] This might lead us to suppose that Freud phantasied a life for and with his objects, as a child will with its dolls, and that therefore he took solace in their immortality. However, every thought that we have followed out in this chapter speaks against such an interpretation. Freud's life-long fascination with archaeology, the practice of digging up the past which had been newly systematized as an interpretive science in the nineteenth century and which was a natural metaphor for psychoanalysis, was driven not by a dream of unending life but rather by the eerie temporal discoordination of the past, present, and future that it generated. Freud was moved by his statues, in other words, not because they were alive but because they embodied the ceaselessness of death. They were powerful because they were dead but unburied. They were ghosts.

During his treatment of the "Rat Man," Freud makes reference to his collection while trying to explain to the patient the point of pursuing the buried content of his symptoms.

> I then made some short observations upon *the psychological differences between the conscious and the unconscious,* and upon the fact that everything conscious was subject to a process of wearing-away, while what was unconscious was relatively unchangeable; and I illustrated my remarks by pointing to the antiques standing about in my room. They were, in fact, I said, only objects found in a tomb [*Grabfunde*], and their burial had been their preservation: the destruction of Pompeii was only beginning now that it had been dug up.[40]

Pompeii was destroyed not by Vesuvius but by the archaeologists. The priceless and mutilated relics toward which Freud gestures did not, in other words, have to survive the volcano, for the volcano was their preservation; they have had to survive their excavation. Their proper death sentence was signed not, then, by the eruption but by the modern present into which they have been disgorged—and it is from this second death that Freud tries to snatch them. He does not try to save them because they are alive, but because they are dead in an age in which, as Benjamin puts it, even the dead are not safe.[41] This is the most

perfect metaphor for the psychoanalytic treatment of the neurotic: the neurotic is not wrong to fear that the present of adult life is hostile to the past on the wreckage of which it is built, but in her constructions of a life devoted to protecting the dead actors in her psychical fantasies even from herself, she refrains from acknowledging that they are dead. She has thus survived deaths that have not happened for her yet. Neurosis is the inability to mourn the dead, the inability to survive having survived. Psychical "health," by contrast, is merely the ability to live mournfully.

In his statues, therefore, let us suppose that Freud saw the buried contents of Pompeii that needed saving, not from burial, for burial was their saving, but from immortality. The task of the archaeologist is to rebuild Pompeii in thought, to make an indestructible home in which the shards of the past can live again. But the relics of the past do not live forever, as they did in the founding Greco-Roman fantasies of connoisseurship and idealist aesthetics, but die forever. When Freud looked at his archaeological treasures, he saw relics of a past *threatened with immortal life* in a present that cannot bear the dead who reflect back to it that it has accidentally survived. Immortality, for Freud, is not the carriage of tradition but the phantasy that arises in place of tradition in an age of transmissive crisis; it is the idol that must be overthrown again and again if there is to be any prospect of posttraditional thinking. Freud thus stored his antiquities in his Biedermeier cabinets, touched them, talked to them, perhaps even asked them for their secret counsel. But in the sliver of time between the death of Pompeii and his confrontation with their beautiful forms, Freud felt the unforgiving force of history, the violent gusts of suffering over which we are not masters. At his fourth session with the "Rat Man," Freud asked him, or, more properly, asked the ghosts the patient harbored, the characteristic question of psychoanalysis: "And how do you intend to proceed today?"[42] And when Freud went into exile, he worried over the fate of his figurines, commanding all the remaining power a dying man could muster to try to insure that they, too, would continue to wander in their own, proper exile.

The Tomb of Art and the Organon of Life: What Gerhard Richter Saw

In the struggle, if that can be called a struggle in which
the Ghost with no visible resistance on its own part was
undisturbed by any effort of its adversary, Scrooge observed
that its light was burning high and bright; and dimly
connecting that with its influence over him, he seized the
extinguisher-cap, and by a sudden action pressed it down
upon its head.

The Spirit dropped beneath it, so that the extinguisher
covered its whole form; but though Scrooge pressed it down
with all his force, he could not hide the light: which streamed
from under it, in an unbroken flood upon the ground.

CHARLES DICKENS,
A Christmas Carol

Asked what he would take if the house should ever burn
down, [Cocteau] replied without a moment's hesitation,
"I'd take the fire!"

JEAN COCTEAU,
Professional Secrets: An Autobiography of Jean Cocteau

I

The aim of this chapter is to establish a critical rendezvous with Gerhard Richter's cycle of paintings *October 18, 1977* (1988). The manifest content of the paintings is the famous political event of the arrest, imprisonment, death, and funeral of the core members of the notorious Baader-Meinhof Komplex (Baader-Meinhof Group) of the German terrorist Rote Armee Fraktion (Red Army Faction). Because *October 18, 1977* engages contemporary history at its hottest, it has not

lacked for critical attention.[1] In part, this chapter may be understood as a contribution to the ongoing debate about the meaning of this powerful work of art.

However, what I wish to say about *October 18, 1977* inhibits me from joining the critical fray immediately. In its manner of taking on the highly publicized end of life of Andreas Baader, Gudrun Ennslin, Ulrike Meinhof, Holger Meins, and Jan-Carl Raspe, Richter's group of paintings proposes itself as their afterlife; its ghostly imagining of a second recording of their deaths raises the possibility for us that the deaths in question were not properly experienced when they first happened and, in that sense, that they are not over yet. In the face of this possibility, one that Richter's cycle squeezes out of a flat, photojournalistic actuality, we find ourselves confronted with the question of whether our experience of the events depicted by *October 18, 1977* is even properly historically contemporary with the events themselves. As I will argue, Richter does not propose an answer to this question in the form of an alternative, more proper experience of the events; rather, in lingering with the unlaid ghosts of Baader-Meinhof, Richter mimes the delay in the achievement of contemporaneousness that constitutes the claims those deaths might still have on us. My adding straightaway to the corpus of Richter criticism is inhibited by the wish to say something intelligible about this delay in comprehension.

There is a further idea at work in *October 18, 1977* that strengthens my inhibition. To my eyes, the paintings offer up the possibility that our convictions about what is historically contemporary, about what makes something historically momentous for us, may themselves be obstacles to engaging with the specific events they depict. By way of introduction, I can only suggest what that possibility amounts to: perhaps being committed to our beliefs about what is contemporary for us is a form of defense against the untimeliness of the events we undergo, and perhaps that very mismatch between event and experience, experience's endless belatedness, just is the historical significance of the events in question. If this should be so, then our commitments stand accused of being efforts to impede, or even to escape, a history yet to happen. In light of this possibility, *October 18, 1977* does not so much mime an historical delay as open one; the paintings force to the surface (to their surface) the unresolved problem of how to live with our undying dead, a problem which, in its unforgiving power to generate ever more elaborate defenses, is our "contemporary" problem. Richter's craft works to undo some of those defenses against suffering what, as I have been arguing all along, the work of art itself suffers. In order, then, to encounter his paintings well, we need to reflectively undo those convictions that stand in the way of seeing them in the first place. The materialist history of aesthetics that has occupied us up to now, culminating in Freud's account of the work of art as a vessel of historical la-

tency, is a medium of such an undoing. Still, to counter the powerful obstacles to suffering the work of art, we need to marshal our resources once more, this time before *October 18, 1977*. So permit me to begin again.

II

The aim of this chapter is to give form to an emotion, which is to say to a movement, provoked by Gerhard Richter's cycle of paintings called *October 18, 1977*. I would like to be able to say that the emotion is the one I feel when I am moved by these paintings and, good Kantian that I am, feel called on to communicate to others. However, because what is in question is an emotion, which is to say a movement, I am doubtful I shall be able to say precisely where it is—in which case giving it form would be, of course, a hapless pursuit. To give a movement form is to impede it, and to take that resistance for the movement itself is to mistake the measure for the flow. While locating a movement is a prerequisite to grasping it, it is also a way of missing the mark. I start, then, with a dilemma: to give form to the emotion provoked by *October 18, 1977* is to locate it so that it may be comprehended and communicated, but to do so is to substitute for the movement an obstacle which brings it to a halt.

Barring the invention of some new calculus of the emotions, the task being pursued here is quixotic. If a movement becomes sensible, and so measurable, only in the resistance to it, in the moment of conflict between mobility and what halts it, then cognitively I am stuck just because affectively I am moved. Now, it might reasonably be responded that mistaking resistance for movement is a necessary moment in the apprehension of movement, much as light falling (and failing) on the retina is a necessary moment in the apprehension of the world and of light itself as part of the visible world. If this is so, then a path might be cleared through the dilemma: if we apprehend the necessity of the mistake, we can factor it in and thereby comprehend the movement itself subtractively or dialectically. This path, however, can be opened only if resistance is *demonstrably* necessary to the comprehension of movement, if, that is, there has already been a comprehension of the resistance mounted by the power of movement to the form that in turn resists it. The prospect of cognitive mastery this path promises is therefore prematurely comforting—and where there is premature comfort there a wish is at work. In this case, the wish is expressed as the presumptive reassertion of the intelligibility of what resists all efforts at formal apprehension, as, that is, the return of mastery at the moment when all the techniques of mastery have been exhausted.

While the wish-fulfillment of having jumped over the obstacle of form-as-

resistance must itself be resisted, its very wishfulness offers us a clue about the nature of my dilemma. The initial perception of the dilemma as a mutual resistance of form and movement is already in the service of preserving the integrity of the two antagonistic poles. The apprehension of movement *behind* resistant form generates an epistemic dilemma, but for just that reason allows form to remain impervious to the movement it halts. The epistemic dilemma can thus be embraced gratefully, not despite being unresolvable but because of it, insofar as it effaces the mutability of form itself. Suspending all such gratitude might permit us to entertain another possibility lurking behind: while the resistance of form may appear as objective, this objectivity is itself the dissembling appearance of obstacles we have tossed into the path of movement. The objectivity of form is, in short, the dissemblance of subjectivity. When I feel the sand running through my fingers, I feel it in (the) place of my grasping; I feel my grasping *in the sand*—and thus efface that grasping by instead apprehending the sand as "running." I attribute the motion to the sand instead of to myself, as if the sand were somehow grasping at me, trying to avoid running through my fingers; but further, I also fail to apprehend the fact that I have made this attribution, apprehending instead the sand as the object in which "running" is made manifest, as, so to speak, the formal presentation of its own mutability. Put generally: the "objective form," which permits the measure of a movement by resisting that movement, is itself a symptom of a more archaic movement that has been rendered invisible, which is to say immeasurable, by the apparent objectivity of the form. Here is the source of my dilemma, then, for the form with which I would like to measure my emotion threatens to obscure the subjectivity of that emotion before I even start.

My aim to give form to my emotion—the very intentionality of the emotion—thus stands revealed as a desire to give form to what I have already felt as a threat of deformation. To have said that I do not know the location of the movement is to have acknowledged that my very capacity to give form has been challenged, in response to which my impulse is to rise up and meet the challenge by reobjectifying the movement. Here we stumble upon the brilliant opacity of *October 18, 1977*: the perfect, even virtuosic form of these paintings gives rise to an emotion they do not succeed at containing. My own emotion, put simply, appears to me in Richter's paintings, but that appearance is the provocative semblance of a movement that never stops recurring. Richter's paintings thus give rise to a feeling of displacement relative to which I feel that I have an aim, but relative to which I also cannot quite imagine how to execute it. With every effort I make in pursuit of this simple, everyday job of expressing my emotion, I feel my aim blown back to me as a velleity.

An understandable impatience may set in at this point. If my emotion is felt by me in my powerlessness to give it form, perhaps I am just bereft of resources and so ought to contemplate Richter's moving pictures in silence. That option is a legitimate one; it is, though, not the only one. I am not entirely depleted by my emotion: in feeling it as a subjective countermovement emerging through the space between my aim and the resistance to it in Richter's pictures, I have received that aim back from the pictures transmuted into a feeble wish. If being left with one's aims reduced to wishes is bereftness, then perhaps I am simply stuck; however, as Adam Phillips puts it, "It is impossible to imagine desire without obstacles, and wherever we find something to be an obstacle we are at the same time desiring."[2] Where there is a wish there is an unfulfilled expectation and so, also, an anticipation. As we trace out the fate of this anticipation, the attenuation of the aim of expression may yet turn out to be a strange sort of gift from Richter. We shall see.[3]

III

The point we have reached in articulating our dilemma is this: if giving form to movement is bringing movement to a halt and thus mastering its deforming power, but for just that reason it is also losing track of the movement we wanted to get hold of, then the aim to give form to movement can never be truly satisfied. There is a comic air to this mismatch of form and feeling that is structurally reminiscent of the familiar situation of romantic farce, in which, in a narrative of extended coitus interruptus, the lovers' efforts to find their way into bed is tripped up by the excessive energy of the very passion they are seeking to discharge. In fact, because the characteristic resolution of the romantic impasse is the submission by the lovers to the necessity of their situation—they finally stop trying so hard and allow nature to take its course, which means that the narrative comes to an end—this comedic angle will prove useful later in helping us get closer to Richter. For now, though, let us push on. In the face of its unsatisfiability, our aim continues nonetheless to strive to force itself against movement as if enticed by the promise of a later, deeper satisfaction, which is why, as was noted above, form may be thought of as a symptom of another, unrecognized countermovement. How, though, can this countermovement of form offer even a semblance of satisfying mastery? Only by appearing as immobile, as adequately resistant to the movement arrayed against it. In other words, in order to satisfy the urge that calls it forth, the formal embodiment of subjective countermovement must appear as objective, as if the world itself contained objects which satisfactorily mastered the movement. The subject who wishes to see evidenced his

own power to grasp movement can be satisfied that the form that captures a movement has not also degraded it only if that form is at the same time a disavowal of the dynamism that brought it into the world. If it *appeared* as a disavowal, of course, it would point back immediately to the subjective dynamism that generated it—as when the child who says "Not me!" thereby confesses too quickly that she ate the cookie, or when the fundamentalist who insists that the flesh or hair of women must be covered thereby announces too loudly his own wild desire. The point, then, can be stated more precisely as follows: the formal representation of movement offers a semblance of satisfaction insofar as it permits a looking away from the subjective movement that generates it. The pleasure of form is generated by not noticing the power on which its stasis rests. We cannot help but be reminded here of Hegel's account of the paradigmatically artistic achievement of the classical art of the Greeks:

> In classical art the peculiarity of the content consists in being itself concrete idea, and, as such, the concrete spiritual; for only the spiritual is the truly inner self. To suit such a content, then, we must search out that in Nature which on its own merits belongs to the essence and actuality of the mind. It must be the absolute notion that *invented* the shape appropriate to concrete mind, so that the *subjective* notion—in this case the spirit of art—has merely *found* it, and brought it, as an existence possessing natural shape, into accord with free individual spirituality. (*ILA* 84)

The pleasure of artistic form derives from the ready-made fit between appearance and inner content, between form and what moves away from it. To be sure, this pleasure is unstable, since it rests on a homeostatic relation between subjective force and the repudiation of that force. Nonetheless, a semblance of satisfaction might be attained, at least for a moment that seems lifted out of time.

Are there any forms which clearly fit this description of movement and countermovement? Indeed, there are several, such as the iterated line in comic strips that signifies that a character is running, or the cinematic fade that signifies the passage of time. However, one in particular comes to mind most forcefully: the memorial. A memorial is a static object the appearance of which visibly takes the place of movement. Moreover, a memorial is not just static—it is manifestly static. Its formal stasis appears as a marked, perhaps even tensed, distance from the change to which it testifies, the change referred to by the roster of the dead inscribed on it or by the flowers wilting at its base. A memorial memorializes by invoking the movement it does not succumb to, the movement away in time; it appears to halt historical movement by giving it form as that which the memorial withstands.

Now, while it may be true to say that a memorial accomplishes its mission by withstanding change, "withstands" remains too passive a characterization of the work of memorializing. Since a memorial invokes the very change it withstands in order to be seen standing against it, it actively *resists* that change. Any old stone tossed on the ground withstands change, but only a tombstone standing erect out of the ground (in imitation of an earlier posture of the deceased) and set firmly into the ground out of which it stands (in imitation of the immovability of an idealized secure subjectivity) resists change.[4] The work of a memorial is thus undertaken ceaselessly, as an ever renewed vigil against the change streaming around it. A memorial is not just an object in place of what has been carried away; it is, rather, a countermovement against the movement itself that carries away. Furthermore, it is crucial to remember that since a memorial is the residue of an experience of loss, the carrying away it invokes is a carrying away from some subject. In its stasis, it is the objective form of the force of subjectivity, subjectivity appearing as an objection. A memorial is a rock placed in the path of history as a marker of impotent desire. It is thus not merely an object but rather a super-object, a self-determining antagonist of loss. Or, we might prefer to say, it is a super-subject. It is hard to tell.

At precisely this point, however, the instability we referred to two paragraphs back begins to emerge. Because the power of subjective countermovement appears as an object, the eternal vigilance it performs must be executed in the form of something stony, something utterly inflexible.[5] Only where subjectivity objectifies itself, which is to say itself aspires to the condition of its own memorialization, is the countermovement against movement sustained. In a memorial, the cessation of movement is thus given a form that at the same time makes potentially visible the hazardousness of the aim of cessation which it calls forth—since that power is sustained only in mimetic self-sacrifice, it is sustained only by being lost. Needless to say, the living person for whose sake the memorial works typically does not perceive the sacrifice it embodies, since a well-formed memorial effaces the person's powerlessness to satisfy her aim; in looking at the memorial, we look in a direction orthogonal to our desire, and so the memorial functions as a memorial not just to our lost object but also to our lost power. But if we happen to turn and look in the direction of our desire, it will become visible anamorphically, so to speak, that the formative memorialization of movement, the countermovement against it, is possible only with the rigidification of movement itself, with a self-immobilizing turning to stone of the capacity for countermovement. What appears in a memorial, then, is not an achievement of memory but memory's failure, not a form which successfully grasps movement but the unsatisfied desire to do so. A world of loss will then appear overlaid on the world of stone.

We may draw an initial conclusion here that the deformative powers of move-
ment are met in the memorial with a powerful formative embodiment of the
desire to resist. But it is the desire to resist, which is to say not the power to do
so but the powerlessness experienced as the persistent need to resist, that the
memorial makes visible in its resistance to history. The stone makes visible the
mere wishfulness of the feeling of power, although it also makes possible an ef-
facement of the wish and so a resurgent feeling of power. A memorial is an un-
stable joint between loss and aftermath because its achievement rests on the
reminder of the loss from which it takes its departure. In the stone's memorial-
izing form is always visible, even if not always manifest, the inadequacy of
form, which is to say the failure of our final burial of the dead. This failure to
solicit the submission of loss to the forms that shape the experience of it is, it
may certainly seem, a morbid twist on the erotic slapstick of coitus interruptus,
but there is reason to think it brings us close to the germ of our dilemma in
speaking well about Richter.

IV

Very close indeed. Much in Richter's art after the mid 1960s, such as *Two Sculp-
tures for a Room by Palermo* (1971) and the cabinet installation from "Documenta
IX" (1992), is approachable in terms of the inability to find suitable form for the
disappearing past, or, as Benjamin Buchloh puts it, "the inability of painting to
represent contemporary history."[6] However, some specific shadow passes over the
plane of the pictures in *October 18, 1977*, some inadequation of the dead and form
so shocking that it renders the phrase "contemporary history" inapt and the char-
acterization of Richter as a memorialist of the impotence of art too abstract. *Oc-
tober 18, 1977* is a cycle of paintings of police and press photographs of the events
surrounding the arrests and deaths of members of the Baader-Meinhof Group.
That their urban terrorist activities and, more strikingly, the end of those activi-
ties in their deaths were traumatic for postwar German politics is shown in the
fact that the question of whether Meinhof, Ensslin, and Raspe killed themselves
in Stammheim Prison in Stuttgart on the eponymous date or were assassinated
there generates so much uncontrollable anxiety that even asking it is illegal. The
determination of what kind of death they suffered—as victims or martyrs, as pas-
sive or active—remains unsettled, which is to say their political lives have yet to
end. (This description is itself politically charged; a German friend with Christ-
ian Democrat politics recently asked me why I continue to waste energy won-
dering about the fate of these people, but he asked with fire in his eyes.) Their
deaths, in fact, were just the beginning of their truly extraparliamentary lives;

perversely, they achieved a version of that radical transcendence of the present that motivated their political action only at the moment when they could pursue it no longer. The irony they are lucky not to have lived to see is that nothing in their lives ever inflicted a political blow as violent as the one delivered by their deaths. The trauma and erasure of their afterlives keeps them posthumously, spectacularly alive in their deadness. In *October 18, 1977*, the endless circulation of the deadness of the dead, the uncanny afterlife into which that deadness was recruited because of its inestimable usefulness, is what drives Richter's pictures. It is as if the deaths of Baader, Ensslin, and the others were being suffered in the act of painting itself.

There is no doubt, of course, that *October 18, 1977* grows out of Richter's other memorial works of art, and especially out of his earlier photopaintings; still, where many of the earlier works were, like *October 18, 1977*, paintings of photographs, the later work is of ostentatiously specific photographs, photographs recalled not just as photographs but as "these" photographs. It is this brutal, frontal, unavoidable specificity of photographed death laid out on the morgue table by *October 18, 1977* that is unspeakably moving. Until we can descry this additional element, we are not yet prepared to be distressed by what is so alarming in these paintings. But something stands in our way; something impedes our mourning for the dead. This should surprise us since, despite the fact that I concluded the second section of this chapter by saying that a slight turn of the head ought to bring the lost object of the memorial into focus, the deaths of these people are supremely hard even to acknowledge. Therefore, we need to think harder about memorialization before we turn to Richter's painting of these deaths.

We have been speaking up until now as if the proper medium for the memorial function is stone. While the imperceptible slowness with which it erodes has made stone a widespread medium of memory, its pride of place in reflections on memorial aesthetics rests only on a metaphorical extension of its literal obstinance.[7] Other materials have served also as media for mnemotechnologies —gems, metals, bone, and hair, for instance. However, over the last 150 years, which is to say beginning in the same nineteenth century that brought us the haunted practices of archaeology, psychoanalysis, and artistic modernism, the memorial medium that seems to have become the most often preferred is the photograph.

The ways in which photography is like other memorial practices have been canvassed so assiduously that we are relieved from having to do that work here.[8] What remains of special interest, though, are the differences that photography introduces into the dynamic of loss, wish, and aftermath embodied in memorial practice. Three of these differences are especially important to consider in

approaching Richter: (1) photography is a medium in which the memorial arti-fact embodies a prior act of looking; (2) the photograph is an archival artifact from the moment it is taken; (3) the photograph is a mechanically produced image. Taken together, these three differences make photography a more thor-oughly effacing medium of memorialization than any hitherto existing. Let us treat them in turn.

A photograph eternalizes the ephemeral moment of the look. In it, the eva-nescence of the accomplishment of a look exchanged between seer and seen is transmuted into a frozen scene. Thus, when one looks at a photograph, one sees not only the thing photographed but also the way it looked, or the look at it, at the moment in the past when it was photographed. One may not even notice it, but the thing is presented by means of its look.[9] The look cleaves to the thing like a second skin, uncannily protecting it from the decay implicit in the tran-sience of all regard. At the same time, this prophylactic look disjoins the action of looking at the photograph from the time of the frozen look itself. The look in the photograph has been made immortal and so presents she who views it now with the past, the present, and the future simultaneously. In other words, the photograph renders the look, the perceptual embeddedness of the perceiving subject in the world and time, as an objective fact. André Bazin argues that the photograph brings the world itself into the space of the spectator, thus forging a more immediate relationship between them.[10] He is correct, but with the pro-viso that the world brought close is a world now gone. This is why, when one looks at a photograph of oneself and sees the look that will be given over to those with whom one will exchange no looks, one sees one's own death.

In a photograph, in other words, looking becomes fixed, immune to change, and so *achieves its own, proper memorial.* The peculiar blank stare characteristic of even the most engaged (nonacademic) study of photographs is the expression proper to eyes with nothing left to do except register the closed visual fact. When the prior act of looking comes down to the present, the act of looking in the present witnesses its own turning to stone. Now, the contrast between this and older modes of memorialization is sharp, since in those older modes the em-bodiment of countermovement that aims to deny movement also makes visible the inadequacy of memorial form. Older memorials make visible, by means of the parallactic shift we call mourning, the unfulfilled desire, the memorious and unending wish, for the past to become past. Put differently, they make mourn-ing possible by making palpable the loss they resist, and in that way, deputizing vision, or *aesthesis* more generally, as a rhythmic project of loss and retrieval. Pho-tographs, however, disable vision precisely by having already performed the per-ceptual retrieval of the lost before the witness to it ever looks. This is why it

makes sense to say of a photograph, but not of a stone memorial, that it is a record of the past.

This brings us to the second difference. The instability of the older memorial form, its threat to provoke memories and therefore its power to renew movement, is tendentially overcome in the photograph. In doing the looking for us, the photograph performs the entire act of memory before our eyes (in both the temporal and optical senses of "before"). It is, with the photograph, as if the promise of redemption at the end of history had withered away in virtue of its premature fulfillment. *From its moment of being taken, a photograph is a preservation of a moment now gone and thus is destined for the archive, for the rationalized institution of memory.* The uncertainty opened in the future by the wishfulness at work in older memorials is thereby foreclosed. This, perhaps, helps us understand why even the most cherished photographs may be stored properly enough in a shoe box, whereas to do something comparable with a memorial—to put it, say, in a museum—is to strip it of its power. Consider, for instance, the point of the protest by Native Americans against the collector's trade in funerary artifacts. Memorials only become objects for archival display when there is no one left for whom they serve as goads to recollection; they become objects instead of memorials when no one is left who can still look at them and fail to see what the memorial fails to make present. In short, the funerary artifact enters the archive only when its objective status is secured by the death of all the mourners. (Of course, it is not surprising that Native Americans would notice the genocidal hope implicit in such musealization.) In the era of the photographic memorial, by contrast, that objective status is secured in the midst of the present by the essentially archival nature of the photograph itself.

While the photograph's archival nature rests on its eternalization of the ephemeral, that function itself rests on the mechanical nature of the photographic apparatus. Photography, as Roland Barthes has pointed out, was an invention not of the opticians who focused the image but of the chemists who fixed it; a photograph, in other words, does not offer us an image we never had before (although, to be sure, it can be manipulated to do so), but instead *fixes the image without any subjective intervention.*[11] Prior to the invention of photography, all images oriented toward the presentation of the world required a constructive act and so entailed the possibility of failure.[12] The photograph is a new kind of thing, neither wholly object nor wholly subject; and this artifact, which fixes the disappearing world it pictures by simultaneously freezing out the subjective effort to fix it, is passed on into the future in which it is fated to be seen as a message from the past. Pre-photographic images, we can say, have a history, in the sense of carrying with them a story of their making the retelling of which is part

of their reception. With the photograph, on the other hand, the object is used to send its own look into the future by a past which seeks to predetermine its own reception.[13] The photograph is the denial of memory by the object itself, a denial which develops even as the object moves into the past.

Photographic memorialization thus unleashes a particularly modern danger to the past—one we might think of as the opposite of historical consciousness— that the present will not be the aftermath of the loss of the dead. The photograph enables the look of the past to be present without remainder, with no trace of failure, and so leaves no residue of loss in the present, no sense that the worms which eat the dead thereby eat the living too. It renders the present adequate to itself, thus rendering the past ever more incapable of defacing the present and, therefore, ever more effaced. In the age of photography, if the past is not remembered it has no one to blame but itself (which is why it can feel now like a sort of moral defect not to be a celebrity). This danger has not been universally actualized, since photographs of our dead intimates still have the power to enforce the undeniable fact of absence by producing the stabbing regret that we have outlived them. However, not only is there no guarantee that the mechanical look of the photograph will not ultimately deprive even the immeasurable loss of love of the power to distort the present—than which no greater threat to the dead can be imagined—there is, indeed, good reason to fear even for that. The terroristic aspect of Steven Spielberg's *Schindler's List* is the systematic manner in which it obliterates the idea that any loss can ever be so deep that it might destroy the very power to give it form as a determinate loss; in bringing the techniques of documentary film and photography to bear on what Jean-Luc Godard called, in despair and wrath, the "rebuilding" of Auschwitz, the film shows that nothing is ever really past because nothing can escape the photographic.[14] History thus collapses into an omnivorous timelessness where the need to look, fail to find, and thus feel history's deformations disappears. In bringing the thing itself too close, *Schindler's List* did incalculable violence to the delicate ethos of looking and thus fulfilled singularly well the mandate of photography: to deny the ethical possibility that *not* seeing, out of which memory flows, is the proper outcome of looking. Every earlier mnemotechnology, including painting and even the camera image itself in its pre-photographic uses, has been a means of looking in order to retrieve, of sensing the past's absence from the present in its abundant absence from its image. The photograph is a technology that relieves us of the need to go on looking.[15]

The unavoidable conclusion of this worrisome line of inquiry is that photography is a means for memorialization through which the living seal a pact against the dead, against those whom we see but who cannot see us back. In

popular imagination it seems as if the problem of the resistance of movement and form has been overcome, as if the phenomenality of historical deformation has been transcended in a blaze of instantaneity without end. In some sense, perhaps, it has. The belief that it has is rationally unjustified, of course, since it rests on a faulty inference from the loss of the experience of distance to elimination of distance itself, from the cultivated failure to notice deformations to their absence. It rests, that is, on an inference with a wish as its premise and a wish-fulfillment as its conclusion. Now, the insight into the rational unjustifiability of the belief may comfort those of us who theorize about the problem, but so what? The antisubjective mechanization of form generates just that effacement of the needfulness of memory and mourning on which we might otherwise hang our critique. Photographic theory is an effort to halt a practice which is more powerful than memory itself, but it is belated; the wishfulness which follows loss as a pact with the dead is already too much in danger of disappearing from view, and with it the instability of form and movement implicit in older memorial practices.[16]

Here, finally, we confront our dilemma in its most vicious form, for the disappearance of the wish from the joint between the living and the dead is also a manner of its fulfillment. It might be proposed as a general rule of wishfulness that every wish carries with it a metawish for the first-order wish to be gone, and, for the fulfillment of this metawish, oblivion will do as well as satisfaction—a wish, after all, is the subjective face of the failure of satisfaction and thus entails a moment of self-revulsion, of the desire to be someone without the wish. The photograph overcomes the destabilizing wishfulness of the desire to give form to the movement away from us of the dead by denying the deforming power of the memory of the dead. With the advent of the photographic memorial, the past ceases to be another country with the strange qualities of receiving many travelers but sending none back, and having no established touristic infrastructure. With this modern alteration in time, the acknowledgment of the dead—the acknowledgment that the living are only the survivors—is lost. Photography buries memory instead of burying the dead, and so the dead stick around unacknowledged. The wish for formal mastery over movement thus finds its apotheosis in the photograph.

It is in the realm of the photographic that Richter is preoccupied with the question of what life might be now that we can no longer either remember or forget the dead. We do not know how to bury the dead, which is to say how to come after them, how to live in the aftermath of their loss, and all of the practices given rise to by the need to bury them keep driving us farther from our aim. We need help, from some technique other than a direct assault on our goal in

burying our dead, in paying them love's due of remembering them as dead when even their death does not keep them out of our sights. This, again, is the comic condition of coitus interruptus, albeit with the dead. Granted, impeded necrophilia seems singularly unfunny, but when we need to laugh, we call on the help of a joke. A joke, after all, is a way of giving an unsatisfied desire a proper burial. So let's make a joke.

Delay

A village woman's husband has passed on. Her friends try to comfort her in the usual ways, but in her great grief she turns from facing facts and calls on an ancient, magical rabbi. "Yes," the rabbi tells her, "I can raise him." After the required exchange of coins, the rabbi sets to his cultic prayers, chanting in a mysterious old tongue. The husband, though, remains unmoved. "Well, that didn't work," says the rabbi to the wife, "but don't you worry. This will." With this assurance the rabbi brings out his secret ointments and applies them in odd and complicated ministrations to the husband's body. Nothing doing. With one further assurance to the wife, the rabbi moves to the most drastic measures. He begins to dance a fierce whirl—not an easy chore for the ancient rabbi, who begins to huff and sweat. But still, the husband's body sits there immobile. "What's wrong?" cries the wife. "What's wrong? I'll tell you what's wrong," the rabbi wheezingly replies. "*That*," he gestures at the husband's corpse, "is *really* dead!"

I have been told that this old joke is actually a screen for a dirtier one about sexual impotence, but in any case both incarnations of it have the same manifest topic: the projective and defensive nature of the affirmative judgment that something is dead. The joke depends for its setup on the contrast between the frantic old rabbi and the dead body, between the almost dead and the really dead. However, in the spirit of Wittgenstein, the punch line invites us to look up the demonstrative arm and see the almost dead losing the last remnant of its power and, in that sense, becoming dead. While the setup of the joke is in the contrast between the almost dead and the really dead—a contrast out of which a world can be made since we are all, at least, almost dead—the payoff is in the collapse of the contrast that the old rabbi is then at pains to deny by declaring the husband too-much dead.

One way to characterize the subject matter of this joke, then, is by saying that it is about the overemphatic denial of death by means of trying to point at it (ostension, it is worth remembering, refers in one of its traditional usages precisely to a miscognition of death).[17] Since this denial is, in essence, what this chapter is about, let us try to make the idea more precise by refreshing the inter-

pretation. A moment ago we observed that the payoff of the joke is in the effort, which comes too late, to reinstitute the collapsed distinction between the almost and the really dead. However, if we have been using the rabbi's expectations as the source of our perspective on the narrated events, then the contrast he aims to reinstitute, between the almost and the really dead, only emerges for us at the moment of its collapse. In other words, while the joke is being set up, and with it our expectations for the husband's reanimation, the relevant contrast is between the living rabbi and the not yet dead husband. The joke itself is thus a hiding place for the contrast its punch line explosively unveils. The recognition of the deadness of the husband emerges only out of the recognition that he is really, emphatically dead, dead beyond recall. Death, it seems, does not happen until it happens twice. And from this belated recognition that the husband has been really dead all along, a beam of dark light shines backward over the joke to reveal that the husband has always been beyond the rabbi's reach and that therefore the rabbi's actions were always ineffective. Indeed, to the extent an action is defined by its anticipated effect, we see retrospectively that the rabbi's actions were not just contingently but essentially impotent and that all along it was the rabbi, as the self-proclaimed owner of magical powers, who was dead. Death, we might say, inheres neither in the rabbi nor in the husband alone, but rather in the space of powerlessness which yawns between them. The magical petitions can thus be understood as a re-enactment of the death the rabbi was aiming to deny—unsuccessfully, if the joke has its way.

While this analysis may go some way toward tracking the joke's dynamic hiding and revealing of its content, it still neglects to specify the source of its funniness. I would mount no strong argument against the view that the humor of the joke resides in its depiction of the dynamics of disavowal. Disavowal, after all, is frequently a funny spectacle (unless you are the misrecognized one—and it is sometimes pretty funny even then, if what is misrecognized is something you do not regard as an essential characteristic of yourself, so that you can witness the misrecognition from a safe spectatorial perch). Nonetheless, at least in the version told here, the humor of the joke resides not just in the epiphany of the unconscious repetition at the heart of denial, but also in its hostile puncturing of the belief in magic. The widow, recall, goes to the rabbi with what the grief-stricken always bring to holy men, their loss. But rather than focusing on the wife's grieving, the rabbi instead turns toward the fantastic, perhaps delusional, solace offered by magical protestations that typically would be the griever's share; he takes advantage of the grieving, in other words, by appointing himself guardian of that one of its possible fates which inflates his own power. The rabbi does not deny only death therefore, but, more profoundly, the widow's grief. In its sac-

rilege against the rabbi's power, the joke is thus an instance of the revenge of the profane against the sacred—its vengefulness forges an alliance with the wife's grief against the rabbi's effort to kidnap it. The two strands of the analysis rejoin here; the joke on the rabbi's denial of death, proceeding from the disclosure of the mimetic relation between magical beliefs and practices and the really dead, is itself the bearer of the joke's re-establishment of an allegiance to human suffering.[18] The joke, we might say, retrieves the husband's corpse from the network of beliefs that would keep him around even after his loss had been sustained, and it does so in order that the widow might be able to bury him—to help him on his way. Life, in the form of the demands of suffering, here twits magical denial for the sake of the proper burial owed to the dead.

V

While this joke's subject matter makes it helpful for thinking about the dead and the living, its vengeful profanity also makes supremely vivid a feature which Freud argues is characteristic of jokes in general and that, we shall see, is at work in Richter, too: they are bits of culture that make manifest protests against other bits of culture when those protests cannot make themselves manifest directly. In this particular instance, the claims of grief present themselves indirectly, under disguise, as the source of blasphemy against the exploitative use of the dead. Freud's analysis of jokes goes even deeper, however, than merely characterizing them as hidden protests. In tracing the explosive power of a well-timed joke to unconscious sources, Freud also explains why the protest is pleasurable. A joke has its roots in the unconscious, Freud argues, because its protest is against the nonrecognition by cultural norms of the unsatisfied demands, the old demands to which culture is dead, expressed in the joke.[19] Jokes interrupt powerful expectations and thereby force acknowledgment of what those expectations are set up against. They offer the pleasures of suddenly satisfied desires in a context in which it was rightly expected there would be hostility to their satisfaction. The laughter enabled by a joke, then, is an expression of triumph and gratitude.

Jokes, put most simply, are satisfactions taken against the calculated odds. This is why they form one leg of the canonical triad of psychoanalytic theory, along with dreams and parapraxes. In each of these phenomena the agent (the joke teller, the dreamer, the tongue slipper) can say after the fact that "it was only a joke, only a dream, only an accident"; "joke," "dream," and "accident" are what Arthur Danto has called ontologically extruding concepts.[20] In other words, in each case the agent acts under the protection of not having meant it *really*. But "not meaning it really" is not the opposite of "meaning it"; it is, instead, a way of

meaning it. Doing something without intending to is a strategy for acting while striving to escape the network in which praise and blame are apportioned to self-conscious behavior. (And I say "while striving to escape" rather than "escaping," since the dreamer may feel guilty about the dream, or the queen may say, "We are not amused.") Jokes are a form of revenge by the weak against the strong, or, put another way, they are a kind of overturning of the conception of weak and strong that would measure strength by its capacity to render agents unable to act purposively. Jokes, like dreams and accidents, are actions under conditions where action is explicitly forbidden.

Because mistakes, dreams, and jokes are acts under the prohibition of knowing the significance of one's action, they are all instances of what we may think of as techniques of suffering, that is, as forms of action which embody simultaneously a desire and its being forbidden. As actions, they express the desires that are their motivations, but as disavowed actions—actions which in their constitution are also nonmanifestations of intentionality—they also express the prohibition of that same desire. It is important to remember that the disavowal which shapes dreams, jokes, and parapraxes is not the same as a lie, since the nonknowledge that constitutes the disavowal does not mendaciously keep secret from others what the disavower herself can avow. The dreamer, joker, and slipper of the tongue genuinely do not know the purpose served by the disavowed action. An action under disavowal thus exhibits a strange structure. It attains its end only in appearing to attain no determinate end at all, only in appearing idle or beside the point. Put differently, it attains its end in virtue of not appearing to have any specifiable one.[21] It is thus always hard to decide whether to call an action under disavowal an expression of its intention, as we say of a successful conscious action, or a nonexpression of its intention, as we say of a failed conscious action. Jokes, dreams, and parapraxes carry out their aims, when they do, only in keeping those aims hidden from scrutiny and thereby making the actions look aimless. They achieve their ends, in short, only by building for those ends a tomb that obtrudes into the world of avowed action. This, of course, is just another way of saying that actions under disavowal require interpretation, even by the agent herself. Indeed, we might go so far as to say that the disavowal turns the agent herself into a spectator of the doings of an obscure psychical force. In the case of dreams most obviously, the dreamer is more the witness than the creator of her nocturnal visions, even though no one else is the creator either. In any case, the important point is that insofar as the disavowal at the heart of these actions marks the nonknowledge of the agent, the agent is as much the sufferer of the desires as the source of them. Jokes, dreams and parapraxes are acts we commit, but they are also, as Slavoj Žižek has said of fantasies, plagues that afflict us.[22]

If we are to understand how and why we suffer jokes, dreams, and para-praxes, we need to understand how we come to be in the position to suffer our desires. A desire is suffered when it insists on satisfaction, not just despite our being unable to act on it consciously, but by means of that inability; we can understand such a desire's form of expression only when we can grasp how a prohibition renders the desire not dead, as the prohibitor might hope, but rather objective (or autonomous, even), originating elsewhere than in the conscious, that is, experiential, life of the agent who suffers it. Perhaps we can put it this way: because we suffer our desires in order to protect them from conscious awareness, to keep them from eroding under the force of prohibition, we suffer them as demands. Dreams, parapraxes, and jokes, we can say then, are techniques of suffering because through them we sustain our desires by sustaining the loss of the ability to say, finally, what we want. They are, in that sense, ways of feeling the violent gusts of suffering from the past.[23]

However, even as we say that dreams, parapraxes, and jokes are all techniques of suffering desire, it would be perilous to mistake the similarity for identity. We also need to attend to the differences between them, differences which can be ar-rayed along a spectrum from lesser to greater publicity. Dreams are purely pri-vate affairs, in the sense that the agent and the spectator, while functionally dif-ferentiated, are nonetheless merged. Parapraxes, by contrast, take place in the midst of acts consciously performed in a shared world; the agent is still a specta-tor, but not necessarily the only spectator. A parapraxis, we might say, is suffer-able by more than just the person who slips up; it is, like a breach of etiquette, an occasion for shared suffering. Jokes, finally, not only *can* be witnessed by oth-ers, but are *necessarily* witnessed by them. (Thus, a parapraxis will seem to be a joke if a spectator, other than the one who slips up, mistakes the accident as a purposeful public act; this is the distinction thrown into hyperbolic doubt in split-personality comedies such as Jerry Lewis's *The Nutty Professor*.) The phrase "a private joke" refers to an intimacy shared by a couple or small group; a joke which is private in the same sense as a dream is a symptom. While all three are techniques of suffering buried desires, we can mark the difference by saying that dreams are had, parapraxes are acted out, and jokes are performed.

To focus again just on jokes, we can make the point this way: jokes disavow their motivations and so preserve them, but they do so in plain sight. Two con-nected consequences follow from this. First, every joke, however good-spirited, has a degree of malice in it. It proposes a kind of secret conspiracy between the desires of the teller and the auditors against the expectations of the auditors. Sec-ond, jokes, unlike dreams and parapraxes, depend on a degree of conscious tech-nique. The expectations against which the joke transgresses must be weighed in

the telling. Just as with a dream or a slip, a joke submits to the demand of the un-conscious desire it aims to satisfy, but to forge this alliance with unconscious de-sire, the public performance of the joke must be crafted by means of an assess-ment of the fear—which is simply another name for the expectations—of the audience. Timing, as they say, is everything. Jokes use conscious knowledge to ally themselves with collectively suffered unconscious desires. They are tech-niques of social suffering.

VI

It is time now to extend the notion of techniques of the social suffering of desire to a cultural practice other than jokes. Of course, since our aim is to find our way into Richter's *October 18, 1977*, the practice I have in mind is art. However, the category "art" is too general to focus our efforts, so let us build our extension by choosing a particular art which bears direct comparison both to our specimen joke, on the one hand, and to Richter's artistic practice, on the other—the art of burying the dead.

At first glance, it might seem as if the point of burying the dead is artistic in the strictest of senses—that is, to get them out of the elements and thus to pre-serve them. Otherwise, the body left unburied will begin to putrefy and turn back into the earth it rests upon. Some treatments of the dead, such as em-balming, do indeed seem to be responses to an imperative to protect the body from decay. Egyptians, Leninists, and followers of Jeremy Bentham come to mind here. However, the prevention of decay is not a universal norm for the treatment of the dead. I will return to this issue later, but for now let us note that many other burial practices acknowledge openly the inevitability of decay. Some—certain Jewish rituals, for instance—even seek to hasten it by getting the body into the ground not only as quickly but also as nakedly as prudence permits. The aim, then, cannot be to prevent decay, but rather to let it happen out of sight. Even that most famous enforcer of burial law, Antigone, did not wish to preserve Polyneices's body but rather to assure that Creon's decree that Polyneices "must be left, unwept, unsepulchered" would not carry the day. Bur-ial rituals are not for preventing decay but rather for preventing it from being witnessed. For the sake of the dead—or for memory's sake, as we say—such rit-uals hobble our vision.

It thus seems implicit in burial rituals that the afterlife of the dead, whether or not it be construed in spiritualized terms, is threatened by and needs protec-tion against the living. The dead have a claim on us the normative power of which is captured in the ritualized demand for entombment. No one is more

helpless, more at the mercy of others, than the dead; their helplessness is rendered in a notorious jab at politically correct language, which suggests that the prejudicial label "dead" be dropped in favor of "ontologically challenged." At the moment we see that the dead are "really dead," they need our help to veil this naked fact, and so it is more appropriate to say that our eyes are a threat to them than that they threaten our eyes. We bury them in order to preserve their claim, in order to sustain it as a claim in its detachment from any ability of the claimant to enforce it.

But what claim might the dead have on the living? This question can receive no ontologically novel response; the claim of the dead on the living is no different in kind than the claim of the *living* on the living—continued participation in the collective life of the society and the private lives of their intimates. Of course, that the claim is not different in kind does not mean that the techniques for pressing it are the same (a bad inference relied on by opponents of affirmative action). We have special practices for pressing and honoring the claims of the dead, such as grieving and remembering. This, I speculate, is why funeral rituals are cultural universals, for in every culture the special claiming of the dead imposes unique burdens of recognition on the living. The claims of the dead must be suffered, and suffered in an absolute sense.

This argument, however, still leaves unanswered our initial question, for we still have said nothing about why the claiming of the dead requires of us that we put them out of sight. I have hinted that the explanation is to be sought in the danger that we pose to them. Let us follow out this hint by pursuing the point that the helplessness of the dead requires that their claiming must be absolutely suffered. No one is more in danger of exploitation, of instrumentalization, than the dead. They are utterly unable to protest their being treated as mere means. In a very real sense, no claims are harder to sustain than those of the dead, for in their endless silence they do nothing on their own behalf. It is in this way that the burden of heeding their demands is absolute, even as human psychology seems to rebel against doing for those who do nothing for themselves. Thus, we put the dead out of sight by detaching their claims from the claimants' bodies and preserving them in or as grief and memory. The claims thus come to have legal standing even though their enunciators are silenced. We suffer the dead by hiding from ourselves their legal disability. Put simply, the claims of the dead are suffered through rituals of nonknowledge, through a kind of art.

Let me now clean up some unfinished business by returning momentarily to body-preserving rituals. I warned earlier that practices of preserving the dead might pose a challenge to my argument that we bury the dead not to protect them from the elements but to protect them from us. It is clear, though, that

such practices among the Egyptians pose no real challenge to my view; embalming was for them part of proper entombment, part of the recognition of the claims of the dead. The Lenin and Bentham examples—and, I might add, the increasingly common practice of pet taxidermy—are, by contrast, instances of the exploitation of the dead by means of nonburial. Such figures are ghoulish not because they are preserved but because they are displayed. They are wheeled out as if to show that they are not really dead and could continue to press their own claims. With the impossibly horrifying counterexample of Bentham, they cannot do so, and thus they are forced to parrot the claims of the living, of those who preserve them. In their unburied state, they are exploited by a kind of cultural taxidermy. Those for whom they are mouthpieces cannot suffer them to die.

Burial rituals, thus, are techniques of collective suffering because what they accomplish is the preservation of *the claims* of the dead against the instrumentalities of the living by means of a segregation of the dead across a border of unknowability. We entomb the dead so that their intimate participation with life will not be extinguished. A successful burial, thus, despite being a technique of suffering, is nonetheless not all agony (even as, to be sure, there is no greater agony than the loss of a loved one). Some burial rituals conclude with singing and dancing, as if the successful negotiation of the difficult change in legal ability is most appropriately marked by celebration. But even without open celebration, the connection between suffering the dead and agony is always shadowed by the *promesse de bonheur*. Let us consider briefly the agony of grieving. What all the incompatible psychoanalytic accounts of grieving share is the view that the rhythm of mourning is governed by the difficult work of decathecting the psychic traces of the lost object. Although Freud erred grievously in inferring from the theoretically finite set of memory traces to the completability of mourning, he did effectively bring into focus how mourning is not a technique of mere forgetting, but of, as we say now, letting go.[24] The mourner decathects the psychic traces of the lost object not to forget them, but to detach them from the lost object and thus render them memorable for the very first time. In this way, grieving preserves the intimacy with the lost object through alchemical transformation; we can continue to love the lost object despite its being lost to us. The loss always shadows, but it does not swallow, the mourner's love. The lost object is permitted to go its way, the decathected memory traces theirs, and thus the joy in having suffered love is sustained. When we grieve the dead to protect them from us, then we do so also for the sake of living. Memory is mourning: it is the artful tomb of the dead. Needless to say, of course, even when we know how to bury the dead, our art never works perfectly.

Let me sum up this last line of inquiry by recapitulating some key points.

Burial rituals are techniques of collective suffering that protect the dead from the living; memory is a technique of suffering that protects the intimacy with the lost object from the hatred generated by its having abandoned us. Both are techniques of suffering insofar as they protect the dead from exploitation and vengeance by allowing them to press their claims in the form of grief and memory. Here we can rejoin our discussion of jokes, for in joking, memory, and burial rituals alike the technique is a means of forging an alliance with suffering against the demand that all suffering find its proper form in an instrumentalized culture. Each builds tombs and each is an organon of life.

VII

I am tempted simply to say right now that photography is the modern alternative to burial, the modern technology which renders burial inauthentic. This is no doubt too simple, though, since, as argued earlier, photography is but one among the many nineteenth-century practices devoted to keeping the dead above ground. We would be operating on the proper level of generality only if we were to say instead that modern life itself, to the extent that it is built on a refusal to let the dead stay buried, is the alternative to burial. And here, indeed, we come face to face with one consequential version of modern historical self-consciousness, that we perpetually disinter our dead in an effort to assure ourselves that we have outlived them in the right way. Memory drifts and requires discipline, which is what the work of mourning is, but the thought that such discipline is itself subject to drift, the thought at the heart of post-traditional culture and its discontents, seems to lead us into demanding of the dead that they animatedly transmit themselves to us directly. We want the dead around because we have a use for them. The culture of *this* modernity is built out of both accumulated insults to the dead, which they have earned merely by being so weak as to die, and insults to the living, merited merely by our mortality. In this light, photography is only one instance of a more profound difficulty that has been imposed on us by the unending birth of our modernity: we must live in the aftermath of dead traditions, including dead traditions of entombment, that no longer orient us. Modernity is rent by anxiety over the ceaseless death of what came before it, and the vituperation we hurl at the dead betrays the non-development of a culture of mournful life after the end of mournful tradition. The unmet challenge of our modernity is the invention of post-traditional forms that do not insult the dead.

Photography, then, needs to be thought of not as the modern alternative to burial but, more specifically, as the modern *pictorial* alternative to burial. It is an

old saw of the history of nineteenth-century art that photography spelled the death of painting. While this is no doubt true in some sense, the specific aspect of photography that made painting die remains unclear. Can it be, as figures as diverse as Gombrich and Danto have argued, that photography replaced painting merely because it was more adequate to the task of depicting the visual world realistically?[25] Such an explanation seems unlikely; the comparative judgment of realism it invokes supposes that the photographic image offers to the connoisseur of images a better match between its motif and the world represented by it than the painted image does, whereas no one, as far as I can tell, has ever even tried to provide a metric for such a comparison.[26] However, that such a comparative judgment is the specialty of the connoisseur puts us on the path of a more likely, which is to say more amateurish, explanation. It is not the better matching of the visual world that enabled photography to kill painting, but rather the photographic fusing of object and appearance that made visual comparison otiose. The practice of visual comparison, in other words, supposes some gap between image and object, some space which imagination and cognition must cross in order to get at the object which the image, therefore, has left incompletely represented. Photographs, on the other hand, present the object by means of its own look and, in virtue of this peculiar objective self-validation, cannot be said to mediate the object at all. In one swoop, photography transformed the image-as-mediation into the image-as-excess.[27] And, insofar as painting as an art is simply another name for pictorial mediation, photography rendered painting idle by making all of its techniques into obstacles to the past's self-presentation. On May 30, 1990, Richter wrote the following note to himself: "The invention of the Readymade strikes me as being the invention of reality, that is to say, the incisive discovery that reality, in contrast to the picture of life, is the only thing of relevance. Since then, painting no longer depicts reality but is reality itself (which presents itself)."[28]

Although Richter's reference here is clearly to Duchamp's Readymades, he might as well have been speaking of photography. Both are inventions in which the world ascends to its own presentation. And once the world no longer lacks the ability to preserve itself forever, the world no longer needs artistic mediation. Painting becomes now not a mode of seeing but an obstacle to what the world wants to see. Putting this point well requires special delicacy: it is not that all of a sudden the techniques of painting become newly visible, since painting, as an art, always had to be visible. It is, rather, that the visibility of the painted image becomes an order of visibility now newly incompatible with the visibility of the object. Painting becomes a practice of all too visible, all too abundant, all too sensuous appeal to the eyes. It becomes an aesthetic practice without a world. It

is thus not so much photography that killed painting, but the whole world of the nineteenth century. Painting simply cannot any longer carry conviction once memory itself becomes an archaic practice.

In a photograph, what stares out at us is a past world that does not decay, a world about which it no longer matters whether it dies. It is a world in which Dorian Gray's erotic dream of eternal coitus with the now has been achieved perfectly, but in reverse: the organic body putrefies while the look of it stays unchanged. Indeed, as the look of things becomes immortal, the mutable body becomes as good as dead already as far as representation is concerned. The closing of the gap between outer and inner, between surface and what lies behind, renders the confrontation with mutability unthinkable, and the appearance of mutability, which was the preserve of painting as an art, becomes intolerable. This is another way of saying that in a world in which the photograph is a preservation of life against what thus becomes its own perpetual rot, the mournfulness of painting, its inability to contain fully its represented object, itself becomes a thing of the past. The Veronica-dream here bears delayed fruit, since the image finally becomes the transcendence of decay and history. The palpable other side of this achievement, however, is the forging of an identity between, on the one hand, the body that is rotting just insofar as it is changing and, on the other, what cannot be pictured.[29] The only aspect of life which remains beyond the photograph is its mortality, for while the photograph renders the dead, it cannot render their deadness, their having once been alive to return the look now directed at them. It is with the deadness of the dead, their unburied rotting which is hidden by the splendid visibility of photography through which it nonetheless burns a hole, that Richter's painting forges an alliance.

The dead and sensate beings in photographs have in common that we can see them but they cannot see us. The problem of what to make of this imbalance between the living and the dead is at the heart of the memento mori, which traditionally straddled the border between them. In the memento mori, the art of the living took the side of the dead by calling on us to remember not their lives but the fleeting finitude of them. Richter's photopainting *Skull with Candle* (1983) has the appearance of just such a traditional memento mori. A skull balances upside down on a table along with a single candle which illuminates it. The skull's eye sockets face toward the picture plane, but they are empty of the organic stuff of the eyes and so offer no resistance to our regarding the skull as a relic, or a fossil, of a life now over. The whole ensemble sits in a room, which, while only dimly illuminated by the candle, is lit well enough for us to see on the picture's right side the front of the back of a hard chair (or bench) where the contemplator of death can sit. The chair is unoccupied, however, so

FIGURE 1. Gerhard Richter, *Skull with Candle* (1983). Oil on canvas. 100 x 150 cm. Courtesy of the Böckmann Collection, Berlin, Germany.

the picture is not of an act of contemplating death; still, since everything is set up for contemplation—the skull carefully placed and the candle lit—this must be the scene of a contemplation either past or future. In either case, because the contemplator is absent, *Skull with Candle* is a narrative picture visibly lacking the central action of its narrative, the remembering of death that memento mori are supposed to provoke.

This scene of nonremembering is not, however, perfectly contained by its imputed narrative. The bottom edge of the picture cuts off the bottom of the candle, obscuring from view the spot on the table where the candle sits. The painting is framed less like a formally complete depiction of a closed memory theater than like a photographic slice of it. The effect of this quite traditional technique for bringing the space of the image into the space of the viewer is echoed by the dark stripe which constitutes the picture's left edge. There is no way to tell precisely what this element represents—the edge of a half-wall, perhaps, or the door from an (unpictured) room to the left through which the contemplator has left or will come—but in either case it is an outcropping of the frame of the theater of memory into the theater itself. As the frame and the candle are in our viewing space, the figure for whom this is a theater of memory, the figure who

is absent from the empty seat of memory, is us. No life intrudes to mediate between us and the skull we are offered for contemplation.

This description of *Skull with Candle* has been entirely photographic so far. Since the painting displays its subject matter with the verisimilitude of the photograph that is its source, that is not entirely inappropriate. However, something does intervene between us and the scene, something which cannot be described purely in terms of the photographic image but which, nonetheless, depends crucially on a feature specific to the photographic image: "overexposure." Despite the fact that the scene is dark, the photograph of it from which Richter paints is too brightly lit. Perhaps the photographer feared that the skull otherwise would look less than gleaming white and so still organic, still vaguely clothed in rotting flesh, but regardless of the specific motive the candle's flame is white-hot. While the effects of this overexposure are cast elsewhere *in* the picture—in the glare coming from the skull's brow and in the liquifying waxiness of the top of the candle—it also burns a hole *through* the picture. In its blinding incandescence, the candle's flame breaks through the illusionistic surface of the painting, thus, perversely, turning the condition for seeing the scene into an interruption of the scene's transparency. The candle's flame, in other words, operates in two visual registers, in one of which it is an anomalous artifact of the photographic process and in the other of which it is an act of painterly virtuosity. It is Richter's working in this latter register on top of, or along with, the photographic one that draws the painting away from an identification of the memento mori with its photographic preservation. At the source of light, the painting of the photographed flame disrupts the work of the photograph itself. What lets us see into the past also punctures *Skull with Candle*. The painting thus brings to light not the dead but the condition of believing that the dead can be kept alive to begin with. It is not a memento mori but the scalding memory of one. *Skull with Candle* works over the photograph with the aimless techniques of painting; from the scene of memory it ponders, it does not save the dead but the beautiful burning fire.

VIII

October 18, 1977 is not about the deaths of Baader, Meinhof, Raspe, Ensslin, and Meins. It is, rather, about the photographs of their deaths and of the circumstances which surrounded them, and in being about those photographs it is about the recycling of their deaths in the memorial medium of our time. The photographs from which Richter works are the vehicles of the eternalization to which the deaths they show have been subjected, of the undeadness against

which the individuals photographed have no defense. We see in the photographs historical actors who in their unburied state continue to live on ghoulishly in the uses to which they are put. Insofar as we are taken by the spectacle of their photographed dead faces and bodies, we have yet to receive the news that they are dead. *October 18, 1977* is here to try to bury them.

It is impossible to look at the photographs of Baader, Meinhof, Raspe, Ensslin, and Meins without participating in the political afterlife in which the meaning of their deaths is contested. Every photograph represents its subject as having been overpowered, and never more so than when the image shows a person whose death we turn to our own purposes by using it as a justification of our having survived. In no photograph are the dead safe from our prying eyes, and in this sense there is no innocent photograph. However, if there is any candidate for innocence, it is the earliest photograph Richter paints. In *Youth Portrait* (Jugendbildnis; 1988), the young Ulrike Meinhof meets the gaze of the camera with a direct and confident one of her own. She is unafraid of the camera's power, unafraid of the photographer who is recording this moment for some later time when the older Meinhof can look back and feel herself to be the justification of the hopeful expectation shining in the face of her younger self. That later time has come, however, and we know that the innocent girl became a dead terrorist. The naivete of the photograph, the hopeless banality of its expectancy, no longer attests to the innocent "youth" which Richter's title invokes; now, it is saturated by the significance rushing backward out of the future and remaking it into an image of threatening duplicity or obliviousness to fate, depending on the political afterlife in which one's survival of Meinhof is put to work. The photograph now means either "even our children are not to be trusted" or "history is a slaughter-house."[30] In being vulnerable to either of these meanings, which is to say undefended against both, the photograph of the young Meinhof shows not innocent youth at all, but the lost moment, or the last moment, before the start of the full-bore instrumentalization of her image. The young Meinhof knows no death, and for precisely that reason is so drenched in sentimental possibilities that she is vaporized by her afterlife.

As Richter paints the photograph, however, he effects a transformation of it such that to be able to see it—the painted photograph—at all, we must engage in close visual interpretation. The tonal contrasts of gray, black, and white through which Meinhof's face is presented in the photograph become softened in the painting by Richter's having dragged the paint across the contours separating hair from wall, flesh from cloth. Her face thus floats out of its determinate relation to her photographed spatial context and into a formal relation to her equally floating right hand and wrist. Meinhof's face still cannot defend itself against sen-

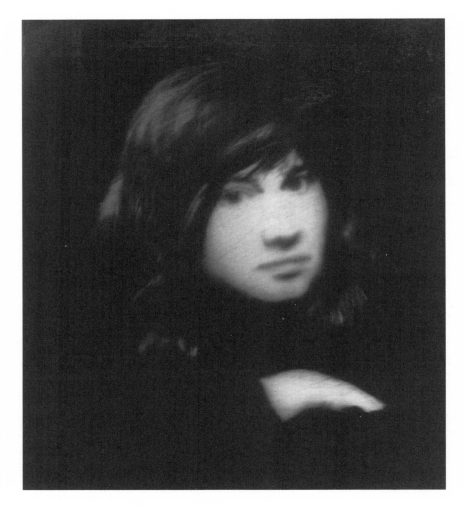

FIGURE 2. Gerhard Richter, *Youth Portrait*, from *October 18, 1977* (1988). Oil on canvas. 72.4 cm. x 62 cm. © 2000 The Museum of Modern Art, New York.

timental appropriations, but now it is allied in the painting to that patch of flesh with indeterminate meaning that Richter's masterful inverted use of techniques of painterly modeling has made of her hand and wrist. In the painting, there is something domineering about the hand and wrist; Richter's modeling withdraws gestural significance just enough for them to demand close and specific attention. In his painting of the photograph of the young Meinhof, Richter does not efface

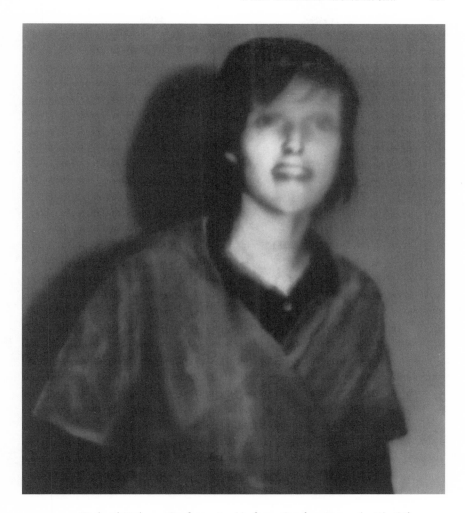

FIGURE 3. Gerhard Richter, *Confrontation* (1), from *October 18, 1977* (1988). Oil on canvas. 112 cm. x 102 cm. © 2000 The Museum of Modern Art, New York.

his source photograph, which, after all, is plain to see; rather, by traditional paint-erly means, he impedes its utter vulnerability to sentimental regard.

Uncertainty about what faces the plane of the painting, and so about what re-mains unabsorbed by the frontality of the source photograph, arises also in the three versions of *Confrontation* (Gegenüberstellung; 1988). The sources for these paintings are police photographs of Gudrun Ensslin. In the first two she faces us

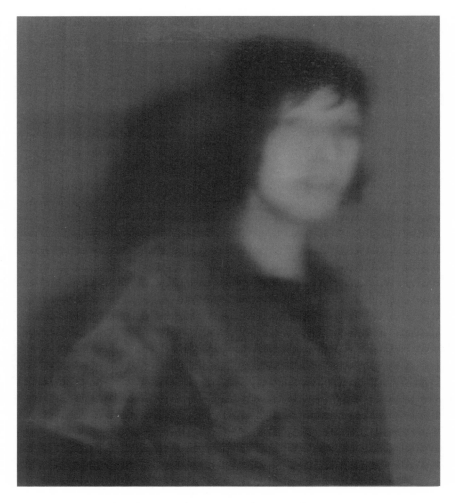

FIGURE 4. Gerhard Richter, *Confrontation* (2), from *October 18, 1977* (1988). Oil on canvas. 112 cm. x 102 cm.© 2000 The Museum of Modern Art, New York.

warily, her posture betraying a defensive awareness that she is not in control of the space of the photographic encounter; her entire bearing, in fact, is almost the exact opposite of the young Meinhof's direct facing toward the camera. Ensslin looks as if she had been commanded to stand back, but also as if she remains un-convinced that her compliance is sufficient to forestall the blow that sanctions the command. In the third image she shows the camera her profile, her head cast

FIGURE 5. Gerhard Richter, *Confrontation* (3), from *October 18, 1977* (1988). Oil on canvas. 112 cm. x 102 cm. © 2000 The Museum of Modern Art, New York.

down slightly, and exhibits defeat by withdrawing her eyes from the possibility of acknowledging the gaze of the photographer. The condition of being photographed has cowed Ensslin, but the entire contest with the photographer is transformed into objective intimidation before our eyes by, if nothing else, the godlike invisibility of the photographer from the scene of the photograph.[31] His overpowering work has already been completed by the time we look.

Richter uses the same technique in the *Confrontation* images as he does in *Youth Portrait*. By working the surface of the painting, he subdues the tonal contrasts and thereby disjoins the photograph from its photographic immediacy. The effect in the *Confrontation* paintings, however, is not the same. Specifically, the paintings do not detach Ensslin's flesh from the photographic setting but rather render it less distinct from her clothing and the wall against which she is backed up. All three *Confrontation* paintings, and especially the first of them, have an all-over surface that faces out in such a way as to deface the visual articulation of the photographed space. Richter's nonmanipulation of the photograph's subject matter while displacing its "photographicality" creates the effect of a blurred photograph. This effect is, of course, a painterly illusion, since blur is a property of photographs and not of paintings; nonetheless, the beautiful crafting of the surfaces neither discloses the photographic subject matter of the source images nor substitutes the pleasures of beautiful painting for it. Instead, the work of making the photograph into a painting sets up a visual dissonance between subject and surface that is the precondition for the beauty of the paintings. Put another way: while the paintings share with the source photographs *point for point* the dominating visibility that being photographed imposed on Ensslin, the work of art comes to Ensslin's assistance by offering us something else to look at by means of which the all too public meaning of her photographed face remains, for a brief but perpetual moment of delay, indeterminate.

Our observation that Richter's paintings share their gaze with the source photographs allows us to make a general point about the intersection of painting and photography in *October 18, 1977*. Whenever he paints photographs, Richter imposes on his practice a specific constraint: that he not change the subject matter of the image by painting it. In a more traditional context, this constraint would go without saying; the painter hired to do a portrait or a landscape or, even, an allegory of virtue had no choice in what to paint. In modern contexts, by contrast, the painter is liberated from the traditional demands of subject and in that sense has to invent from the ground up. In practice, this liberation perversely entails an even stricter constraint since, in the absence of traditional norms for successful painting, the modernist painter must invent a personal style, an expressive style, by means of which the work will find its way into the lineage called "the history of painting." In painting from photographs, Richter deprives himself of this dubious emancipation by binding his practice of painting, not to subject matter traditionally understood, but to the subject matter of photographs in particular: the very act of looking itself.[32] Taking photographs as subject matter requires painting an impersonal perspective, a subject as it has already been seen. In painting the mechanically produced picture, the picture without subjective

mediation, Richter thus leaves for painting only the matter of what more there is to see than what the transparent surface of the photograph shows. He leaves himself no other choice than to rework the surface of the image that the photograph has rendered obsolete for the purposes of seeing. The *rigor* of Richter's painting arises from his accepting the constraint of the photographic source absolutely, and so from his painting only what can be elicited from the surface of the completely, transparently visible. The *beauty* of Richter's painting is thus, like the beauty of all beautiful modernist painting, the beauty of the worked surface, but in working over a surface that is irrelevant to the penetrating work of vision, Richter identifies the beauty of painting with a face that cannot imaginably be expressive of its inner content. In another context, we might even call the beautiful faces of Richter's photopaintings "deadpan." We see in Richter that photography killed painting by destroying the relevance of the power of visual mediation for visual orientation in the world, but also that photography therefore made beautiful painting possible for the very first time. Only that gesture whose purpose is unclear can be beautiful—and modernist painting is born functionless.

This thought is at work in all of Richter's photopaintings, however, so it is not enough to get us to the threshold of the specific achievement of *October 18, 1977*. Let us turn, therefore, to another painting in the cycle, *Hanged* (Erhängte; 1988). The source photograph is a medium shot of Ensslin hanging by her neck from the bars of her jail cell. That, however, is all the painting lets us see clearly. The blur effect is so pronounced, which is to say the surface of the image is so obviously painted, that only the barest photographic fact remains visible. What else, though, do we need to know? What else do we want to see? Would Ensslin's deadness be more palpable if we could make out the features of her face or the positioning of her hands? We have her death, we who have survived to gaze at it, yet we want, by means of the photograph, what Ensslin herself could never have—a look at what she looks like dead. The beauty of the surface of the painting here allies itself with Ensslin's deadness, making it both vivid and hidden—in short, buried—all at once.

Yet a detail of *Hanged* continues to haunt. On the wall facing Ensslin's face, but also facing ours, is a frame. What is in the frame? We cannot say for sure, but whatever it is, we can infer that it has a shiny or glossy surface because on it we can discern a shadowy reflection of the hanged figure. It could be a mirror or a window or a picture under glass—or even an oil painting. All we can say with assurance is that in it Ensslin could see her appearance in the moment before she died of hanging. Richter's painting thus elicits from the source photograph a double obliteration of its transparency by interposing a beautiful surface—the painting called *Hanged*—between our eyes and Ensslin's dead body, as well as a

FIGURE 6. Gerhard Richter, *Hanged*, from *October 18, 1977* (1988). Oil on canvas. 201 cm. x 140 cm. © 2000 The Museum of Modern Art, New York.

beautiful surface where a reflection of death would duplicate the dead face. Ensslin's last look does not accede to the demands of photographic visibility in *Hanged*, and where it might, in the reflective framed thing hanging at the center of the painting, we get instead a hauntingly beautiful Richter painting.

Hanged offers us both more and less than its photographic source. The "less" is shockingly obvious: we cannot see Ensslin's face even though all the machinery of transparent reflection is in place. The "more" is harder to describe. We could make it easy on ourselves and play at connoisseurship by saying that what we get is a painting instead of a photograph. That way out is risibly evasive, though, since the entire painting rears up out of the vision of death that continues to hover over it. The "more," whatever we say about it, must be consistent with what the hanged painting *en abîme* fails to show: the look of death that belongs only to Ensslin. It is, thus, the "more" of a beautiful painted surface, but not a painted surface *instead* of a photographic one, not a painted surface that lets us look away from the deadness of that hanging body; it is the more of a painting where a photograph would otherwise have been the path into the unburied death Ensslin is fated to suffer. The "more" *Hanged* offers is its beauty as a painting, when that beauty is also the visible tomb which Ensslin's afterlife perpetually denies her. It is the more of the reflective but opaque image at the center of painting.

This brings us, finally, to *Funeral* (Beerdigung; 1988), which, since its German title is a gerund, could also be translated *Burying*. The photographic source of this enormous painting is a perfect performative contradiction, an image of an entombment that at the same time prevents it from happening. The public spectacle of getting rid of the bodies is memorialized in perpetuity, thus forcing even the rites of mourning into the service of the survivors. Richter's working of the surface here is a spectacle in its own right. No bit of the surface of *Funeral* escapes Richter's overtly gestural swiping of brush and stick across the painting from left to right, across, that is, the line of march. We cannot help but be reminded of a mishandled old-fashioned Polaroid across which the fixing wand was stroked too soon, thereby stopping the image's development prematurely and leaving behind a broken but visible promise. Richter's painting is the perfect exemplar of how to make a picture filled with the motion of nothing but picturing in the absence of effective modeling. This separation of painting from modeling, achieved in a painting bound to the gaze of its photographic source, thus tells us what kind of spectacle *Funeral* is: a counterspectacle.

Of course, since *Funeral* is a history painting, we want it to exhibit the virtue of its genre by making visible the meaning of the event it depicts. We want it, in other words, to offer us a form that will capture this movement of passing

FIGURE 7. Gerhard Richter, *Funeral*, from *October 18, 1977* (1988). Oil on canvas. 200 cm. × 320 cm. © 2000 The Museum of Modern Art, New York.

FIGURE 8. Gerhard Richter, *Funeral* (detail). © 2000 The Museum of Modern Art, New York.

away. Giving form to movement, however, is exactly what *Funeral* does not do. The coffins stand out from the painting's gray-on-gray surface, slabs of white elevated on the shoulders of pallbearers, but they are frozen in their movement toward burial, fated to be the perpetual containers of the dead bodies they shield from view. They ignite—what else can we call it?—a drive to know what showing them cannot reveal; they are the erotic center of a spectacle that therefore is full of the emptiness we wish it to fill. What wish does *Funeral* cast back at us in its inhibition of a transparent view of the unburied dead? What mourning does it remind us has been left undone?

These are questions *Funeral* provokes but does not answer. The surface of the painting, the locus of all the beauty of which painting is capable, intervenes in the spectacular nonrepression of the deaths of Baader, Raspe, and Ensslin. It does not do so, however, by giving us something else to look at, since nothing else is represented here in the place of burying. It does only what painting can do after photography has killed it, which is to insist forcefully that there is more to see than we can at present see, and that we have no idea how to see it. *Funeral* interferes with the afterlife of the deaths it is about by putting an obstacle between our eyes and the funeral procession, by making us not see finally because something keeps moving across our encompassing field of vision. *Funeral* keeps the past stuck in the moment before it has been diverted to the aims and purposes of the living. When Richter looks at the photograph from which he painted *Funeral*, he sees that we do not know how to bury these people, our homegrown terrorists, which is to say we do not know how to take their claims into ourselves. The painting suspends the art of burial by suspending the photographic transmutation of it. In that way, it maintains the memorial vigil for deaths that have so traumatized us that we no longer know how to stand vigil. The aimless gesture of Richter's breathtaking painting keeps us trying to see and keeps us failing at it. *Funeral* thus forces us to feel a violent gust blowing from the past. To be sure, the narrative entailed by *Funeral* ends with the burying of these dead people, but the painting insists: not before our self-possessed eyes. Perhaps, Richter's frozen picture says, we must ourselves die a little first.

SIX

Art and Lamentation: Aboard
Ilya Kabakov's Lifeboat

Rivers would say, remember *now*—any suppressed memory
stores up trouble for the future. Well, too bad. Refusing to
think's the only way I can survive and anyway what future?

PAT BARKER,
The Ghost Road

It may sound reactionary, but I think that in the future it will
be important to look back to the nineteenth century.

ILYA KABAKOV,
David A. Ross in Conversation with Ilya Kabakov

I

Over the last several years, the Russian artist Ilya Kabakov has discussed the dis-
appointing reception in the West of most Soviet-era artists. A few artists who
emigrated, such as Ernst Neizvestny and the collaborative team of Vitaly Komar
and Alexander Melamid, received at least respectful responses, but the larger
number who stayed and continued working in the unofficial milieu of the un-
derground regularly had their hopes for recognition in Europe and America
frustrated. This was an especially harsh blow because, according to Kabakov, in
place of the audience officially made absent by the censors, the underground
artists had imagined an ideal audience in the West, even imagined the West as
such to be the ideal audience. "Everyone waited for the West, for the moment
when it would find out about this art, when everyone would turn their heads
and say: Wow!"[1] No single encounter, especially one marked by the normal
give-and-take and ranking of preferences characteristic of looking at and criti-
cizing art, could embody this idealized acknowledgment the artists wanted from
the West. Thus, each opening to the West, in the form either of smuggled paint-
ings or studio visits by foreign critics and collectors, remained unsatisfying.

These disappointing encounters, however, did not help the artists to develop a more realistic perception of the West. Rather, in a perfect exemplification of the logic of idealization, the artists blamed every failure of acknowledgment on themselves, thus preserving the ideal even in the nonperformance of its imagined role. The psychical function of the ideal was not to craft an audience under dire conditions, but to hallucinate one as actually existing so that life in the underground could be experienced as on a road toward emergence into the light. Put otherwise, the imagined audience was a symptom of the isolation and false inwardness cultivated in the cramped spaces carved out by rigorous repression, which, like all symptoms that ripen under long-term deprivation, appeared to the sufferers as a cure. Only with the collapse of the rigors of that deprivation—in this case, the crumbling of the Soviet state—did the hallucinatory nature of the cure meet its unsatisfying real counterpart face-to-face. That the imagined audience never existed, that its not existing was a condition of its psychical functioning, has led to disillusionments of variously dramatic, comic, and pathetic turns. It has also led to the path of disenchantment taken by Kabakov.

If we work our way carefully on to Kabakov's path, we will discover there a surprising dialectical twist in the modernist relation to loss. Kabakov is an installation artist whose works are assemblages of garbage; he is, as he named one of the figures who populated his 1989 exhibition *Ten Characters*, "The Man Who Never Threw Anything Away."[2] However, unlike other garbage artists such as Allan Kaprow and Robert Rauschenberg (and perhaps more like Kurt Schwitters and Dieter Rot), Kabakov collects not just trash but also the trash collectors themselves, that is, people and places where trash congregates. What Kabakov "never throws away" but which, in being denominated as disposable, is nonetheless already garbage, is *trashed subjects*. And by making the condition of the preservation of garbage the preservation of the disposed sites of human living, Kabakov's art generates a ruthless formal challenge: to distinguish the artist from the ghosts he carries with him, or, to put the point another way, to distinguish the life of the work of art from the claims of the dead which that art is called on, as a condition of its possibility, to preserve. As we shall see, Kabakov's art rests on an iterated recognition that making this distinction in such a way that we might come to know with conceptual clarity how to tell the living from the dead would destroy the memorious relation to our histories from which modernist art flows. It is this formidable disenchantment of the idea of an artistic transcendence of the past that we shall track in this chapter.

To work our way into Kabakov's disenchantment, it will help to linger a little longer over his descriptions of the lack of fit between censored artists and

their idealized Western audience. In assessing the situation of the underground artist, Kabakov identifies two conceptually distinct, but psychically and practically linked, disjunctions: one separating the artist from the rest of social life and the other from the history of art. Kabakov's thought is that it is only in the experiential conjoining of these two disjunctions that the specific melancholic position of the Soviet underground can be grasped. Nonetheless, it will be more illuminating to deal with the two disjunctions discretely.

On the one hand, Kabakov discusses how the psychological strategy of the censored artist was to become reconciled to his alienation, albeit, in Adorno's phrase, under duress, by cultivating art away from the official gaze.[3] Art was an activity defined by its lack of an appropriate audience, by its being done in isolation, and so to be a real artist, as opposed to an agent of the official State art-apparatus, was to aim at being and remaining invisible. "I very quickly learned everything that my [art] teacher instructed me in order to go by the rules, but the person inside never understood what was going on. I was like a trained monkey or dog. The person inside me didn't have any contact with my hands, with what was produced by these hands."[4]

To the extent that the art produced embodied this disjunction of artist and society, it expressed the psychological condition of the artist for whom solitude and having been hunted to ground had become indistinguishable. Kabakov comments: "In unofficial art there were no leaders, because everyone was under police observation; it was a very dangerous existence all the time. This was, moreover, a group of extreme individualists; no one acted as a teacher. Each one of us searched in his own depths for his own language, his own problems, only for himself."[5]

At the early stage of this withdrawal from the official gaze, we can readily imagine how official invisibility and unofficial visibility were palpably two sides of the same action. Not being seen by the censors was an essential condition for being visible, that is, authentically real and present to oneself and others; to the extent that the maintenance of the disappearance—and, to be sure, the vigilance of the artists needed to be perpetual—remained a conscious project, making unofficial art was the visible face of one's own integrity. Art under these conditions would be a form of protest, a rebellion against the human disintegration threatened by smothering officialdom. Looked at this way, though, the artistic embodiment of the disjunction of artist and society would not be purely a form of withdrawal or social unrelatedness, but also a rebellion against withdrawal, a form of social relatedness, produced under conditions of dire threat of loss. Art would not be a home away from home but rather a way to maintain one's capacity to refuse the thought that one's exile is acceptable—a mode of mainte-

nance developed, of course, under conditions in which it was impossible to make a public appeal for recognition. We might think here of Gustave Courbet's paintings during his period of post-Commune banishment from Paris: still lifes of dead trout, *nature morte* taken literally, painted with a vivid, concentrated realism, as if the liveliness of the technique were being willed ever more ferociously in the absence of the living nature which could sustain it.

Many great chronicles of imprisonment, hiding, and exile—of, that is social death—either speak of or, as in the case of diaries and journals, simply are, implicit protests, ways of searching for the lost aim of art by continuing to practice its techniques under conditions of its impossibility. Looked at in this light, such documents, to alter our earlier formulation, testify not to the identification of the artist with herself as forcibly privatized, but to a painful and costly objection to such identification. Privacy is not here experienced as an integral realm apart but as itself the wound in need of healing; it takes on its original political coloration of privation, of the loss of social place without which one's humanity disintegrates. The art of privation, then, is a refusal to accept the loss of publicity that takes on the form of a continued effort to identify with what has been lost rather than with the self who has lost. This refusal is an instance of the experience of loss that underlies both mourning and melancholia as, in Freud's description, the shadow of the object falling upon the ego.[6] The thing that matters most is lost, and its absence, its unimaginable distance from life, saturates the activity of the mourner. In the cases we are thinking about here, the loss is a social one in a double sense; the thing lost is the society and it is a loss imposed by the society which has been lost. Mourning thus is a socially necessary labor, and, since it is necessary, it expresses some degree of truth.

Thinking of the art of privation as protest, as the form of an alienated social relation, brings into relief an important feature of the connection between isolation and the structure of experience. To put it in a formula: isolation is a psychosocial fact that is never immediately experienced. Whether it is experienced as abandonment or the hallucination of an unavailable object or audience, isolation is experienced as a relation to a loss. Indeed, we may suspect that some of the extreme behaviors characteristic of total isolation can be made sense of this way. A psychologist friend who works with prison inmates reports that after forty-eight hours of sensory-deprivation isolation, prisoners begin to hurt themselves; they throw themselves against the walls of their cells, scratch themselves and draw blood, bite themselves. His analysis is that isolates are providing themselves with sensations, sensations being the point of contact between person and world, which they can then experience. The implicit dissociative thought is, "I am in pain, hence there is a world, hence I am not alone." Such behavior can be

interpreted, in other words, as the embodied form of the experiential impossibility of isolation. Generalized, the point is that the intolerability of isolation produces split self-identification that enables the isolation to be experienced as nondeprivation, even if, from an outsider's perspective, it can be seen as nothing but a symptom of the isolation it both embodies and denies. And not just as a symptom: this is pathology in a strict sense, self-mutilation taken as a sign of integral connectedness.

With this speculation about the experience of isolation in mind, let us recall that the cultivation of subjective inwardness characteristic of the Soviet underground was also a typical strategy of the European and American avant-garde protest against bourgeois aesthetic norms. The internal connection between aesthetic value and artistic authenticity, while not universal, is nonetheless a familiar feature of avant-garde art.[7] The great difference between this avant-garde strategy in the West and the tendency of unofficial Soviet art was that the imagination of the avant-garde, soaked in what Greenberg called advanced historical consciousness, was, as the very name "avant-garde" suggests, oriented toward the future. The oppositionality of avant-gardism was oriented toward a determinate negation of the present for the sake of calling the future into being out of it.[8] The cultivation of inwardness as a strategy of protest entailed holding out for an audience yet to come, and was in this sense dependent on both the expectation of revolution and the fact of its nonoccurrence. The unofficial Soviet artist who came of age after the imposition of Stalinist censorship, on the other hand, had neither a living past nor the hint of a future to anticipate. The freeze was so deep that both past and future were cordoned off. As Kabakov puts it:

> In our generation, to start from the beginning was simple because the Soviets had destroyed all culture; what surrounded us was nothing more than the songs of pigs. And so each artist established that empty territory on which he planted his tree and watered it carefully. But there is a profound difference between the avant-garde of the beginning of the century and the unofficial art in Moscow in the middle of the century. At the beginning of the century the visionaries were easily able to break with the past because all of their hopes were located in the future; they believed that a new era had begun and that they were part of it. Our generation, the generation of unofficial artists, did not have any future, because all of us were convinced that Soviet power would last for 10,000 years, that nothing would ever change. If someone had told us that the Soviet system would come to an end in 1989, we would have considered it to be complete delusion.[9]

It is in the shadow cast by the eternalizing of avant-garde inwardness that the conjuring of an audience took the form of a geographical hallucination of the

West. This West, far from being a version of the real thing, was entirely an artifact of the psychical flinching produced by the censor's threat. "In the unofficial world the West was imagined as a kind of mystical, mythological expert who would see Russian art and confirm its value."[10] The moment of contact, then, with the desired audience was guaranteed to be no more satisfactory than Brecht's with his East German hosts after his return from exile.[11]

This disappointment, though, is just a part of Kabakov's analysis of the unhappy fate of unofficial art, because in the end it explains only the subjective disappointment felt by the artists. Indeed, even allowing for the clear differences between the European and Soviet contexts, this subjective disappointment would not be unlike what was experienced by the Western avant-garde as it suffered the recalcitrant, even magnified philistinism of its wished-for Western audience. In other words, this portion of Kabakov's reflections, taken on its own, would make it seem as if the Soviet underground had undergone a slightly deferred version of the disenchantments of Western avant-gardism. What it does not yet touch is the reason why unofficial Soviet art has also met with such a cool reception in the West. Indeed, with few exceptions (and not especially notable ones), Soviet underground art has gone directly into archives documenting Soviet totalitarianism with barely a moment's life in the Western art world. What remains in need of explanation is the objectivity of the disappointment. To understand that we must turn to the second of the disjunctions Kabakov discusses.

Kabakov's remarkable second insight is that Western critics' and collectors' lack of interest in unofficial art is a function of the disenchantment of the Western avant-garde itself, the loss of what Daniel Herwitz has called the avant-garde's authority.[12] Having been driven underground in the 1930s, driven away, that is, from a geographically articulated but still pan-European artistic modernism, Soviet artists simply maintained the project of modernism. The cultivation of subjective inwardness, the striving for authenticity, the commitment to originality, these values were frozen and preserved by the *cordon sanitaire* of the censor.

> This situation inevitably meant that all criteria for the quality of a work were distorted. What were these pictures or concepts for the disinterested outside world? What were they not only for us, their creators, but also for other people? This tormenting question hung like the sword of Damocles over everyone who had to work for many years without objective criticism or—and this was even worse—only ever met with the well-meaning approval of family and friends.[13]

Conviction in the value of early modernist values was maintained, in other words, by the censorship's insuring that underground art would never be able to reach that essential moment of contact when art fails to move its audience. The

values themselves became uninterpretable symptoms of the isolation. That un-
official art would be modernist was thus doubly determined, since both the
alienated social conditions in which the modernist avant-garde first developed
as well as the memory of the effort of art to find a way back home underwent a
cryogenic preservation under censorship. History stopped, and with it the trans-
formations in artistic practice attendant on the struggle to preserve art's adver-
sarial relationship to, precisely, history itself. Soviet art went underground when
the art world was oriented by Cézanne and his heirs; indeed, many of the older
underground artists in Moscow worked in a tradition that was referred to as
"Cézannism" into the 1960s.[14] It then re-emerged when the art world was dom-
inated by Duchamp and his heirs. The disenchantment that is postmodernism
now held sway. As Kabakov says:

> When Russian unofficial art entered the art scene in the 1970s and '80s, the
> problem was that an enormous number of artists in Russia found themselves
> to be in the situation of modernists: each was inventing his own language,
> each was experiencing the power of his own concepts and his own artistic
> world. But when these artists arrived in the West, they turned out to be part
> of the modernist past. . . . They were not to blame, it was just the tragedy
> of an isolated, closed society unsynchronized with the development of
> Western art.[15]

This is a more radical disjointedness than the lack of fit between the real and
the imaginary West. The most advanced art of the underground emerged into
its surrogate for the future, only to find itself regarded as inherently retrograde
for adhering to the ideas of surrogacy and the future. Not just the art and its au-
dience but history itself was out of joint; the future and belief in it had become
art's past. In the dark light of this revelation, the cultivation of hope was re-
vealed as the visible sign of self-mutilation it perhaps always was. Only those
unofficial artists who had not conceived art as the making of an authentic pri-
vate language could recognize this utterly new world; only those for whom sub-
jective inwardness was no goal but rather an attenuated mockery of the idea of
goals could breathe here. Perhaps the larger fate of the Soviet underground is
emblematized better by Alexander Solzhenitsyn than by Komar and Melamid.
Solzhenitsyn carried his aesthetic modernism and cultural archaism to an Amer-
ica that was particularly hostile to both; he thus traded in his internal exile for a
foreign one, found himself exiled, so to speak, from his proper exile, and finally
had to return home to rail against its not being home. His trading in of protest
for rant is an exemplary instance of the common enough modernist incapacity
to register the disenchantment of modernism itself.

II

Kabakov has not himself suffered the same dizzying fate as the lost Russian modernist underground. He has found a place in the Western art world, regularly getting gallery shows and museum and art-fair commissions. "Finding a place," however, may be too rosy a description of Kabakov's post-Soviet life. The question of place, of locatedness, is one of the rare topics about which this otherwise plainspoken artist is unclear, perhaps even obfuscatory.

> I was offered a grant by the Kunstverein in Salzburg in 1986 and received permission to leave. It was the first time that someone was granted such permission, an artist by himself, alone, for three months. So I left not because I was a heroic person, not because I decided to change, but because the situation had changed. I have to say that today I have a comfortable psychological feeling that I didn't emigrate, I didn't leave my country. I simply work. I receive many invitations and I am constantly working around the world. This has a long tradition, for example Chagall worked outside of Russia, and Kandinsky left and worked in Paris. In any case, I know for sure that I will never return.[16]

The certainty in this self-description that he will never return to Russia is at odds with the lack of will Kabakov ascribes to his departure. He did not emigrate, he says, because he never willed himself to leave; rather, he just finds himself perpetually abroad. However, by finding himself abroad Kabakov also finds himself in the company of great Russian artists of an earlier period, Kandinsky and Chagall. These artists, however, were only Russian artists for Kabakov once they were emigres; when asked whether he knew the work of any earlier Russian artists while working in Moscow, Kabakov replies no, but then remembers that "in the Pushkin Museum in the 1960s Kandinsky's paintings appeared in the section of Western art with the label: 'Wassily Kandinsky. French Painter.'"[17] Russia is the place where Russian artists are unrecognized, so only by leaving home can Kabakov accede to the position of Russian artist. Only by leaving can he arrive where he belongs. This suggests that Kabakov never was at home when he was in Russia; hence his inability to recognize himself as an emigre simply in virtue of leaving—after all, one cannot emigrate from a constitutively foreign land. Put otherwise, Kabakov was an emigre before he left, and so arriving nowhere in particular was a way of attaining to the possibility of being certain that he would never go back. It is not so much that Kabakov found a place in the Western art world as that the floating Euro-American cosmopolitanism of it gave him the comfortable feeling that he had arrived where Kandinsky and Chagall had arrived, and in that sense that he never left his country. In a place

which is no place, Kabakov has been accepted as a proper resident. Here is the nucleus of his identification with garbage.

However, even this less homey formulation of Kabakov's place is problematic. He typically has been accepted in the cosmopolitan art world as a documentarian of Soviet life, as a Russian artist unable to stop carting the experience of home on his back, turtlelike, wherever he goes. *The Toilet* (1992), for instance, has been taken as an authentic report of Soviet apartment life, and *School No. 6* (1993) as a re-creation of a rundown Soviet schoolhouse. Even when the cosmopolitans invite him in, he is welcomed as someone who cannot ever become quite cosmopolitan enough. It is easy enough to imagine the aesthetic reasons for Kabakov's distaste for these interpretations, since despite their recognition of his anti-aesthetic commitment to the real, they end up embodying nonetheless just the conception of withdrawal into authenticity Kabakov rejects. Taking his installations to be works of reportage presumes that unless a work exhibits a privatizing distance from reality it must be fully penetrated by reality. The thought, in other words, is that the only artistic distance there is is withdrawal into subjective inwardness. And it is this thought that Kabakov combats.

Put differently, Kabakov has been embraced by the postmodern Western art world, but that embrace has missed the mark by taking him to be an ironizer of subjective inwardness. Even Boris Groys, a fellow emigre who has been both Kabakov's most astute commentator and, along with Kabakov's wife Emilia, his familiar spirit, labels Kabakov's art "ironic," thus lumping him together, perhaps inadvertently, with the genuine ironists of the New York art world of the 1980s like David Salle or Barbara Kruger.[18] Groys errs here because he infers too quickly from an anti-aesthetic, antitranscendent comportment to an ironic one; while the premise of this inference is true of Kabakov, the conclusion is not, demonstrating therefore that the inference is invalid. Indeed, such an inference effaces the specificity of Kabakov's practice, which moves in exactly the opposite direction, taking the issue of artistic flight, of the drive to inwardness, as its central subject matter. Insofar as his work embodies a critique of the cultivation of inwardness that reveals it to be a movement toward self-preservation, it repudiates the ironic and superdetached posture, itself so committed to sacrificing whatever is necessary for self-preservation, typical of much so-called postmodern art. We cannot live in our secret gardens, Kabakov's art says, but neither can we ignore the experience of history the impulse to do so embodies. That impulse contains truth. In its treatment of loss, flight, home, and exile, Kabakov's art is at odds with the private pleasures of irony, and for just this reason it is a preservation, even a salvation, of the failed protest inherent in the modernist project. To put the point bluntly: Kabakov's disenchantment of the modernist artistic

project is not also a disillusionment with its aims, but rather a continuation of those aims made possible by stripping modernism of its affirmative character.[19] His turning against subjective inwardness is for the sake of the pain it encodes, and so it does not yield a liberation from the ethical intent of modernism. In Kabakov's hands, the disenchantment of modernism is modernism's own self-critical perpetuation.

Delay

Before turning to a direct consideration of Kabakov's disenchanted preservation of artistic modernism, a certain skepticism must be aired: that Kabakov is a theorist of art rather than an artist. His work often has something of the clever construction about it, as if an established concept were being buried in a mass of stuff in order to initiate a philosophical version of treasure hunt.[20] When we examine his albums, for instance, it is plausible to judge that they are more nearly texts to be read than objects to contemplate. They are populated with individual characters and narrators—Mathematical Gorsky and Sitting-in-the-Closet Primakov, for instance—and intended to be consumed as narratives rather than at a glance. Kabakov's description of the exhibition of the albums even calls into question whether "exhibition," which is the standard format for works of visual art, is appropriate for them.

> The exhibition of these albums represents a unique "concert," a special sort of show. During this concert each album is placed in turn on a special upright music stand . . . and the viewers sit down near it (the drawings are a comparatively small size) as if in a theater. . . . The author stands to one side of the music stand supporting the album, turns the pages, and reads the text written on each page. In the event that a translation is required, the translator sits down on the opposite side of the album from the author and translates the text read by the author, phrase by phrase.[21]

Further, the albums share with the installations that they are not sensuously rich and rarely exhibit any sort of special dexterity or craftsmanship; in general, they seem to invite us to see or listen through them rather than to look at them. Because Kabakov's art narrates fables about human beings in a sensuously deplete medium, the perception of them as theoretical is not without grounds.

Let us review this concern by starting with the worry about the medium. Even if we remind the skeptic that Kabakov's medium is an untraditional one for theoretical work, that will not be enough to allay the suspicion that his works are theoretical rather than artistic projects. It is of course true that Kabakov's

medium is not adequately described as language, the traditional medium for theory; a better description of it is "scraps," on some of which one can find writing. Theoretical work, however, is also not infrequently done in a medium that resembles traditional text without itself becoming a traditional text. This is especially true of postmodern theoretical work, in which the independence of the matter being considered from the form in which it is being considered is challenged by the theoretical form being based on a mimetic rather than a purely conceptual relation to its subject. Jacques Derrida, for instance, was once a familiar practitioner of this form of theory, but so, too, was a writer as traditional in his concerns as John Berger.[22] Thus, the skeptic about Kabakov's artistry can maintain that Kabakov's atypical medium notwithstanding, the interest of his projects is not in their artistic but rather their theoretical innovation.

Second, that Kabakov's fictional characters are allegories of art, so that fiction, a paradigmatic technique of making art, is both the means and subject of his works, is also not enough to suppress the suspicion that he is a theorist. That art is the subject of his work is obviously insufficient to establish its artistic nature, since art can be the subject of theoretical work. If anything, the explicitness with which Kabakov makes art his subject matter is part of the grounds for the suspicion, since nowhere does he exhibit that naive joy in artistic semblance that we might expect of artistic making. Thus, even when the skeptic acknowledges that the use of fictional characters is unusual in theoretical inquiry, he might maintain that the obvious reflective content of Kabakov's work can be translated without remainder into a more standard form of aesthetic theory. It would be strange to deny, for instance, that Plato is a philosopher of art simply because his philosophy emerges through the voices of Socrates and Ion, as long as one also believes that the philosophical content could be taken out of the mouths of the fictional characters and translated into alternative yet still equally appropriate forms. Because Kabakov's manifest theoretical content seems to offer itself in just this way for appropriate restatement in alternative forms, the skeptic can reasonably doubt whether the form in which he offers it is crucial to the work and, so, whether the work is properly artistic.

The suspicion that Kabakov is a theorist cannot be put to rest once and for all. It is in the nature of his practice that it engages the projects and promises of aesthetic theory at every turn and, therefore, that reflective thought appears in his art as a privileged vehicle. The way to confront this suspicion, then, is not by seeking to defeat it but rather by inquiring further into what is at stake in it. What is the danger named in referring to "theoreticism" in art? Why would we value an art that avoids it? What might art look like and how would it work if it threatened to cross the line that separates it from theoretical reflection? Why,

in the name of what prospects, would art approach the moment of trespass? These questions must be pressed while approaching Kabakov's art.

By "theoreticism" we can understand the tendency in art to supplement or supplant the artistic elements in artistic practice by reflective ones. Art is one way of experiencing and thinking about the world, one that undertakes its experiencing and thinking in a sensuous medium; theoretical reflection is another way of experiencing and thinking about the world, one that has no sensuous medium proper to it. Art and theoretical reflection thus are not just different ways of thinking and experiencing; insofar as the non-necessity of any particular medium is an essential part of theoretical self-consciousness, they are incompatible ways. Therefore, if theory appears in art, if art grows discursive in its articulation of experience and thinking, then the specifically artistic elements of art lose their specificity. Some art works are obviously theoreticist in this sense: Daniel Buren's antipainterly stripes, for instance, or Hans Haacke's sociological document-installations. In works like these, key features of artistry, such as design and pattern or the autonomy of image from label or caption, are colonized by discursively articulated reflection. The increasing appeal of theoreticism in late modernist art corresponds to the developing conviction that art, in its uniqueness as art, is ceasing altogether to be a way of experiencing and thinking about the world. Theoreticism, or even philosophical theory itself, has become not only a competitor to art but also its successor. Put differently, theoreticism names both a practice or disposition through which art ceases to function and, at the same time, a novel practice that successfully replaces it.

As may well be clear already, the rise of theoreticism is another version of Hegel's story of the end of art in which the postmodern ironic displacement of authentic subjective inwardness is that end's delayed arrival. In its replacement of art's artistic elements with discursively grounded and medium-depleting references to art, theoreticism is the crafting of a new and different practice on the site where the old one has been dismantled. In that sense, theoreticism is the most perfect attainment of the Hegelian end because it disjoins not just the relation between subjectivity and expressive media, but the relation between subjectivity and recalcitrant media. If the nineteenth-century irony that Hegel had in his sights turned sensuousness into garbage, which it then, in a moment of affirmation, discovered itself to be different from, theoreticism, in its turn, makes the garbage of sensuous experience reflectively transparent, thus rendering pointless the question whether we differ from it or not.

Let us return briefly to Hegel to make this point concrete and to discover precisely how Kabakov, despite his theoretical moment, is not a theoreticist. Hegel's insights into the internal contradictoriness of the very idea of ironic art,

that it expresses disdain for sensuousness in order to maintain the abstract disengagement of the ego, in order, that is, to maintain the ego's sense of mastery by scorning the significance of what it has no mastery over, are still unsurpassed. The ironic artist is for Hegel the artist who has rejected art but refused to go over to the objective content of that rejection, philosophical theory. Ironic art invites aesthetic theorizing, not as the respectful gesture toward art's truthfulness, but as the discipline within which the ironist's sense of mastery can lord it over what thereby becomes mere particularity. That the ironist continues to make artistic fables and parables as a way of giving theory an ever fresh supply of false claims to dissect makes him into a perpetuator of the theatrical moment of art's death. Ironic art, in Hegel's view, is a mockery of the demands of subjective inwardness; it is thus a way of torturing the wounded.

The affirmative character of Hegel's argument that ironic art is art's self-announced end is the emergence from art's ashes of philosophy proper. Philosophy is the expression of the spiritual culture of an age in which the alienation of the universal and the particular can no longer be overcome on sensuous terrain; it is the disenchantment of art. Hegel writes:

> What is required for artistic interest as for artistic production is, speaking
> generally, a living creation, in which the universal is not present as law and
> maxim, but acts as if one with the mood and the feelings, just as, in the
> imagination, the universal and rational is contained only as brought into unity
> with a concrete sensuous phenomenon. Therefore, our present in its universal
> condition is not favourable to art. As regards the artist himself, it is not merely
> that the reflection which finds utterance all round him, and the universal habit
> of having an opinion and passing judgment about art infect him, and mislead
> him into putting more abstract thought into his works themselves; but also the
> whole spiritual culture of the age is of such a kind that he himself stands within
> this reflective world and its conditions, and it is impossible for him to abstract
> from it by will and resolve, or to contrive for himself and bring to pass, by
> means of peculiar education or removal from the relations of life, a peculiar
> solitude that would replace all that is lost. (*ILA* 12–13)

From the point of view of the culture of our age, art is the realm of subjective particularity, of the expression of the self that has become just one more particular thing in the world; as such, art becomes a subjective insistence on what subjectivity knows itself to be unable to attain through its own agency. The nonreconciliation of world and sensuous experience cannot be bridged by means of a deepening of sensuous experience but rather only by a reflective bracketing of it; only philosophical insight into the disharmony of the world of objects and the realm of persons is capable of reconstituting the totality of life in its diremption.

Not merely the language emerging from privation but only the language also transcending it is capable of representing what has been lost; after all, the privation is just a symptom of the loss in question and not any sort of reparation for it. Philosophy thus replaces art as the representation of the proper reconciliation of persons and world. Art's capacity to heal the wound of the world is absorbed by philosophy, and art becomes an inessential, which is not to say inconsequential, form of action.

What is left out of the Hegelian picture of the philosophical overcoming of art—what, in being left out properly constitutes the overcoming—is longing. The philosophical succession is a theoretical consolation for the diremption of the world and the sensuous immediacy of personal experience, a reconciliation to the need for a theoretical perspective on the nonreconciliation of the ego and its object. This need, this somatically experienced absence of reconciliation, remains unsatisfied on its own terms—that is the precondition for and the hard wisdom of the Hegelian end of art. Hence, the propriety of the Weberian designation of this end as a disenchantment. Further, it is just this gap between sensuous immediacy and the whole world of things that calls forth theoreticism in art, as if art could only preserve itself by abandoning its own insistence on reconciliation on the terrain of the sensuous. Theoreticism in art, the completed affirmation of irony, is in this light the dismissal of the claims of longing against false universality, the treatment of it as nothing but a subjective phenomenon.

Looked at this way, theoreticism turns out to be a deeper entrenchment of the cultivation of subjective inwardness despite—or, rather, because of—its consciousness of itself as alienated from such cultivation. The cult of authenticity turns the capacity to long into its own bathetic satisfaction; theoreticism in art strives to guarantee cultic self-sufficiency by turning art over to discursive reflection and thereby immediately forgiving subjective inwardness its foregoing of the world. Kabakov's achievement is to break the connection between the repudiation of modern inwardness and the irony that necessitates theoreticism. He criticizes modernist inwardness not from a theoretical point of view, which would translate, and so give ear to, the powerlessness of longing, but rather in order to unlock the longing itself. Kabakov's art presents the longing as having no object to satisfy it, and so as a reproach to the conditions that have made it necessary.

In its rejection of simple inwardness on the one hand and the philosophical pretense to reconcile us to our nonreconciliation on the other, the proper name for Kabakov's art is lamentation. A lamentation is a nonsilence in the face of a loss. Not just any loss elicits a lament, however, but only the loss of a loved object. In having been loved, the lost object had been the moment of mediation between the lover and the world, the object into which the lover had been psychi-

cally merged. To pick up the language I used before, the loved object was the obstacle to privacy, the absence of privation. The loved object, we might say, is a person's place in the world, the space filled, albeit not filled up since it is still an object, with the person. It is, in short, the person's home. Home is the zone of no privacy; to be at home is to be amidst. Lamentation, thus, is the song of exile.

It is in this sense that Jeremiah laments. However, we need to remember, as the contemporary sense of "jeremiad" suggests, that lamentable noise is a plea, or rather a plaint. Jeremiah intones, "Remember, O Lord," and, in a pregnant performative contradiction, "Thou hast utterly rejected us," a plaint which, if heard as intended, could not be true. The exile laments in order to perform this contradiction, in order not to accept the silence imposed by homelessness. Lamenting sings home back into existence out of the experience of its withdrawal. Lamentation is thus more than the song of remembrance, although it is that, too, but is also the song of mourning that strives to reconstitute the space of home in a new register.

It is equally important to note, however, that lamentation is sad singing. As it strives to reconstitute home by filling the empty space left by the absconding object, lamentation never lapses into the joyful mistake of taking its noise to be a compensation, a fair exchange (by contrast, Job's complaint was never a lamentation but rather purely a demand for compensation, which, of course, he received). The congregation of lamenters constituted against God's abandonment is not a substitute for God; it is a lamentable congregation. In never ceasing to plead, the lamentation insists on the necessity, the unexchangeability, of home; perpetuated mournfulness is the maintenance of the reproach against the lost loved object. Indeed, the greatest source of lamentation would be the forgetting of exile embodied in the renewed joyfulness of the hymn or ode.

Lamentation, hence, is the protest song of a privacy that does not rest satisfied in its privation. It is the production of art which revolts against being forced to sing for its supper. Far from being the cultivation of subjective inwardness as a haven from alienation, lamentation is the artistic refusal of subjective inwardness; rather than identify with himself as a private person, the lamenting artist cultivates distance from the distance he himself is. In its insistence that the lost object must not be lost forever, lamentation is the mediated memory of mediacy.

The spirit of lamentation as the memory of a world, exile from which constitutes homelessness, is thus at odds with the spirit of withdrawal into authentic private language. Indeed, if privacy is exile there can be no authentic private language; rather, private language, fantastically stripped of empirical resistance, appears as the sign of the impossibility of communication, which is to say the impossibility of language. Every idiolect is a gnomic demand for communica-

tion that does not depend on a sacrifice of authenticity, and so is essentially in-authentic. Now, despite having identified the withdrawing cultivation of sub-jective inwardness as a characteristic strategy of modernism, it seems to me that it is a feature of the greatest of modernist works that they brood over this truth. It is only when we forget the experience of loss at the heart of Cézanne's paint-ings that we need to read Maurice Merleau-Ponty's "Cézanne's Doubt."[23] It is only when we begin to affirm cultural production as an overcoming of loss and exile that we need to be taken to the peak of Thomas Mann's magic mountain.[24]

III

The work we shall focus on is *The Boat of My Life* (1993), a wooden boat, hardly seaworthy, containing twenty-five crates packed with objects from Kabakov's past. In interpreting it, I will set loose a chain of associations that, like the work, reaches its destination only indirectly. Let me begin by proposing an alternative name for the work: *Lifeboat*. A lifeboat, the ambiguity of its name notwith-standing, is not a home that contains life but a craft in which the survivors of a disaster hope to reach a safe haven where life will be possible. Indeed, despite my proposal to refer to the work as a lifeboat from here on, the cognate concept in Russian is "saving boat"; this reference highlights how life is not so much lived in such a vessel as preserved away from some earthly calamity until it can be restarted.[25] In the boat of his life, the boat which saves his life, Kabakov stores the possibility of life after the disaster.

In *Lifeboat*, Kabakov refuses to confuse life after the disaster with flight from the disaster. The title *The Boat of My Life* invokes the age-old trope of life as a bark tossed about on the open seas;[26] however, Kabakov also repudiates this identification of life and the boat, since despite all the elements of life being present in the boat, they are, so to speak, present in the mode of absence, left in their packing crates until, presumably, shore is reached. Even if this is the boat of his life, it is still merely a lifeboat. The provision of the things necessary for life which are nonetheless kept in storage is a characteristic technique in Kaba-kov's work—he also uses it in *The Life of the Flies* (1992), *School No. 6*, and *NOMA* (1993). What distinguishes *Lifeboat* from those other installations is that it does not even imply that anyone has ever lived in it. On the lifeboat, life is suspended, as is the boat itself; a vehicle made for motion is here immobilized in a moment of expectancy that cannot be confused with its satisfaction.

To bring this point home more fully, consider the differences between a lifeboat and an ark. Both are vehicles for escaping calamity, but in the ark it is life itself which is the cargo. When God commands Noah to build the ark He

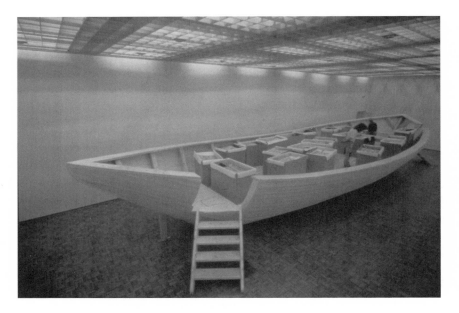

FIGURE 9. Ilya Kabakov, *The Boat of My Life* (1993). Wood construction, boat, steps, twenty-five cardboard packing boxes, found objects, photographs, texts. The boat is 260 cm. × 550 cm. × 1750 cm. Courtesy of Barbara Gladstone.

instructs him to "come thou and all thy house into the ark" along with the animal couples which will repopulate the earth after the flood. The ark is a temporary home, but it is a home nonetheless; in it, the past, Noah's house, and the future, the couples which will produce the new generations, live together under God's covenant month after rainy month. Life is not suspended in its detachment from the earth, since, under God's covenant, it is protected from the disaster. Noah's house is not in flight; with God's assurance it is merely waiting out the storm. The shadow that has fallen over the earth has not fallen over Noah's house or, therefore, his life. This is why God commands Noah to make the ark with rooms, not crates; it is a mark of civilized life that its discrete functions find a proper spatial articulation rather than being jumbled together. A lifeboat, by contrast, has no rooms because life is not lived there (and notice that problems of triage are referred to as lifeboat ethics, not ark ethics). Kabakov, unlike Noah but like Jeremiah, is in exile in his lifeboat, and for the exile to mistake the lifeboat for the ark would be to mistake the flight from disaster with life itself.

A lifeboat, in other words, is filled with detritus, whereas an ark is filled al-

ready with the future. In chapter 8 of Genesis, the ark alights on Ararat, that magic mountain, and in chapter 9 God says be fruitful and multiply and replenish the earth; in chapter 10 begins the future, the list of generations, which was carried in the ark. A lifeboat, by contrast, is full not of the future but of the disaster itself in the form of things snatched from it; they may later prove valuable, either in themselves or as memories of the disaster, but they are not themselves the future toward which the boat is heading. An ark, in other words, leaves a wake, but a lifeboat both leaves and is a wake; in the case of Kabakov's immobilized boat, perhaps it is only a wake that does not leave one.

What would it mean for *The Boat of My Life* to be an ark? *The Ark of My Life* would be an allegory, a way of signifying distance from the disaster it would nonetheless be about. It would be a mode of self-preservation, a truly magic mountain. But this is just what Kabakov refuses. In not being an ark, *The Boat of My Life* is not an artwork in which life goes on by means of self-removal. Art is not an ark; the disaster that has induced flight has also struck art. *Lifeboat* carries with it the wounds of the past and so is a part of the disaster it is about.

This is Kabakov's critical turn. Art cannot be an escape from disaster into the exile of subjective inwardness, for the disaster of modernity for art is expressed in the forged identity of art and inwardness. To escape the disaster, then, we must criticize the very form escape has taken; we must not love our exile. A lifeboat is an escape from death, but to confuse the impulse to flight with life is itself mortification. And here we arrive at the cargo of *Lifeboat*, the crates. We literally enter this work of art, but what do we find there? In the modernism of subjective inwardness we would expect to find the precious life of the artist hidden away for safekeeping. Here, though, we find mere things. This is the stuff of history carried away from history, and its being carried away is what has reduced it to mere stuff. It is life in which possibility truly precedes actuality, life that might be lived again if these things find a home where they would no longer be mere things. But perhaps it is wrong to call them mere things, for they are the artifacts Kabakov has carried with him into exile. They are his own life alienated from him in the form of things (and, as Marx and Freud noted, to the extent a thing is an object without a home, an object glaringly indifferent to both us and itself, a thing is nothing but alienation). This is the material out of which Kabakov would make art were he to do so, but here he does not. Hence, when we enter this work we find, not the inwardness of the artist, but the locked up inwardness of things. Where privacy was to be, there privation is. Or, put otherwise, where a safe haven should have been, there the calamity has penetrated.

At the heart of *The Boat of My Life* is the mystery of things, a mystery that is the central fact of exile. Answering the question "Where do things come from?"

FIGURE 10. Ilya Kabakov, *The Boat of My Life* (detail). Courtesy of Barbara Gladstone.

has become impossible because it is mere things to which the question is put. The cultivation of subjective inwardness magically converts this mystery into freedom by identifying the alienation of things from subjectivity with subjectivity's overcoming of the world. The disastrous ejection of subjectivity from the world, which is the work of our time, finds expression in the idea of artistic freedom insofar as that idea represents a new home, a cessation of protest against the political divestitures of history. The art of withdrawal, especially in its affirmative and transcendent character, is in this light a kind of manic triumphalism, a blindness which takes itself for insight. Nothing, the artists says flinchingly, can hurt me. Kabakov's vehicle, however, carries the past it is fleeing. Indeed, as a lifeboat it is built to do just that. Exactly where the past should be transfigured into art, there it sits, boxed-up things, ready, as only things can be, for the moment when art will again be possible. This refusal to be transfigurative is the source of lamentation in Kabakov's art; the sound coming from the singer's throat is still noise, a tonic emanation not mediating life but tolling its absence. It is, however, not silence. Rather, it is a protest against being struck mute, which, as protest, must not pass itself off as a full voice still capable of song. The revolt against transfiguration is the refusal to give up the insistence on justice.

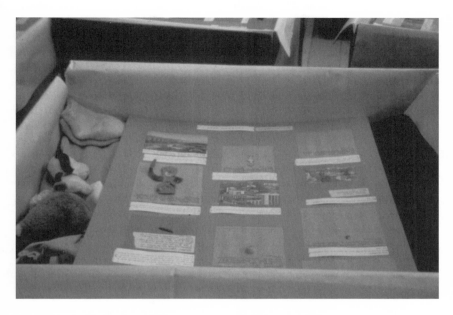

FIGURE 11. Ilya Kabakov, *The Boat of My Life* (detail). Courtesy of Barbara Gladstone.

One additional point is required to bring my interpretation home. We spectators board this boat to wander in its cramped space. When we look down into the crates we see things, but we cannot see all the things that are there to be seen. It is important that the crates are open, since then we can see that we cannot see everything. Of course, all we can see is more things, but think how different this work would be were the crates closed. They then would be coffins where the things would lie, like corpses, enclosed by their inwardness. The open and full crate, by contrast, at least hints at the inner life of things. Kabakov's thought, perhaps, is that if there are more things yet to see, then re-engagement with the world might yet be possible, but only as a re-engagement with the shattered and alienated stuff of the past.

What I am calling the stuff of the past has its more prosaic name also: garbage. That Kabakov is in the grip of garbage has become increasingly clear since he began working in the genre he calls "total installation."[27] It needs to be admitted that *Lifeboat* is sufficiently fastidious, especially as compared with, say, *The Toilet*, that it resists the ready identification of its cargo as garbage; nonetheless, the logic of garbage is already at work in it. Garbage is what society ejects in order to keep itself orderly; it is social superfluity incarnate. Every society

needs to make garbage as a receptacle of the expelled, but garbage's necessity functions in an odd way; it founds societies, makes them real as forms of order, but at the same time trails behind the societies it founds. Garbage is a stream made up of unactualized potentialities, which, as a stream of, specifically, what has been thrown away, embodies the nonidentity of social history and what a society recognizes as its own.

The specificity of garbage is lodged in this nonrecognition. Just because we do not look at it, and in the case of organic garbage often cannot do so, garbage serves as a means of preserving past moments from being reinscribed in present projects. It is, as Kracauer put it, the "refused" which is constituted as garbage by our cultivated inability to attend to it.[28] Thus, garbage is one of the ways we hide things from our own conscious instrumentalities. In this light, our inability to look at or touch garbage, our revulsion by it, looks strikingly like taboo. We are afraid of it the way we were afraid of the divine. Fear is our way of experiencing garbage's unapproachable inner life.

In our fastidious relation to garbage we acknowledge it as one of our privileged expressions of intrinsic value. Whereas of people Kant had to say we should treat them as ends and never *merely* as means, of garbage we feel we should treat it as a true final end and never as a means at all. What does not fit in with social order we allow to ripen as trash and so leave undisturbed by our future projects. This inner life of garbage once was ours, of course, since garbage is our product, but we no longer recognize it as our own. It lingers in the present as the past we cannot avow, and our being disgusted by it is thus an expression of our inability to live with our own history.

The prohibition on garbage through which it escapes our touch and sight establishes a gap between our fate and its. The garbage taboo is therefore the other face of its transcendence. Because having no future is another description of the eternal, the absolute pastness of garbage, its utter saturation by disposability, makes it the best image of what remains uncontaminated by time.

> Day creeps down. The moon is creeping up.
> The sun is a corbeil of flowers the moon Blanche
> Places there, a bouquet. Ho-ho . . . The dump is full
> Of images.[29]

Or: in its disarticulation of history and social order, garbage is the negative image of the future. As Groys has noted, there is an inner affinity between garbage and art because both are materializations of the socially superfluous;[30] art's *promesse de bonheur* arises only when it, too, resides on the dump. Thus it is in garbage that Kabakov sees the future for *Lifeboat*, a future that glimmers in a history he nei-

ther avows nor disavows but rather carries forward in its "unredeemed" condition. The salvage operation of this saving boat is the preservation of the future from redemption. Freud, recall, observed that it was not Vesuvius that destroyed Pompeii but the archaeologists.[31] The interest in Pompeii is also the agency of its evanescence. It is in this spirit that Kabakov's art of garbage is true neither to our past nor our future but rather to an unanticipated future the interest of which would be not the disavowing of garbage, but, on the contrary, the wondrous regard for that which has always failed to be identical with any recognizable interest.

That the past has become garbage is a function of an identity that we have forged, perhaps as the linchpin of our self-consciousness, between our recognizable futures and the nonrecognition of the passé. Thus, as we shield ourselves from the future in which we will no longer recognize ourselves, garbage, with its guarded inner life, becomes the most precise image of what we might all become. The question raised by Kabakov can be put this way then: is the recognition of the intrinsic worth of garbage, expressed in our fear of perceptual contact with it, also an image of a different future which can live with, be brought to life by, its relation to the nonidentical? *Can garbage yet be tolerated in its unredeemed state?* When we look into the crates on *Lifeboat*, can we see what the future might be built of, despite the obvious fact that they are filled with nothing but the wasted scraps, the rubble, of history? Might history meet up with its own most abject and still acknowledge its abjection?

The simplest form of Kabakov's question, the question *Lifeboat* poses literally, is whether there is a future in which garbage might have its own heading. That this is a question and not an answer is central to Kabakov's nonredemption of garbage. That it would be up to him to turn garbage into art, to redeem it by finding it a new home, would be to add insult to injury. Indeed, that he himself is anything but the man on the dump, living with *and as* the garbage of history, never quite seems to cross his mind. *Lifeboat* is the image of a civilization for which the only source of hope is stowed obscurely in its detritus. In this sense, its genre might be called "the ready-unmade." Kabakov's nonheroic goal is to save garbage not by redeeming it but by sharing its secrets.

Kabakov's artistic response to Hegelian theoreticism should by now be clear. Hegel is right that art is impossible, if by art we mean the special domain of artifice produced for the sake of the cultivation of subjective inwardness. But *that* art was always impossible; indeed, it was born of the experience of the impossibility of artistic mediation in the face of the obdurate stoniness of the world. That art, in short, was always the art of exile. The experience of the calcification of things is, however, the sensuous experience of alienation. It is the experience of loss out of which arises lamentation. Lamentation refuses to give up the loss

and so refuses to accede to the worldly wisdom of Hegel that ours is a philosophical age in which alienation is to be grasped instead of contested. In Kabakov's version of late modernism, philosophy's lesson that we need to see through our alienation by seeing through sensuous immediacy is learned, but the conclusion that it is in the nature of the world that we are not at home in it is turned into the story of exile—we continue to need what, and where, we have lost. Perhaps we are not at home, perhaps artistic mediation of the wound of subjectivity is not possible; in the face of this brute fact, we ought to recall that home is the first place we are homesick.

Let us introduce one more ship association as a way of drawing to a close. In what must be read as a critique of Hegel's obituary for art, Nietzsche attempts in *The Birth of Tragedy* to show that the tragic imperative scorned by Plato's Socrates was not simply overcome but also preserved in Platonic philosophy. "The Platonic dialogue," Nietzsche writes, "was, as it were, the barge on which the shipwrecked ancient poetry saved herself with all her children."[32] The impulse toward the artistic mediation of subjective individuality and the wheel of fate is salvaged from the Euripidean catastrophe. The tragedy of philosophy is its incapacity to carry through the project of reconciliation it has retrieved from tragedy's suicide. Hence, the famous Nietzschean call for a Socrates who practices music. The nontragic mistake in this beckoning that transforms it into pathos is the idealizing maintenance of music as in some sense having been preserved as a cultural resource even after poetry and her offspring have boarded the barge. Perhaps this error can be written off to Nietzsche's youthful infatuation with Wagner, but, in any case, the wish for a reconciliation to come is a symptomatic bit of nostalgia. It is of the essence of the barge that to board it is to suffer psychically the damage one has escaped bodily, so to dream of the Greek home is to fall prey to a mortified life of false enchantments. It has been the work of lamentable modernism to disenchant this, its own dream, and it is at the heart of Kabakov's late modernist art to carry through that disenchantment thoroughly and thereby to reveal that the true function of the Nietzschean barge is as a garbage scow. Avoiding the nostalgic expression of the exile's longing is a route to the preservation of the critical edge of art. It is one way of holding open the possibility of future artistic failure.

In an interview, Kabakov takes responsibility for the consequences of the disenchantment of artistic authenticity and subjective inwardness. If it is true that the artist's will is a symptom and not a cure for the alienation of modern life, then that will, far from being an end in itself, is a target of critique. Thus, in accounting for his own ambivalence about modernism in the face of official censorship, Kabakov says:

It must be said that I am talking about not my own will, but about how the natural circumstances took shape. In my situation, the circumstances were such that art was not my native home. I looked at art almost from the perspective of art history, from the perspective of the overall cultural situation. For me, painting was not like my own family but like a neighbor whom I would sometimes visit, just as I visited other neighbors who also interested me.[33]

In this curt declaration of worldly embeddedness, Kabakov sharply distinguishes himself from the Western, ironizing, self-preservative postmodernism I referred to earlier. If our interpretation of *The Boat of My Life* is apt, then modernist art never was anyone's native home but rather always exile. This does not lead Kabakov to deride the effort to build a home; he did, after all, drop in on his neighbors to see how they were making out. This respect for the art activity he himself has had to reject by force of circumstance is rooted in this thought: the longing matters. Even as, or especially as, that longing yields a phantasmagoric relation to an ideal other world that cannot exist, the longing matters. Inside its self-idealizations is the commitment to exile from the *alienated* world, a commitment Kabakov transforms into exile from the exile's imagined native home, into the vision of a future home for the historically outmoded. We are moderns, after all, so any civilization we yet may have will be made of garbage. Our exile is not lived through anywhere but in the scraps of the world. This thought is itself a piece of garbage. It is also, lamentably, true.

Conclusion

Ending poorly is the philosopher's nightmare. Our Platonic legacy anathematizes loose ends and binds us to the belief that we have ended well only if we have stripped our goals of their commanding impersonality, their perpetually extrinsic relation to our self-consciousness and self-conscious practices. This impulse to transform what we suffer—what we are committed to a priori—into a consequence rather than a cause of our activity is almost the defining need of philosophy. And that formulation, even with its whiff of exaggeration, captures the understanding of freedom as action undetermined, or incompletely determined, by its contingent historical antecedents (the understanding that is the central ideal of philosophical modernity) well enough to allow us to see why no philosopher can simply dismiss the ideal of ending well. I too, then, ought to be able to end with a purely retrospective summary of what I have discovered, but I fear that I cannot. The heart of my project, its beacon if not precisely its aim, has been to establish that when modernist art becomes an unavoidable moment in the self-reflection of philosophical aesthetics, the impulse to incorporate the end into the project and, thereby, to slip the bonds of the finite by means of a

conceptuality discrete from what it conceives, is endlessly impeded. The point has not been that modernist art, its historical self-awareness notwithstanding, offers a better way of ending; rather, I have been arguing that in lingering with the dead such art presses the claims of mortal life against the moment of philosophical consolation in which transient life would be surpassed in an ending that, at the final last moment, redeemed all unpaid claims. As a practice in which the end does not finally happen, modernist art enters philosophical reflection as the reminder of its unredeemed promise to secularize life, a promise that remains unredeemed as long as the notion of the proper end stays above the fray. Modernist art is the practice in which the impossibility of "the proper end" confronts the form of reflection that finds itself disoriented without such a concept; and in that confrontation, the effort to attain a strictly philosophical transcendence stumbles over the compelling repetition of what continues to trail behind.

In this light, Kabakov's *The Boat of My Life* appears to be the perfect work with which to end *Sustaining Loss*. By speaking in the name of a future that will be built neither on nor as the repudiation of what will be old when it arrives, *The Boat of My Life* exemplifies the residual power of art to jam itself in the gears of unrelenting modernization. It is art for a future in which, as Kant put it, "peoples will be ever more remote from nature" (*CJ* 60, p. 232)—a future, in other words, in which the measure of the distance traveled will itself recede into prehistory. Nonetheless, the spirit of our inquiry encourages us to hesitate in the face of such a perfect fit between an argument and its instantiation. *The Boat of My Life*'s exemplarity for the purposes of our wrapping up arises, after all, from its historical indeterminacy, from the uncertainty it forces on us about how art threads together the past, the present, and the future; in virtue of being composed of lives that do not cease to compel us merely in virtue of having been cut short, the boat's cargo is a load of works of art that will remain, perpetually, not yet even begun. Kabakov's work assiduously undoes the idea of "the final work of art" and thus stands apart from the effort to make it serve as a determinate final marker. Put otherwise: beyond suggesting that other works *might* stand with it as concluding instances of this book's argument, *The Boat of My Life* insists that other works *must* be able to stand with it as a condition for its standing at all. Because such a desideratum imposes demands on us that it is technically impossible to satisfy, we find ourselves threatened with ending poorly at the same moment that we seem to have espied a safe way out. *The Boat of My Life*'s luxurious aimlessness thereby provokes the ambivalence that, I am recommending, ought to haunt any philosophy of modernist art: we want a proper end in which our philosophical concepts keep everything in its proper place, but if our past is

still waiting for us in the wreckage of the future, then we are also obliged to learn to live with, and think in the shadow of, an improper end.

Hence, we have satisfied our philosophical impulses by finding Kabakov's boat at the end of our inquiry, but, in a kind of insult to those same impulses, finding it there has brought us face-to-face with the ambivalence of the modern idea of the end. But this is as it should be. Since the general argument of the preceding chapters has been that modernism, even in its premature Kantian expression, has been on a course toward a collision with the ruined significance it began by trying to leave behind, it has also been inevitable all along that we would find ourselves holding out at the last moment for a figure in which we could encounter the concept of the proper end in all its glorious, ignoble indeterminacy. *The Boat of My Life* is such a figure, since in it the philosophical dream of a concept of the end that will remain immune from all further transformation is confronted with the history it can never escape. The abstract concept (whose proper functioning depends on the severing of all ties to what it therefore enables us to repudiate) finds itself cohabiting with the deformed return of that from which it has been carved out; the repudiation has turned out to be the agent of the wheel of fate. From the point of view of the image of philosophy as the final ordering of what continues to disorder thinking—a characterization, arguably, of the highest Hegelian goal—Kabakov's nearly conceptual art harbors the prospect of perpetual disarrangement. It turns out, then, that we have gathered the strands of our story together in Kabakov's memorious (which is just another way of saying luxuriously aimless) boat full of junk in order to see what remains of philosophical aesthetics as it sinks back into the untranscended history of its own emergence. It is no use denying that this is a vengeful operation, but it is also nonetheless a compelling one: it challenges philosophical thinking to attain to its proper secularity by remaining oriented to what it never masters. *The Boat of My Life* is, we might say, the content of a conscience that is never purged of its (therefore) endless coming-to-be, and thus it undermines the effort to foreclose all future remembering of suffering. For a materialist philosophy true to its calling, *The Boat of My Life* represents the modernist form of hope.

If we capture something of the power of Kabakov's art in calling it luxuriously aimless, then perhaps we can invert the formula and think of Richter's art as aimlessly luxurious. The sheer lusciousness of Richter's paintings makes us wish we could call them "beautiful," and we might even accede immediately to that extortionate demand were it not for the shame we feel in using such a spoiled concept. But because shame signals a transgression that has already occurred, even if we do not know how, we ought not shy away from "beauty" too quickly. The beauty of Richter's art is its ungrounded insistence on a response

required of us *in extremis*. It has been said of Richter that his paintings are beautiful regardless of their subject matter, a lack of regard exemplified by the indifference of his source photographs and his "daily practice of painting."[1] While this sentiment is right, I would prefer to put it this way: his paintings exercise a compulsive force because the luxe, what is beautiful "regardless," is the uncanny leftover of an imperative, an embodied norm, that continues to press on us from the hollows of life. Richter's art is helplessly beautiful, even shamelessly so. Were we to try tying its beauty back to its source, treating that beauty as if it were the inherent claim of the scene it inhabits, our explanatory efforts would be frustrated; that failure, however, is the location of his art's homeless power. With Richter, we respond to what is extraneous to everyday life yet which nonetheless remains at home only there. If garbage is the form of the unredeemed for Kabakov, then the beauty of painting is its form for Richter. Thus, despite their diametrical practices, these two artists can stand together at the end because trash and diamonds are the two versions of the aimlessly significant.

Might this oscillation between the contradictory but mutually implicating paths of diamonds and trash be the logical space of modernist art? Might the dialectic of modernism, insofar as it works itself out in the repetitive, compulsive return to the scene of the endless death of nature, be powered by the traumatic incomparability of the nearly intelligible and the nearly ornamental that grants art a logical space? In terms of the materialist argument we have elicited from Kant, Hegel, and Freud, it becomes comprehensible that the fate of art should be suspended between dereliction and voluptuousness since they are the two obstacles modernist art encounters in its efforts to leave behind the impulses of its past. However, if the power of Kabakov and Richter is that they make the possibility of art now turn on its inability to do without a formal acknowledgment of those impulses—which is to say, of course, that they practice art in its most traditional, even archaic, manner—then, contrary to a certain popular Hegelian strain of contemporary discourse about art, they are not artists of or after the end of art. To the contrary: in their work, the end never passes away, even if, *or especially if,* it has already come and gone.

It was in order to describe with some precision how the endings and beginnings that make up the fabric of artistic modernism are the carriers of the undigested plaints of historical life that we took our pass through Freud. Just as Freud, in his taste both for people and artifacts, was a collector of the ruins of lost civilizations (childhood, for Freud, is the lost civilization of the adult, and a neurotic the ruins of that civilization), so too are Kabakov and Richter. The collector attends to the voices of the dead speaking within the living; this is not to say that the collector speaks to the dead, but rather that he attends to how the

living bear the voices of the dead in and as the texture of their lives. More emphatically, the collector treats the unconscious bearing of those voices as the pivot of historical consciousness, not because the past is lost but because the loss of the past is the prehistorical condition of modern life (and this, recall, is why Kant saw art as the afterlife of politics). Even the most artful denials of the voices of the past that we hear in those uniquely modern voices that declare fresh starts for us bear the burden of their historical trajectories, albeit in the theological tones of the end of history. Indeed, it is here most of all, when the modern voice boasts of its historical disorientation, that the presence of the past is at its most stutteringly awesome, since the radical defense of the new reveals unwittingly what a high price must be paid for the privilege of even imagining exiting history. This modern voice is the bearer of the demand for more creative forms of burial, which is to say of memory that feels the force of its undone work. To be a modernist artist is to respond to this demand; to be a philosophical aesthetician now is thus to have the taste for mournful life.

In a meditation on Darwin, Freud, and the spirit of modern materialism, Adam Phillips characterizes Freud's reverence for transience and mortality by putting a twist on Kafka's dark aphorism about hope. "For Freud," Phillips writes, "there was an after-life, but not for us."[2] At a trivial level, this means simply that we will not be around to live through our own aftermaths. But Freud is not simply saying that we will die. Ceaselessly across his writing, Freud tried to steal death back from the gods, and so to steal back living. The cutting edge of this reappropriation was not the thought that there is no afterlife (to deny that is to deny history), but rather that my afterlife happens here, in the same world I now inhabit, and not in another world in which I survive my death. Indeed, insofar as that "other world" would be the one in which I will still live, it is an artifact of the imaginative denial of the very possibility of an *after*life and so, also, a denial of history. The only afterlife there is, which is to say the only end that really is an end because it is also a beginning, is a secular one. The secular afterlife of the dead, I have been arguing, is another name for artistic modernism. And the question remains whether this mournful practice of living, a practice stripped of all hope that it will reauthorize living in history, can orient us to our future.

Reference Matter

Notes

Chapter 1: Introduction

1. T. J. Clark, *Farewell to an Idea: Episodes from a History of Modernism* (New Haven, Conn.: Yale University Press, 1999), p. 15.

2. The notion of historical truth as the traumatogenesis of formal and revisionist history will appear again in my argument. It is borrowed from Freud's *Moses and Monotheism*, *SE* 23: 127–32.

3. By modern philosophical aesthetics I mean the tradition which emerges in the eighteenth century in Joseph Addison and Francis Hutcheson, and which continues into the twentieth century with Frankfurt School critical theory, in which reflection on art is mediated by reflection on the judgment of it. The specifically modern component of this tradition is its so-called subjectivism, its view that what is intrinsically valuable about art is the valuable experience it uniquely makes possible for the person who attends to it. Modern philosophical aesthetics is thus a branch of social philosophy and psychology first and foremost, although it arises from historically emergent ethical, epistemological, and metaphysical issues. For historical background on the emergence of modern aesthetics, see Jerome Stolnitz, "On the Origins of 'Aesthetic Disinterestedness,'" *Journal of Aesthetics and Art Criticism* 20 (Winter 1961): 131–44, and Peter Kivy, *The Seventh Sense: A Study of Francis Hutcheson's Aesthetics and Its Influence in Eighteenth Century Britain* (New York: Burt-Franklin, 1976). For the canonical account of the subjectivism of modern aesthetics, see Hans Georg Gadamer, *Truth and Method* (New York: Continuum, 1975), pp. 29–90.

4. Michael Fried, "How Modernism Works: A Response to T. J. Clark," in *Pollock and After: The Critical Debate*, ed. Francis Frascina (New York: Harper and Row, 1985), p. 70; originally published in *Critical Inquiry* 9 (September 1982): 217–34.

5. Frederick A. G. Beck, *Greek Education 450–350 B.C.* (New York: Barnes and Noble, 1964).

6. Plato, *Ion* 541b, trans. Lane Cooper, in *Plato: The Collected Dialogues*, ed. Edith Hamilton and Huntington Cairns (Princeton, N.J.: Princeton University Press, 1961), p. 227.

7. The argumentative strategy Socrates uses against Ion is a standard one in those of Plato's dialogues in which he seeks to rescue knowledge from its divine or traditional vehicles. As Socrates presses Ion to conceptually distinguish between something's being wise because Homer teaches it and Homer's having taught it because it was wise, so too does he press Euthyphro to distinguish between an action's being pious because the gods love it and the gods loving it because it is pious. This is the perfect strategy for interrogating a structure of action or knowledge in which traditional modes of justification have given way. See *Euthyphro* 10a–11c, in *Plato: The Collected Dialogues*, pp. 178–80.

8. In addition to Homer, we might also adduce Hesiod, through whom agricultural, climatological, and cosmological knowledge is poetically delivered, or Herodotus—as does Aristotle, as we shall see shortly. See Herodotus, *The History of Herodotus*, trans. George Rawlinson (New York: Tudor Publishing, 1947), and Hesiod, *Works and Days*, ed. M. L. West (Oxford: Clarendon Press, 1978).

9. E. H. Gombrich, *Art and Illusion: A Study in the Psychology of Pictorial Representation* (Princeton, N.J.: Princeton University Press, 1960), pp. 116–45. See also the suggestive comments in Beck, *Greek Education*, pp. 80–81.

10. Jan Assmann writes: "Since Mnemosyne was the mother of the nine Muses, her name came to stand for the totality of cultural activities as they were personified by the different Muses. By subsuming these cultural activities under the personification of memory, the Greeks were viewing culture not only as based on memory but as a form of memory in itself." Jan Assmann, *Moses the Egyptian: The Memory of Egypt in Western Monotheism* (Cambridge: Harvard University Press, 1997), p. 15.

11. Gombrich also makes the important point that Plato's arguments against the art of his time were not arguments against art as such. Rather, Plato targets specifically the conscious fabrication of mnemic fictions as an inadequate response—perhaps even a dangerous one—to an already ongoing crisis of transmission. Once the sanction for legitimate inheritance has entered a phase of crisis, fictionality becomes mendacity. Thus, Plato's disdain for Greek artistic practices was consistent with his admiration for those of the Egyptians; the latter remained unchanged for ten thousand years, regulated by law, a feature Plato infers to be a function of their divine status. A practice initiated by Isis is one that ought not to change, and its not changing is the preservation of its divine origin. Change, that is, the deleterious loss of traditional sanction, cannot be overcome through practices of fiction; indeed, it can only be compounded as false sanctions take on the force of the original. Of course, that Plato says the Egyptian traditions remained unchanged for "ten thousand years" also may be a signal that this is an ironic argument. Plato, *Laws* II 656d–657c, in *Plato: The Collected Dialogues*, pp. 1253–54.

12. Friedrich Nietzsche, *The Birth of Tragedy out of the Spirit of Music; or, Hellenism and Pessimism*, trans. Walter Kaufmann (New York: Vintage Books, 1967).

13. Aristotle, *Poetics* 1451a37, trans. Richard Janklo (Indianapolis: Hackett Publishing, 1987), p. 12.

14. On Thucydides, see J. B. Bury and Russell Meigs, *A History of Greece to the Death of Alexander the Great* (New York: St. Martin's Press, 1975), p. 251.

15. Leon Battista Alberti, *On Painting*, trans. John R. Spencer (New Haven, Conn.: Yale University Press, 1966).

16. The reflection of the legitimacy of the state that supports art in art's own legitimated derivation from classical models was a long-lived trope in apologies for art. When Giorgio Vasari began his *Lives* by distinguishing the *antico* from the *vecchio*, he thereby described how the *rinascimento* in the arts was to be understood as establishing a relation to what in the classical tradition remained undying, that is, remained continuous with present practice. The glory of this re-established continuity was then a synecdoche of the state's own classical virtue. Giorgio Vasari, *Lives of the Artists*, sel. and trans. George Bull (New York: Penguin Books, 1965), p. 45.

17. Although his subject is the use of images in late medieval and early Renaissance criminal law, Samuel Y. Edgerton, Jr., in his *Painting and Punishment: Art and Criminal Prosecution During the Florentine Renaissance* (Ithaca, N.Y.: Cornell University Press, 1985), spells out beautifully the essential role of the pictorial instantiation of the most abstract philosophical and civic concepts in Alberti's era.

18. The description of Alberti's vernacular for craftsmen is from Joan Gadol, *Leon Battista Alberti* (Chicago: The University of Chicago Press, 1969), p. 22.

19. The socially radical intent of Alberti's defense of painting can be grasped best against the background of the fourteenth-century resurgence of the Gothic style. As Millard Meiss explains, the move against naturalism was a reassertion of a priestly power to interpret images against the transparency, the "common" interpretability, of Giottoesque innovations. Alberti was intervening in a political struggle over sites of historical transmission. See Millard Meiss, *Painting in Florence and Siena in the Age of the Black Death: The Arts, Religion, and Society in the Mid-Fourteenth Century* (Princeton, N.J.: Princeton University Press, 1951).

20. David Summers, *The Judgment of Sense: Renaissance Naturalism and the Rise of Aesthetics* (Cambridge: Cambridge University Press, 1987), pp. 125–50.

21. By not even trying to present post-Renaissance examples of art's traditional transmissive function, I am attempting to dodge the formidable debate over the origins of modern historical self-consciousness. That there is the germ of an antagonistic differentiation between past and present times in Alberti which is not present in the ancients seems to me incontestable, but whether it is merely a germ or has already flowered in Renaissance thought—indeed, whether the germ is really first planted in Renaissance thought—is beyond my competence to resolve. Reinhart Koselleck's influential book *Kritik und Krise: Eine Studie zur Pathogenese der bürgerlichen Welt* (Freiburg: Karl Alber, 1959), translated as *Critique and Crisis: Enlightenment and the Pathogenesis of Modern Society* (Cambridge: MIT Press, 1988), established the contemporary terms of this debate by locating the emergence of modern historical self-consciousness in the seventeenth- and eighteenth-century European Enlightenment. In his inaugural lecture as professor in Heidelberg in 1965, Koselleck makes his point beautifully by staging a contrast between Altdorfer's view of the relation between past and present in his painting of *The Battle of Issus* and Schlegel's view of that relation three hundred years later when he studies Altdorfer's painting:

[For Altdorfer] the present and the past were enclosed within a common historical plane. . . . Schlegel praised the work in long sparkling cascades of words, recognizing in it "the greatest feat of the age of chivalry." Schlegel was able to distinguish the painting from his own time, as well as from that of the Antiquity it strove to represent. For him, history had in this way gained a specifically historical dimension, which is clearly absent for Altdorfer. . . . Stating my thesis simply, in these centuries [separating Altdorfer and Schlegel] there occurs a temporalization of history, at the end of which there is the peculiar form of acceleration which characterizes modernity. (R. Koselleck, "Modernity and the Planes of Historicity," in *Futures Past: On the Semantics of Historical Time* [Cambridge: MIT Press, 1985], pp. 4–5)

David Lowenthal, however, pushes the same break with which Koselleck is concerned back into the Renaissance itself:

The benefits and burdens of the past first came under scrutiny in the Renaissance. Previous epochs had not wholly ignored these issues—the promises and perils of imitating Greek forerunners were much debated in early Imperial Rome—but not until the mid-fourteenth century, with Petrarch, did self-conscious concern about the rival merits of old and new become a dominant theme, first in Italy, then in France and England. Its importance followed directly from the Renaissance perspective that there was a past as such, a valued realm of antiquity admired by and distinct from the present. (David Lowenthal, *The Past Is a Foreign Country* [Cambridge: Cambridge University Press, 1985], p. 75)

While Koselleck agrees with Lowenthal to a degree that there is an implicit contest between past and present in Renaissance culture, he denies that the Renaissance form of the contest is a symptom of specifically modern historical self-consciousness:

The doctrine of rebirth, of "Renaissance", which was consciously opposed to the *mittlere Zeiten*, took much longer than the term *Mittelalter* to become condensed into a general concept of periodization. While humanists favored verbs and adjectival expressions for the renewal of return, awakening, or blooming, or for the description of return, the term "Renaissance" first appeared as late as the mid-sixteenth century and then only in an isolated fashion. . . . As a term primarily characteristic of epochs in the history of art and literature, "Renaissance" first entered regular use during the Enlightenment. The term "Renaissance" therefore did not appear together with that of "Middle Ages" as a counter-concept, but rather established itself in a delayed manner as a form of historical-chronological determination after the establishment of *Mittelalter*. ("'*Neuzeit*': Remarks on the Semantics of the Modern Concepts of Movement," in *Futures Past*, p. 236)

My marginally educated sympathies are with Koselleck here, but his disagreement with Lowenthal does not even map out all the relevant possibilities. Anthony Kemp argues that both Renaissance and Enlightenment historical self-consciousness alike are responses

to a crisis of historical time that emerges in the Christian notion of sacred time in the twelfth century; see his *The Estrangement of the Past* (New York: Oxford University Press, 1991). It is not possible for me to evaluate Kemp's general argument, but I take some comfort about my own taking liberties from the inability of historiographical experts to agree even on which half of the second millennium witnesses the beginning of historical time.

22. The funerary stone is exemplary in another regard also. That the self-transmission of art was the bearer of the transmission of its semantic content is evidenced by the fact that the imperative to remember can still be read on monuments, and in some sense still grasped, long after it can be heeded. We cannot remember what we never knew, so "forget me not" falls on deaf ears when the pleader has been forgotten by all survivors; the stone, though, carries on in its unstinting command. When the particular imperative becomes impossible, the imperative of art becomes independently audible.

23. I do not mean to suggest here that this mnemic function of art has simply vanished. When we teach children the alphabet, we do so by teaching them the alphabet song. We do not teach the song and also the alphabet; rather, we teach the alphabet as a song. When children try to recite the alphabet they do not yet firmly know, they know when they make an error not because they know they have gotten the sequence of letters wrong, but because they have gotten the song wrong. The rhythm of the song carries the alphabetic sequence along its path of necessity. Since adult learning is by now so radically stripped of its artistic discipline, we might be inclined to understand the alphabet song as a crutch which can be thrown away once the alphabet has been learned. If we are so inclined, we will be tempted also to disidentify the alphabet and its song, with the former being what is remembered by sheer force of habituation and the latter a mere childish leg up on the process. But who hasn't, when asked what letter comes three after *k*, sung a little ditty to themselves?

24. "The Platonic dialogue was, as it were, the barge on which the shipwrecked ancient poetry saved herself with all her children." Nietzsche, *The Birth of Tragedy*, p. 90.

25. The sheer quantity of historical work needed to undo the tendency to anachronism is exemplified in the encyclopedism brought to bear on this problem by Hans Belting, *Likeness and Presence: A History of the Image Before the Era of Art*, trans. Edmund Jephcott (Chicago: University of Chicago Press, 1994), and David Freedberg, *The Power of Images: Studies in the History and Theory of Response* (Chicago: University of Chicago Press, 1989).

26. For instances of this, see Nelson Goodman, "When Is Art?" in *Ways of Worldmaking* (Indianapolis: Hackett Publishing, 1978), pp. 57–70, and Marx Wartofsky, "Art as Humanizing Praxis," in *Models: Representation and the Scientific Understanding* (Boston: D. Reidel Publishing, 1979), pp. 357–69. Although Goodman and Wartofsky did important work in the philosophy of art from, respectively, contextualist and historicist perspectives, their work against decontextualizing and dehistoricizing intuitions was never done.

27. The claim for the ontological distinctness of art has its origins prior to this century, of course. In fact, one finds it at work already in Kant and Hegel, and it is their the-

ories with which I shall be concerned in Chapters 2 and 3. The drawing of ontological boundaries is most pronounced in Hegel, for whom the question of what art is must be made distinct from the question of the extrinsic purposes to which it may be put. But in Hegel this is a distinction between intrinsic and extrinsic purposes rather than between intrinsic nature and extrinsic purposiveness. Hegel's boundary drawing is for the sake of specifying the kind of transmissiveness art supports. I suspect it never would have occurred to him to consider art as anything other than a mode of spirit's historical self-making, but since this is due to his quite specific sense of the transmissive function of philosophical reflection in general I must defer considering it.

28. Arthur C. Danto, *The Transfiguration of the Commonplace* (Cambridge: Harvard University Press, 1981).

29. The historicist slander "degenerately" is intended to distinguish contemporary views of art as unhistorical in virtue of its privileged relation to the selves it embodies from earlier expressivist views which held artistic expression to be part of the history of human practices and thus part of the history of human self-making. The earlier views are exemplified by Benedetto Croce, *Aesthetic as Science of Expression and General Linguistic*, trans. Douglas Ainslie (New York: Farrar, Strauss and Giroux, 1969; first published in 1901); R. G. Collingwood, *The Principles of Art* (Oxford: Oxford University Press, 1958; first published in 1938), and Ernst Fischer, *The Necessity of Art*, trans. Anna Bostock (Baltimore: Penguin Books, 1963). While the unhistorical view has become common cultural property, influential versions of it can be found in Suzanne Langer, *Feeling and Form: A Theory of Art* (New York: Charles Scribner's Sons, 1953), and Harold Rosenberg, "The American Action Painters," in *The Tradition of the New* (London: Thames and Hudson, 1962), pp. 23–39. For a selection of the range of expressivist positions, see the appendix to Alan Tormey, *The Concept of Expression: A Study in Philosophical Psychology and Aesthetics* (Princeton, N.J.: Princeton University Press, 1971), pp. 143–52.

30. Arthur C. Danto, "The End of Art," in *The Philosophical Disenfranchisement of Art* (New York: Columbia University Press, 1986), pp. 81–115.

31. Noël Carroll, "Essence, Expression, and History: Arthur Danto's Philosophy of Art," in *Danto and His Critics*, ed. Mark Rollins (Oxford: Basil Blackwell, 1993), pp. 79–106.

32. The examples of this conceptual mishap are too numerous to list. Behind many of the lesser examples, however, we can often detect the deformed heritage of Arnold Hauser (see *The Sociology of Art*, trans. Kenneth J. Northcott [Chicago: University of Chicago Press, 1982]), and Pierre Bourdieu (see *Distinction: A Social Critique of the Judgment of Taste*, trans. Richard Nice [Cambridge: Harvard University Press, 1985]). Now, this peremptory accusation obliges me to note that neither Hauser nor Bourdieu can be held directly responsible for the patently deflationary sociologies that have been developed in their names. The subtlety and self-reflexivity of Bourdieu's thinking suggests that it might be construed rightly as antideflationary. For instance, *Distinction* concludes with the emphatic reminder that its aim has been not to reduce culture to some already given *socius* but rather to inflate it by discovering the social secrets it shields even from its own gaze:

The philosophical sense of distinction is another form of the visceral disgust at vulgarity which defines pure taste as an internalized social relationship, a social relationship made flesh; and a philosophically distinguished reading of the *Critique of Judgment* cannot be expected to uncover the social relationship of distinction at the heart of a work that is rightly regarded as the very symbol of philosophical distinction. (pp. 499–500)

Bourdieu's analysis of aesthetic sociality leads him to claim that "sociology is rarely more akin to social psychoanalysis than when it confronts an object like taste" because "here the sociologist finds himself in the area par excellence of the denial of the social" (p. 5). However, this antideflationary posture is nonetheless coupled with a restricted sense of social difference as what divides a *socius* rather than as what totalizes it. Thus, he can make claims such as, "The cultural divide which associates each class of works with its public means that it is not easy to obtain working-class people's first-hand judgments on formalist innovations in modern art" (p. 33). Bourdieu is restlessly aware of the problems he confronts in joining a nondeflationary account of art and culture to a deflationary classificatory scheme—that is what makes his sociology of art endlessly fascinating and useful. The same cannot be said for the rigorous deflationists who follow him.

33. There are two claims at work here that it would be judicious to distinguish: that philosophy is only recently concerned with timeless truths; and that philosophy, in its concern with timeless truths, is only recently unconcerned with issues of transmission. It is the dominant interpretation of the Platonic legacy in philosophy that the centrality of metaphysics to the history of philosophy expresses a "timeless" concern with timeless truths. Perhaps this is so, but it by no means entailed an unconcern for pedagogy. Indeed, it ought at least give us pause whether the "two-world" interpretation of Platonic metaphysics characteristic of the Christian era can be as unimpeachable as it often appears in the face of the unceasing concern in Plato and his followers that "love of wisdom," or philosophy, is ceaselessly in danger of disappearing and so itself needs another discipline—also, oddly, called "philosophy"—to preserve it. The standard interpretations of the Platonic legacy are consistent with my second point (that philosophy is only recently unconcerned with issues of transmission) but inconsistent with the first point (that philosophy is only recently concerned with timeless truths). A similar point can be made in regard to the dominant interpretation of the Cartesian legacy as making epistemology rather than metaphysics central to philosophy. No reasonable interpreter can deny Descartes' concern with method and transmission, but that this concern was intrinsic to the philosophical enterprise, rather than an extrinsic and separable adjunct to its focal pursuit of timeless truths, is mooted. In either case, though, a change is notable in contemporary philosophy, in which philosophy of education, and philosophy *as* education, is a mere subspecialty. It is an inquiry worth pursuing how philosophy became detached from either its intrinsic or extrinsic concern with historical transmission.

34. I leave it an open question whether Foucault himself ever wholeheartedly embraced radical historical heterogeneity in the manner of his epigones. That he was unable to clarify the relation between historical ruptures and continuities, however, is in-

dubitable. Nowhere does his uncertainty obtrude more clearly than when he tries to dispel it. For instance, in arguing against the apparent relativist implications of archaeology, Foucault writes:

> To say that one discursive formation is substituted for another is not to say that a whole world of absolutely new objects, enunciations, concepts, and theoretical choices emerges fully armed and fully organized in a text that will place the world once and for all . . . it is to say that statements are governed by new rules of formation, it is not to say that all objects or concepts, all enunciations or theoretical choices disappear. On the contrary, one can, on the basis of these new rules, describe and analyze phenomena of continuity, return, and repetition.

What could be clearer? However, Foucault's argument here leaves unexplained whether the relation between the continuities and repetitions disclosed within distinct discursive formations is itself to be thought of as a continuity or a discontinuity between formations. Hence, he completes this thought by taking back the concession it appears at first to make.

> Archaeology does not hold the content for the primary and ultimate *donnée* that must account for all the rest; on the contrary, it considers that the same, the repetitive and the uninterrupted are no less problematic than the ruptures; for archaeology, the identical and the continuous are not what must be found at the end of the analysis; they figure in the element of a discursive practice; they too are governed by the rules of formation of positivities; far from manifesting that fundamental, reassuring inertia which we like to use as a criterion of change, they are themselves actively, regularly formed.

It is assuredly more than a matter of liking and disliking whether an historian or an archaeologist needs to make clear his or her criteria of change. To the extent that those criteria are themselves shaped by the discursive formations the ruptures between which they are supposed to help explain, they cease to be *criteria* of change at all. It is to the avoidance of this incoherency that I am devoting my next few paragraphs. Michel Foucault, *The Archaeology of Knowledge*, trans. A. M. Sheridan Smith (New York: Pantheon Books, 1972), pp. 173–74.

35. This, of course, is the theme of many of Kant's political essays. When human reason develops sufficiently to address to itself the question of its emergence from nature, it is confronted all around with the hideous and demeaning spectacle of its non-autochthony. In its recoil, reason finds itself impelled to wish for a different history and so compelled to falsify its own conditions of possibility. To combat this compulsion, the motto of Enlightenment must be: Dare to be wise. In other words, Enlightenment demands not the use of reason detached from its awareness of reason's sordid history, but rather the courage to rationally face reason's own proper history. See "An Answer to the Question: 'What Is Enlightenment?'" and "Conjectures on the Beginning of Human History," in *Kant: Political Writings*, ed. Hans Reiss, trans. H. B. Nisbet (Cambridge: Cambridge University Press, 1970), pp. 54–60 and 221–34.

36. It is the unsurpassed achievement of Theodor Adorno to have shown that the logic of reflection, and not just its most obvious failures, is endless. I have aimed to indicate that I work here in his debt by choosing a passage from *Negative Dialectics* as my epigraph. Adorno's own questioning, to which he implicitly refers in the epigraph, is often spurred by a turn toward Kant which is simultaneously a dialectical turn away: "There is one variant that should not be missing from the excessively narrow initial questions in the *Critique of Pure Reason*, and that is the question how a thinking obliged to relinquish tradition might preserve and transform tradition." This is the spur I am trying to preserve and transform in my own turn. See *Negative Dialectics*, pp. 54–55.

Chapter 2: Kant's Discovery of Artistic Modernism

1. That this view is a truism is exemplified in the second edition of Paul Guyer's groundbreaking study, *Kant and the Claims of Taste* (Cambridge: Cambridge University Press, 1997). In the first edition, Guyer explicated the structure of aesthetic judgment in Kant without exploring its relation to art; in his new edition, Guyer adds a chapter on "Kant's Conception of Fine Art" but otherwise leaves the structure of his argument unchanged. While it is not an explicit part of Guyer's argument that art raises no independent philosophical problems for Kant, that he leaves his original argument essentially unchanged nonetheless implies that considering the specific problems of art requires no novel assessment of Kant's overall aims and achievements. In that sense, Kant's theory of art is, for Guyer, logically subsidiary to his theory of aesthetic judgment and natural beauty. Although I will soon veer from Guyer in ways he would find disagreeable, on this structural issue I am in agreement with him.

2. In the most extreme version of this criticism, Noël Carroll denies that Kant has any proper philosophy of art at all. See his "Beauty and the Genealogy of Art Theory," *Philosophical Forum* 22, no. 4 (1991). In *A Philosophy of Mass Art* (Oxford: Oxford University Press, 1997), Carroll argues that most contemporary critical theories of modernism and mass culture are misguided because they take their bearings from the false supposition that there is a Kantian philosophy of art. I have already taken issue with Carroll about the consequences of his denial in a review of *A Philosophy of Mass Art*, in *Journal of Philosophy* 96, no. 2 (February 1999): 99–105; it is the burden of this chapter to show that the supposition Carroll takes to be false is perfectly licit. Whether the chapter carries that burden is for readers to judge, but there is no use in hiding from the fact that speaking blithely of Kant's "philosophy of art" will strike at least one such reader as wholly inventive.

3. No question is more central to Kant scholarship than the systematic relation between the *Critique of Judgment* and the first two critiques. In the introduction, Kant refers to this third book in the critical project as providing a mediating connection (*Verbindungsmittel*) between the first two, but this obvious signal of systematic intent does not tell us quite how to interpret the specific sense of mediation it carries. Now is an appropriate moment, therefore, to avow my intention to remain agnostic about this issue. Since my aim is explore how far a reinterpretation of certain apparently marginal argu-

ments in the *Critique of Judgment* might allow us to evaluate afresh the purpose of Kant's text, an answer to the question of its relation to the rest of the critical project must await my results. In other words, what Kant means in the *Critique of Judgment* depends in large measure on what we can make of what he wrote, and a premise of my inquiry is that our making sense is not done yet. But this agnosticism can be given a more concrete justification also. After all, it is just the concept of "mediation" that Kant's aesthetic theory (or *any* systematic aesthetic theory) seeks to analyze and explain; because the interpretation of how the *Critique of Judgment* is to serve as a *Verbindungsmittel* depends on what its arguments can show that very concept to mean, we can presume no interpretive standpoint independent of the text from which to evaluate Kant's systematic intentions.

4. David Hume, "Of the Standard of Taste," in *Selected Essays*, ed. Stephen Copley and Andrew Edgar (Oxford: Oxford University Press, 1993), pp. 133–54, and George Santayana, *The Sense of Beauty*, ed. William G. Holzberger and Herman J. Saatkamp, Jr., (Cambridge: MIT Press, 1998).

5. Freud later reformulates this synthetic a priori truth as the pleasure principle.

6. See Dieter Henrich, *Aesthetic Judgment and the Moral Image of the World* (Stanford, Calif.: Stanford University Press, 1992).

7. The wonder of Kant's writing is its refusal to back down from the terror of having lost the world. We cannot precisely appreciate Kant for this, of course, for it is a stance coldly lacking in benevolence, which he himself calls an element of moral taste (*CJ* 5, pp. 52–53). Rather, we ought to regard him with awe; he is a sublime masochist for whom the comforts against terror that nostalgia for the lost world might provide are themselves the source of greater terror. His comportment toward the loss of the world cannot help but remind us of what Kant admires, finds sublime, in the comportment of the military leader.

> Even war has something sublime about it if it is carried on in an orderly way and with respect for the sanctity of the citizens' rights. At the same time it makes the way of thinking of a people that carries it on in this way all the more sublime in proportion to the number of dangers in the face of which it courageously stood its ground. A prolonged peace, on the other hand, tends to make prevalent a merely commercial spirit, and along with it base selfishness, cowardice, and softness, and to debase the way of thinking of that people. (*CJ* 28, p. 122)

Kant seems to have acknowledged that we are not free to lift the burden of melancholy, yet he stands his ground rather than pursuing peace.

8. "We can see at this point that nothing is postulated in a judgment of taste except such a *universal voice* about a liking unmediated by concepts" (*CJ* 8, p. 60).

9. This option appears as the reconciliation of nature and her lost son, man, in Nietzsche, *The Birth of Tragedy*, p. 37.

10. This is a central theme of J. M. Bernstein's invaluable essay "Memorial Aesthetics: Kant's *Critique of Judgment*," in his *The Fate of Art: Aesthetic Alienation from Kant to Derrida and Adorno* (University Park: Pennsylvania State University Press, 1992). Bern-

stein defends his conclusion that we know about knowing only by not knowing, that is, only at the limits of cognitive grasping that rear up in aesthetic judgment, as follows:

> Resistance to the memorialization of aesthetics on the grounds that it destroys the universality of Kant's critical system through the introduction of an essentially aporetic moment, a non-recuperable indeterminacy at the core of determinate reason, is nonetheless misplaced since it ignores the fact that [Kant's] metaphysics was aporetic from the beginning, invoking, as it did, inscrutable conditions for understanding (the "I think," and the spontaneous powers of the mind), unknowable domains and untotalizable totalities. It is only against the background of these aporetic moments that Kant feels constrained to promote the ideal of determinacy. However, to ignore the moments of limit and opacity in the critical system is to render it uncritical. (p. 64)

The impact of Bernstein's work on Kant on my own thinking began long before my good fortune in coming to have him as my colleague at Vanderbilt.

11. As Kant puts it late in the argument, beauty is but a symbol of the morally good (*CJ* 59, pp. 225–30).

12. For instance: "A practical precept which presupposes a material and therefore empirical condition must never be reckoned a practical law. For the law of pure will, which is free, puts the will in a sphere entirely different from the empirical." Immanuel Kant, *Critique of Practical Reason*, trans. Lewis White Beck (Indianapolis: Bobbs-Merrill, 1956), p. 34.

A similar point is made in the *Critique of Judgment* as a scolding reminder to sloppy readers:

> One of the various supposed contradictions in this complete distinction of natural causality from the causality through freedom is given in the following objection to it. It is held that when I talk about nature putting *obstacles* in the way of the causality governed by laws of freedom (moral laws), or about nature *furthering* it, I do after all grant that nature *influences* freedom. But this is a misinterpretation, which is easily avoided merely by understanding what I have said. The resistance or furtherance is not between nature and freedom, but between nature as appearance and the *effects* of freedom as appearances in the world of sense; and even the *causality* of freedom (of pure and practical reason) is the *causality* of a natural cause (the subject, regarded as a human being and hence as an appearance) subject to [the laws of] nature. It is this causality's *determination* whose basis is contained, in a way not otherwise explicable, in the intelligible that is thought of when we think freedom (just as in the case of the intelligible that is the supersensible substrate of nature). (*CJ* 9, p. 36, n. 39)

Kant's pique notwithstanding, it is, as we shall see, the troubles that remain attached to the idea of "effects of freedom in the world of sense" even after it has been transcendentally clarified that provide the content for the *Critique of Judgment*.

13. This is why the *Critique of Judgment* aims to establish only one concept: the purposiveness of nature. Although purposiveness is a quality of a concept, and as such is at home in the space of consciousness, to the extent it is at home *only* in the space of consciousness it fails to attain the end in the world of which it is putatively, qua purpose, the cause. While the purposiveness of nature is established only through consciousness, it remains unestablished in consciousness alone. Thus, Kant writes that "it is through [the concept of the purposiveness of nature] that we cognize the possibility of the final purpose, which can be actualized only in nature and in accordance with its laws" (*CJ* 9, p. 37). That freedom which has its basis supersensibly only happens in nature.

14. It is worth restating that I am discussing the *appearance* of freedom here; I am not making the rather different metaphysical assertion that all negation a priori requires preservation of what it negates. This would certainly be false to Kant and it may well be false overall, but in any case a defense of it would require other arguments than the ones being made now. I am concerned only with how freedom shows itself, and that display, I am arguing, requires the display of mechanism and hence can only establish itself in failure.

15. There are textual difficulties in this passage which need to be noted. In his manuscript, Kant wrote *nachahmung* both where Pluhar translates "copied" and "imitated." Kant later corrected his error so that the distinction is between *nachmachung* and *nachahmung*. Pluhar translates this faithfully as "copied" and "imitated," but then objects that Kant surely meant to write *nachahmung* and *nachfolge*, "imitated" and "followed." Pluhar must be wrong, however, because in the context Kant is distinguishing imitating, which the pupil should do, from copying, which the student ought not to do. In other words, Kant is distinguishing two manners of intentionality. "Following," however, is not explicable in intentional terms alone, since the capacity to follow is genius.

16. To my knowledge, this theme has received scant direct critical attention. For further treatment of it, see Gianni Vattimo, "The Structure of Artistic Revolutions," in *The End of Modernity: Nihilism and Hermeneutics in Postmodern Culture*, trans. Jon R. Snyder (Baltimore: Johns Hopkins University Press, 1991), pp. 90–109; Paul Guyer, "Genius and the Canon of Art: A Second Dialectic of Aesthetic Judgment," in *Kant and the Experience of Freedom* (Cambridge: Cambridge University Press, 1996), pp. 275–303; and Jonathan Salem-Wiseman, "Modernity and Historicity in Kant's Theory of Fine Art," *Philosophy Today* 42, no. 1 (1998): 16–25.

17. The power to follow, then, can also be construed as the power to overcome the fear of the master's revenge. See Allan Kaprow, "The Legacy of Jackson Pollock," in *Essays on the Blurring of Art and Life*, ed. Jeff Kelley (Berkeley: University of California Press, 1993), pp. 1–9.

18. It is easy game to make fun of Kant's taste on the grounds of its provinciality. It is, of course, irrelevant to my argument whether Kant's taste harmonizes with his philosophical account; as I warned in the opening paragraphs, we ought not expect an untimely explication of modernism to cohere neatly with its context of presentation. Still, it bears noting that in many respects Kant's taste also anticipates later developments in art, his preferences for *designs à la grecque* notwithstanding. His formal analysis of the possi-

bility that the beauty of color may be independent of charm under certain circumstances has the quality of the kind of defense of the minimum necessary for aesthetic judgment; not surprisingly, therefore, it is a useful model for thinking about the place of the monochrome in the history of modernism. In *Kant After Duchamp* (Cambridge: MIT Press, 1996), Thierry De Duve almost makes just this connection. In tracing out the importance of Frank Stella's stripe paintings of 1959–60 on the subsequent development of minimalism, De Duve raises the fascinating question why, despite the specter of blankness that haunted the monochrome, no one has yet offered a blank canvas as a monochrome painting. Stella's paintings avoided blankness only by the differentiating effect of the stripes, but the stripes were themselves only the secondary effect of the laying down of paint. Thus, whether the stripe paintings really are blank paintings remains systematically undecidable, depending utterly on whether one sees the minimal differentiation of *this* lane of paint from *that* one as the minimum necessary for a painting to deserve the name. Is monochromaticism sensation or reflection, nature or artifact? "We cannot say with certainty whether a color or a tone (sound) is merely an agreeable sensation or whether it is of itself already a beautiful play of [component] sensations and as such carries with it, as we judge it aesthetically, a liking for its form" (*CJ* 51, p. 194). Out of this undecidability flows the question of the disciplinary specificity of "pure" painting.

19. Thomas Mann, *Doctor Faustus*, trans. H. T. Lowe-Porter (New York: Random House, 1992), p. 478.

20. This is the point that most drives a wedge between my view and Hannah Arendt's, who also reads the *Critique of Judgment* as a political text. See her *Lectures on Kant's Political Philosophy* (Chicago: University of Chicago Press, 1982). The difference between us is that she reads it as spelling out Kant's substantive political philosophy and thus as a sort of addendum or grounding to his formalist political writings, whereas I am arguing that it helps us to understand why Kant has no *substantive* political philosophy at all. The only political philosophy that is possible for Kant, and therefore for us, is one that can justify the formal-procedural norms of politics in the absence of any political motivation to abide by them; it is then up to a critical philosophy, of which the *Critique of Judgment* obviously is a part, to explain the conditions of possibility for that kind of political philosophy. Critical philosophy, in other words, does not restore the substantiality of norms but rather addresses the displacing of them. Whether Kant restores demolished political normativity in the form of a substantive philosophy of history is a vexed question, an affirmative answer to which, I must acknowledge, is consistent with my argument in this chapter. In other words, I acknowledge the criticisms of my argument by my colleagues Jay Bernstein and Idit Dobbs-Weinstein, as well as several of my graduate students, and apologize for deferring a proper response to them until a later time.

Chapter 3: The Afterlife of Normativity in Hegel

1. Bosanquet's translation translates *Geist* as either "spirit" or "mind," depending on the context. Although not without motivation, his choice nonetheless introduces a mo-

ment of decision into Hegel's writing where, importantly, Hegel avoided it. When quoting from the translation, I will use Bosanquet's words; however, in my own writing I will stick with "spirit" especially since I will be emphasizing certain moments of unconsciousness which are spiritual but arguably nonmental. Were I talking about Freud, "psychical" might help to split the difference.

2. This idealist definition of mind as freedom from nature remains central, if not precisely normative, in the view that minded creatures are such as to have reasons as the causes of their actions. John McDowell's *Mind and World* (Cambridge: Harvard University Press, 1996) is exemplary in its defense of the compatibility of the spontaneity of the mind with the passive reception of the contents of experience. Also see Robert Pippin's argument, from which the following programmatic statement is culled, that the legitimacy of the modern age—which is to say its capacity to support any human goods at all—depends entirely on our capacity to redeem this (putatively Kantian) notion of freedom as spontaneity:

> The claim to be defended [in this book] concerns why this ideal, human freedom, understood ultimately as being a law, a compelling norm, wholly unto oneself, in a wholly self-legislated, self-authorizing way, should be touted as a supreme or even absolute ideal, or that the enjoyment of many manifestly satisfying human goods, like love, friendship, security, and peace, would not be worthwhile ends to pursue were they not "truly mine," truly legislated as ends by me.

See Robert Pippin, *Idealism as Modernism: Hegelian Variations* (Cambridge: Cambridge University Press, 1997), p. 7.

3. Danto, "The Philosophical Disenfranchisement of Art," in *The Philosophical Disenfranchisement of Art*, pp. 1–21.

4. For the specific formulation of this theme, I am indebted, again, to Jay Bernstein, and especially his *The Fate of Art*.

5. This is why Hegel regards art as the lowest level of absolute spirit. Absolute spirit is spirit's awareness of itself as freely self-determining, that is, as arising after the death of nature. In virtue of its premise that something survives that death, art is absolute spirit; in virtue of its pretense that it is nature that survives its own death, art is the initial and lowest form of absolute spirit.

6. The difficulty of this passage justifies reproducing the original passage in its entirety:

> Was nun der Geist in Kunstwerken seinem eigenen Innern entnimmt, dem weiß er auch nach seiten der äußerlichen Existenz hin eine Dauer zu geben; die einzelne Naturlebendigkeit dagegen ist vergänglich, schwindend und in ihrem Aussehen veränderlich, während das Kunstwerk sich erhält, wenn auch nicht die bloße Dauer, sondern das Herausgehobensein geistiger Beseelung seinen wahrhaftigen Vorzug der natürlichen Wirklichkeit gegenüber ausmacht.

7. By "our best interpreters of Hegel," I might as well mean Robert Pippin, who argues against "the familiar claims of the late Schelling, Kierkegaard, Schopenhauer, Adorno,

and most recently Habermas" (and, for present purposes, we can add Freud) that self-consciousness remains dependent on the conditions that make it possible.

> To identify such dependencies is always to claim a renewed form of independence, and it is a claim for independence or autonomy that now (after Hegel) can seek no reassurance in self-certainty or foundations, and provokes again the groundless search for reconciliation with other self-conscious agents unavoidable in modernity.

This argument can arrive at its conclusion only if the identification of dependencies issues in an historical reconstruction of the emergence of self-consciousness. If, on the other hand, the critique of autonomy aims, not at establishing the cognitive transparency of that emergence (and hence not at the reassertion of the autonomy of the present moment), but at the specific ways self-consciousness bears (and fails to bear) the burden of a past it does not overcome, then Pippin's conclusion that such a critique must be aiming at renewed independence fails to follow. See Pippin, *Modernism as a Philosophical Problem*, 2nd ed. (Oxford: Basil Blackwell, 1999), pp. 176–79.

8. For a practical application of this idea, see Gombrich's analysis of the increasing mobility of Greek *kouroi*, in *Art and Illusion*, pp. 117ff.

9. Karl Marx and Friedrich Engels, "The Manifesto of the Communist Party," in David Fernbach, ed., *The Revolutions of 1848: Political Writings*, vol. 1 (New York: Vintage Books, 1974), p. 70.

10. Flannery O'Connor, *Wise Blood* (New York: Farrar, Straus, and Giroux, 1949), p. 105.

11. Indeed: Gombrich refers to Hegel as the father of art history; see E. H. Gombrich, "The Father of Art History," in *Tributes: Interpreters of Our Cultural Tradition* (Ithaca, N.Y.: Cornell University Press, 1984), pp. 51–69.

12. Both Plato and Aristotle may be adduced as evidence here. For both, if art were mere artifice it would not be worth knowing; indeed, it would not be a proper object of knowledge. That they disagree whether it is mere artifice thus accounts for their differing comportments toward art.

13. Thierry De Duve (in conversation) has argued that one obvious sign that Abstract Expressionism is now in our historical past is that we must now struggle to understand it beyond the interpretive parameters provided by the nutty, macho metaphysics in the context of which it was created. In other words, our problem with Abstract Expressionism is structurally identical to our problem with Giotto; we need to be able to offer a nonexpressivist account of Pollock's achievement just as we need to be able to offer a secular account of Giotto's. A sure index of the passing of an historical era is that its self-understanding does not help us in grasping its achievements because its achievements have, in surviving into our moment, outlived their home contexts. De Duve's thought translates splendidly Hegel's critique of the discipline of art history, since, as I am arguing, Hegel's central point is that the passing of an historical era is the necessary condition for art history—otherwise, it would not be a field of knowledge production but a realm of everyday talk among those who continue to share a living dis-

course—but a condition the satisfaction of which guarantees that the question of the survival of the work into the present in which we ask art historical questions cannot be addressed. The fact that the work lasts raises questions for which art history is necessary to answer—what did the work mean? why and how was it made?—but also questions for which art history, as a necessary adjunct to all knowledge of art, can offer no answers. To understand Giotto one must know he was a Christian artist; that we care about Giotto *because* he was a Christian artist is a risible parody of an answer.

14. It is a striking fact about Hegel's demotion of art scholarship to a necessary but inherently insufficient condition for responding to art that if we treat it as prophecy it is a nearly perfect prediction of the contemporary fate of the academic discipline of art history. In its autonomous development, art history has excised its relation to philosophical speculation in order to found a positive science. As a consequence, the knowledge that it produces is not specific to art; hence, large chunks of the field are being consumed by an amalgam of social history and anthropology called either visual studies or material culture studies. As a further consequence, the elaboration of the art institution's relationship to other domains of culture falls outside the purview of the discipline; hence the growth of crass materialism's necessary counterpart, ungrounded speculation, which in this case calls itself "theory." This intellectual comedy is portrayed perfectly in Hegel's assessment of the self-limiting positivity of art scholarship's "object."

15. That a task is not included in a job description of course does not make the task logically incompatible with the job. It is perhaps possible to imagine a suitably enriched art history that would be attuned to the conditions of its knowing. However, there may be an affective incompatibility even where there is no logical one: there are good reasons surgeons typically do not operate on their near and dear, and one would need to think twice about the pathologist who does the autopsy on her close relative.

16. Yosef Hayim Yerushalmi puts this point beautifully in his study of the rise of historicism out of the rubble of traditional orientation in the Jewish Enlightenment. "Those Jews in the early nineteenth century who first felt an imperative to examine Judaism historically did so because they were no longer sure of what Judaism was, or whether, whatever it was, it could still be viable for them." The uncertainty that gives rise to historicism is at the same time perpetually expressed in it; as a motive that never finally goes away it is both a lack of, and simultaneously a kind of, orientation. Yerushalmi makes this argument in *Zakhor: Jewish History and Jewish Memory* (Seattle: University of Washington Press, 1996), p. 86.

17. The shame experienced by children of immigrants at the fact that their parents cannot shed the skin of the old world is one famous lived version of this dynamic.

18. In philosophy, all examples are interchangeable so long as they do their work in stimulating reflection. Examples are, in this sense, mere particulars circulating discursively with no friction at all.

19. See Clark, "Clement Greenberg's Theory of Art," in *Pollock and After*, pp. 47–63; originally published in *Critical Inquiry* 9 (September 1982): 139–56.

20. Clark, *Farewell to an Idea*, quoting Wallace Stevens, "The Auroras of Autumn,"

The Collected Poems (New York: Vintage, 1990), pp. 411–21. Although he does not say so, Clark must be thinking of the third section of Stevens's poem, of which, as utterly apropos the theme of this chapter, I reproduce the first portion:

> Farewell to an idea . . . The mother's face,
> The purpose of the poem, fills the room.
> They are together, here, and it is warm,
>
> With none of the prescience of oncoming dreams,
> It is evening. The house is evening, half dissolved.
> Only the half they can never possess remains,
>
> Still-starred. It is the mother they possess,
> Who gives transparence to their present peace.
> She makes that gentler than gentle can be.
>
> And yet she too is dissolved, she is destroyed.
> She gives transparence. But she has grown old.
> The necklace is a carving not a kiss.

It is less clear that Clark is thinking of the fourth section of the poem, which is equally apt for me, but less for him. The first two stanzas only:

> Farewell to an idea . . . The cancellings,
> The negations are never final. The father sits
> In space, wherever he sits, of bleak regard,
>
> As one that is strong in the bushes of his eyes.
> He says no to no and yes to yes. He says yes
> To no; and in saying yes he says farewell.

21. The end of this vacillation is also the end of art history, that is, of art having an internal developmental structure. If the impulse to retreat from proper sensuous form which has become inadequate to its representational function turns back to the world of concrete sensuous existence in a reformist spirit, it becomes the impulse to improve the sensuous world, thus giving rise to a history structured by the idea of artistic progress. Even the most openly anti-Hegelian art historians, like Gombrich, see something like this dialectic of repudiation and reform at work in any story of art that sees later developments growing out of the failures of earlier ones. The end of the story of art, therefore, is just the end of the idea that the sensuous world can become adequate to the representation of the interests that have hitherto driven its development.

22. Inevitably, Adorno's thought comes to mind: "contradiction is nonidentity under the aspect of identity." *Negative Dialectics*, p. 5.

23. During the safety instruction session before the airplane takes off, the flight attendant recommends that all passengers take a moment to locate their nearest exit. As a final tip, the attendant then says, "And remember, your best exit may be behind you." At that moment, the attendant becomes an aesthetician.

Chapter 4: Death and Form in Freud

1. See also Freud, *New Introductory Lectures*, *SE* 22: 161.

2. It was part of Freud's carefully crafted personal mythology that he was philosophically uneducated, that is, outside of conversation with philosophers. In the same lectures in which he mocks philosophy with Heine's help, he judges himself unqualified to judge the various philosophical systems (*New Introductory Lectures*, *SE* 22: 175). However, it does not require psychoanalytic detective work to discover that this is a fiction. In *ID* alone, we find references to Plato, Aristotle, Kant, and Schopenhauer. We also know that Freud was a reader of Nietzsche and a translator of John Stuart Mill into German. There are several possible explanations for Freud's protestation of philosophical incompetence, but I think in all likelihood it had to do with an elevation of his preferred conversation partners—neurotics—and their inescapable relation to their own historical dimensionality. At a minimum we can say this: Freud invited philosophers to join the conversation only insofar as they were themselves interested in the historical opacity of reflective thought; hence his return at key moments of argument to Plato's thinking. See, for instance, *Beyond the Pleasure Principle*, *SE* 18: 57–58.

3. For those who have been following my argument up to now, it will likely seem puzzling that I have omitted artistic modernism from my list of nineteenth-century cultural phenomena. A reading of Baudelaire, for instance, could carry much of the weight of specifying the endless new time of nineteenth-century urban culture, as it did for Walter Benjamin in such essays as "The Paris of the Second Empire in Baudelaire" and "Paris—the Capital of the Nineteenth Century," both in *Charles Baudelaire: A Lyric Poet in the Era of High Capitalism*, trans. Harry Zohn (London: NLB, 1973). I will try to make good on the exclusion later in this chapter and, more explicitly, later in the book. For now, let me note briefly that my decision is motivated by the desire to forge a serviceably clear distinction between triumphal new time and mournful new time.

4. Theodor W. Adorno, "The Sociology of Knowledge," in *Prisms*, trans. Samuel Weber and Shierry Weber (Cambridge: MIT Press, 1981).

5. This is the theme of Thomas Mann's great essay on the occasion of Freud's eightieth birthday, May 9, 1936, "Freud and the Future," in *Essays of Three Decades*, trans. H. T. Lowe-Porter (New York: Alfred A. Knopf, 1947), pp. 411–28.

6. Freud, "Mourning and Melancholia," *SE* 14: 258.

7. The characterization of psychoanalysis as a response to the historical self-disenchantment of modernity has been offered frequently, but see especially Peter Homans, *The Ability to Mourn: Disillusionment and the Social Origins of Psychoanalysis* (Chicago: University of Chicago Press, 1989).

8. It is a version of the thesis of T. J. Clark's *Farewell to an Idea* that the possibility of modernist art depends on there being at least one horizon on which this separation is an historical possibility.

9. The notable exception to this fate was Marx, whose still incompletely understood achievement was to demolish the boundary between the aesthetic and the political on two fronts. First, in his early critiques of the Hegelian theory of the state and utopian so-

cialism, Marx criticized the corporatist political ideal of an organic social totality as an aestheticization of politics that drew its ideological resources from the dream of an aesthetic harmony barricaded against political struggle. Second, in his mature critique of the commodity form, Marx demonstrated how aesthetic ideals were necessary to the maintenance of the illusion of the seamlessness of the capitalist mode of production and exchange. From the point of view of the problems discussed in this chapter, we might say that in both of these cases Marx was striving to avoid being seduced by the emergent centrality of aesthetic theory to political life by treating such theorizing as already a political phenomenon. Of course, despite rejecting aesthetic theory as a philosophico-political resource, Marx clung no less than Nietzsche to the flotsam of triumphal culture—indeed, he counted on the abject to be the gravediggers of the society that relied on their abjection. For the critique of Hegel and the Hegelian theory of the state, see *Critique of Hegel's "Philosophy of Right,"* trans. Annette Jolin and Joseph O'Malley (Cambridge: Cambridge University Press, 1970), and "On the Jewish Question," in Tucker, ed., *The Marx-Engels Reader*; for the critique of utopian socialism and the politico-ethical reliance on the abject, see the *Economic and Philosophic Manuscripts of 1844*, 5th ed. (Moscow: Progress Publishers, 1977), and *The Communist Manifesto*; for the critique of the commodity form, see *Capital*, vol. 1, trans. Ben Fowkes, ed. J. M. Cohen (New York: Penguin Books, 1992), esp. chap. 1.

10. Freud, "Fragment of an Analysis of a Case of Hysteria," *SE* 7: 12.

11. Freud, "Contribution to a Questionnaire on Reading," *SE* 9: 245–47.

12. Freud, "Leonardo Da Vinci and a Memory of His Childhood," *SE* 11: 63–137.

13. This important reminder is treated thematically in Richard Wollheim's "Freud and the Understanding of Art," in Wollheim, *On Art and the Mind* (Cambridge: Harvard University Press, 1974), pp. 202–19. Wollheim's essay is one of the few discussions of Freud's thinking about art that gets absolutely right the importance to Freud of art's cognitive opacity:

> We have now gone far enough to see that part of understanding how it is that a work of art affects us is recognizing the confusion or the ambiguity upon which this effect in part depends. One of the dangers in psychoanalysis, but also one of those against which it perennially warns us, is that in trying to be clear about our state of mind we may make the state of mind out to be clearer than it is. (p. 217)

14. Ronald Britton, "Reality and Unreality in Phantasy and Fiction," in *On Freud's "Creative Writers and Day-Dreaming,"* ed. Ethel Spector Person, Peter Fonagy, and Servulo Augusto Figueira (New Haven, Conn.: Yale University Press, 1995).

15. Ernst Gombrich displays the antiformal consequences of the play/art analogy in his essay "Meditations on a Hobby-Horse." Since representation is the transmutation of objects into signifiers, and anything can represent anything else, Gombrich regards "stick-like-ness" as the only restraint on playing at hobby-horses; in other words, there must be a screen for the projection at the heart of play, but since the screen need not bear any resemblance to the projection it supports, a formal analysis of the screen would almost entirely miss the point of play. What guides the projection is not the stick but the

child's desire, grounded in the play itself, to see a horse. Gombrich analogizes the guided projection of play to the guided projection of art, in which the wish is the cause of the work's artistic properties. Later in his career Gombrich would back away from the thoroughness of the perceptual constructivism implied in this argument. See "Meditations on a Hobby-Horse," in *Meditations on a Hobby Horse and Other Essays on the Theory of Art* (New York: Phaidon, 1971), and, later, *The Image and the Eye* (Ithaca, N.Y.: Cornell University Press, 1982).

16. Thus, in the Dora case history, Freud writes, "The symptoms of the disease are nothing else than *the patient's sexual activity.*" It should hardly be necessary to add that sexuality is, for Freud, not free from the demands of reality ("Fragment of an Analysis of a Case of Hysteria," *SE* 7: 136).

17. Hanna Segal offers a salutary reminder of Freud's point that dream interpretation can only begin once it has been acknowledged that dreams are not made with the intention of being understood. "It must be remembered," she writes, "that Freud did not say that dreams are the royal road to the unconscious. He said that the understanding of dreams is the royal road to the unconscious, and this understanding has to be reached by psychic work" (*ID* 608). See Hanna Segal, *Dream, Phantasy, and Art* (London: Tavistock/Routledge, 1991), p. 12.

18. Freud, "Formulations on the Two Principles of Mental Functioning," *SE* 12: 222.

19. It bears repeating that the freedom of the unconscious from reality-testing is not to be thought of as a form of transcendence. We could say with equal justice that the unconscious is ignorant of reality rather than free of it; the hesitation in doing so stems from the effort not to define the unconscious merely negatively and thereby to leave open for inquiry the psychical phenomena that are products of the hard work humans need to do to maintain their ignorance of reality.

20. Freud, *New Introductory Lectures, SE* 22: 58–59.

21. *On Dreams, SE* 5: 672.

22. Here, perhaps, we can hear the thought that is in the background of the anti-ekphrasis sentiment of modern art history.

23. The connection between this thought and Walter Benjamin's philosophy of language is too tight to escape comment. "Language," Benjamin writes, "is in every case not only communication of the communicable but also, at the same time, a symbol of the noncommunicable. The symbolic side of language is connected to its relation to signs, but extends more widely, for example, in certain respects, to name and judgment. These have not only a communicating function, but most probably also a closely connected symbolic function." The symbolic function Benjamin mentions is a close parallel to Freud's notion of perceptual identity; in both cases, the idea of the object fails to completely shed its association with the object of which it is the idea, and thus conceptual abstraction remains disturbed by mimetic identification, that is, by name and judgment. The quote here is from Benjamin, "On Language as Such and On the Language of Man," in *Reflections*, trans. Edmund Jephcott (New York: Harcourt Brace Jovanovich, 1978), p. 331; but see also, in the same volume, "On the Mimetic Faculty," pp. 333–36.

24. For the context of this essay in Freud's intellectual development and personal

life, see Peter Gay, *Freud: A Life for Our Time* (New York: W. W. Norton, 1988), pp. 314–17, and Homans, *The Ability to Mourn*, pp. 41–57.

25. It is worth noting, in anticipation of the argument of the next few paragraphs, that in his 1917 essay on "Mourning and Melancholia" Freud already entertains the possibility that there is no such thing as natural grief. Overall, the essay suggests that mourning is normal and melancholia pathological, but more than once Freud allows his doubts to seep through. First he writes: "Although mourning involves grave departures from the normal attitude to life, it never occurs to us to regard it as a pathological condition and to refer it to medical treatment. We rely on its being overcome after a certain lapse of time, and we look upon any interference with it as useless or even harmful" ("Mourning and Melancholia," *SE* 14: 243–44). But almost immediately after, he writes: "It is really only because we know so well how to explain [grieving and mourning] that this attitude does not seem to us pathological" ("Mourning and Melancholia," *SE* 14: 244). The friction between these two thoughts is a real katzenjammer. That it never occurs to us to regard mourning as pathological, and that the only reason we do not regard it as such is because we know how to explain it, are, to put it mildly, incompatible accounts of its apparent "normalcy." Indeed, Freud's overemphatic argument brings to mind one of his favorite joke forms, in which a person accused of a misdeed uses every available counterargument without concern for their relations to each other ("I never borrowed your car, and anyway it already had that dent when I borrowed it, and what dent anyway?"). Just as too much insistence on one's innocence amounts to a confession, so too does Freud's multiplication of explanations for mourning's naturalness betray his doubts.

26. Freud's career breaks roughly into three phases: (1) the early period before the detailed examination of the dreamwork during which he was under the theoretical and therapeutic influence of a variety of neurologists and psychiatrists, most especially Josef Breuer, and during which he held to the seduction theory of neurotic disturbance and became an adept at hypnotic treatment; (2) the canonical period of *Interpretation of Dreams*, the early studies of sexuality and sexual development, the invention of the case-history form for the presentation of clinical material, the replacement of hypnotic treatment with the talking cure, and the elaboration of the concept of "the dynamic unconscious"; (3) the late period of the revision of the theory of anxiety, the attendant revision of the theory of the instincts to include the death drive, and elaboration of the structural theory of the mind.

27. See also Freud, *Beyond the Pleasure Principle*, *SE* 18: 13.

28. The proximal impetus to Freud's investigations of traumatic neurosis was the Great War. The outbreak of shell shock, as it was commonly known once, among veterans of battle suggested to Freud a most puzzling etiology: the veterans appeared to be suffering from having *survived without injury* a risk to life and limb. Cathy Caruth, in her *Unclaimed Experience: Trauma, Narrative, and History* (Baltimore: Johns Hopkins University Press, 1996), brilliantly analyzes traumatic neurosis as survivor guilt. Her arguments about trauma have had sufficient impact on my thinking that I hereby pay her my debt of general gratitude in order to avoid having to cite her after every paragraph. The epidemic of shell shock during and after the Great War has been analyzed in terms

of the lack of anticipation of mechanized total war by soldiers who had been trained to think of war as a human encounter. See John Keegan, *A History of Warfare* (London: Hutchinson, 1993). Although Freud does not even raise this hypothesis, its spirit is at work in the two other sources of traumatic neuroses he mentions in *Beyond the Pleasure Principle*: the survival of railway disasters and the survival by both Freud and his grandson of the death of Sophie, the boy's mother, in the 1919 flu epidemic. In all three cases, a specific form of defense, which is to say a specific form of anxiety tailored to guard against an old threat, did nothing to psychically prepare the survivor for the disaster in question. The great achievements of modern civilization—the defenses against the threat to life provided by the canons of civilized warfare, the mechanization of long-distance travel, and improved hygiene—made possible the specifically modern malady of being scared to death by humanity's oldest and most constant companion—unanticipated and uncontrollable death. While traumatic neurosis must be a disease as old as love, since the idea of being adequately prepared for the death of a loved one is incoherent, its epidemic outbreak in this century suggests an especially intimate connection between the illness and modern life. Perhaps the return of the past is more traumatic for inhabitants of an age which measures the degree of civilization of forms of life by the weight they accord their specific differences from a past they have left behind.

29. Freud, *Beyond the Pleasure Principle*, SE 18: 32.

30. In "The Uncanny," Freud makes reference to *Beyond the Pleasure Principle* as if it had already been published (*U* 238). He does so to direct readers to the supporting evidence for the hypothesis that experiences of the uncanny can be derived from infantile experiences. The fact that *Beyond the Pleasure Principle* was not published until the following year makes this reference stand out as a spectacularly good example of the way Freud presented his ideas; while the key concepts are woven together in complex and ramifying fashion, he writes them up as if they had developed in linear fashion, only to then let that linearity unravel.

31. "A Difficulty in the Path of Psychoanalysis," *SE* 27: 143.

32. What can be more startling than the statistic that in 1861, shortly before national unification, only 2.5 percent of the people living in Italy spoke Italian? What does this do to the idea of "Italy"? What does it do to the historical relation between "dialects" and the idea of "nation"? In what form does the institution of the state carry this fact, its own proper past? "Harper's Index," *Harper's*, July 1999, p. 17.

33. Or, as Freud put it in his study of *Gradiva*, Wilhelm Jensen's Pompeiian phantasy of 1903, this is the nightmarish "fatal truth that has laid it down that flight is precisely an instrument that delivers one over to what one is fleeing from" ("Delusions and Dreams in Jensen's *Gradiva*," *SE* 9: 42).

34. The uncertainty whether it is even coherent to imagine a culture that lives with the deadness of its dead is, I think, what is at stake in one of the most mysterious passages in *Beyond the Pleasure Principle*. After stepping back from the flow of his argument to observe that it has depended all along on the assumption that all organisms are bound to die from internal causes, Freud asks whether this assumption might not be an illusion.

Perhaps we have adopted the belief because there is some comfort in it. If we are to die ourselves, and first to lose in death those who are dearest to us, it is easier to submit to a remorseless law of nature, to the sublime Ἀνάγχη [Necessity], than to a chance which might have been escaped. It may be, however, that this belief in the internal necessity of dying is only another of those illusions which we have created *"um die Schwere des Daseins zu ertragen"* [to bear the burden of existence]. It is certainly not a primaeval belief. The notion of "natural death" is quite foreign to primitive races; they attribute every death that occurs among them to the influence of an enemy or of an evil spirit. (*Beyond the Pleasure Principle, SE* 18: 45)

It is hard to grasp how the necessity of death, once stripped of all the religious adorn-ments that its teleological interpretation had lent it, can be comforting. Indeed, we are used to thinking that part of the solace to be found in religion is its redemption of death from the realm of remorseless necessity. Freud's thought seems to be that the necessity of death continues to carry with it the significance of submission to a higher power even after losing its specifically deific interpretation, and that therefore our belief in the ne-cessity of death is simply our version of death's intolerability. Perhaps, then, death with-out a specific meaning for the living is incompatible with the demands of life, and the thought of a culture living with the deadness of the dead is itself a comforting illusion. If so, I welcome all criticisms that will help me to discover the fears it shields me from.

35. Freud, "Notes upon a Case of Obsessional Neurosis," *SE* 10: 157.

36. The biographical information in the following discussion is indebted to *Sigmund Freud and Art: His Personal Collection of Antiquities,* ed. Lynn Gamwell and Richard Wells (Binghamton: State University of New York, and the Freud Museum, London, 1989). This volume includes essays by Martin S. Bergmann, Lynn Gamwell, Peter Gay, Donald Kuspit, and Ellen Handler Spitz. I will cite essays individually only when I in-cur specific debts to their authors.

37. Lynn Gamwell, "The Origins of Freud's Antiquities Collection," in *Sigmund Freud and Art,* p. 23.

38. Ellen Handler Spitz, "Psychoanalysis and the Legacies of Antiquity," in *Sigmund Freud and Art,* p. 159.

39. Gamwell, in *Sigmund Freud and Art,* p. 24.

40. Freud, "Notes upon a Case of Obsessional Neurosis," *SE* 10: 176.

41. Walter Benjamin, "Theses on the Philosophy of History," in *Illuminations* (New York: Schocken Books, 1968), p. 255.

42. Freud, "Notes upon a Case of Obsessional Neurosis," *SE* 10: 174.

Chapter 5: What Gerhard Richter Saw

1. See, for instance, Benjamin H. D. Buchloh, Stefan Germer, and Gerhard Storck, *Gerhard Richter: 18. Oktober 1977* (Cologne: Verlag der Buchhandlung Walther König, 1989); Jan Thorn-Prikker, "Ruminations on the *October 18, 1977* Cycle," *Parkett* 19 (March 1989): 143–53; Hubertus Butin, *Zu Richters Oktober-Bildern* (Cologne: Verlag der

Buchhandlung Walther König, 1991), which includes a reprinting of Michael Brenson's "A Concern with Painting the Unpaintable," from the *New York Times*, 25 March 1990; Desa Philippi, "Moments of Interpretation," *October* 62 (Fall 1992): 115–22; and Luc Lang, "The Photographer's Hand: Phenomenology in Politics," in Gertrud Koch, Luc Lang, and Jean-Philippe Antoine, *Gerhard Richter* (Paris: Éditions Dis Voir, 1995), pp. 29–52. The essay by Buchloh, from the Walther König volume listed first above, has been multiply reprinted, including in English in *October* 48 (Spring 1998): 89–109, as "A Note on Gerhard Richter's *October 18, 1977.*" Also informative, although they touch on the Baader-Meinhof pictures only tangentially, are Thomas Crow, "Hand-Made Photographs and Homeless Representations," *October* 62 (Fall 1992): 123–32, and Gertrud Koch, "The Richter-Scale of Blur," *October* 62 (Fall 1992): 133–42.

2. Adam Phillips, *On Kissing, Tickling, and Being Bored: Psychoanalytic Essays on the Unexamined Life* (Cambridge: Harvard University Press, 1993), p. 83.

3. On the principle that what goes around comes around, it is worth noting that the significance here being attributed to wishing, to desiring even when one is aware of one's powerlessness to produce the desired outcome, is an extension of a claim Kant makes in a footnote to the second introduction to the *Critique of Judgment.* Kant admits that wishes are impotent desires, but he insists that they are nonetheless genuine instances of desire, that is, of powers of causality. The evidence for this, he says, is the characteristic affect of wishing—longing (*Sehnsucht*). Nature has prudently equipped us with the capacity to long, Kant argues, since:

> It seems that if we had to assure ourselves that we can in fact produce the object, before we could be determined [by the presentation] to apply our forces, then our forces would remain largely unused. For usually we do not come to know what forces we have in the first place except by trying them out. Hence the deception contained in vain wishes is only the result of a beneficent arrangement in our nature [*in unserer Natur*]. (*CJ* intro., p. 17)

Only because nature appears to us welcoming for our projects, even if we know it not to be, do we develop our capacities to transform nature in accord with our desires. Nature's transformability, its nontotality, is, as we have seen, an alternative characterization of aesthetic appearance; aesthetic appearance is thus the critique of nature driven by what the apparent totality of nature has rendered mere wish. Further, however, since this critique is possible in virtue only of a beneficent arrangement in our nature, it seems to amount to nature's self-critique. Thus, while desire may be the father of the act, the wish is the sustaining mother of desire.

4. After a cemetery visit, a stone is sometimes left behind. The stone's unsettledness shows it to be not a memorial to the visit but a promise to return; since we will all come back to the cemetery eventually, the unsettled stone is thus a temporary marker left where a permanent one shall be. This is why a pebble found on a tombstone can be more moving than the tombstone it is perched on.

5. Sentries may guard the Tomb of the Unknowns, but only the Tomb itself can me-

morialize them. The insufficiency of the human soldier for the task is made vivid in the imitation of a machine with which he performs his guard duty. The soldier must appear both mobile and inflexible, as if the superobjectivity of the memorial had struck him, too. It is interesting in this light that despite the fact that they have seen combat in the U.S. Army, only recently have female soldiers been allowed to guard the Tomb of the Unknown at Arlington National Cemetery—the demands of inflexibility, even more than of agility, are especially masculine.

6. Benjamin Buchloh, "A Note on Gerhard Richter's *October 18, 1977*," *October* 48 (Spring 1989): 97.

7. See, for instance, John Sallis, *Stone* (Bloomington: Indiana University Press, 1994).

8. The most important texts on this issue are André Bazin, *What Is Cinema?* vol. 1, trans. Hugh Gray (Berkeley: University of California Press, 1967); Siegfried Kracauer, *Theory of Film* (New York: Oxford University Press, 1960); Roland Barthes, *Camera Lucida: Reflections on Photography*, trans. Richard Howard (New York: Hill and Wang, 1981); Stanley Cavell, *The World Viewed: Reflections on the Ontology of Film* (Cambridge: Harvard University Press, 1979); Gilberto Perez, *The Material Ghost: Films and Their Medium* (Baltimore: Johns Hopkins University Press, 1998).

9. Roger Scruton has denied that photography can be an art because it presents its intentional perceptual objects through the same medium as does nonphotographic perception; see Roger Scruton, *The Aesthetic Understanding* (London: Methuen, 1983), and "Photography and Representation," *Critical Inquiry* 7 (Spring, 1981): 577–603. This is also the possibility that so exercised Rudolf Arnheim in the photographic considerations that initiate his *Film as Art* (Berkeley: University of California Press, 1957).

10. André Bazin, "The Ontology of the Photographic Image," in *What Is Cinema?* 1: 9–16.

11. Barthes, *Camera Lucida*, p. 80.

12. In light of ambiguities in the notion of construction, this point ought not to be overstated. The fixity of the photographic plate and print had precedents in various protophotographic media, such as that macabre exercise in physiognomy, the silhouette. Even the silhouette, however, required the tracing of the shadow.

13. Another expression of the absence of subjective intervention in the formation of the photographic image, albeit one more freighted with the metaphysical presupposition that where there is no subjectivity there is also nothing human, is the characteristic nineteenth-century trope that nature makes its own image through photography. See, for instance, William Henry Fox Talbot, *The Pencil of Nature* (London: Longman, Brown, Green, and Longmans, 1844–46) and Oliver Wendell Holmes, "Sun-Painting and Sun Sculpture," *Atlantic Monthly* 8 (1861): 13–29.

14. J. Hoberman, "*Schindler's List*: Myth, Movie, and Memory," *Village Voice*, 19 March 1994, p. 24.

15. A new worry about the contemporary practice of medicine has recently cropped up. Because of the flood of new technologies for imaging the interior of the body, doctors are not maintaining the skills required to infer causes of illness by touching the sick

person. While diagnostic accuracy is undoubtedly improved by the new technologies, they also eliminate the lived experience of illness from the diagnostician's view. Thus, the sense of disease as a form of haunting, as an uncanny sharing of one's body with another occupant with a claim on it, gets driven out of the practice of medical arts. The new power of imaging disburdens doctors of the need to imagine illness from the inside, but if a condition is an illness, rather than a mere abnormality, in virtue of how it is lived from the inside, those new powers also disburden doctors of the need to distinguish being diseased and being different. The loss of the need to imagine the inside through touching its symptomatic outer life offers a close analogy to the loss of the need, generated by the photograph, to imagine the historical life of the dead through witnessing its symptomatic afterlife.

16. Older memorials have even become to seem quaint, that is, too much of the time of the dead to provoke mourning rather than museal appreciation, hence the need for jolts of self-implication in recent memorials such as the Vietnam War Memorial in Washington, D.C. But the question arises: why have photographs of mourners at the Vietnam War Memorial become icons of forgetfulness?

17. While ostension means the act of exhibiting, it also means more specifically the act of showing the eucharistic elements to the sight of the people.

18. There is a large class of jokes that takes on this project of detaching suffering from religious poaching in order to reattach it even more firmly to human life. Here is one more instance:

> As the river overflows its banks, an old man's friends come to his house in their truck. "Come on, old man," they yell, "let's get out while the getting is good." But the pious old man replies calmly, "No, I'll stay here. God will save me." The waters continue to rise, so the friends return in a boat. By now, the old man has been forced up to the second floor, but his answer to their imprecations is the same. Finally, near the peak of the flood, the friends return in a helicopter. Yet again, the old man's deep piety holds. "Go away," he bellows over the roar of the helicopter. "God will save me." After the old man drowns, he find himself before God. With fury in his voice, he says to God, "And just exactly what was that all about? All my life I put my faith in you and this is what happens?" To which God replies, "Why are you blaming me? I tried *three* times."

On the surface this joke trades on competing senses of the Messiah as either outside of history and capable of intervening to change its course or at the end of history and capable only of awaiting its outcome. However, the joke uses this contrast to puncture the very idea of salvation. At the end of the story, the old man stands facing God. This, of course, ought to count as his being saved, yet he is furious at God for saving him *in the wrong way*. But it turns out that the joke is on the old man: God tried to save him in the only way possible, by not intervening in the worldly friendship which, it is belatedly disclosed, was the only means of surviving. The old man thus died unsaved because of his mistaken belief that saving is external to life rather than something that happens, if it

happens at all, only within life. To be granted eternal life after this misunderstanding is to be condemned to an eternity of resentful contemplation and atonement for one's error, so penitence and salvation change places in the economy of happiness. The failure to understand that justice, which is to say the cessation of suffering, is only of this world condemns us to an eternity of suffering.

19. Freud, *Jokes and Their Relation to the Unconscious, SE* 8: 100–102.

20. Danto, *Transfiguration of the Commonplace*, pp. 16–18.

21. Jokes differ from other actions under disavowal in at least this respect, that they often appear to achieve aims, such as breaking the ice among strangers, other than the disavowed aims they also achieve. In *Jokes: Philosophical Thoughts on Joking Matters* (Chicago: University of Chicago Press, 1999), pp. 12–32, Ted Cohen argues that jokes normally aim at establishing intimacy between the teller and the hearer. I suppose this is probably true, even though, as we shall see, I must disagree with Cohen as to why that aim matters. Even on Cohen's analysis, however, jokes can attain this end only if they do not appear to have a *determinate* end, since establishing intimacy entails highlighting the *indeterminate* extent of what goes without saying between speaker and auditor. If one has to explain a joke, one must undertake an activity with the determinate end of achieving shared understanding, and that makes nonintimacy manifest (which is at least part of the reason explaining a joke is one sort of acknowledgment of its failure). Avowing the aim of achieving intimacy (just imagine saying aloud, "I'm now going to tell you a joke so that we can become friends") would be another instance of a motivation tripping up the end it intends, so the isomorphism between jokes, dreams, and parapraxes holds up even if we acknowledge that jokes may have aims other than the disavowed ones they achieve.

22. Slavoj Žižek, *The Plague of Fantasies* (London: Verso, 1997).

23. This paragraph has been almost entirely an effort to translate Freud's claim that desire burdens the ego with two incompatible tasks, to master it and to seek its satisfaction by calculatingly manipulating a world that is not naturally fitted to its demands.

> If now we apply ourselves to considering mental life from a *biological* [i.e., functional] point of view, an "instinct" appears to us as a concept on the frontier between the mental and the somatic, as the psychical representative of the stimuli originating from within the organism and reaching the mind, as a measure of the demand made upon the mind for work in consequence of its connection with the body. ("Instincts and Their Vicissitudes," *SE* 14: 121–22)

Instinct is experienced as a call from outside the ego, so the aim of satisfying it is to master it, in the sense of canceling its impulsive force against "me." The aim of the ego, in this light, is to maintain the *status quo* against stimulation, the aim of the instinct to restore the *status quo ante*, and this subtle difference is, in practice, the source both of strife and development. Instinct, thus, is a counterforce to the ego from which the ego must draw its energy in crafting its purposes, among which is the repudiation of the instinct's impulsive claim against it. Instinct becomes traumatic when no purpose the ego proposes can ameliorate its demand. Thus, after defining "the outside" as whatever excites

the ego into defensive action, including organically internal stimuli (such as sexual de-
sire) that are projected outside, Freud writes:

> We describe as "traumatic" any excitations from outside which are powerful enough
> to break through the protective shield. It seems to me that the concept of trauma
> necessarily implies a connection of this kind with a breach in an otherwise effica-
> cious barrier against stimuli. . . . At the same time, the pleasure principle is put out
> of action. (*Beyond the Pleasure Principle, SE* 18: 23)

Trauma, to refer back to our last chapter, is thus the ego's suffering of a desire that will
not accept remaining under an alias, that is, remaining mediated by the "mental repre-
sentation" offered to it.

24. Freud, "Mourning and Melancholia," *SE* 14: 244–45.

25. Gombrich, *Art and Illusion,* and Arthur C. Danto, "The End of Art," in his *The
Philosophical Disenfranchisement of Art* (New York: Columbia University Press, 1986),
pp. 81–115.

26. This, of course, is something of an exaggeration. Gombrich, for instance, applies
the canons of perspectival painting, all derived, he says, from the fact that the eye can-
not see around corners, to photography, and finds photography more visually faithful.
But this makes my point even more dramatically, since it shows that the only metric
available is one already derived from painting itself. It is, as the next few sentences claim,
a connoisseur's metric.

27. One can hear the romantic aspirations of Friedrich Schiller falling to earth here.
Schiller thought of artistic mediation as the mediation of subjectivity and the world that
had cast it out since it was the work of subjectivity to remake that world in its own im-
age. Hence, he wrote that "the reality of things is the work of things themselves, the sem-
blance of things is the work of man." Photography begs to differ. See Schiller, *On the
Aesthetic Education of Man in a Series of Letters,* trans. Elizabeth M. Wilkinson and L. A.
Willoughby (Oxford: Oxford University Press, 1967), p. 193.

28. Gerhard Richter, *The Daily Practice of Painting,* ed. Hans-Ulrich Obrist, trans.
David Britt (London: Thames and Hudson, 1995), p. 218.

29. Perhaps this might provide us with another clue for understanding the cult of the
touch that entered painting in the late nineteenth century. See Richard Shiff, "Cézanne's
Physicality: The Politics of Touch," in Salim Kemal and Ivan Gaskell, eds., *The Lan-
guage of Art History* (Cambridge: Cambridge University Press, 1991), pp. 129–80. The
denial of vision's carnal intertwining with the decaying body, such that touch and smell
threaten to overtake the too visible, is prefigured in Hegel (*ILA* 43), who argues that vi-
sion and hearing are the proper senses of art because all of the other senses are stimulated
by the effects of a destruction of the world. Freud seems to agree with this argument, but
he concludes that the privilege of seeing is tied to our having superseded the primacy of
smell in assuming the upright posture. *Civilization and Its Discontents, SE* 21: 99, note,
and 105–7, note. Vision's privilege is thus the site of the organic repression of the attrac-
tion to smell that threatens to make dogs of us all.

30. These alternative interpretations of the Baader-Meinhof Group in general are captured perfectly in two books on the subject: Jillian Becker's *Hitler's Children: The Story of the Baader-Meinhof Terrorist Gang* (Philadelphia: J. B. Lippincott, 1977), and Stefan Aust's *Der Baader Meinhof Komplex* (Hamburg: Hoffmann und Campe Verlag, 1985), in English as *The Baader-Meinhof Group: The Inside Story of a Phenomenon*, trans. Anthea Bell (London: The Bodley Head, 1987).

31. This godlike invisibility may be more than a structural feature of the encounter. In *The Baader-Meinhof Group*, Aust reports that Ennslin refused to be photographed when taken into police custody (pp. 221–22). A photographer hidden in the next room shot the photographs through a hole in a picture of flowers hanging on the wall of the interrogation room. If this story is true, the pictures are then not properly described as photographs of Ennslin; they are, rather, photographs of Ennslin-refusing-to-be-photographed.

32. In case someone following my interpretation of Richter's self-binding is inclined to think it false in light of Richter's abstract pictures, let me observe that, if anything, the abstractions strengthen my point. Richter's entire technique is abstract and remains the same regardless of whether the source is photographic; that is, he uses the traditional means of painting, not to impose significance on a space empty of meaning, but rather to beckon meaning from a space already *too filled* with meaning. A discussion of the abstract pictures would thus help me to further entrench my characterization of Richter's technique of collective suffering, but I prefer to let the interpretation of *October 18, 1977* develop without the support a survey of Richter's career would offer.

Chapter 6: Aboard Ilya Kabakov's Lifeboat

1. Ilya Kabakov, interview by Robert Storr, *Art in America* 83, no. 1 (January 1995): 66.
2. Ilya Kabakov, *Ten Characters* (London: ICA, 1989).
3. Theodor W. Adorno, "Extorted Reconciliation: On Georg Lukács' *Realism in Our Time*," in *Notes to Literature*, vol. 1, trans. Shierry Weber Nicholson (New York: Columbia University Press, 1991).
4. Ross interview, p. 11.
5. Storr interview, p. 66.
6. Freud, "Mourning and Melancholia," *SE* 14: 249.
7. Barnett Newman gave voice to this connection when he wrote, in a barbed reply to a request for a quote, that "an artist paints so that he will have something to look at; at times he must write so that he will also have something to read." Barnett Newman, *Selected Writings and Interviews* (Berkeley: University of California Press, 1992), p. 160.
8. László Moholy-Nagy, for instance, described one of the most important tasks of art as "bring[ing] out the most far-reaching new contacts between the familiar and the as-yet unknown optical, acoustical and other functional phenomena and by *forcing* [my emphasis] the functional apparatuses to receive them." Thanks to Daniel Herwitz for alerting me to this reference to Moholy's "Production-Reproduction," *De Stijl*, no. 7 (1922): pp. 97–101. A famous exception to the strategy of connecting social regeneration

to artistic withdrawal was the postrevolutionary Russian avant-garde, but the present context of discussion almost makes one want, out of tact, not to mention it. A recurrent theme in Kabakov's writings and interviews is the absence of Soviet art history for working artists in the 1950s in virtue, again, of censorship. "I didn't see the works of Malevich, Tatlin and others," Kabakov reports, "because their works weren't exhibited and publications didn't exist." Ross interview, p. 13.

9. Storr interview, p. 66.

10. Ibid.

11. Because of his titanic efforts to believe that the GDR's government was the essential organ of the working class, Brecht's forced acknowledgment of its falsity was bitterly cynical. After the 1953 workers' uprising, a government official in charge of ideological issues suggested it was up to the people to win back the government's confidence. Brecht replied in a poem.

> After the uprising of June 17
> The Secretary of the Writers' Union
> Had leaflets distributed in the Stalinallee
> In which it was said that the people
> Had lost the government's confidence
> Which it would only be able to regain
> By redoubling its efforts. In that case, would it
> Not be simpler if the government dissolved the people
> And elected another?

Perhaps needless to say, Brecht never published this poem in his lifetime. See John Fuegi, *Brecht and Company: Sex, Politics, and the Making of the Modern Drama* (New York: Grove Press, 1994), p. 549.

12. Daniel Herwitz, *Making Theory/Constructing Art* (Chicago: University of Chicago Press, 1993).

13. Ilya Kabakov, in foreword to Paul R. Jolles, *Memento aus Moskau* (Cologne: Wienand Verlag, 1997). Cited in Boris Groys, "The Movable Cave, or Kabakov's Self-Memorials," in Groys, Ross, and Blazwick, *Ilya Kabakov*, pp. 42-43.

14. Ross interview, p. 13.

15. Storr interview, p. 67.

16. Ross interview, pp. 17-19.

17. Ibid., p. 13.

18. Groys, "The Movable Cave," p. 37.

19. Herbert Marcuse, "The Affirmative Character of Culture," in *Negations: Essays in Critical Theory*, trans. Jeremy J. Shapiro (Boston: Beacon Press, 1968), pp. 88-133.

20. I thank my colleague Henry Teloh for helping me give proper voice to this formulation.

21. Amei Wallach, *Ilya Kabakov: The Man Who Never Threw Anything Away* (New York: Harry N. Abrams Publishers, 1996), p. 115.

22. Jacques Derrida, *Glas*, trans. John P. Leavey, Jr., and Richard Rand (Lincoln: University of Nebraska Press, 1986), and John Berger and Jean Mohr, *Another Way of Telling* (New York: Pantheon Books, 1982).

23. Maurice Merleau-Ponty, "Cézanne's Doubt," in *Sense and Non-sense*, trans. Hubert L. Dreyfus and Patricia Allen Dreyfus (Evanston, Ill.: Northwestern University Press, 1964). Merleau-Ponty describes stunningly the experience of and anxiety about skepticism in Cézanne's painting: "Cézanne does not try to use color to *suggest* the tactile sensations which would give shape and depth. . . . The lived object is not rediscovered or constructed on the basis of the contribution of the senses; rather, it presents itself to us from the start as the center from which these contributions radiate" (p. 15).

24. Thomas Mann, *The Magic Mountain*, trans. John E. Woods (New York: Alfred A. Knopf, 1995) is a perfect test case for the capacity of us moderns to hear lamentation. It is tempting now to read Mann's novel as an allegory of European culture in flight from reality, as if the form of allegory is not itself a mode of distancing characteristic of that very culture. The mountain onto which the lowlanders have retreated in search of cure is the same chilly site from which Mann examines that retreat; if the allegory were to achieve its ends, it could only be in virtue of criticizing the means it uses in that pursuit. Allegory is itself an allegory of bereftness, the mark of the emptying out of the ideal of artistic authenticity. As Freud describes melancholia, "by taking flight into the ego love escapes extinction" ("Mourning and Melancholia," *SE* 14: 257), but in doing so it also annihilates the conditions for the possibility of its satisfaction. So, too, with allegory.

In Mann, the means of novelistic art stand unmasked as the dissembling of alienated subjectivity, and therefore so too does the novel in which that unmasking is performed. The condition of inwardness conceals a longing for life, which, in its presumption that all such longing leads to disappointment, demands an endless stay on the mountain. Mann's seemingly ironic distance from his cast of distant characters strives to give voice to the longing that the characters do not themselves experience, but insofar as *The Magic Mountain* is a product of that same strategy it must remain fearful of doing so. The allegory of loss is the loss of allegory; the shadow of the object has fallen over art, too, and stricken its relation to the world.

Mann is a lamentable modernist, but taking him as affirmative is not simply an error. In preserving the point of view of the subjective inwardness being criticized, Mann maintains a commitment to the resources of culture—reserve, tact, self-control. It is this ambivalence that allowed both Lukács and Adorno to be his admirers: Lukács because Mann seemed an alternative to Beckett's picture of culture as a demolition derby of careening corpses, and Adorno because Mann demolished the possibility of any more affirmative conception of culture. See Georg Lukács, "The Ideology of Modernism," *Realism in Our Time: Literature and the Class Struggle* (New York: Harper and Row, 1964), pp. 17–46, and Adorno, "Extorted Reconciliation." Both were correct. Lamentable modernism refuses to give up on what it knows: as the precondition of its privilege to refuse, it cannot claim achievement for itself. It refuses to give up the impulse to gain distance from the alienated world despite seeing all too clearly that this distance is itself the form

of subjectivity proper to such a world. It is this refusal that Kabakov retrieves from modernist withdrawal.

25. I owe thanks to my colleague Konstantin Kustanovich for his help with the Russian word for *lifeboat*.

26. For a history of this metaphor, see Hans Blumenberg, *Shipwreck with Spectator: Paradigm of a Metaphor for Existence*, trans. Steven Rendall (Cambridge: MIT Press, 1997).

27. Ilya Kabakov, *On the "Total" Installation* (Stuttgart: Cantz, 1995).

28. Siegfried Kracauer, *Theory of Film: The Redemption of Physical Reality* (London: Oxford University Press, 1960), p. 54.

29. Wallace Stevens, "The Man on the Dump," in Holly Stevens, ed., *The Palm at the End of the Mind: Selected Poems and a Play by Wallace Stevens* (New York: Random House, 1972), p. 163.

30. Groys, "The Movable Cave," p. 50.

31. Freud, "Notes upon a Case of Obsessional Neurosis," *SE* 10: 176–77.

32. Nietzsche, *The Birth of Tragedy*, p. 90.

33. Storr interview, p. 68.

Chapter 7: Conclusion

1. The abstractive relation of Richter's technique to his subject matter is humorously exemplified in a two-page spread by the painter Orion Wertz in which he lays out in technical detail, so that anyone can do it, how to make a Richter. I suspect Wertz is trying to make an ironic point about the star system in the art market, but the cartoon comes across only as charming. After all, that anyone can be taught to make a Richter means that the technique is the agency of a beauty that is indifferent to its particular psychological motivations. For Wertz's joke to have a more malicious barb, it would have to convey the thought that only a nonteachable technique could generate art, which is the extreme and incoherent version of Kant's insight into the traumatic scene of artistic instruction. That such a thought expresses the widespread contemporary expectation that artistic beauty must be absolutely distant from instrumental rationality shows how little we have come to expect of everyday life. Orion Wertz, "How to Paint a Richter Abstraction: A Guide for Student Painters," *New Art Examiner* 27, no. 6 (March 2000): 14–15.

2. Adam Phillips, *Darwin's Worms: On Life Stories and Death Stories* (New York: Basic Books, 2000), p. 110.

Index

Abstract Expressionism, 215n13
Addison, Joseph, 201n3
Adorno, Theodor W., 3, 25, 172, 214n7,
 231n24; on Kant, 209n36; on knowledge, 1;
 on reflection, 1, 209n36
aesthetics. *See* modern aesthetic theory;
 philosophy of art
Ainslie, Douglas, 206n29
Alberti, Leon Battista, 11–12, 16, 203nn19,21
Altdorfer, Albrecht, 203n21
Antigone, 151
Arendt, Hannah, 213n20
Ariosto, Ludovico, 98
Aristotle, 10–11, 215n12, 218n2
Arnheim, Rudolf, 225n9
art: as absolute spirit, 214n5; as artifact, 26, 27,
 37–39, 40–43, 75–76; beauty in, 4, 25–28,
 50, 52, 54, 56–59, 60–62, 64–66, 69–70,
 86, 87, 165, 167, 169, 196–97, 212n18, 232n1;
 and contemporary history, 133–35, 140–41;
 crisis of transmission in, 6, 7–8; definitions
 of, 6, 15, 16–17, 205n26; end of, 23, 52,
 59–60, 71–73, 74–77, 82, 85–86, 89–90,
 120–21, 128, 130, 181–83, 191–92, 197; fine
 arts vs. crafts, 11; form in, 67–70, 72,
 75–77, 86–87, 98–99, 100, 102, 119–22,
 125–128, 130, 137–41, 181–82, 217n21; history
 of, 5–6, 8–14, 22–23, 27, 44–53, 55, 71,
 74–77, 81, 87, 118–20, 129, 164, 175–76, 193,
 197–98, 215nn11,13, 216n14, 217n21; idea-
 tional content in, 12–13, 67–70, 72, 75–76,
 86–87, 121, 138, 181–82; marketplace for,
 84–85, 232n1; and memory, 12–13, 19,
 202n10, 205n23; normativity in, 3–4, 23,
 47, 66, 67–68, 72, 89, 164–65; and politics,
 53–54, 203n16; relationship to culture, 3–6,
 13–14, 16–17, 27, 28, 43, 59–60, 69, 89–90;
 relationship to discursive rationality, 59–60,
 179–83; relationship to nature, 47, 49–50,
 52, 57–67, 70–72, 76, 77, 81–82, 87, 93–95,
 121; relationship to the past, 5–6, 23, 171,
 195, 197–98; relationship to philosophy,
 60–62, 87, 90, 182–83, 192–93, 194–95;
 representation in, 99; semblance in, 36,
 60–61, 65, 138, 180, 228n27; and sustaining
 loss, 23; theoreticism in, 179–83, 191–92;
 transmissive function of, 5–18, 23, 27, 28,
 46–50, 52–54, 73–74, 129–30, 132, 202n11,
 203n21, 205n22, 205n27, 206n32; as wish-
 fulfillment, 105–8, 127. *See also* art educa-
 tion; artists; Greek art; modernism, artistic;
 modernist art; philosophy of art
art criticism, 16–17
art education, 40, 48–50, 52–55, 73–74, 232n1
The Art of Hitting, 14
artifactuality, 26, 27, 37–39, 40–43, 75–76
artists: childhood experiences of, 99, 106–8;
 genius among, 27, 28, 39–42, 45–46; inten-
 tions of, 26–27, 111, 112–13, 118–19, 126;
 and irony, 67, 74, 77–82, 181–82; relation-
 ship to society, 39, 172–75; in Soviet Union,
 170–76, 230n8; subjective inwardness
 cultivated by, 174–76, 178–79, 181–82,
 183, 185, 188, 191–93, 231n24; training of,
 40, 48–50, 52–55, 73–74, 232n1
Assman, Jan, 202n10
authoritarianism, 30–32
autonomy, 32–33, 35, 36, 41

Baader, Andreas, 134, 140–41, 158–59, 169
Barker, Pat, 170
Barthes, Roland, 143
Batteux, Charles, 120
The Battle of Issus, 203n21
Baudelaire, Charles, 15, 218n3
Bazin, André, 142

beauty: in art, 4, 25–28, 50, 52, 54, 56–59, 57,
60–62, 64–66, 69–70, 86, 87, 121, 165, 167,
169, 196–97, 212n18, 232n1; in modernist
art, 165, 167, 169, 196–97; in nature, 4,
25–26, 27–28, 29, 35–37, 50, 52, 54, 64,
209n1
Becher, Bernd, 1
Becher, Hilla, 1
Beckett, Samuel, 99, 231n24
Belting, Hans, 205n25
Benjamin, Walter, 56, 131, 218n3, 220n23
Bentham, Jeremy, 151, 153
Berger, John, 180
Bernstein, J. M., 210n10, 213n20, 214n4
Beyond the Pleasure Principle, 122, 124, 125–26,
128, 222nn28,30,34
The Birth of Tragedy, 192, 205n24
Blanchot, Maurice, 99
Bloomsbury group, 98
The Boat of My Life, 185–93, *186, 188, 189,*
195–96
Bonnard, Pierre, 1
Bosanquet, Bernard, 213n1
Bourdieu, Pierre, 206n32
Brecht, Bertholt, 175, 230n11
Breuer, Josef, 221n26
Britton, Ronald, 100–102
Buchloh, Benjamin, 140
Buren, Daniel, 181
Burial at Ornans, 1
Burke, Edmund, 16

Carroll, Noël, 209n2
Caruth, Cathy, 221n28
catharsis, 10
Cézanne, Paul, 3, 51, 176, 185, 231n23
Chagall, Marc, 177
Christianity: and death, 2; Freud on, 122;
Hegel on, 79–80, 95–96; and time,
205n21
Clark, T. J., 85, 216n20, 218n8
Cocteau, Jean, 133
cognition vs. feeling (*aesthesis*), 2–3, 4
Cohen, Ted, 227n21
Collingwood, R. G., 206n29
comic, the, 80. *See also* jokes
commodities, 84–85, 219n9
Confrontation, 161–64, *161, 162, 163*
connoisseurship: Freud on, 110–11, 113–15,
116, 117–22, 127, 132; Hegel on, 74–77, 81,
120, 215nn11,15, 216n14; Kant on, 120
Cornell, Joseph, 1
Courbet, Gustave, 1, 2, 173

"Creative Writers and Day-Dreaming," 99,
101, 102, 106–8, 126
Critique of Practical Reason, 211n12
Critique of Pure Reason, 209nn3,36
Croce, Benedetto, 206n29
culture, 231n24; and artistic modernism,
96–98, 218n3; and death, 222n34; Kant on,
33–37, 43, 45–46, 50–51, 52, 54–55, 195; and
modern aesthetics, 95–96; vs. nature, 9–10,
195; relationship to art, 3–4, 5–6, 13–14,
16–17, 27, 28, 43, 59–60, 69, 89–90; rela-
tionship to philosophy, 95–96; triumphal-
ism in, 92–93, 95–98, 218n3,9

Danto, Arthur, 148, 155
Darwin, Charles, 198
David, Jacques-Louis, 1
The Dead Toreador, 1
death, 130–32, 144–48; and artistic form,
120–22, 125, 138–41; burial rituals, 151–54,
167, *168,* 169; and Christianity, 2; and
culture, 222n34; denial of, 146–48; Freud on,
122, 125, 198, 221n26, 222n34; in modernist
art, 1–2, 23, 24, 134–35, 195; in modernity,
154; of nature, 32–37, 47, 49–50, 52, 54–55,
59–60, 62–63, 64–67, 70–71, 73, 76, 77,
80–82, 87, 93–94, 197, 214n5; and photo-
graphy, 154, 156, 158–59; as unanticipated,
222n28. *See also* memorials; past, the
Death of Marat, 1
De Duve, Thierry, 213n18, 215n13
De pictura, 11–12
Derrida, Jacques, 180
Descartes, René, 207n33
desire: Kant on, 33–34, 224n3; and techniques
of suffering, 149–51, 227n23. *See also* wish-
fulfillment
Dickens, Charles, 133
discursive rationality: relationship to art,
59–60, 179–83; vs. sensuous particularity,
59, 86, 87–88. *See also* spirit
disinterestedness, 29–31, 34–35, 37–38, 65
Dobbs-Weinstein, Idit, 213n20
Doctor Faustus, 51–52
dreams, 100–105, 106–8, 123, 148–51, 220n17,
221n26, 227n21
Duchamp, Marcel, 51, 155, 176

Eakins, Thomas, 1
Edgerton, Samuel Y., 203n17
Egyptians, 151, 153, 202n11
Ellis, Havelock, 103
emotion and form, 135–38

Enlightenment, the, 203n21, 208n35
Ensslin, Gudrun, 134, 140–41, 158–59, 161–65, *161*, *162*, *163*, *166*, 167, 229n31
Euthyphro, 202n7
exile: and *The Boat of My Life*, 186–88, 193; as condition of subjective life, 85–86; from home, 176, 183–85, 191–92; from nature, 71–72, 73, 87, 89; from the past, 82–83, 90, 193; and lamentation, 183–85, 191–92

Faulkner, William, 99
feeling (*aesthesis*) vs. cognition, 2–3, 4
Fichte, Johann Gottlieb, 77–79
Fischer, Ernst, 206n29
Fliess, Wilhelm, 131
form: in art, 67–70, 72, 75–77, 86–87, 98–99, 100, 102, 119–22, 125–28, 130, 137–41, 181–82, 217n21; death and artistic form, 120–22, 125, 138–41; and emotion, 135–38; and movement, 135–40, 145, 169
"Formulations on the Two Principles of Mental Functioning," 101–2
Foucault, Michel, 19, 207n34
Frankfurt School, 201n3
Freedberg, David, 205n25
freedom: of Fichtean ego, 77–79; and judgments of taste, 30–31; Kant on, 30–36, 39, 40–44, 45, 211n12, 212nn13,14, 214n2; relationship to nature, 65, 77–79, 214n2; of spirit, 214nn2,5
Freud, Sigmund, 201n2, 231n24; on alienation, 187; as antitriumphalist, 92–93; and artistic form, 98–99, 100, 102, 119–22, 125, 126–27, 128, 130; attitude toward philosophy, 91–92, 218n2; on Christianity, 122; as collector, 130–32, 191, 197; on connoisseurship, 110–11, 113–15, 116–22, 127, 132; content analysis of art in, 99, 106–19, 134–35; on death, 122, 125, 198, 221n26, 222n34; on dreams, 100–105, 106–8, 123, 148–51, 220n17, 221n26, 227n21; vs. Hegel, 6–7, 20–23, 24, 82, 91, 94, 97–98, 112, 119–20, 127, 129, 197, 214n1, 215n7, 228n29; historical reflection in, 20–23; on instincts, 227n23; on jokes, 148–51; vs. Kant, 6–7, 20–23, 24, 91, 94, 97–98, 119–20, 126, 127, 129, 197; on latent content, 103–6, 107; on Leonardo da Vinci, 98, 99; on manifest content, 103–4; as materialist aesthetician, 24, 119, 127–29, 134–35, 197; on Michelengelo's *Moses*, 109–19; on mourning, 153, 173, 221n25; on narcissism of small differences, 82; on neurosis, 100–103, 122–25, 132, 197, 221n28,

228n23; on parapraxes, 148–51, 227n21; on perceptual identity, 112–13, 220n23; on play, 100–102, 219n15; on pleasure principle, 100–103, 105–6, 107–8, 122–23, 124, 128, 228n23; on psychoanalysis, 91–92, 93, 97–98, 109–10, 112–13, 117–18, 120–23, 125, 128–29, 131–32, 148–51, 218n7, 219n13; on reality principle, 100–103, 105–6, 107–8, 220nn16,19; relationship to artistic modernism, 96–99, 128–30; on repetition, 122, 125–27; on repression, 122; on secondary revision of dreams, 103–4; on sexuality, 220n16, 221n26; on sublimation, 124; on thought identity, 112–13; and transmissive function of art, 16, 18; on traumatic neurosis, 122–25, 221n28, 228n23; on uncanniness, 96, 119, 122, 125–27, 128, 129; on the unconscious, 101–2, 104–5, 122, 131, 148–51, 220n19, 221n26; on wishfulness and wish-fulfillment, 100, 104–6, 124, 127
Freud, Sophie, 221n28
Fried, Michael, 201n4
Funeral, 167, *168*, *169*

Gamwell, Lynn, 131
Gangster Funeral, 1
garbage: Kabakov's use of, 171, 178, 189–91, 192, 197; as negative image of future, 190–91; the past as, 189–91, 193; sensuous experience as, 181
genius, 27, 28, 39–40, 41–42, 45–46
Giotto, 203n19, 215n13
Godard, Jean-Luc, 144
Goethe, Johann Wolfgang von, 98
Gombrich, Ernst H., 9, 155, 202n11, 215n11, 217n21, 219n15, 228n26
Goodman, Nelson, 205n26
Greek art: Aristotle on, 10–11, 215n12, 218n2; Hegel on, 3, 69, 138; Homer, 8–9, 202nn7,8; and memory, 202n10; Nietzsche on, 3, 9–10, 15, 205n24; Plato on, 8–10, 14–15, 17, 180, 192, 202nn7,11, 215n12; as transmissive, 8–11, 202nn7,11
Greenberg, Clement, 3, 174
grief. *See* mourning
The Gross Clinic, 1
Groys, Boris, 178
Guernica, 1
guilt for murder of nature, 62–63, 67, 70–72
Guyer, Paul, 209n1

Haacke, Hans, 181
Habermas, Jürgen, 215n7

Hammons, David, 1
Hanged, 165, *166*, 167
Hauser, Arnold, 206n32
Hegel, G. W. F., 196; on art as absolute spirit, 214n5; on artistic beauty, 56–59, 61–62, 64, 65–66, 121; on art as thing of past, 23, 52, 59–60, 71–73, 74–77, 82, 85–86, 89–90, 120–21, 128, 181–83, 191–92, 197; on Christianity, 79–80, 95–96; on connoisseurship, 74–77, 81, 120, 215nn11,15, 216n14; on Fichte, 77–79; vs. Freud, 6–7, 20–23, 24, 82, 91, 94, 97–98, 112, 119–20, 127, 129, 197, 214n1, 215n7, 228n29; on Greek art, 3, 69, 138; historical reflection in, 20–23; on ideational content of art, 67–70, 72, 75–76, 86–87, 181–82; on irony, 67, 74, 77–82, 85–86, 87, 90, 181–82; vs. Kant, 6–7, 20–23, 24, 62, 74, 90, 93–98, 119–21, 127, 129, 197, 205n27; as materialist aesthetician, 24, 93–95, 127–29, 197; on natural beauty, 26, 56–59, 64; ontological distinctness of art in, 205n27; philosophical aesthetics of, 56–59, 70–71, 73, 74, 85–89; on relationship between art and nature, 57–67; on sensuous form in art, 68–70, 72, 75–77, 86–87, 138, 181–82; and transmissive function of art, 15–16, 18; on Winckelmann, 120
Heine, Heinrich, 91–92
Herodotus, 10–11, 202n8
Herwitz, Daniel, 175
Hesiod, 202n8
history: of art, 5–6, 8–14, 22–23, 27, 44–53, 55, 71, 74–77, 81, 87, 118–20, 129, 164, 175–76, 193, 197–98, 215nn11,13, 216n14, 217n21; discontinuities in, 18–19; and normativity, 19–20; vs. poetry, 10–11; reflection on, 20–23; relationship to modernity, 19–20; transcendence of, 22–23
Homans, Peter, 218n7
Homer, 8–9, 202nn7,8
Hume, David, 16, 210n4
Hutcheson, Francis, 201n3

idealism, 6–7, 24, 39, 43–44, 77–79, 129, 214n2
identity, 7, 18–19
The Interpretation of Dreams, 91–92, 103–5, 108, 218n2, 221n26
Ion, 8–9, 180, 202n7
irony: and artists, 67, 74, 77–82, 181–82; Hegel on, 67, 74, 77–82, 85–86, 87, 90, 181–82; and modernity, 82
isolation, 173–74

Jensen, Wilhelm, 222n33
jokes, 9, 80, 146–51, 154, 226n18, 227n21
Joyce, James, 99
judgments of taste: and freedom, 30–31; Kant on, 2–3, 25–26, 27, 28–38, 45–46, 50, 207n32, 209n1, 210n8; and normativity, 3–4, 28–30; objectivity in, 28–29, 34–35; and social practice, 3–4; subjectivity in, 28–29, 34–35; as universal, 28, 34–35, 37, 210n8. *See also* modern aesthetic theory

Kabakov, Ilya, 1, 6; as artist/theorist, 179–81; *The Boat of My Life*, 185–93, *186*, *188*, *189*, 195–96; as disenchanted with artistic modernism, 171, 178–79, 183, 191–93, 232n24; as garbage artist, 171, 178, 189–91, 192, 197; and lamentation, 183–85, 188, 191–92; *The Life of the Flies*, 185; and modern aesthetics, 7–8, 24; *NOMA*, 185; *School No. 6*, 178, 185; on Soviet artists, 170, 171–72, 174–76, 230n8; *Ten Characters*, 171; *The Toilet*, 178, 189; and transmissive crisis in art, 7–8
Kafka, Franz, 99, 198
Kandinsky, Wassily, 177
Kant, Immanuel, 209nn1,2, 211n10, 218n2; on art education, 40, 48–50, 52–55, 73–74, 232n1; on artistic beauty, 25–28, 50, 52, 54, 121, 212n18; and artistic modernism, 26, 27, 48, 50–51, 52, 54, 55, 108, 195, 196, 197, 212n18; on authoritarianism, 30–32; on autonomous subjects, 32–33, 35, 36, 41; on connoisseurship, 120; *Critique of Practical Reason*, 211n12; *Critique of Pure Reason*, 209nn3,36; on culture of discipline, 33–37, 43, 45–46, 50–51, 52, 54–55, 195; on desires/wishes, 33–34, 224n3; on disinterested pleasure, 29–31, 34–35, 37–38; on Enlightenment, 208n35; on following vs. copying, 46–50, 212n15; on freedom, 30–36, 39, 40–44, 45, 211n12, 212nn13,14, 214n2; vs. Freud, 6–7, 20–23, 24, 91, 94, 97–98, 119–20, 126, 127, 129, 197; on genius, 27, 28, 39–40, 41–42, 45–46; vs. Hegel, 6–7, 20–23, 24, 62, 74, 90, 93–98, 119–21, 127, 129, 197, 205n27; historical reflection in, 20–23; and idealism, 6–7, 24; on judgments of taste, 2–3, 25–26, 27, 28–38, 45–46, 50, 207n32, 209n1, 210n8; as materialist aesthetician, 24, 93–95, 127–29, 197; on mechanism, 28, 40–44, 45, 212n14; on the moral law, 32–34, 211n12; on natural beauty, 25–26, 27, 35–37, 50, 52, 54, 209n1;

ontological distinctness of art in, 205n27; on politics, 53–54, 198, 208n35, 213n20; on purposiveness, 37–39, 40, 43, 212n13; and transmissive function of art, 16, 18; on universality of judgments of taste, 28, 34–35, 37, 210n8
Kaprow, Allan, 171, 212n17
Kemp, Anthony, 204n
Kierkegaard, Sĩren, 96, 214n7
Kipling, Rudyard, 98
knowledge: Adorno on, 1; Bernstein on, 211n11; vs. feeling, 2–3; and the past, 1; as transmitted by art, 5–18; as transmitted by philosophy, 17–18, 207n33
Komar, Vitaly, 170, 176
Koselleck, Reinhart, 203n21
Kracauer, Siegfried, 190
Kruger, Barbara, 178

lamentation, 183–85, 188, 191–92, 231n24
Langer, Suzanne, 206n29
Lenin, V. I., 151, 153
Leonardo da Vinci, 16, 98
Lermolieff, Ivan, 117–18
Lessing, Gotthold Ephraim, 120
Lowenthal, David, 204n
Lukács, György, 231n24

The Magic Mountain, 185, 231n24
Malevich, Kazimir, 230n8
Manet, Édouard, 1
Mann, Thomas, 51–52, 98, 99, 185, 231n24
Martin, Agnes, 2
Marx, Karl, 72, 91, 93, 130, 187, 218n9
materialism in aesthetics, 4–5, 24, 93–95, 119–20, 127–29, 134–35, 196, 197
Matisse, Henri, 2
McDowell, John, 214n2
mechanism, 28, 40–43, 44–45, 212n14
Meinhof, Ulrike, 134, 158–61, 160, 162
Meins, Holger, 134, 158–59
Meiss, Millard, 203n19
Melamid, Alexander, 170, 176
memorials: funerary monuments, 12–13, 138–41, 142–43, 205n22, 224n4,5, 226n16; and mourning, 142–43; and photography, 141–45
memory: and art, 12–13, 19, 202n10, 205n23; and mourning, 153–54; and photography, 145; and reflection on history, 21, 23
Merleau-Ponty, Maurice, 185, 231n23
Michelangelo, 98, 109–19
Middle Ages vs. Renaissance, 204n

Mill, John Stuart, 218n2
mind. See spirit
modern aesthetic theory: artistic beauty vs. natural beauty in, 4, 25–26, 27, 50, 54, 56–59, 64; and culture, 95–96; definition of, 201n3; and Kabakov, 7–8, 24; and lack of transcendence, 2–3, 4–5, 22–23; materialism in, 4–5, 24, 93–95, 119–20, 127–29, 134–35, 196, 197; mournfulness in, 87, 88–90, 120, 121–22, 125, 129, 198; and the past, 4–5; relationship to modernist art, 2–5, 6, 7–8, 23–24, 194–96; relationship to psychoanalysis, 117–18, 120–23, 125, 128; and Richter, 7–8, 24; and subjectivism, 201n3; and transmissive crisis in art, 6, 7–8, 16–17. See also Freud, Sigmund; Hegel, G. W. F.; judgments of taste; Kant, Immanuel; philosophy; philosophy of art
modernism, artistic: and culture, 96–98, 218n3; innovation in, 51, 98–99, 164, 174–76, 198, 229n8; Kabakov's disenchantment with, 171, 178–79, 183, 191–93, 232n24; and Kant, 26, 27, 48, 50–51, 52, 54, 55, 108, 195, 196, 197, 212n18; and lamentation, 183–85, 188, 191–92, 231n24; mournfulness in, 23, 130; vs. postmodernism, 176, 178, 180, 181, 193; relationship to Freud, 96–99, 128–30; relationship to history of art, 118–19, 129, 164, 197–98; subjective inwardness in, 174–76, 178–79, 181–82, 183, 185, 188, 191–93, 231n24. See also modernist art
modernist art, 218n8; the avant-garde in, 174–76, 229n8; beauty in, 165–69, 196–97; death in, 1–2, 23, 24, 134–35, 195; and lack of transcendence, 2, 198; marketplace for, 84–85; relationship to history, 19–20, 171, 230n8; relationship to modern aesthetic theory, 2–5, 6–8, 23–24, 194–96; relationship to the past, 23, 171, 195, 197, 198; relationship to society, 3–4, 13–14, 39, 172–75; theoreticism in, 179–81; and transmissive crisis in art, 6. See also modernism, artistic
modernity: art in, 59–60, 72–74, 86; death in, 154; identity in, 7; and irony, 82; noninheritance in, 19–20; and normativity, 19–20, 82–84; particularity and universality in, 84–85, 88–89; and psychoanalysis, 93, 218n7; relationship to the past, 82–84, 129–30, 154, 193, 194, 197–98; and sustaining loss, 20. See also modern aesthetic theory; modernism, artistic; modernist art
Moholy-Nagy, László, 229n8

"Moses and Michelangelo," 109–19
mournfulness, 127, 130, 132, 154, 218n3; in
 aesthetic theory, 87, 88–90, 120, 121–22,
 125, 129, 198; in artistic modernism, 23, 130
mourning: and burial rituals, 152, 153–54;
 Freud on, 153, 173, 221n25; as impeded, 141,
 145–46, 226n16; lamentation as, 184; and
 memorials, 142–43; as socially necessary, 173
movement and form, 135–40, 145, 169

nature: beauty in, 4, 25–26, 27–28, 29, 35–37,
 50, 52, 54, 64, 209n1; vs. culture, 9–10, 195;
 death of, 32–37, 47, 49–50, 52, 54–55,
 59–60, 62–63, 64–67, 70–71, 73, 76, 77,
 80–82, 87, 93–94, 197, 214n5; and desire/
 wishing, 224n3; as external, 63–64; guilt
 of spirit for murder of, 62–63, 67, 70–72;
 normativity of, 62, 64, 67, 71, 72, 73;
 relationship to art, 47, 49–50, 52, 57–67,
 70–72, 76, 77, 81–82, 87, 93–95, 121; rela-
 tionship to freedom, 65, 77–79, 214n2;
 relationship to spirit, 40–43, 44–45, 49–50,
 61–67, 68–72, 80–81, 87–90, 138, 182–83,
 188, 214n2
Neizvestny, Ernst, 170
neurosis, 100–103, 122–25, 132, 197, 221n28,
 228n23
Newman, Barnett, 229n7
Nietzsche, Friedrich, 96, 218n2, 219n9; on
 Apollonian culture, 83; on Greek art, 3,
 9–10, 15, 205n24; on Plato, 192; and trans-
 missive function of art, 15–16
normativity: in art, 3–4, 23, 47, 66, 67–68, 89,
 164–65; and history, 19–20; and judgments
 of taste, 3–4, 28–30; loss of, 33, 45, 78–79,
 80–81, 87, 89; and modernity, 19–20,
 82–84; of nature, 62, 64, 67, 71, 72, 73;
 of the past, 83; in politics, 53–54, 213n20
Nude in Bathtub, 1

O'Connor, Flannery, 73

painting: Alberti on, 11–12, 203n19; as
 pedagogical, 9; vs. photography, 154–56,
 158, 164–65, 167, 169, 228n26, 229n32
parapraxes, 148–51, 227n21
past, the: estrangement from, 17; as garbage,
 189–91, 193; and knowledge, 1; and modern
 aesthetic theory, 4–5; normativity of, 83;
 relationship to art, 5–6, 23, 171, 195, 197–98;
 relationship to future, 5–8, 11–12, 13–14,
 16–17, 21–22, 23, 50, 55, 91, 143–44, 170,
 190–91, 193, 195–96, 198, 245; relationship

to modernist art, 23, 171, 195, 197, 198;
 relationship to modernity, 82–84, 129–30,
 154, 193, 194, 197–98; relationship to
 present, 19–23, 56, 71–74, 82–84, 91, 92–93,
 122–25, 129–32, 143–48, 150, 151–54, 169,
 170, 171, 187–91, 193, 194, 197–98, 203n21,
 222n28. See also death
Petrarch, 204n
Phillips, Adam, 137, 198
philosophy: Freud's attitude toward, 91–92,
 218n2; relationship to art, 60–62, 87, 90,
 182–83, 192–93, 194–95; relationship to
 culture, 95–96; and transmission of
 knowledge, 17–18, 207n33; and truth, 17–18,
 207n33. See also modern aesthetic theory
philosophy of art: definitions of art in, 6, 15,
 16–17; Hegel on, 56–59, 70–71, 73, 74,
 85–86, 87, 88–89; and transmissive function
 of art, 8–11, 14–18. See also modern aesthetic
 theory
photography, 225nn9,10,13; and death, 154,
 156, 158–59; and memorials, 141–45; vs.
 painting, 154–56, 158, 164–65, 167, 169,
 228n26, 229n32
Picasso, Pablo, 1
Pippin, Robert, 214nn2,7
Plato, 194, 205n24, 207n33, 218n2; on art,
 8–10, 14–15, 17, 180, 192, 202nn7,11, 215n12
pleasure principle, 100–103, 105–6, 107–8,
 122–23, 124, 128, 228n23
Pluhar, Werner S., 212n15
poetry, 8–11, 205n24; vs. history, 10–11;
 Homer, 8–9, 202nn7,8
politics, 53–54, 198, 203n16, 208n35, 213n20,
 218n9
Pollock, Jackson, 215n13
postmodernism, 176, 178, 180, 181, 193

Raspe, Jan-Carl, 134, 140–41, 158–59, 169
Rauschenberg, Robert, 171
reality principle, 100–103, 105–6, 107–8,
 220nn16,19
reason. See discursive rationality
reconciliation of spirit and nature, 87–90,
 182–83
reflection: Adorno on, 1, 209n36; on art, 5–6,
 15–18, 16–17, 110–15, 179–83; on history,
 20–23. See also modern aesthetic theory;
 philosophy of art
Renaissance, the, 3, 16, 203n21, 204n
The Republic, 9
Richter, Gerhard, 1, 6, 137, 145, 196–97;
 Confrontation, 161–64, 161, 162, 163;

"Documenta IX," 140; on Duchamp's Readymades, 155; *Funeral*, 167, *168, 169*; *Hanged*, 165, *166*, 167; and modern aesthetic theory, 7–8, 24; *October 18, 1977*, 133–35, 136–37, 140–41, 151, 158–65, *160, 161, 162, 163, 166*, 167, *168*, 169, 229nn31,32; *Skull with Candle*, 156–58, *157*; and transmissive crisis in art, 7–8; *Two Sculptures for a Room by Palermo*, 140; Wertz on, 232n1; *Youth Portrait*, 159–61, *160*, 162, 164

Rimbaud, Arthur, 51
romanticism, 36, 39, 43–44
Rosenberg, Harold, 206n29
Rot, Dieter, 171
Rousseau, Jean-Jacques, 55
Ryman, Robert, 1

Salle, David, 178
Santayana, George, 82, 210n4
Saturday Disaster, 1
Schelling, Friedrich Wilhelm Joseph von, 214n7
Schiller, Friedrich, 3, 98, 228n27
Schlegel, August Wilhelm von, 203n21
Schlindler's List, 144
Schopenhauer, Arthur, 15–16, 96, 214n7, 218n2
Schwitters, Kurt, 171
Scruton, Roger, 225n9
sculpture, 9
Segal, Hanna, 220n17
semblance: in art, 36, 60–61, 65, 138, 180, 228n27; world as, 78
Shakespeare, William, 98
Sherman, Cindy, 1
Skull with Candle, 156–58, *157*
Socrates, 8–9, 180, 192, 202n7
Solzhenitsyn, Alexander, 176
spirit: and artistic beauty, 57, 60–61, 69–70, 86, 87; as free, 214nn2,5; as guilty of nature's murder, 62–63, 67, 70–72; nature of, 57, 213n1, 214n2; relationship to mechanism, 40–43, 44–45; relationship to nature, 40–43, 44–45, 49–50, 61–67, 68–72, 80–81, 87–90, 138, 182–83, 188, 214n2

Stella, Frank, 213n18
Stevens, Wallace, 85, 216n20
Summers, David, 12
surrealism, 98

Tatlin, Vladimir, 230n8
techniques of suffering, 149–54
Thucydides, 11
The Toilet, 178, 189
tragedy, 9–11, 192
transcendence: of history, 22–23; and modern aesthetic theory, 2–3, 4–5, 22–23; and modernist art, 2, 198
traumatic neurosis, 122–25, 221n28, 228n23
The Trout, 1, 2, 173
truth: in history, 4, 201n2; and philosophy, 17–18, 207n33
Twain, Mark, 98

The Uncanny, 122, 125–27, 128, 222n30
unconscious, the, 101–2, 104–5, 122, 131, 148–51, 220n19, 221n26
Untitled (Bébé Marie), 1

Vasari, Giorgio, 16, 48, 203n16

Wagner, Richard, 192
Wall, Jeff, 1
Warhol, Andy, 1
Wartofsky, Marx, 205n26
Weber, Max, 183
Wertz, Orion, 232n1
Williams, Ted, 14
Winckelmann, Johann, 120
wish-fulfillment, 22, 135–36, 145; art as, 105–8, 127; Freud on wishfulness and, 100, 104–8, 124, 127
Wollheim, Richard, 219n13

Yerushalmi, Yosef Hayim, 216n16
Youth Portrait, 159–61, *160*, 162, 164

Žižek, Slavoj, 149
Zola, Émile, 98

Atopia: Philosophy, Political Theory, Aesthetics

Gregg M. Horowitz, *Sustaining Loss: Art and Mournful Life*

Robert Gooding-Williams, *Zarathustra's Dionysian Modernism*

Denise Riley, *The Words of Selves: Identification, Solidarity, Irony*

James Swenson, *On Jean-Jacques Rousseau: Considered as One of the First Authors of the Revolution*